ABSTRACT ... CAN ... SM

TATE GALLERY LIVERPOOL CRITICAL FORUM

Acknowledgment
The Editorial Board gratefully acknowledges
the financial contribution of the Eleanor
Rathbone Charitable Trust to the staging of
the Critical Forum Symposium which
initiated this collection of essays.

AMERICAN ABSTRACT EXPRESSIONISM

Editor DAVID THISTLEWOOD
Critical Forum Coordinator ANNE MACPHEE

LIVERPOOL UNIVERSITY PRESS and TATE GALLERY LIVERPOOL

First published 1993 by
Liverpool University Press
PO Box 147
Liverpool
L69 3BX
and
Tate Gallery Liverpool
Albert Dock
Liverpool
L3 4BB

British Library Cataloguing-in-Publication Data
A British Library CIP Record is available
ISBN 0 85323 338 1

Set in 11/13pt Linotron 202 Bembo by
Wilmaset Limited, Birkenhead, Wirral
Printed and bound by
Henry Ling Limited,
The Dorset Press, Dorchester

CONTENTS

ILLUSTRATIONS

1 ADOLPH GOTTLIEB; *Labyrinth No. 2*, 1950; oil on canvas 914 x 1219mm; Tate Gallery, purchased 1980; T03095.

2 JACKSON POLLOCK; *Birth*, c. 1938–41; oil on canvas 1164 x 551mm; Tate Gallery, purchased 1985, T03979. © 1993 Pollock Krasner Foundation/ARS, New York.

3 JACKSON POLLOCK; *Yellow Islands*, 1952; oil on canvas 1435 x 1854mm; Tate Gallery, presented by Friends of the Tate Gallery (purchased out of funds provided by Mr and Mrs H J Heinz II and H J Heinz Co. Ltd.) 1961; T00436. © 1993 Pollock Krasner Foundation/ARS, New York.

4 ARSHILE GORKY; *Waterfall*, 1943; oil on canvas 1537 x 1130mm; Tate Gallery, purchased with assistance from Friends of the Tate Gallery 1971; T01309. © ADAGP, Paris and DACS, London 1993.

5 FRANZ KLINE; *Meryon*, 1960–1; oil on canvas 2359 x 1956mm; Tate Gallery, purchased 1967; T00926.

6 WILLEM DE KOONING; *Women Singing II*, 1966; oil on paper mounted on canvas 914 x 610mm; Tate Gallery, presented by the artist through the American Federation of Arts 1970; T01178. © 1993 Willem de Kooning/ARS, New York.

7 HANS NAMUTH; photograph of Jackson Pollock, *Art News*, Vol. 50, No. 3, May1950.©EstateofHansNamuth/DACS,London/VAGA,NewYork1993.

8 HANS NAMUTH; photograph of Jackson Pollock, *Art News*, Vol. 50, No. 3, May1950.©EstateofHansNamuth/DACS,London/VAGA,NewYork1993.

9 JACKSON POLLOCK; *Number 14*, 1951; enamel on canvas 1465 x 2695mm; Tate Gallery, purchased with assistance from the American Fellows of the Tate Gallery Foundation 1988; T03978. ©1993 Pollock Krasner Foundation/ARS, New York.

10 PHILIP GUSTON; *Black Sea*, 1977; Tate Gallery, purchased 1982, T03364.

11 BARNETT NEWMAN; *Eve*, 1950; oil on canvas 2388 x 1721mm; Tate Gallery, purchased 1980; T03081.

12 CLYFFORD STILL; *1953*, 1953; oil on canvas 2359 x 1740mm; Tate Gallery, purchased 1971; T01498.

13 BERNARD PERLIN; *Orthodox Boys*, 1948; Tate Gallery, presented by Lincoln Kirstein through the Institute of Contemporary Arts 1950; N05956.

CONTRIBUTORS

DAVID THISTLEWOOD, Reader, School of Architecture, University of Liverpool.

DAVID ANFAM, National Gallery of Art, Washington DC.

DAVID CRAVEN, Associate Professor of Art History, Department of Art and Art History, University of New Mexico, Albuquerque.

ANN GIBSON, Associate Professor of Art History, State University of New York, Stonybrook.

JONATHAN HARRIS, Senior Lecturer in Art History, Leeds Metropolitan University.

CHARLES HARRISON, Reader and Staff Tutor in History of Art, Open University.

NANCY JACHEC, Department of Art History, University College London.

FRED ORTON, Senior Lecturer in Fine Art, University of Leeds.

PHYLLIS ROSENZWEIG, Associate Curator, Hirshhorn Museum and Sculpture Garden, Smithsonian Institution, Washington DC.

ANNE MACPHEE, Lecturer in Art and History of Art, University of Liverpool/ Tate Gallery Liverpool.

Introduction

DAVID THISTLEWOOD
Historicity and Mythology in American Abstract Expressionism

From 10 March 1992 until 10 January 1993 the Tate Gallery Liverpool (TGL) presented an exhibition entitled *Myth-Making: Abstract Expressionist Painting from the United States*. It comprised twenty-one works by thirteen painters [1] including Adolph Gottlieb, Jackson Pollock, Arshile Gorky, Franz Kline and Willem de Kooning, who, despite their differences, are conventionally regarded as belonging to a general movement (Figs. 1–6; see also Appendix). During the course of the exhibition the Gallery held a one-day symposium, involving speakers from the international community of scholarship in American Abstract Expressionism [2]. Its objectives were (i) to elicit new observations, critical judgments and proposals from the field of Abstract Expressionism knowledge and perhaps challenge some of its prevailing conventions, and (ii) to debate the role of the TGL as a *modifier* of this field of knowledge through its acts of exposition [3].

Institutional complicity in the formation of art history (or histories) is a relatively neglected subject within a discipline in which virtually every other question—down to the smallest details of documentary and technical evidence—is endlessly rehearsed. Art history may be regarded as a construct of 'truths', each of which is to some degree provisional, each relying for its validity on relationships with others. As all of these 'truths' are subject to continuous academic scrutiny and questioning, their individual degrees of validity fluctuate, giving rise to a *dynamic* within the construct as a whole. The role of the art museum [4], as an agency in the establishment of 'truths', is correspondingly active.

When art history is regarded as a 'science' of conventionalised principles and practices, this dynamic is far less evident. Convention requires a largely unquestioned body of extant knowledge about the art of the past which provides an effective criterion for judging the quality of the relatively-recent and for determining admission to the canon of the 'authentic'. There are many contexts within which this view of art history persists. The role of the art museum here is *revisory* and *supplementary*—it improves familiarity with what is regarded as *the known* while perhaps adding increments of scholarship that are assimilable to it without challenging its canonical authority.

However, in accommodating newer models of art history the art museum is *revisionist* and *questioning*. In fact there is little precise agreement about its purposes

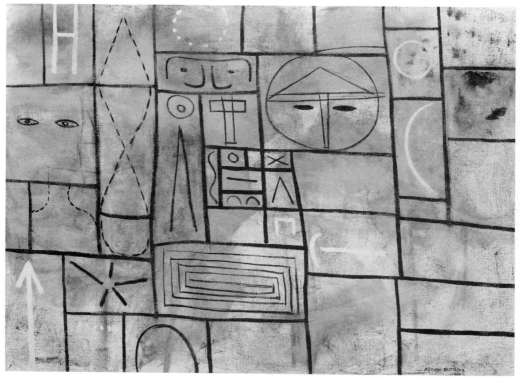

Fig. 1 ADOLPH GOTTLIEB *Labyrinth No. 2* 1950

in contemporaneity, and it is probably unsafe even to hazard the following tentative summary. The art museum brings artworks and related, illuminating phenomena into conjunctions that *condense* knowledge about art and artists. On the objective side of this equation the art museum's purview is aesthetic and technical; on the human side it features artists' individual and collective circumstances and the tasks they seem (sometimes profess) to set themselves. The two sides overlap in consideration of evidence of artistic accomplishment in sequences of works perceived as embodying 'durations' of ideas or strategies of creative development.

This bare description characterises the art museum's interests as evidential and interpretative—interests which are *dynamic* because interpretations change with the ebb and flow of evidence. Interpretations of artists' 'intentionality' and the 'problematics' they engage are prone to fluctuation, especially when art historians enter the realm of informed speculation—for example, concerning artists' tacit, unconscious, or simply unacknowledged, purposes.

The art museum's role here is both vital and perilous: *vital* because along with the conference and the learned journal it is an indispensable agent of knowledge transmission; *perilous* because every new 'truth' it provisionally fixes is likely to challenge the validity of others within the construct at large. Its new role is thus

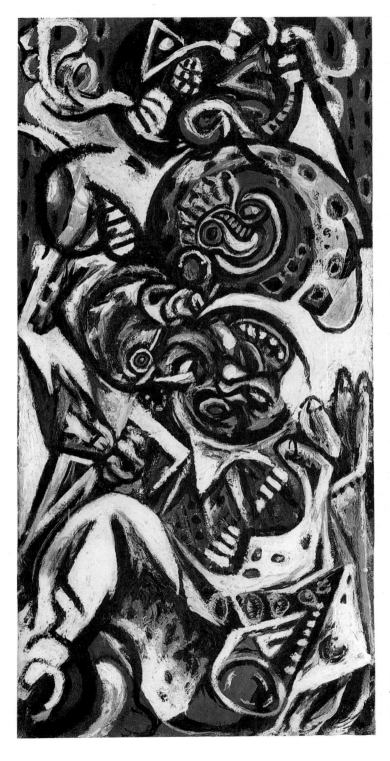

Fig. 2
JACKSON POLLOCK
Birth c. 1938–41 ©1993
Pollock Krasner Founda-
tion/ARS, New York

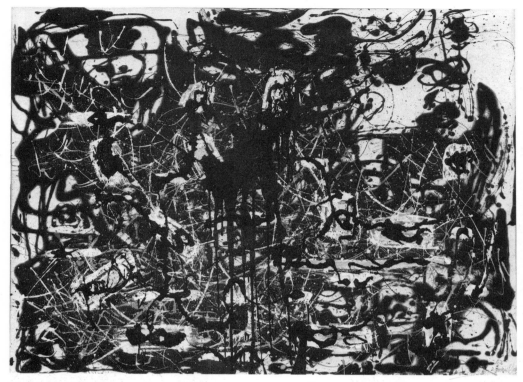

Fig. 3 JACKSON POLLOCK *Yellow Islands* 1952 ©1993 Pollock Krasner Foundation/
ARS, New York

controversial for it is actively involved in dispensing, questioning and trading
validity within the field of principles that presently constitute art historical and
critical knowledge. This is not to say that it functions as an academy, for it is of
course art historians as *individuals* (including museum curators and educationists
when they function as historiographers) who are the main participants in this
discourse. However, to the degree to which art historians make use of the art
museum as a condenser of their exchanges, these exchanges become depersona-
lised and indeed dignified by the reputation of the institution concerned.

 Within the (small) community of art historians the arising 'truths' are 'persona-
lised': convincing paradigms, interpretations and critiques are attributed to those
who insert them into the prevailing discourse. For the great majority of people
outside this community of interest, however, the 'truths' of art history are
fundamentally depersonalised: authentication is given by the institution that
provides witness. Depersonalised (relieved of their associations with the specific
preoccupations of art historians), these 'truths' are in effect mythologised. In this
form they are not spurned by art historians but rather accepted as evidence of vital
cultural necessity or potency. The art museum is therefore implicated in the

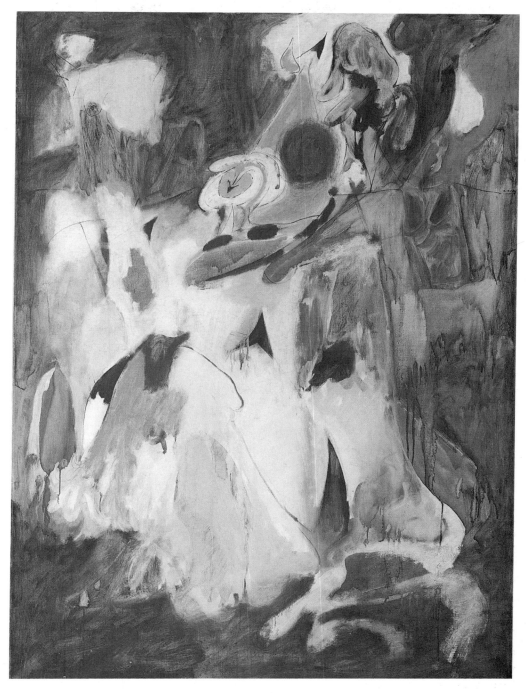

Fig. 4 ARSHILE GORKY *Waterfall* 1943 ©ADAGP Paris and DACS London 1993

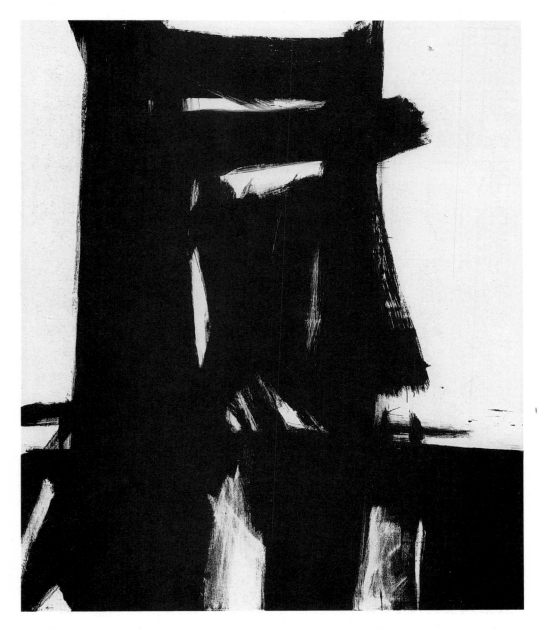

Fig. 5 FRANZ KLINE *Meryon* 1960–1

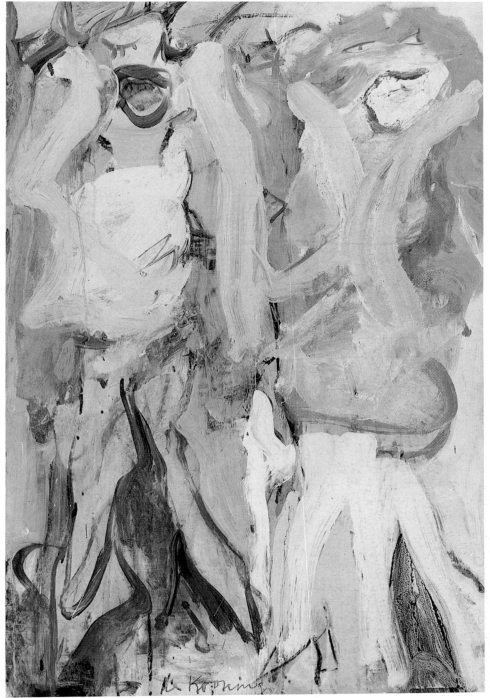

Fig. 6 WILLEM DE KOONING *Women Singing II* 1966 ©1993 Willem de Kooning/ARS, New York

generation and dissemination of 'myths' in a most active way. This is more than analogy: art historical 'truths' are condensed in the art museum, depersonalised, and located within a flux of meaning that is *characteristically* mythological in the sense of being both profound and indeterminate.

In presenting an exhibition of American Abstract Expressionist paintings, the TGL was handling a cultural phenomenon of high mythological significance. American Abstract Expressionism has the status of a threshold event in the history of the avant-garde 'project'. It is regarded by many art historians as mid-century's equivalent of Analytical Cubism in the way in which it seemed to illuminate new aesthetic problematics and demand novel paradigms for their explanation. It is associated with the politicisation of art during the Cold War, its images symbolising patriotic nationhood (alternatively, protest against American imperialism) while its originators were regarded as enemies of (ambassadors for) the state. It conjures up notions of artists recording on canvas their own self-destruction as they abused their minds and bodies in order to win icons. It was both apparently de-skilled and yet beyond the competencies of all but a precious few. Its objective remains are legendary—they locate in an era that is continuously recalled because of its attendant triumphalism—and the acts of their creation must forever be ritualised in repair and conservation because of an inherent vulnerability to decay. American Abstract Expressionism is thus a highly active and competitive locus of aesthetics, politics and psychology. It does not age gracefully but shocks the fabric of art history with emergent 'truths' long after later movements have subsided into relative consensus. In dealing with such a potent cultural phenomenon the curatorial and educational staff of the TGL were concerned to ensure that adjustments to the field of Abstract Expressionism's meaning and interpretation *that would inevitably arise from this particular exhibition* should be explicit. The selection of twenty-one images to represent all that is associable with American Abstract Expressionist painting was itself an act of modification. It highlighted the fact that all exhibitions are reductivist: simplifying by exclusion; divorcing works from proximate frames of meaning; presenting stages in creative developments as if they were goals. This is what art museums do: they condense, dislocate, reorder (fictionalise) and mythologise. It was decided that as this process is inevitable it should be *open*, and that similar transparency be encouraged in respect of future concentrations of objects of comparably powerful mythologies [5]. Hence this volume initiates a series in which the TGL and the University of Liverpool collaborate to focus attention on the dynamic construction of art histories as stimulated by the act of exposition.

If the present enterprise is to be regarded as representative, future symposia and their resulting publications will condense four identifiably distinct aspects of the process of historicising. These are: (i) the offering of new factual or interpretative information to an existing field of art historical and critical knowledge without necessarily speculating on the consequences for that field; (ii) critical reflection on individual art historians' achievements of historicising, implicitly or explicitly

requiring reappraisal of the field; (iii) reflection on already-mythologised aspects of the canon of art under consideration; and (iv) awareness of the act of bringing into conjunction the mythologised phenomena and the mythologising institution.

The first two of these categories constitute the personalised realm of art history and they characterise the normal exchanges of 'insiders'. They comprise observational data, hypotheses and informed speculation, and their first purpose is to sustain the dynamics of critical discourse within the community of art historians. They remain personalised by virtue of the academic convention of crediting individuals' abilities to construct models of explanation that are accepted into and endure within the material consensus. The archetypal example of this is a model pedigree for early C20th avant-garde art that afforded progenitive significance to Analytical Cubism, and which still memorialises its originator, Alfred Barr [6].

The third and fourth categories of the process of historicising constitute the depersonalised or 'mythologised' realm and affect deeply the percolation of histories into the culture at large. They are characterised by questions that run laterally across the field of art historical enterprise, and in the specific instance of the exhibition *Myth-Making: Abstract Expressionist Painting from the United States* they include the following. What is the effect of the conjunction of two cultural projects, Abstract Expressionism and the TGL, each of which is a product of distinct and powerful sociopolitical interests? Can dissemination be *disinterested*, or does the conjunction contribute to some *strategic* development of the 'mythology' of American Abstract Expressionism? If so, would the mythologising effect of siting representative works in Liverpool be consequentially (because ideologically) different from exhibiting them in, say, Moscow or Paris?

It was not supposed that the symposium, this resulting publication, or the series it inaugurates would provide decisive answers to such questions as these, but it was a prime intention to *articulate* them by encouraging 'conjunctions' of the four categories of historicising in relation to contentious subject matter. It was hoped that the result would be to 'freeze', for close inspection, the mythologising of American Abstract Expressionism as it is currently taking place. What has emerged on this occasion is an image not unlike a canonic work of Abstract Expressionism—a stage arrested from within a process of argument and debate, suggestion and refutation, theoretical advance and retreat, that characterises the continuing mythologising.

This is a concentrated representation of what is continuously happening as historians and critics do their work, make discoveries and construct interpretations, test old models of explication and, when these fail, offer new ones that impart significant order to staked-out portions of the art historical and critical field. Many would say this is an inappropriate analogy—it is more like an ecology in which every act of expansion or contraction demands adjustment throughout the whole organism. Thus this collection of essays may be read as individual examples of scholarship responding to aesthetic and documentary evidence; but it also provides admission to the dynamic give-and-take that ultimately resolves into

'mythology'—what remains when individual scholarship becomes depersonalised by countless shadings into consensus.

An example of an interpretative contribution that will reverberate across the art historical and critical field with differential effect is offered in the first essay following this introduction. Here David Anfam notes that the historicising of Abstract Expressionism has virtually neglected questions of *narrative* intentionality or content, but he proposes that a complete critique of the idiom must include recognition of an at least implicit tendency to narration. This proposal will alert respondents because at the heart of Abstract Expressionism's mythology is an assumption that its images provide *discontinuous* access to *unreasoned* creativity. If it may now be suggested that they in effect 'tell stories' it is legitimate to ask whether this was involuntary (as mythology insists) or rehearsed. Anfam tends towards the suggestion that Abstract Expressionism embodied specific sociopolitical messages that were rehearsed in general rather than in each specific act of painting.

Now the art historical field reacts to this suggestion in different ways depending upon interpretation. If it is understood as maintaining that American Abstract Expressionism in its completeness is an uncoordinated critique of the world while each representative work of art is a critique of an unspecific fragment of the world, the concept of narration may be regarded as inappropriate because narration must *develop*—it cannot be permanently inchoate. The art historical and critical field is largely undisturbed by this, and the idea of a canonical Abstract Expressionist work as constituting some 'provisional' apprehension is if anything strengthened.

However, the field will not be undisturbed by Anfam's suggestion that Abstract Expressionism's period of uncompromising abstraction was an interval within a *greater* project that was essentially figurative—a project abandoned in order to serve a tactical need for non-figuration, but resumed when artists' reputations were sufficient to command forgiveness for their 'lapse' into abstraction or their 'relapse' into figuration (a distinction dependent on critical standpoint). He maintains that the return to figuration so obvious in the work of Philip Guston is an extreme example of a tendency inherent within the movement as a whole. It should be noted that this contribution in the context of *Myth-Making: Abstract Expressionist Painting from the United States* is in effect an aside, for Guston's work did not contribute to this particular mythologising event. Such references to Guston in effect signal recognition of a particular view of American Abstract Expressionism as an 'unfinished project', with Guston's figuration posited as both exerting an influential pull on the movement and pointing towards the direction of its fulfilment [7].

The sort of shading necessary to accommodate Anfam's interpretation to the field is already evident in his overlapping of figuration and narration. But figuration is not narration. Narration connotes rehearsal and one-way transmission; figuration embraces spontaneity and even the *instantaneous* and perhaps highly provisional apprehension. Figuration necessitates what narration does not—a reciprocal exchange between an image and the receptive observer, in other

words an *interested* response. This is the territory here explored by Charles Harrison whose contribution includes an extended memorandum on iconic signification. Images bear meaning to the interests they address. They do this subjectively (as in Harrison's cited example of an Impressionist delivery of the female form to bourgeois male gaze). A complete appreciation of an Impressionist or any other work requires an attempt to identify with the interests it originally served. This is perhaps most obvious in the case of self-portraiture, the 'mirrored' nature of which requires identification with the actuality of the depicted. For Harrison, a work's potential for evoking an observer's *self*-identification is a measure of its value in the present reality. We cannot adequately identify with a Manet without imaginary transmogrification into bourgeois Parisian; but we *can* identify with a Rothko or a Newman without adopting the standpoint of a New York liberal.

In Harrison's view American Abstract Expressionism enables several character-istically different forms of exchange to which critical attention must be equally receptive. The work of art may be regarded as intended primarily for consumption in its making—that is, for the artist's own experience of the event in occurrence. There is a form of critique which is an attempt to reconstruct this making so that it becomes palpable to receptive observers who do not make, or whose making serves other problematics. At its most effective it promotes a sense of 'self-forgetfulness' that immerses the receptive in a state of being comparable to that which produced the image. The most elusive problematics may be revealed, as in Harrison's conducted excursion into a Reinhardt. The critic or historian in this event cannot inform others of what 'messages' they might expect (as they might in respect of narration) but they can advise on how to look.

There is another form of critique in which figuration predominates, even when the work is ostensibly non-figurative. At the Constructivist extreme, a work may be a figuration of a non-figurative object, though this is outside Harrison's present discussion. Here he posits the canonical image as possessing quasi-human attributes—to be approached as if approaching a personality; to be 'read' for signifiers comparable to the signifiers of a human face, gesture or posture, and to be engaged in the equivalent of 'social' space. Apart from its implications for museology—clearly it would be inappropriate to display Abstract Expressionist works on the floor (where they may have been made) or in other superior or inferior relationships to normal viewpoints—this proposal is at variance with 'consumerist' predispositions of the typical art museum visitor. People are not producers and consumers of social discourse. Perhaps a basic distinction may be made between works that have entered conventional currency and may be so consumed, and those which retain a vital, active potency by their resistance to cynical exploitation but which are approachable, as Harrison says, in 'acts of consummation' of productive and receptive interests.

'Consummation' is sufficiently related to 'reconciliation' to suggest some continuity between two very different principled positions. Nancy Jachec retrieves

evidence of a willingness on the part of originative Abstract Expressionists to abandon figuration, and thus a popular audience for their work, for the sake of the purifying aesthetic idealism that has been characteristically articulated by Clement Greenberg. A subsequent return to figuration may indeed be regarded as reconciliation with the appreciative needs of ordinary people, and this view would not be incompatible with Anfam's interpretation. However, what Jachec seems to identify is a 'return' to figuration-in-abstraction, a figuration re-emergent in aesthetic outcomes of the pure experimentation. This is a reconciliation that requires the popular audience to travel further than the artist, and there is a strong sense, described by Jachec, in which the Abstract Expressionists determined to educate the masses in a connoisseurship previously monopolised by a cultural élite.

This is much closer to Harrison, and thus the art historical and critical field absorbs the shock of disagreement. But contradictions remain. At certain moments key artists retreated into private mythology and refused to exhibit. On whether this was aberrant or representative behaviour hang essentially different, if occasionally fine, interpretations. These are ingrained within prevailing mythology: the Abstract Expressionists gradually abandoned a 'morality' of practical necessity (the commodification of their art) in favour of a 'morality' of idealism with all its attendant sacrifices and hardships. This approximates to the abandonment of a socialist purview in recognition of Cold War realities. Alternatively it may be read as the cynical abandonment of a popular market for one that was highly specialised and lucrative. This in turn may be condoned as a willingness to consort with high culture in order to claim it on behalf of the masses. What is not in dispute is an essential ingredient of politicisation that has become paradigmatic for subsequent avant-gardes.

It was customary to suggest that the Abstract Expressionists' dalliance with Communism was the result of sophisticated exploitation by the Party, or that, alternatively, it was a sort of intellectual conceit and substantially fictionalised. David Craven, however, provides evidence of its reality in the records of United States surveillance of those among the Abstract Expressionists who were considered political 'subversives'. Ad Reinhardt's case is cited as an extreme that nevertheless indicates the general levels of suspicion. There is more than a hint of official paranoia in the routine filing of reports on Reinhardt's writings, utterances, travels and acquaintances. However, the same unearthed records that suggest unreasonable persecution of Reinhardt also reveal that his Leftist interests were a species of commitment politics, challenging the established 'myth' of Communist entrapment of artists made vulnerable through poverty in the Depression [8].

This convention serves a Greenbergian theory of depoliticisation and pursuit of art-intrinsic principles. Fred Orton, in the first of his contributions, takes issue with a view which he maintains has thrived substantially by marginalising Harold Rosenberg. Orton reconstructs Rosenberg the Marxist critic and percipient observer of Marxism in art. He 'recalls' someone whose devotion to socialist principles was too sincere either to be jettisoned for convenience or to be fooled by

romantic lip-service. The Marxism Rosenberg recognised in incipient Abstract Expressionism was *genuine*. So was the commitment to a programme of cultural revolution which—like its prototype in Russia in the second and third decades of the century (though Orton does not refer to this precedent)—was predicated on releasing the masses from a culture which confirmed their inferiority, by pioneering a culture in which all citizens could participate on equal terms. Here the Marxist artist is both executive and exemplar, renouncing the values of a culture in which he or she is competent, liberating the creative personality in order to engage new problematics which, if successful, would result in artistic anonymity and derecognition of individual achievements.

To politicisation by commitment add politicisation by social predicament. Ann Gibson's work on Norman Lewis reveals that he at least was not motivated so much by formalist imperatives as by an urgent need to find an idiom through which he could express revolt against social and cultural authority. Convention recognises a united attempt, on the part of Black and White artists in New York, to realise a universal abstract language that would symbolise humanity's common condition rather than its differences. Lewis is presented by Gibson as a key participant in this endeavour, though not one engaged in the problematic of reductivist purification. She recalls an artist who tried caricature, pastiche and a biting realism on route to Abstract Expressionism, in the process interrelating Surrealism, Abstraction and Expressionism in ways that parodied their respective claims to authority. This is to acknowledge an alternative convention—that such tendencies *converged* in American Abstract Expressionism—while questioning whether *synthesis* was in fact the aesthetic outcome that some maintain [9].

If this was myth-making it was different from Rosenberg's classic interpretation of an essentially private act of renouncing past values and rejoicing in the liberation of the personality. In Lewis's experience the 'private' world of the Black American was no freer than the social world, and his parodying of aesthetics that (for him falsely) connoted freedom of choice and action may be interpreted variously as ironic commentary, a critique of the myth of originality, and the *realpolitik* of cultural empowerment. Its most obvious consequence is to cast doubt on the idea that an artist like Lewis was, because of poor circumstances, an unwitting recipient of 'influence'. As Gibson suggests, he systematically *prepared* himself for social action, which indicates objective selectivity. It also raises the critical question as to whether Abstract Expressionism in one phase of an artist's working life is to be regarded as fulfilment of an *inevitable* programme. In Lewis's case, do caricature, pastiche and a biting realism constitute American Abstract Expressionism in embryo?

There is more than a hint here of the 'myth' that American Abstract Expressionism *recapitulates* pioneering modernist movements prior to superseding them. According to this view, the validity in Cubism, Expressionism and Surrealism becomes evident in retrospect and in an American arena. American Abstract Expressionism *authenticates* past European achievements and sets the agenda for

their selective development beyond its watershed. American Abstract Expressionism interposes and *mediates* between early and later phases of European modernism. That this cultural farming was not disinterested but both economically and politically motivated is of course one of the principal mythologies of the field [10]. It requires acceptance that this threshold modernist event could only have taken place in exclusively-American consciousness. Participants of European origin had to become wholehearted Americans. In this respect Jonathan Harris questions the peripheral status afforded to Hans Hofmann who was an apparently exemplary Abstract Expressionist, who sited his creativity in New York, but was marginalised, it is suggested, because he retained allegiance to Paris, the European International.

Here is the compelling 'myth': the great dialectical advance occurred because European contradictions were brought into collision and resolution in New York. Take New York out of this model of the movement's origination, take out the prolonged exposure of New York artists to the early modernist Abstract Expressionism of Wassily Kandinsky [11], remove the critical synthesis of influences drawn from Picasso, Matisse, Ernst, Mondrian and Albers that was deemed possible only in this magnetic centre, and there would have been no movement—it fused *there*. However, by proclaiming credentials for Abstract Expressionism that were elsewhere-located (in Hofmann's rootedness to a continuing European modernism despite his New York domicile) Harris is in effect questioning the Jerusalemic significance of New York. He compounds this with the suggestion that Abstract Expressionism could be the legitimate product of a healthy artist with an angst-free mind, but the most consequential implication in Harris's work on Hofmann is that New York interests acquired Abstract Expressionism partly by suppressing other claims.

This contextualises attempts that have occasionally been made to broaden the ownership of Abstract Expressionism. For example, claims on behalf of originative contributions by British artists, though well-documented, have tended to be dismissed as idiosyncratic [12]. There was once a promising attempt to connect American Abstract Expressionism with contemporaneous French painting of apparently similar intentionality, as a means of proposing an unconscious commonality of purpose evident on either side of the Atlantic in the years immediately following World War II. Though the Institute of Contemporary Arts, London, invested in this possibility [13] it gained no purchase on what was already a convention. Harris's work on Hofmann and the British artist he influenced, John Hoyland, in effect requires such forgotten enterprises as the ICA's to be recalled. But such recollection will entail reconsideration of the 'myth' of a dislocated European modernism. The prevailing model requires acceptance that European modernism was a project defeated by totalitarianism. The works of artists who stayed in occupied Europe, for example Picasso and Matisse, are disparaged as their 'wartime works'; there can be no contemporaneous sharing of the Abstract Expressionist problematic with Europeans but only an emulative

European response. In the context of *Myth-Making: Abstract Expressionist Painting from the United States*, Harris's evocation of the unrepresented Hofmann is an assault on this convention.

Similarly, as Fred Orton notes in his second contribution, there was no willingness to share Abstract Expressionism's threshold status with other American modernism either. What Orton says here is equally traumatic for the art historical and critical field. He tests ingrained mythology with social history and concludes that in all the acknowledged sites of conflict between European-inspired modernist American art and art of more conventional disposition—where great cultural forces are said to have forged Abstract Expressionism in a spirit of ideological conflict—there was no Abstract Expressionist presence. 'Old guard' conservatives and modernising 'business liberals' fought for taste-making superiority with, respectively, all-American and quasi-European art. All European modernism was suspect in this surrogate war against internationalism, and it was here that *future* Abstract Expressionists became suspected of unpatriotic values, which tainting they then brought to the new movement. The subsequent cleansing of this tainting is one reason why Rosenberg's critique was downgraded, featuring as it did the concept of art as a reflex social action tuned to a particular politics. As Orton points out in his longer essay, it is fundamentally ill-informed to associate Rosenberg's concept of 'action' with the idea of 'physical action' epitomised in Hans Namuth's photographs of Jackson Pollock at work (Figs. 7–8); but it is undeniable that the latter interpretation contributed substantially to a depoliticisation of the idiom that disarmed the 'old guard'. So Abstract Expressionism itself was not a weapon of the Cold War so much as a symbol of 'business liberal' victory in a civil war.

Is the 'Cold War weapon' mythology then immune to revision? What complicates this question is the intimate connection of matters political, aesthetic and psychological that forms the greater mythological system. When one mythology wobbles a domino effect soon destabilises the whole art historical and critical field. It has already been suggested that the questionable status of some aspects of mythology can be dampened with fine adjustments. What is becoming clear is that there is an order of intensifying consequences which contributions to this volume effectively sample.

Anfam demonstrates the *fine* degree of difference between confirming a relatively minor myth and requiring its revision. His suggestion that Abstract Expressionism 'communicates' by narration is assimilable to the relatively uncontentious proposal that observers must 'interrogate' its images in order to negotiate their content and meaning. Abstract Expressionist images signify the intentionality that formed them—even if, as in the case of an Ad Reinhardt, this only becomes apparent as a result of intense and meticulous scrutiny. This observation of Anfam's is actually to enhance another myth—that of the 'open work' as typified by a Jackson Pollock, an image that stands as a stage arrested from within a creative process and invites speculation as to its potential continuity. However,

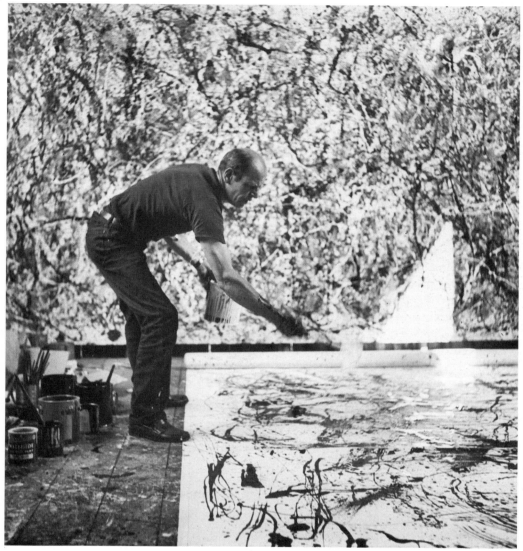

Fig. 7 HANS NAMUTH photograph of Jackson Pollock © Estate of Hans Namuth/
DACS London/VAGA New York 1993

recognition of the *fine* difference between admitting of American Abstract
Expressionism's communication and narration demands a *vast* difference of
opinion with Greenbergian criticism, for Greenberg, as is well known, maintained
this idiom to be part of a desirable purification of painting to its flat and chromatic
essentials. To admit into a critique of Abstract Expressionism something that is
not specifically painterly in this limited sense is in effect to call the authority of
Greenberg into question and thus to demand *considerable* adjustment within the art
historical and critical field.

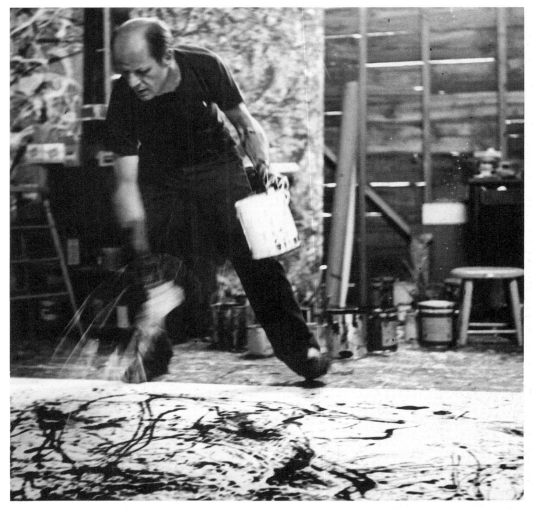

Fig. 8 HANS NAMUTH photograph of Jackson Pollock © Estate of Hans Namuth/
DACS London/VAGA New York 1993

Anfam argues that an early Pollock 'emulates' the layering, framing, concealing and revealing that are characteristic of narration (that is, of its form) while resisting the communication of deep meaning (its content). This interpretation's implicit target is the argument that Abstract Expression tends towards the maximisation of content and the elimination of form [14]. Take this the stage further that is indicated by Harris and Orton and the form that is divested is *European* form while that which is engaged by Pollock is a substitute and not even painterly. Abstract Expressionism thus becomes a medium, both all–American and ideologically purified, for the global projection of the interests of those who own it. Thus the myth must be suppressed that it had antecedents in Munich and Weimar. Thus

Hofmann is excluded and the claims of Paris and London are denied. These dominoes are surely set to fall.

If Old World antecedents *must* be acknowledged (as the significant participants had well documented histories of deference to European art there could be no question of a *tabula rasa*) these cannot be Russian. It is convenient then to suggest that Abstract Expressionism conforms more to a Surrealist than a Constructivist problematic, the latter requiring orchestration of meaning *and* form within iconic unity. The discrediting of modernism's left wing casts doubt on the *synthetic* assimilation that historians have detected and affords splendid irony to Harold Rosenberg's disliking for 'virtual revolution' [15].

Ironic too is the fact that some of the icons of Abstract Expressionism are in chronic decline. Just as they must be sustained spiritually in dedicated criticism they need to be maintained physically in dedicated conservation. The often experimental techniques of their production have given rise to chemical changes that, forty years on, have resulted in all too visible surface changes. As Phyllis Rosenzweig points out, this presents museologists with an acute dilemma— whether to preserve the relics of original handling, facture and gestural intentionality, accepting that these must inevitably *transform*, or to suppress this transformation by constant repair and repainting, accepting the risk of replacing so much original material that works become little more than 'replicas' or 'reconstructions'.

In the case of Ad Reinhardt, Rosenzweig's special concern, the problem is complicated by his explicit rejection of other hands in his own work. His images were especially vulnerable to damage each time they left the studio. When they returned bearing accidental marks and blemishes in effect they had become *other* works of ambiguous authorship, a limbo from which only Reinhardt could release them by his repainting. If others did the repainting the images became theirs. By this criterion the Reinhardt canon is fast diminishing.

Thus the museologist's dilemma transfers into the art historical and critical field. Here there is a further complication. Art historians have learned from their difficulties of calling-up lost works of early modernism that good photographic records of important works are priceless. American Abstract Expressionism is a threshold event in this sense also: while the documentary evidence of its incipience is often affected by the distracting properties of inexpert or inappropriate photography (casual snaps, press illustrations, etc.) the photographing of its later phases set the standards of visual accuracy that have since endured.

This means that the provenance of a canonical image may contain blurred or bleached images of it in the studio, half-tone reproductions of its exhibition in a lower Manhattan gallery, and later museum photographs that record its every gradation of visual change in duration. Add to this a legacy of technically poorer commercial reproductions, and while the historian may be in no doubt as to which is the best visual referent, he or she can never be confident of evoking this in discourse. Rosenzweig's essay is therefore a reminder of something fundamental to mythologising. Each concept of a work of Abstract Expressionism (as of any

other recent idiom) is a locus of two iconic trajectories. The work itself in the moment of its completion is a stage arrested within a continuing creative project, while each subsequent photographic image of the work is a stage arrested within a process of inevitable departure from original appearance. This latter trajectory is occasionally reversed by conservation, and by historians' attempts to reconstruct *provisional* stages of the work as revealed by electromagnetic radiation or extra-spectral light. Thus the tacit notion that art history deals principally with *the image that embodies the artist's satisfaction with the work* is discredited.

However, questions of the definitive image are on the relatively uncomplicated side of an equation which contains a vast array of possible claimants for inclusion within wider definitions of the 'work'. Candidates include predisposing circumstances and intentionality, not merely of artists who fashion them but also of critics who endow them with significant interpretation. Here the work is a locus of both creative and critical interests, a matter which Jonathan Harris, in his second contribution, controverts further by including the political. For example, he asks whether accounts of Abstract Expressionism that foreground the politics of its time do so in order to contextualise the works of art within a political climate or to annex the politics to the artistic project. He is not against either enterprise but he does criticise a prevalent *unacknowledged* confusion of intrinsic and extrinsic criteria. He himself requires a critique of involved but clearly identified constituents: 'text' and 'context', 'internal' and 'external' criteria, 'viewer' and 'object', together with identification of the standpoints from which individual and collective interests are 'projected'. While other historians might ponder on the cultural significance of taking American Abstract Expressionism to Paris, the International New York is said to have usurped, Harris reflects on its presence in Liverpool, the former principal port of embarkation for New York. He sees not a noble 'return' but a rather shabby connivance in political palliation. He wants this to be explicit, to clear the sites of interest and then to reconstruct.

This is the scholar expressing the exquisite contradiction of American Abstract Expressionism—for an *accountable* art history we must have a complicated diversity of approaches, yes, but with clarity of method and openly acknowledged motivation. This is the personalised realm in which it is vital to know who is speaking to whom, with what referents, and why. But we need also to sustain the power of the idiom to generate mythologies, which means accepting the barely provable and the indistinct into a rich and romantic critique. It is for its multiplicity of mythological associations that American Abstract Expressionism still has a popular audience, not because it aspics the gestures and imaginative traces of individuals who wanted just to paint.

NOTES AND REFERENCES

1 And two works by a sculptor, David Smith.

2 Throughout this volume the term 'Abstract Expressionism' denotes American Abstract Expressionism of the 1940s-1960s unless qualified with reference to earlier, European tendencies, for example in the work of Wassily Kandinsky.

3 Other aims were to show most of the Tate Gallery's holdings in American Abstract Expressionism, which are obviously disparate, within a common context, and also to open them to outside interpretation. The curator, Penelope Curtis, invited David Craven to provide a commentary in the form of a catalogue essay: CRAVEN, DAVID (1992) 'Myth-Making in the McCarthy Period', in: CURTIS, PENELOPE (Ed) (1992) *Myth-Making: Abstract Expressionist Painting from the United States* (Liverpool, Tate Gallery Liverpool). Besides providing chronological and theoretical references for the show, this essay was consistently acknowledged throughout the Symposium that this volume records. It was at David Craven's request that two works by Norman Lewis were included from outside the Tate Gallery holdings.

4 The term 'art museum' is used throughout the Introduction to signify the major art museum or art gallery of sufficient national or international reputation to affect automatically the historicism of the objects and subjects it presents in exposition. It is the 'normality' of this phenomenon that is recognised here, as distinct from the extraordinary occasions when institutions of more modest pretensions nevertheless succeed in making proposals which demand historiographic reappraisal and adjustment.

5 TGL forward planning includes Critical Forum symposia on *Joseph Beuys* (Vol. 2) and *Barbara Hepworth* (Vol. 3).

6 See MUSEUM OF MODERN ART (1936) *Cubism and Abstract Art* (N.Y., Museum of Modern Art) cover illustration plus text by ALFRED H. BARR Jr; [(1966) reprint (N.Y., Arno Press) frontispiece plus Barr's text].

7 For an indication of this position see STORR, ROBERT (1992) 'Guston's Trace', in (1992) *Philip Guston in the Collection of the Museum of Modern Art* (N.Y., Museum of Modern Art), pp. 7–27.

8 See SANDLER, IRVINE (1970) *Abstract Expressionism: the Triumph of American Painting* (London, Pall Mall) pp. 7–8.

9 For example Sandler, who writes that 'Gorky, Hofmann, Pollock, De Kooning, Baziotes, Rothko and Gottlieb . . . wanted to employ automatism—to arrive at their forms freely and directly—but at the same time they desired to cultivate the pictorial values threatened by this technique—the structural cogency and painterly finesse that they admired in the works of Picasso, Matisse, Mondrian and Miró.' *Ibid.* p. 41.

10 See GUILBAUT, SERGE (1983) *How New York Stole the Idea of Modern Art: Abstract Expressionism, Freedom, and the Cold War* (Chicago, University of Chicago Press).

11 See HUGHES, ROBERT (1980) *The Shock of the New: Art and the Century of Change* (London, British Broadcasting Corporation) pp.313–23.

12 See HERON, PATRICK (1974) *The Guardian*, 10, 11 and 12 October.

13 The ICA exhibition *Opposing Forces*, January-February 1953 brought into conjunction works by Sam Francis, Jackson Pollock, Georges Mathieu, Henri Michaux, Alfonso Osorio, Jean-Paul Riopelle and Iaroslav Serpan. The interpretation it promoted was that Abstract Expressionism was a genuinely international medium for expressing a common 'world view'.

14 See ROSENBERG, HAROLD (1959 [62]) *The Tradition of the New* (London, Thames & Hudson), p. 48.

15 *Ibid.* pp. 50–7.

DAVID ANFAM

Interrupted Stories: Reflections on Abstract Expressionism and Narrative

> After they had visited one another's studios, Rothko once said to my father, 'Philip, you are the best storyteller around, and I am the best organ player.' Two years before his death, my father was still puzzling over this comment. 'That was in 1957,' Philip said, 'and I still wonder what he meant.' [1]

It is not altogether surprising that the ongoing tendency to revise and redefine Abstract Expressionism has almost completely overlooked the issue of narrative. For whatever its definition, Abstract Expressionism is hardly associated with story-telling. On the contrary, narration is the antithesis of the iconic immediacy that the most famous works of the movement aspire to embody. But extremes have a way of presupposing each other and there are reasons to suggest that narrative and its complicities play an unusual and important role behind the scenes, as it were, of the superstructure of the art [2].

If the familiar icons from the later 1940s onwards by Mark Rothko, Clyfford Still, Barnett Newman, Jackson Pollock, Willem de Kooning, David Smith and others constitute the ostentatious centre of the subject, its so-called 'triumphal' apex, then narrative could be considered as the margins which frame this crux. One corollary is that a whole complex of issues affiliated with the narrative process may resemble some unmoved mover: by turns vital through its absence, suppressed in the artists' discourse and practice, yet everywhere tending to exert pressures from outside upon the nominal core. Hence, it is perhaps most revealing to approach the subject itself indirectly. In sum, to focus more upon what the climactic artworks seem to leave behind; upon what the artists appear *not* to wish to engage; and to scrutinise what stands after, as well as before, the phase which is usually regarded as the decisive one. From that more oblique angle Abstract Expressionism starts to look rather less clear-cut; indeed, to be even powerfully problematised by what it seeks to exclude, by its framing edges and a play of contradictions [3].

Two figures in particular come to mind as having stood just outside the main currents of Abstract Expressionism. They are Ad Reinhardt and Philip Guston. Their careers of course spanned its entire evolution and, from a tangential vantage point, each evidently had a special awareness of the impulses that fuelled the movement at its inception—impulses which were then driven underground as it

took a definitive shape, only to rise to the surface again (or else be denied all the more strenuously) in the later years when a driving artistic logic faltered. Among the most obvious symptoms of this eventual volte-face was the resurgent figuration in Pollock's 'black pourings' of the early 1950s (Fig. 9), de Kooning's abruptly representational *Woman* series from the same period and the clear narrative implications of the concept underlying Newman's *Stations of the Cross* (1958–66). In these parallel developments a certain pattern emerges (and comparable observations apply to Rothko's three excursions into the mural format, an idiom historically loaded with narrative associations, as well as to Still's curiously retrospective later manner from around 1957 onwards which was haunted by the ghosts of figuration): a sense on the part of otherwise very dissimilar artists that something had been interrupted by their most 'abstract' years of achievement which had to be resumed, albeit vicariously. An inclination to narrativise their own developments may even have been a factor here [4]. It was Reinhardt and Guston who most sharply articulated these countervailing forces.

The late styles of Reinhardt (Figs. 32, 34) and Guston (Fig. 10) hinged upon their respective responses to the potent narrative momentum that we impute to reality by way of structuring it. The plainest statement of this strategy is the 'Chronology' that Reinhardt constructed for himself towards the end of his life [5]. In this anti-narrative schema the world and the artist's life are juxtaposed so as to negate any causal links between them. A sequence of notable historical events is pulled up short by the non-events of Reinhardt's own activities. In 1949, for example, we are told that the Irish Republic is established, while Reinhardt himself 'paints water colors in Virgin Islands, waiting for divorce'. The results approximate a double-column entry. On one side bristles life, history, diversity, causality, temporality—everything to do with the art of telling. On the other stands negation, repetition, monotony, timelessness—whatever attends Reinhardt's non-mimetic 'art-as-art' doctrine. The biography overall is therefore a story of disjunctions. Its ironic 'meaning' derives from constant interruptions as time's flow is sandwiched between the artist's stasis. Chronology becomes deferment.

This irresolution carried over into Reinhardt's 'ultimate' paintings, extremely tenebrous five-foot square canvases divided into nine equal rectangles. Manifestly, such works were driven by negation. As Reinhardt often wrote, there was to be no colour, no content, no life, no composition, no action, no time, and so forth. In being difficult to perceive, they even move against the basic ground rule of art (at least prior to Conceptualism)—that it be visible. At root, these are retorts to one *sine qua non* of narrative: mimesis [6]. And this is the key feature that connects them, though of course at a diametrical remove, to Guston's late pictures. If Reinhardt's approach, as Richard Wollheim has subtly noted, appears to execute the work of dismantling or obliterating some implicit preexistent image [7], then Guston's summons back that mimetic paradigm in all its naked crudeness [8]. The rationale behind the divergent choices was also like the two extreme poles of a dialectic. For Reinhardt, painting would function 'not as a likeness of anything on

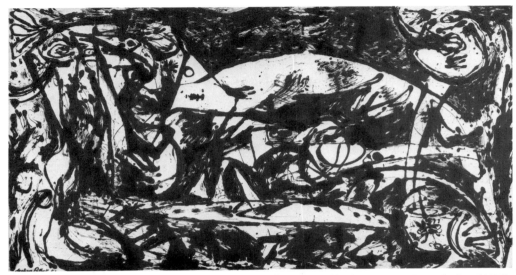

Fig. 9 JACKSON POLLOCK *Number 14* 1951 © 1993 Pollock Krasner Foundation/ARS, New York

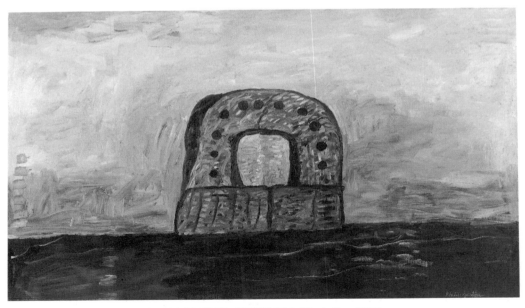

Fig. 10 PHILIP GUSTON *Black Sea* 1977

earth', whereas Guston declared: 'I got sick and tired of all that Purity! Wanted to tell Stories' [9]. Here we have the origin and end of mimesis, its ultimate denial confronting its primal task as a means of re-presentation [10]. In both instances the act of picturing is identified with the start and close of a world. What else explains

the ubiquitous references to termination that preoccupied Reinhardt and Guston alike?

Reinhardt's 'black' paintings, for instance, reverse the principles at stake in his own previous canvases such as the Tate's early 1950s *Abstract Painting* (c.1951–2) where the 'bricks' of colour convey a constructive purpose in their resemblance to the building blocks of a relational dynamic, a cooler version of Hans Hofmann's 'push-and-pull' scenario. By the time of *Abstract Painting No.5* (1962) (Fig. 32), however, the image has become darkly obstructive, blackness replaces brightness, variation cedes to symmetry, movement to stillness. Pictorial life is, in short, finished by the same negating spirit that Reinhardt's statements articulate. Yet therein lies a paradox. To negate is always to invoke, to practise apophasis, as Yve-Alain Bois has noted [11]. Significantly, Reinhardt's writings built an entire discourse—parallel to his paintings—around the extinction of referential meaning. In fact, he even allowed that the termination of speech led to its opposite: 'Last word must always be secretly the first' [12].

The final pictures likewise hover at the threshold between breaking off and starting over again from scratch. Bois describes this differential as Reinhardt's 'almostness' [13]. As is well known, the paintings exploit it to the utmost and evolve by stealth. After considerable scrutiny the beholder discerns that there are colours (almost imperceptible) within the blackness, a cruciform composition (extremely faint) behind the blankness, meticulous brushwork (barely palpable) defining the surfaces and, above all, an uncanny aura about their very bid to deny authorial presence. Given this perceptual process, the supposedly 'timeless' images therefore actually evolve in time. It is as if matters that they did not wish to reveal or tell the onlooker were indeed present. The synchronic cloaks the diachronic. Such contradictions bring to mind a particular turn associated with literary structures, that of the *aporia*, the built-in critique of a manifest statement. More broadly, they also echo some fundamental principles of narrative constitution, its play upon statement and secrecy, telling and concealing [14].

Guston's case exemplifies the strange, subterranean intercourse between the avowed aim to 'tell Stories' and the urge to block them. His brutal clarity of style, so aptly transparent as a medium for story-telling, conflicts with opacities that bar any continuum between the teller and the told. Not surprisingly, Guston admired Kafka and Beckett [15]. Both are writers of compelling narratives which seem to lead nowhere and whose protagonists, moreover, are subject to persistent interruptions en route. Barriers assume many guises in Guston's iconography from around 1968 onwards. A favourite form is the pile of objects that stubbornly blocks the whole composition, such as the amassed shoe heels in *Ancient Wall* (1976). At times this becomes a literal wall, as in *Untitled* (1969; Museum of Modern Art, New York) which, like any barrier, intimates both entrapment and transgression. In such instances as the Tate's *Black Sea* (1977) (Fig. 10) an analogous flat-iron shape blots the horizon and also mimics the last Greek letter, Omega [16]. Whether actual or metaphorical, the walls, boundaries and termini (for what else

are the soles of our shoes?) are all ripostes to a venerable ambition, the window which gives total accessibility to sight. By foregrounding various signs of closure the iconography insists instead upon the limits of vision [17]. Other motifs reiterate the interruptive thrust. Prominent among them are light bulbs, window blinds (or rather mostly their cords) and cigarette butts, each something that is about to be switched off, pulled down or stamped out.

Nonetheless, the 'stories' take an aporetic turn whereby the virtual *memento mori* are themselves kept hanging in the balance. Counteracting the obstacles to vision are eyeballs that dominate giant heads so that the gaze is literally embodied and, therefore, figured as durational. Clocks are accordingly further prominent features, but their purpose is annulled because the faces are frequently blank, as in *The Studio* (1969). Time—the essential cement of narrative—interposes itself yet is stuck, because unable to measure. The story is fatefully suspended despite all manner of allusions to endings. *The Studio* epitomises the self-reflexive twist: a painting which shows the painting being painted. Worse still, Guston is elsewhere seen scourging himself to continue (*The Desert*, 1974), while the titular verbs stress ongoing, though futile, states (*Talking*, *Painting*, *Smoking*, *Eating*, *Hinged* and *Cornered*). An occasional ladder will extend the gerundive drift and promise to surmount visual and symbolic obstacles but, naturally, leads nowhere (*Ladder*, 1978).

How should we interpret this emphasis upon negation, difficulty, self reflexiveness, barriers, breaks, thresholds, endings and *aporia*? Narration and depiction would here seem to have become self-defeating forces, magnets fixed upon themselves. To be sure, the well documented spread of existentialism, a philosophy perhaps more extensively popularised in America than anywhere else from the late 1940s onwards, certainly provides one ingredient in the general phenomenon. By no coincidence, the Abstract Expressionist who was most closely attuned to existentialism—de Kooning—has indeed battened upon such devices more exhaustively than any other. The disjunctions and 'impossible' passages fundamental to his pictorial methods exactly correspond to the literary ambiguities associated with an unreliable narrator or, translated into Roland Barthes's terms, a 'writerly' (*scriptible*) text [18]. Otherwise, far from being prevalent in the climactic years of Abstract Expressionism, those divisive and obstructive qualities are—at least ostensibly—either overcome, emulsified or proscribed.

One need only consider the rhetoric, spoken and enacted, of the 'classic' Abstract Expressionist phase (roughly identifiable with the late 1940s and early '50s) to encounter the opposite of what would soon re-emerge when the brief and compelling collapse into iconic integrality thereafter broke apart. Instead of negation, opacity and *aporia*, the aesthetic language at that time enunciated openness, expansion, clear-sightedness and continuity. Metaphors of the body were tellingly prominent. Thus, Rothko wrote in his essay 'The Romantics Were Prompted' about

> the need for a group of actors who are able to move dramatically without embarrassment and execute gestures without shame

and concluded that

> It is really a matter of ending this silence and solitude, of breathing and stretching one's arms again. [19]

Another key text, Newman's 'The Sublime Is Now', sounds as though it were almost programmatically at war with *aporia*—couched, as it is, in univocal and absolutist syntax:

> We are reasserting man's natural desire for the exalted, for a concern with our relationship to the absolute emotions . . . The image we produce is the self-evident one of revelation, real and concrete, that can be understood by anyone who will look at it without the nostalgic glasses of history. [20]

As the title of Newman's essay asserts, temporality is defined as an instantaneous present. A cognate outlook marked Still's 1952 Statement for MoMA's *15 Americans* exhibition, a panegyric to moralised 'vision' [21].

Extending this attitude, Pollock's 'drip' technique highlighted accessibility and dialogue, as did Rothko when he wrote:

> A picture lives by companionship, expanding and quickening in the eyes of the sensitive observer. [22]

For Pollock, the large canvas and the new working methods allowed him to be 'in' his painting, ensuring that 'there is pure harmony, an easy give and take' [23]. Various titles express an equivalent optimism. There are cues to the heroic (Smith's *The Hero*, Newman's *Vir Heroicus Sublimis*), to unity (Newman's *Onement* series, Pollock's *One: Number 31*, 1950), to questing (Motherwell's *The Voyage*) and to beginnings: notably in Newman's *Adam* and *Eve* (Fig. 11), primary personifications of one of Western culture's master narratives. Needless to say, the images and their modes of production are also strikingly gendered, whether as the dichotomies of *Adam* and *Eve*, as the hard, thrusting uprights employed by Still, Newman and Motherwell, as de Kooning's idol-like *Woman* series or as Pollock's muscular pourings and flingings.

Most importantly, all the rhetorical language and artistic ruses during the aforesaid period target a single aim: an uninterrupted relation between the beholder and the work. Absorption will be total, unified and directly effected. And this is also the purpose of classical narrative and mimesis, each seeking to be invisible containers where nothing interjects itself between the artwork and our experience of its content. Such a goal may explain aspects as otherwise diverse as the metaphors of active vision, the totalising narrative of the 'sublime', the advent of large open fields of saturated colour which are meant to convey a noumenal weight, the transfixing gaze of de Kooning's *Woman I*, Smith's sculptural meshing

Fig. 11 BARNETT NEWMAN *Eve* 1950

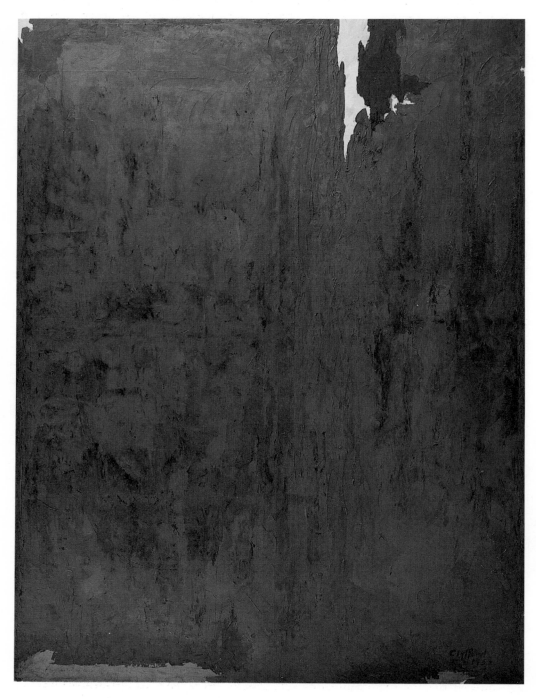

Fig. 12 CLYFFORD STILL *1953* 1953

of solid and void and the apparently interminable, organic flow suggested by Pollock's paint skeins—which the artist himself deemed unbroken by ends and beginnings [24]. The appropriate map for the Abstract Expressionist ideal at this stage would surely be the human body itself, with its implicit sentience, presence and indivisibility. Rothko even put forward such a correlative:

> Any shape or area which has not the pulsating concreteness of real flesh and bones, its vulnerability to pleasure or pain is nothing at all. [25]

But then things fell apart on numerous levels—semantic, iconographic, emotional, even personal. Disjunction became both a liability and a means. If the blazing redness of *Eve*, the indicative title of *Summertime* [26] and Still's monolithic *1953* (Fig. 12) represent, one might say, the noon-tide of Abstract Expressionism, a less sanguine spirit succeeded them [27]. Perhaps several artists lost faith in their ability to communicate to an audience and their creations altered in the process. Whatever the merits of Still's output after around 1954, it differs in essence from the canonical pictures such as *1953*. As that canvas gives the impression of being imploded into a densely pregnant and holistic field, so the later ones tend instead to explode into multipartite incidents and to stretch out horizontally. An almost obsessional darkness starts to infiltrate Rothko's vision by 1957. The change signalled by *Light Red over Black* (Fig. 33) entails not just an increasingly sombre palette, but also the advent of far less permeable images than hitherto. Eventually this led to the 'black and grey' paintings in acrylic on canvas and on paper of 1968–70. Brian O'Doherty has rightly remarked that they were 'a radical break' in the artist's practice because they were calculated to bar empathy [28]. Apart from the inherent dryness of the acrylic medium, the darks that remain uppermost and the starkly separated design, the white borders which were reserved on the canvas versions (and were inspired by the masking tape used on the papers) carry a charge analogous to a Brechtian *Verfremdungseffekt*. The image is reified and held apart from the viewer's realm; its poignancy stems from alienation, not interaction.

The retrospective tenor noticeable in Pollock's remaining productive years after he abandoned the 'drip' technique again gave rise to images whose signification is bifurcated. A string of paintings recollect either his own previous work or that of others: Matisse (*Easter and the Totem*), Benton and perhaps Newman (*Blue Poles*), Still (*The Deep*) and the all-over composition (*Scent*). Consequently, they project a special type of narrative manoeuvre: Pollock's commentary upon his own artistic constitution. *Portrait and a Dream* (1953) displays the image-forming process split apart. A violent though enigmatic 'event' at the left is set off from a self-portrait at the right. Division supplants sequence as the origin and end of the creative span, mimesis and abstraction, disintegrate into two halves. The 'black pourings' had already exploited this radical ambivalence in the way that imagery from a decade and more beforehand intrudes into their basically anti-mimetic stylistic make-up. The illusion of a figurative 'interior' (raw canvas) breaking through an abstract skin or 'exterior' (black enamel) is unmistakable. *The Deep* (1953) confirms that reading

since it presents a veritable interruption. The root meaning of 'interrupt' (*interrumpere*) is to 'break asunder' or to 'break off' (as of speech). Hence, *The Deep* is another dark conceit upon telling: the turbid pictorial fabric does, and does not, disclose insofar as it breaks off to reveal an impenetrable nothingness below [29].

Despite their great differences and regardless of the particular artist in question, all these late aesthetic moves operate around one axis. Whether in a spirit of irony, eschatology, mannerism or even despair, they tended to counter what had immediately gone before them and to lay bare (or to revive merely to manipulate at a distance) longstanding elements that had been briefly and partially submerged during the interlude of the late 1940s and early '50s [30]. Those components reach into the heart of narrative urges and patterns.

It is in the nature of story-telling to at once reveal and conceal. Or, rather more accurately, to at least generate that impression. As Frank Kermode (to cite one especially relevant critic among many on the subject) observes in his study, *The Sense of an Ending*, narrative construction naturally aspires to be a sense-making activity [31]. Beginnings and ends—ubiquitous themes throughout Abstract Expressionism—are nothing if not narrative instruments [32]. However, the attendant ambiguities of story-telling are investigated by Kermode in *The Genesis of Secrecy*, whose conclusions mesh at times with the otherwise remote perspective of the French theoretician Pierre Macherey in his *A Theory of Literary Production*. Both analyses focus upon the dilemma of stories; upon how, as they unfold, narratives promise to reveal yet are ultimately caught between plenitude and concealment [33]. As Macherey writes, the narrative movement 'is an ambivalence, an effort to postpone rather than to hasten revelation' [34]. For Kermode, 'plot' and plenitude appear to be secreted within narrative as interpretative layers seemingly lie upon one another like Russian dolls. Kermode therefore identifies two further narrative keynotes: secrets and boundaries [35].

We have only to look back to early, pre-mature Abstract Expressionism (remembering again that this stage came at somewhat different points in each artist's chronology) for ample evidence of strong—and strongly frustrated—narrative desires, together with the accompanying symptomatic leitmotifs just cited. Firstly, it is a realm of thresholds, boundary-crossers and instability, the *fons et origo* of narrative in the view of the critic Tony Tanner [36]. Among many possible examples are the voyager of Pollock's *Going West* (c.1934–35) who moves in a sinister direction; the schismatic moments alluded to in Newman's *Genesis— The Break* (1946) as well as in Pollock's *Birth* (Fig. 2) and Guston's *Bombardment*; Motherwell's early recurrent window/barrier concepts (and the window was an important detail for de Kooning too during the 1940s); the violent illustrativeness of Smith's *Medals for Dishonor* (1936–40) and his subsequent fixation upon the transgressive act of rape; Rothko's figures in his 1930s pictures, including the subway scenes, who are often confronted by, or crossing, boundaries and frames; and the leftward-striding figure in Still's originary *Oil on Canvas 1934* (San Francisco Museum of Modern Art), the incarnation of a propulsion interrupted

solely by the picture's edge. Likewise, Gottlieb's initial pictographs allude to the tales of Oedipus and Persephone, arch myths of infraction and trespass.

At the same time, nevertheless, early Abstract Expressionism tells no genuine stories. If there ever were sustaining plots, then they yield to enigma. Its mood is fragmentary, emblematic or chaotic. Propulsion swiftly runs down as Still's personages become trapped in the labyrinth of their own bodies. Figures are typically bewildered (Rothko), plunged into darkness (Still) and dwarfed by a macrocosm (Pollock). Space tends to be disjointed (de Kooning) or scrambled and without real sequential order (Smith's *Medals*) so that either tumult or silence dominates. Any potential meanings are occulted, broken apart or made secret [37]. Closer to the decentred universe of the chronicle than to focused narrative proper [38], nascent Abstract Expressionism can be calibrated by the measure of its difference from the then dominant pictorial trends in America. Its relation to Regionalism and American Scene painting is exactly analogous to that between Homeric and Biblical narrative according to Auerbach's famous comparison—the former clear-cut and brightly lit, the latter shadowed, mysterious, pregnant with latent senses [39]. For a short while during the early 1940s, myth offered an abortive escape from this indeterminacy by pointing towards some supra-historical plane of purportedly 'universal' tales and truths. But Pollock's *Guardians of the Secret* (1943) typically exposes the slippery foundations of that contemporary gambit. *Guardians* has prompted numerous diverse explanatory readings, sources ranging over Picasso, Melville's *Moby Dick*, a nineteenth-century photograph, Jung and Egyptian reliefs. Although all may well prove valid, do such interpretations miss the possibility that the canvas emulates the appearance of narrative constitution—the tiers, layerings, framings and secrets—without having any separable 'deeper' meaning or subject? While it exploits narrative dynamics by beckoning towards all manner of relations and concealments, there must be doubts about whether *Guardians* relates any story at all, even though story-telling is its catalytic germ. The power resides in the mode of pronouncement, figured by the title ('let me tell you a secret . . .') and the framing of an illegible centre [40]. Though it claims to tell, it merely shows.

Yet the contradictions that snared the Abstract Expressionists ran wider and deeper. At the personal level, theirs were mostly demonstrative temperaments, given to declarations of meaning or to the search for it. Still, Pollock, Smith and Newman alike conformed to this mould, the first three aggressively so. Rothko had briefly been an actor (Ibsen was one of his favourite writers [41]), as had Guston, while Newman ran for mayor of New York and Still was a passionate enough musician to consider a career as a concert pianist [42]. In Pollock's early admiration for Benton this effusive drive is strenuous:

> Benton has a huge running job out in Indianapolis for one of the state
> buildings—two hundred running feet twelve feet high . . . He has lifted art

from the stuffy studio into the world and happenings about him which has a common meaning to the masses. [43]

The gulf that soon yawned between the Abstract Expressionists and the master-narratives that, for others at least, affirmed an American ideology against the vicissitudes of the Depression, has already been mentioned [44]. Equally decisive were the central tenets of modernism as they permeated the Abstract Expressionists' attitudes from the late 1930s onwards. Very crudely summarised, these ran contrary to narrative and mimesis, had no 'common meaning to the masses', were reductive rather than discursive and argued that meaning and form must merge into an iconic unity—the 'simple expression of the complex thought' and the 'large shape' which Rothko, Gottlieb and Newman eulogised in their 1943 Statement [45]. The evolution and climactic form of this increasingly abstract 'romantic image' coincided, furthermore, with crucial cultural shifts in America during the Second World War and Cold War era.

The largest of these shifts—and they are complex enough to allow no more than the most summary sketch here—related to the breakdown of dominant cultural paradigms under the brunt of war, threatened nuclear apocalypse and then the paranoid politicisation of life (or an insidious inversion of this extreme wherein consumerism became a conformist connective) during the Cold War. Recent scholars such as William Graebner, Dana Polan and J. P. Telotte have charted the collapse or splintering of notions of 'progress' and of 'linear' time in the novel trends taken by scientific thought, politics and the mass media [46]. One joint conclusion of special relevance to Abstract Expressionism is their thesis that narrative was subject to exceptional pressures, most noticeable in the new genre of the *film noir*. Whether the cause was cultural despair, the psychological inertia which attended consumerism (the passive TV viewer need not privilege any particular story or event over another) or the fearful perceptions fostered by McCarthyism, the net result was to compromise the coherency upon which narrative depends. A painting such as Bernard Perlin's *Orthodox Boys* (Fig. 13) speaks the language of *film noir*. Here the human dimension is enmeshed in an excess of fragmented signification (the graffiti). If possible messages are inscribed everywhere, then a coherent story can exist nowhere [47].

A conspicuous, even stereotypical side of Abstract Expressionism runs fiercely enough against war-time anxieties, the ensuing double-binds of consumerism and McCarthyist paranoia. First, its efforts to vanquish the dictatorship of impersonal vision by changing the viewer from a consumer to an evaluator of the image come to mind [48]. So too does its stress upon the physical (the images or sculptures must be experienced directly and are thus the reverse of the consumerist project), the heroic and the emotive [49] and upon an art in general that would not yield any dissociable content vulnerable to being cannibalised by the positivist modes of communication that began to dominate American life in the late '40s [50]. But embedded within these bold pronouncements and their iconic, modernist super-

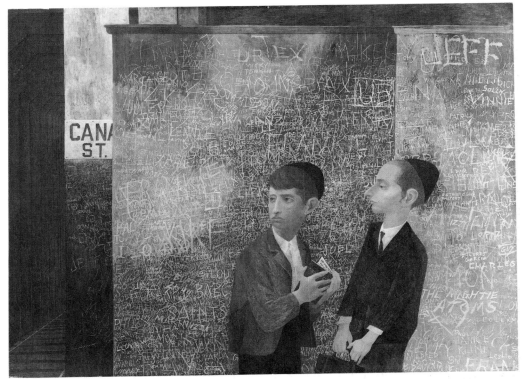

Fig. 13 BERNARD PERLIN *Orthodox Boys* 1948

structure are contrary fragments. Like the distortions of molecular structure that paradoxically lend an alloy greater strength than a pure metal with its regular molecules, they render Abstract Expressionism less univocal and more compellingly impure. Narrative's intrinsic ambivalences seem to have shaped them.

Running throughout Abstract Expressionism in the late '40s and early '50s is a hair-trigger balance that swings between the desire to signify and the will to efface or elide. Like its play upon ends, beginnings and mediating thresholds, the crosscurrents of statement and negation—that whole complex which for the present purposes has been put under the rubric of 'interrupted stories'—suggest the remnants of narrative constitution. Sometimes the parts literally erupted, as in such instances as Pollock's *Out of the Web* (1948) where dancing presences fissure the unitary field. More generally, the stress on seeing, as when Newman or Still will force the eye to correlate a huge chromatic expanse with a tiny or marginal accent, itself generates a quasi-narrative equivocation [51]. The involvement with the labyrinth evident in the work of Pollock, Gottlieb (Fig. 1) and Smith also bears the imprint of the story as something which unravels in space and time. Smith's *The Letter* (1950) is in fact an epistle collapsed into an iconic object that will not of course 'read' as language.

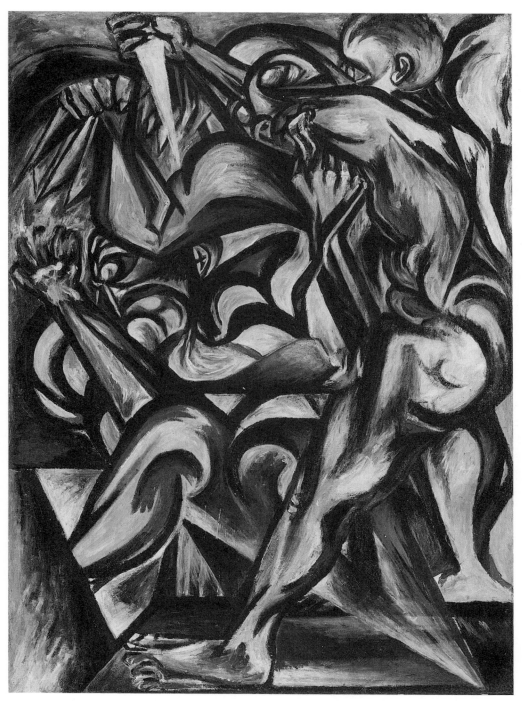

Fig. 14 JACKSON POLLOCK *Naked Man with Knife* c. 1938–41 © 1993 Pollock Krasner
Foundation/ARS, New York

Despite their instantaneity and tactile presence, Pollock's fields have always suggested veils—again echoing the tendency to concealment at the heart of narrative practice [52]. Still's marginal shapes evoke the unseen beyond the picture's edge and, in the way that they destabilise the visible dominant chromatic outburst, retain the aura of their distant transgressive roots. To precipitate the disequilibrium from which narrative starts was Still's stated strategy:

> The best works are often those with the fewest and simplest of elements—pictures that are almost obvious until you look at them a little more, and things begin to happen. [53]

And there flickers in Rothko's famous words the selfsame differential that curbs the plenary radiance of his paintings:

> There are some artists who want to tell all, but I feel it is more shrewd to tell little. My paintings are sometimes described as facades, and, indeed, they are facades. [54]

As with oracles and parables, facades involve curtailment: they announce some larger revelation. To quote James Elkins:

> Effacing a story in paint can have a much subtler effect than erasing a story in words, since the tiniest smears continue to tell their muffled stories . . . [55]

That we have been dealing here with manifold splinters from an erstwhile whole should by now be obvious. The sole frame into which they could all have once fitted is that of narrative. This bodily metaphor proves far from fanciful because the artists themselves evidently set much store on its wider significance. Personification is the postulate of a majority of Smith's sculptures. From another perspective, J. Hillis Miller has called 'personification' a basic trait of narrative [56]. Rothko spoke on behalf of the majority when he recalled that 'a time came when none of us could use the figure without mutilating it' and Still noted of his entire development that 'the figure stands behind it all until eventually it explodes across the whole canvas' [57].

The theme of the body in peril or shattered often presided over the matrix of Abstract Expressionism. It extended, for example, from Guston's *Bombardment* (1937–38) and many of Smith's sculptures in the 1930s, via Pollock's *Naked Man with Knife* (Fig. 14) and Baziotes's *Accordion of Flesh* (1942), to Newman's *Slaying of Osiris* (1945) and the scattered anatomies of the early 1940s in Gottlieb's pictographs and in what Rothko called his 'trunk murders' [58]. Close scrutiny of de Kooning's methods imply that the motif even endured into the zenith of Abstract Expressionism. As his *Pink Angels* (*c*.1945) is based upon Titian's Diana (as seen in the Edinburgh *Diana Surprised by Actaeon*), so both *The Marshes* and *Moraine* (also *c*.1945) share notable similarities with Picasso's knife-wielding female in his Boisgeloup pencil drawing, *The Murder* (7 July 1934) [59]. These

references would then herald one of the likely catalysts for the climactic *Excavation* (1950)—a Picasso etching of *The Death of Orpheus* (1930; first state) [60]. In each instance a violently narrative scene treating dismemberment or transgression has been chosen yet rendered opaque, explicit bodily drama changed into the pictorial movement of planes calving like glaciers. At face value, each of these examples might be 'explained' by quite banal motives relating to wartime destructiveness and male anxieties. But is not the fractured body here a locus of the wider contradictions that drive much of Abstract Expressionism? As a trope for narrative itself, it would speak for the odd and potent desire to embody meaning while riven by the sense of its undoing [61].

NOTES AND REFERENCES

1 MAYER, MUSA (1988) *Night Studio: A Memoir of Philip Guston by His Daughter* (N.Y., Alfred A Knopf) p. 67.

2 On the the complex relation—not in reality a simple binary opposition—between 'iconic' and 'narrative' see ELKINS, JAMES (1991) 'On the impossibility of stories: the anti-narrative and non-narrative impulse in modern painting', *Word & Image*, vol.7, no.4, Oct-Dec, p. 348: 'They ['icons'] replace neither its [narrative's] possibilities nor our continuing desire to tell stories.'

3 Here I follow certain principles set out in MACHEREY, PIERRE (1966; trans. 1978) *A Theory of Literary Production* (London and Boston, Routledge & Kegan Paul) esp. p. 90: 'Thus the critical task is not simple: it necessarily implies the superposition of two questions. To know the work we must move outside it. Then, in the second moment, we question the work in its alleged plenitude . . . Conjecturally, the work has its margins, an area of incompleteness from which we can observe its birth and production.' And, p. 100: 'A true explanation always bears on a composite reality where several determinations converge; it fits together the consequence of laws pertaining to different areas of the reality. This is why we always find gaps and contradictions in the fabric of the work.'

4 *Cf.* Rothko in ASHTON, DORE (1958) 'Art: Lecture by Rothko', *New York Times*, 31 Oct, reviewing the narrative of his development in the Pratt Lecture; the metaphor of the voyage implicit in the *Stations of the Cross*, in Still's often-quoted 1959 allegory which begins 'It was as a journey that one must make . . .' reprinted in ROSS, CLIFFORD (1990) *Abstract Expressionism: Creators and Critics* (N.Y., Harry N Abrams, Inc) pp. 194–196, and, literally, Motherwell's title *The Voyage: Ten Years After* (1968).

5 See ROSE, BARBARA (Ed) (1991) *Art-as-Art: The Selected Writings of Ad Reinhardt* (Berkeley, University of California Press) pp. 4–8.

6 The starting-point for any examination of the relationship between narrative and mimesis remains AUERBACH, ERIC (1953) *Mimesis: The Representation of Reality in Western Literature* (NJ, Princeton University Press).

7 See WOLLHEIM, RICHARD (1973) *On Art and the Mind* (Cambridge, Harvard University Press) p. 110.

8 *Cf.* Guston's statement, quoted in STORR, ROBERT (1986) *Philip Guston* (N.Y., Abbeville Press) p. 57: 'I imagine wanting to paint as a cave man would, when nothing existed before.'

9 Rose (n.5) p. 51. Storr (n.8) p. 52.

10 It is highly indicative that Reinhardt and Guston should both have been involved with cartoons, the quintessential 'low' variant of narrative.

11 See BOIS, YVE-ALAIN (1991) 'The Limit of Almost' in: *Ad Reinhardt* (Los Angeles, the Museum of Contemporary Art, and New York, Museum of Modern Art).

12 Rose (n.5) p. 114.

13 Bois (n.11) pp. 11, 28–29, note 96.

14 See KERMODE, FRANK (1979) *The Genesis of Secrecy* (Cambridge, Harvard University Press) for one of the most trenchant examinations of this broad topic.

15 ASHTON, DORE (1990) *A Critical Study of Philip Guston* (Berkeley, University of California Press) pp. 80, 124.

16 STORR, ROBERT (1992) *Philip Guston in the Collection of the Museum of Modern Art* (N.Y., MoMA) p. 27. In (1986) *The Tate Gallery 1982–84: Illustrated Catalogue of Acquisitions* (London, Tate Gallery) p. 194, the motif in *Black Sea* is identified as a shoe heel, but is surely much closer to the flat irons seen in *Tomb*.

17 As do the leitmotifs of darkness (*Flame*, 1976), blankness (*The Canvas*, 1973), engulfment (*Deluge*, 1979), abyss (*Pit*, 1976), enclosure (*Box and Shadow* and *Tomb*, both 1978) and, in particular of course, hoods or masks (as in the Tate's *Cornered*, 1971) which dramatise the act of being able to see while not being seen.

18 BARTHES, ROLAND (trans, 1975) *S/Z* (London, Jonathan Cape) p. 4. Hence, the enormous stress that de Kooning has placed upon not being able (or not desiring) to finish his works; it becomes the viewer's task to complete the process and thereby 'produce' new meanings. For example, the jump between the jaw area and the nose in *Woman II* (1952) suggests perception refracted in two contending ways. A comparison obtains here with the difficulties identified with the 'unreliable narrator' in BOOTH, WAYNE C. (1983) *The Rhetoric of Fiction* (Chicago, Chicago University Press) pp. 339–74.

19 Rothko (1947) reprinted in Ross (n.4) pp. 167–70.

20 O'NEILL, JOHN P, (Ed) (1990) *Barnett Newman: Selected Writings and Interviews* (N.Y., Alfred A Knopf) p. 173.

21 Ross (n.4) pp. 193–194.

22 *Ibid.* p. 170.

23 *Ibid.* pp. 139–40.

24 NAIFEH, STEVEN and SMITH, GREGORY W. (1989) *Jackson Pollock: An American Saga* (N.Y., Clarkson N Potter, Inc) p. 663.

25 Ross (n.4) p. 170. *Cf.* also, *ibid.*, Rothko, 'Working notes' (undated): 'I use colors that have already been experienced through the light of day and through the states of mind of the total man.'

26 According to O'CONNOR, FRANCIS V. and THAW, EUGENE V. (1978) *Jackson Pollock: A Catalogue Raisonné of Paintings, Drawings and Other Works* (New Haven, Yale University Press) vol. 2, p. 26, the title was Pollock's.

27 Almost melodramatically so, for instance, in Newman's *Stations* with their focus upon mortality, monochrome, bare canvas and broken brushstrokes that serve to define 'negative' zips.

28 O'DOHERTY, BRIAN (1985) *Mark Rothko: The Dark Paintings 1969–70*, (N.Y., Pace Gallery Publications) p. 8.

29 *Cf.* Macherey (n.3) on the interpretative fallacy: 'It is indeed easy to find it [a text] deep, like an enigma or mask behind which lurks some haunting presence . . . Yet this idea of a hidden truth or meaning remains unproductive and misleading: in the proposed exchange between depth and surface there is ultimately just an abstract inversion which disturbs the terms of the problem while leaving the problem unchanged . . . the book is not like a form which so simply hides a depth. The book hides nothing, has no secret: it is entirely *readable*, visible, entrusted.'

30 In this context, Irving Sandler's notion of the 'triumph' of Abstract Expressionism has perhaps been maligned for the wrong reasons. Although it does of course seemingly align the art with an imperialist triumphalism, a possibly more misleading implication is to obscure the fact that the most famous phase of the movement (the aesthetic 'triumph') was a pithy core sandwiched between longer and almost antithetical origins and postludes.

31 KERMODE, FRANK (1966, 1981) *The Sense of an Ending* (Oxford, Oxford University Press). See esp. Chapter II, 'Fictions'.

32 On this issue see ANFAM, DAVID (1993) 'Beginning at the End: The Extremes of Abstract Expressionism' in: ROSENTHAL,

NORMAN and JOACHIMIDES, CHRISTOS (Eds) (1993) *American Art in the 20th Century: Painting and Sculpture, 1913–1993* (Berlin, Martin-Gropius-Bau) pp. 85–91.

33 Macherey (n.3) p. 27: 'The discourse of a work: sealed and interminable, complete or endlessly beginning again, diffuse and dense, coiled about an absent centre which it can neither conceal nor reveal.' Also, p. 38: 'Other than its own unfolding there is nothing within or behind the narrative; thus it reproduces itself. The urgent need to understand, to achieve a transparent reading, paradoxically requires delay and opacity.' Kermode explores similar notions at greater length throughout *The Genesis of Secrecy*, (n.14) esp. in Chapter II, 'Hoti's Business: Why are Narratives Obscure?'

34 Macherey (n.3) continues (p.29): 'The plot emerges disguised as the interruption of a destiny; it takes advantage of something unfinished in order to perfect it.'

35 Kermode (n.14) p. 8 *et pass.*

36 TANNER, TONY (1979) *Adultery in the European Novel* (Baltimore, Johns Hopkins University Press) p. 29: 'Western literature as we know it starts with an act of transgression, a violation of boundaries that leads to instability, asymmetry, disorder, and an interfamilial and intertribal clash that threatens the very existence of civilization (as then known) itself.'

37 Note the highly enigmatic character of the art of Still, Rothko and Pollock in the late 1930s. A perfect encapsulation of this trend is the small, puzzling untitled painting by Rothko (estate no. 3227.36) in the Neuberger Museum, State University of New York at Purchase, where two nudes respectively stand in front of open and shut doors, the latter figure holding her hand to her mouth in a gesture of silence or astonishment. On Smith's interest in concealment see WILKIN, KAREN (1984) *David Smith* (N.Y., Abbeville Press) p. 95. Even Gorky taught a course in 'camouflage' for the war effort in 1940.

38 WHITE, HAYDEN (1980) 'The Value of Narrative in the Representation of Reality', *Critical Inquiry*, vol.7, no.1, Autumn, pp. 11–13, contrasts the chronicle with the narrative. The former reflects 'a culture hovering on the brink of dissolution' where 'there is no story conclusion. How could there be since there is no central subject about which a story could be told?'

39 Auerbach (n.6) pp. 11–12.

40 As noted by LANDAU, ELLEN (1989) *Jackson Pollock* (N.Y., Harry N Abrams, Inc) p. 127, the forms in the central 'secret' are more legible when turned upside-down. Pollock's procedure here therefore resembles a pictorial version of mirror writing or of an anagram. If *Guardians* may be thought to have any story, it seems to me to concern the limits of the knowable. Appropriately, White (n.38) p. 5, notes that the word 'narrative' derives from Latin and Sanskrit roots meaning to 'know'.

41 BRESLIN, JAMES E.B. (1986) 'The Trials of Mark Rothko', *Representations* 16, Fall, p. 3.

42 BRIGGS, ERNEST (1978) interview with the author, 19 Feb.

43 Letter of 3 Feb. 1933, quoted in O'Connor and Thaw (n.26) vol.4, p. 214.

44 White (n.38) p. 22, discusses the ties between narrative and authority: 'Indeed, once we note the presence of the theme of authority in this text, we also perceive the extent to which the truth claims of the narrative and indeed the very right to narrate hinges upon a certain relationship to authority per se.' DOSS, ERIKA (1991) *Benton, Pollock and the Politics of Modernism* (Chicago, Chicago University Press) accurately charts Benton's expression of American producerist and New Deal ideology, but is less reliable on Pollock's divergence from that hegemony.

45 Ross (n.4) pp. 205–7. KERMODE, FRANK (1957) *Romantic Image* (London, Routledge & Kegan Paul) again provides the most insightful analysis applicable to the theory at stake here.

46 GRAEBNER, WILLIAM S. (1991) *The Age of Doubt: American Thought and Culture in the 1940s* (Boston, Twayne Publishers); POLAN, DANA (1986) *Power and Paranoia: History, Narrative and the American Cinema, 1940–1950* (N.Y., Columbia University

Press); TELOTTE, J.P. (1989) *Voices in the Dark: The Narrative Patterns of 'Film Noir'*, (Urbana and Champaign, University of Illinois Press).

47 Exactly the dilemma that will confront the heroine of the novel PYNCHON, THOMAS (1966) *The Crying of Lot 49* (Philadelphia, Lippincott). She, significantly, is torn between reading the world either as a purposeful narrative or a pointless chaos. This is brought out during her nocturnal wandering through San Francisco where random graffiti suddenly start to assume latent meaning.

48 Telotte (n.46) p. 20 makes this point about certain *film noir* techniques such as the subjective camera.

49 Graebner (n.46) p. 131 observes that SCHLESINGER, ARTHUR M. (1949, 1962) *The Vital Center* (Boston, Houghton Mifflin) specifically associates the emotions with traits that gave rise to totalitarianism and communism. Obviously, acute emotionalism was central to Abstract Expressionism at that very moment.

50 In short, those which reduced knowledge and experience to mechanistic processes—whether the rise of television, the Xerox copier, the Polaroid process, Muzak and the long-playing record, B.F. Skinner's behaviourism or Norbert Weiner's cybernetics.

51 Telotte (n.46) Chapter 5, examines how *film noir* 'attempts to turn seeing itself into a sustained narrative device.'

52 Still, in Ross (n.4) p. 196, made this explicit with a quotation from William Blake that ends 'Mine [vision] speaks in parables to the Blind'. As Kermode (n.14) proves, parables are the purest instances of the making-secret

process fundamental to narratives. Still's frequent recourse to metaphors and allegory continues these procedures that ultimately stem from narrative designs.

53 Still quoted in ALBRIGHT, THOMAS (1979) 'The Painted Flame', *Horizon*, vol.22, no.11, Nov., p. 33.

54 ASHTON, DORE (1958) 'L'Automne à New York—Letter from New York' *Cimaise*, 4, Dec.

55 Elkins (n.2) p. 362.

56 MILLER, J. HILLIS (1990) 'Narrative' in: LENTRICCHIA, FRANK and McLAUGHLIN, THOMAS (Eds) (1990) *Critical Terms for Literary Study* (Chicago, Chicago University Press) p. 75.

57 Ashton (n.4); Albright (n.53).

58 BRIGGS, ERNEST (1982) interview, 12 July, in the Rothko Oral History, Archives of American Art.

59 The configurations of *The Marshes* (University Art Museum, Berkeley) and *Moraine* (private collection, New York)—closely related paintings—correspond with the overbearing murderess in *The Murder* (Zervos, VIII, p. 216), her backward-swept victim and the prominent knife in the upper left corner.

60 See Anfam (n.32) pp. 88–90.

61 *Cf.* Rothko, in Ashton (n.54): 'Tension: conflict or desire which in art is curbed at the very moment it occurs.' BRESLIN, JAMES E. B. (1993) 'Out of the body: Mark Rothko's paintings' in: ADLER, KATHLEEN and POINTON, MARCIA (Eds) (1993) *The Body Imaged* (Cambridge, Cambridge University Press) p. 49 quotes Rothko as even saying that 'Paintings are skins that are shed and hung on a wall.'

DAVID CRAVEN

New Documents: The Unpublished F.B.I. Files on Ad Reinhardt, Mark Rothko, and Adolph Gottlieb

In cubist paintings one finds a discipline, a consciousness, an order that implies man can not only control and create his world, but ultimately free himself completely from a brutal, barbaric existence . . .

The way to enrich or socialize painting is to get more and more people to paint, to use and handle colors—not to acquire skills of illustration. Mondrian, like Marx, saw the disappearance of works of art when the environment itself became an aesthetic reality. In its dissatisfaction with ordinary experience, the impoverished reality of present-day society, an abstract painting stands as a challenge to disorder and disintegration. Its activity implies a conviction of something constructive in our own time.

<div align="right">Ad Reinhardt [1]</div>

Just as the last few years have witnessed a revival of interest in the sublime among post-structuralists such as Jean-François Lyotard, there has been a recent revival of McCarthyist invective against prominent figures on the left, some of whom were associated with the Abstract Expressionists. Meyer Schapiro, for example, was attacked in the January 1992 issue of *The American Spectator* for his 'imperishable faith in socialism,' while the late I.F. Stone is now being assailed yet again as a purported 'K.G.B. agent' by a former staff member of the House Committee on Un-American Activities [2]. Ironically, this neo-McCarthyist position is being reasserted even as the triumphalist mainstream interpretation of the Cold War's termination—that is, as a 'victory' for monopoly capitalism and as a vindication of the 'American Way'—is being rendered ever less tenable both by new historical documents and by recent historical developments.

In this paper I shall examine some of this new material, specifically U.S. Government documents that I have only recently obtained through the Freedom of Information Act (F.O.I.A.). These clearly demonstrate the national security threat perceived as being posed in this period by Ad Reinhardt to a notable degree and by Mark Rothko along with Adolph Gottlieb to a lesser extent. This new material will help to consolidate and to extend the theme put forth at the *Myth-Making* exhibition [3].

In 1966, one year before the untimely death of Ad Reinhardt and four years prior to Mark Rothko's tragic suicide, the United States Congress finally passed the F.O.I.A., which for the first time allowed private citizens to have access to records involving the clandestine surveillance of U.S. citizens considered subversive by the Federal Bureau of Investigation (set up in 1908 as the domestic investigative arm of the Department of Justice). According to a congressional audit of 1975 by the General Office of Accounting, there were as many as 160,000 open files concerning 'subversive matters' in the U.S. [4]. Throughout the decade of the 1980s, however, which was generally a period of right-wing resurgence, there was a persistent effort by the Reagan Administration to eviscerate the F.O.I.A. and thus the civil liberties as well as political rights guaranteed by it. This strategy of constraint was advanced through Executive Order 12356 (1982) and through an even more constrictive presidential decree of 1986—a decree which was put forth shortly after the 1985 disclosure of records through the F.O.I.A. that Ronald Reagan had served as an F.B.I. informant, known as 'Agent T-10,' throughout the 1940s while being a member of the Screen Actors' Guild [5].

Of these three artists whose political actions were deemed subversive by the F.B.I. [6], Reinhardt's file is far and away the most extensive. It runs to 123 pages while Rothko's extends to 21 pages and Gottlieb's numbers only five pages. The remarkable size of Reinhardt's file (of which only 100 of the 123 pages were released, with a sizeable portion of those that were released being blotted out for reasons of 'national security') makes it the third largest file on an artist to be obtained to date. The biggest F.B.I. file is of course Picasso's, which is 187 pages in length [7], followed by Ben Shahn's, which consists of 146 pages [8].

A particularly sobering fact about Reinhardt's file, who by his own concession was a lifelong socialist, is that every memorandum about him from 1941–1966 is labelled with the coded designation of 'SM-C' or 'Security Matter-C,' which if spelled out in lay terms means the following: *According to the F.B.I., along with other government agencies, the subject constitutes a national security threat and is a subversive because his or her sympathies for communism and/or socialism make him or her a 'potential' collaborator with foreign agents.* As Herbert Mitgang has noted, these secret dossiers 'cast a shadow of criminality' over the subjects whose actions they monitored. The documents in Reinhardt's file include an eight page F.B.I. memorandum of October 16, 1941 (the earliest report in his dossier), various clandestine reports throughout the 1950s and early 1960s, and his dossier ends with a five page report submitted on 1 November 1966, which was filed a few months before Reinhardt's death. The material compiled by the F.B.I. incorporates substantial information that also originated with other government agencies, including the State Department, foreign embassies of the U.S., the U.S. Navy, and the Counter-intelligence branch of the U.S. Marine Corps [9].

Indeed, so concerned were these various branches of the U.S. Government with Reinhardt's politics that page one of the earliest F.B.I. memorandum states:

Subject is being considered for the custodial detention list. Description set out. Custodial detention memorandum being prepared. [10]

Among the reasons given were Reinhardt's 'membership and apparent activity with the Communist Party' [11]. Here it should be noted that a few months later, in 1942, Executive Order 9066 authorised the U.S. Army to set up just such a detention camp for *every* Japanese American on the West Coast, so that 110,000 people were held prisoner in these concentration camps by the U.S. military for over three years. Furthermore, in 1950 the U.S. Congress passed the Internal Security Act, which allowed for the establishment of more such detention camps during periods of an 'internal security emergency.' Thus suspected subversives such as Reinhardt and Shahn could have been held indefinitely *without* trial (incidentally, this law was repealed only in 1968) [12].

A 23 page F.B.I. document in Reinhardt's file is dated January 5, 1955—this was *after* Senator Joseph McCarthy had been censured by the U.S. Senate. Most of the first page, like many of the subsequent 22 pages, has been blackened-out owing to an exemption called 'b 1'. First authorised in 1986 by the Reagan Administration, this exemption reads as follows:

> (A) specifically authorised under criteria established by an Executive Order to be kept secret in the interest of national defense or foreign policy and (B) . . . properly classified pursuant to such Executive Order. [13]

In short, we cannot know all the details about the Department of Justice's findings in the Reinhardt case, since such general knowledge, according to the Reagan Administration, would threaten 'national security.'

Among the list of groups in this 1955 report—which identifies 'subversive aliases' of Reinhardt for the first time (such as the pseudonym 'Daryl Friedrich' that he evidently used when he was on the Editorial Council of *Soviet Russia Today* in 1937) [14]—are all the organisations classified as 'Communist Party Front Groups' with which Reinhardt either had worked or was still working. This lengthy list included the following organisations and institutions: Friends of the United American Artists Workshop; the ACA Gallery; Committee for the Defense of Public Education; the American Artists Congress; the Artists' League of America; the Book and Magazine Guild [15]; the Thomas Jefferson School [16]; the Civil Rights Congress [17]; the National Council of Arts, Sciences, and Professions [18]; the American Jewish Labor Council [19]; the American Committee for the Protection of the Foreign Born [20]; *New Masses*; and *Soviet Russia Today* [21].

In 1948, Reinhardt had executed a series of drawings for a publication by the American Jewish Council and entitled *The Truth About Cohen*. A prominent feature of this publication that calls for a militant stand against all forms of racism, not just anti-Semitism, is the consistent identification of the class-based exploitation of workers with the socially divisive use of scapegoating by the ruling class. Several passages explicitly relate the logic of capitalist exploitation to the

resurgence of anti-Semitism [22]. Accordingly, some observations are in line here concerning the context of this 1948 pamphlet originating from the U.S. left.

First, we must recall that four of the major figures among the first generation of Abstract Expressionists were Jewish (as was Reinhardt's second wife, Rita)—Barnett Newman, Mark Rothko, Lee Krasner and Adolph Gottlieb—at a time when some sectors of the U.S. Government were openly racist. The Truman Administration actually recruited over 100 scientists who had formerly served the Nazi Government in Germany to work in the U.S. space programme and, in fact, the U.S. Government knowingly admitted as many as 10,000 former Nazis into the U.S. during this period, since they were intransigent opponents of 'communism'. As a member of the U.S. Justice Department conceded in 1987, 'the United States was a haven for Nazi war criminals' throughout the late 1940s and 1950s [23]

Second, we should remember that 1948, the year that Reinhardt's drawings appeared in the pamphlet by the American Jewish Council, was the same year that Robert Motherwell explicitly related an interest in the sublime to a critique of capitalism and it was around the same date when Barnett Newman told art critic Harold Rosenberg that

> if he and others could read it [my work] properly it would mean the end of all state capitalism and totalitarianism. [24]

Earlier in the 1940s in New York City, members of the Frankfurt School had addressed the 'anti-Semitic question' (a locution that they preferred to the 'Jewish question'). After having been affiliated with Columbia University for almost ten years, where he knew and had intellectual interchange with Meyer Schapiro, Max Horkheimer was hired by the American Jewish Committee in 1944 as the director of its newly created Department of Scientific Research. Under Horkheimer's direction, the department launched a multi-volume series of *Studies in Prejudice*, the most famous achievement of which was the volume entitled *The Authoritarian Personality* (1950) that Adorno co-authored with three other scholars [25]. In their section on anti-Semitism in *Dialectic of Enlightenment* (written in the U.S. during 1943–44, and published in Amsterdam in 1947), Adorno and Horkheimer contended that Jews were prime targets of the totalitarian identity principle of instrumental rationality inherent to the capitalist mode of production, since Jews were then the most resolute repository of otherness and difference in a Western system predicated upon ever greater standardisation [26].

Significantly, Ad Reinhardt had already drawn the ire of some U.S. Congressmen in 1944 (which he notes wittily in his 1966 Chronology) when he did a series of drawings for a pamphlet entitled *Races of Mankind* by Ruth Benedict, a professor of anthropology at Columbia University [27]. In this publication the issues of racism and class-based inequality were deftly addressed by Reinhardt in 12 drawings. Particularly impressive also is the way that Reinhardt dealt with the problem of ethnocentrism, or better Eurocentrism, by underscoring the richly multicultural nature of Western cuisine [28]. On several occasions in these

drawings, Reinhardt illuminates the ways in which cultural practices and national traits have been historically constructed, not biologically mandated [29]. Furthermore, the way in which Reinhardt constantly placed the term 'races' in quotation marks, thus highlighting its problematic standing, reminds us of the more recent observations by Henry Gates and others that the category of race is of little merit to biologists. This is the case because the range of physical variations *within* 'racial' groups is often more pronounced than the degree of general physical differences *between* various 'racial' groups [30].

The seventh memorandum in Reinhardt's file, which is from 22 April 1958, exemplifies yet again the wish of some figures in U.S. Government posts to punish Reinhardt for his political commitments. After Reinhardt applied for a passport and denied ever having been a member of the Communist Party, the State Department on 16 April 1958 secretly requested more information about 'his denial of Communist Party membership' [31]. Accordingly, people in the State Department asked the representatives of the Department of Justice 'if there was sufficient information upon which to initiate prosecution under section 1001 or 1542, Title 18, U.S. Code' (22 June 1958) [32]. Fortunately, however, no further action was taken to prosecute Reinhardt for perjury.

Subsequent F.B.I. reports (such as the one on 8 November 1960) make clear that Reinhardt's travels abroad were monitored by the U.S. government [33]. This entry from 1960 notes, for example, that 'there was no indication the subject travelled to a Soviet oriented country' [34]. Later files likewise detail Reinhardt's other foreign travels, but it was in the early 1960s with his support for liberation movements in the Third World through his involvement with anti-imperialist groups that the F.B.I. and other U.S. Government agencies, including the State Department and the Department of Defense, reintensified their surveillance of Reinhardt. Furthermore, it was at this time that Mark Rothko and Adolph Gottlieb were added to the clandestine purview of the F.B.I. owing to their commitment to various progressive movements of the early 1960s.

An F.B.I. memorandum of 25 January 1962, again labelled 'Security Matter-C,' details Reinhardt's involvement with the 'U.S. Friends of Mexico' group—a group that included other members of the Abstract Expressionists' circle aside from Rothko and Gottlieb, namely, David Smith, and less directly Rudolf Baranik and May Stevens [35]. In addition, many prominent figurative painters were involved with this group, the most well known of whom were Ben Shahn, Jacob Lawrence, Jack Levine, and Philip Evergood, as well as both Isaac and Moses Soyer. The specific composition of this group also reminds us that in the future, more broad-ranging discussions of Abstract Expressionism will not only discuss how these paintings related to those by other groups of abstract artists from Canada, Europe, and Latin America, but also how the concerns of the Abstract Expressionists were sometimes interrelated with those of figurative artists such as Shahn or Evergood. To approach the work along these lines—and the paintings of Rudolf Baranik, for example, provide a notable point of intersection for these two

different tendencies—we shall have to advance beyond the tired conceptual framework of 'modernism *vs.* realism' to a less constrictive yet also more critical approach.

Both the F.B.I. and the U.S. State Department considered the 'Artists Committee to Free Siqueiros,' which was the avowed aim of the 'U.S. Friends of Mexico,' to be an alarming organisation. David Alfaro Siqueiros, who was deported from the U.S. in 1932 and who upon his re-entry in 1936 was Pollock's teacher in an experimental workshop, was gaoled in 1960 by the Mexican Government after he supported a demonstration in Mexico City that erupted in violence. Owing to a national law specifying harsh penalties for insurrectionary leaders that foment 'social dissolution,' the judiciary branch of the Mexican Government had sentenced Siqueiros to eight years in prison. In establishing an artists' committee to lobby for Siqueiros' release, the above-noted artists signed public manifestos on Siqueiros' behalf and also held a public art exhibition from 2–6 January in 1962 at the ACA Gallery [36]. As pages one and two of Reinhardt's file for 25 February 1962 clearly show, the F.B.I. did in fact send a secret agent to the art exhibition. This secret agent recorded that he saw no more than 25 people visit the gallery on the two days that he went there [37].

Overlapping with Reinhardt's F.B.I. file during this period are those of Mark Rothko and Adolph Gottlieb, both of whom not only signed the statements in support of Siqueiros but also supported the anti-war movement, as well as the civil rights movement, from the very beginning. An 8 January 1963 communique from the U.S. Embassy in Mexico to the U.S. Department of State is included in Gottlieb's folder [38]. This official report refers to the public letter's appeal that Siqueiros be released from prison and notes that this appeal was the subject of a report in *The New York Times* on 31 December 1962. As the communication from Mexico City states:

> The advertisement mentioned in the *Times* story was placed fairly prominently in *Excelsior*, one of Mexico's leading and conservative daily newspapers, on December 29. It was a salute to Siqueiros on his 66th birthday 'From the Intellectuals of the United States' and urged his release from prison so that 'he may continue enriching the art of Mexico and the world.' The advertisement was dated from New York on December 29 and 'signed' by a number of 'intellectuals,' whose names are listed below as of possible interest to Washington's agencies. [39]

As was true of the information on Gottlieb produced by the F.B.I. in 1965 but detailing earlier dissenting views against official U.S. interests, the material in Rothko's file was also part of a report drawn up by the F.B.I. at the request of the White House staff (11 January 1965), upon receiving a telegram signed by these two individuals [40]—a telegram that, as the F.B.I. responses indicate (1 January 1965 and 4 June 1965) was a strong protest against U.S. foreign policy in Southeast Asia [41]. The secret report on Rothko compiled by the F.B.I. (listing his

address as 'Russia', where he was in fact born), included a subversive pseudonyms check which did not turn-up any alias (as had been done in Reinhardt's case). However, it explicitly linked the 'Friends of Mexico' group with the new anti-interventionist movement that was just then beginning to emerge in the U.S. The F.B.I. assessment, as detailed in the 4 June 1965 memorandum for Rothko's dossier, proceeds along rather ominous lines as follows, after the Siqueiros letter is summarised:

> David Alfaro Siqueiros, a top Mexican Communist Party leader, had been imprisoned for several years for engaging in acts of 'social dissolution,' that is, acting to dissolve illegally the Mexican Government. He reportedly had been engaged in activity in behalf of Soviet intelligence, and in 1940, was reported to have led an abortive attempt on the life of Leon Trotsky.
>
> On April 5, 1965, the F.B.I. received information that an individual by the name of Mark Rothko signed a 'Writers and Artists Protest' against the continuation of the present American policy in Vietnam. The protest was a plea to obtain funds in order to publish an advertisement in 'The New York Times' encouraging individuals to protest to the United States Government . . . [42]

Furthermore, and quite revealingly, it is clear that some of the material about Rothko's involvement with the inception of the anti-war movement was provided by the Head of the Counter-intelligence Branch of the U.S. Marine Corps (5 April 1965) [43]. All of this indicates that especially in the early and mid-1960s—that is, before the anti-war movement gained massive popular support (which occurred only around 1969–1970)—the U.S. Government viewed such opposition to its war efforts, or rather 'police actions,' as highly subversive if not treasonous. Occurring as it did at a time when the Latin American left was experiencing a resurgence inspired by the successes of the Cuban Revolution (including a recent victory in 1961 over U.S.-backed counter-revolutionary forces that Reinhardt sardonically included in his own 1966 Chronology for the Jewish Museum Retrospective as 'the Bay of Pigs fiasco' [44]), this gesture of international solidarity against political repression of the left no doubt alarmed various government agents. And, in fact, as the extensively documented accounts of Noam Chomsky, Philip Agee (himself a former C.I.A. agent in Ecuador), and others make clear, the C.I.A. and the U.S. State Department were even more active in counter-insurgency from the early 1960s onward throughout Latin America than had been the case previously [45].

The reasons that the F.B.I. domestically, and the C.I.A. internationally, so strongly targeted this network of anti-imperialist movements and civil rights groups, and why several of the Abstract Expressionists would be viewed as subversive figures requiring secret surveillance, have been deftly summarised by political economist Paul Sweezy. In discussing why the Vietnam War was 'a turning point in the postwar history of U.S. imperialism,' Sweezy observed that even before the United States plunged into the Vietnam morass, the combination

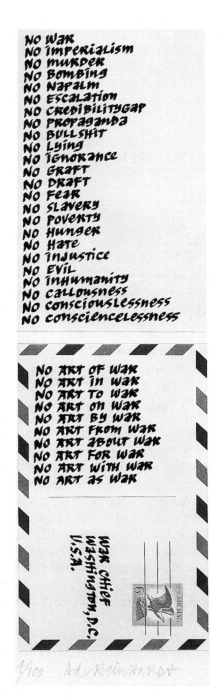

Fig. 15 AD REINHARDT *Untitled*; from the *Portfolio Artists and Writers Protest Against the War in Vietnam*

of the burgeoning civil rights movement and the Cuban revolution had begun to radicalise a part of the white youth. This process notably intensified as the commitment of U.S. troops to Vietnam increased, and as the return flow of casualties swelled. As the 1960s proceeded, these various forces potentiated each other. Thus, the domestic situation resulting from the war reached its nadir after Nixon's invasion of Cambodia in the spring of 1970. By the end of the Vietnam War in 1975, U.S. imperialism found itself in a seriously weakened position, owing in part to the war itself and in part to the relative loss of economic power to its major capitalist allies-cum-rivals [46].

Indeed, when we look back to the first major anti-interventionist manifesto published in *The New York Times* a 'Declaration to [U.N.] Ambassador Adlai Stevenson' (18 April 1965), we find the names of Paul Sweezy and Leo Huberman (the co-editors of *Monthly Review*) along with that of *Dissent Magazine* editor Irving Howe and those of Ad Reinhardt, Rudolf Baranik, and May Stevens. The letter opened with the statement:

> We have watched in dismay as our government—by its actions in Vietnam and the Dominican Republic—has clearly violated the United Nations Charter, international law, and . . . fundamental principles of human decency. [47]

As such, this group with the title of 'Artists and Writers Dissent,' then urged Adlai Stevenson to resign as U.S. Ambassador to the United Nations and to become a spokesperson for those who were opposed to the U.S. Government's recourse 'to unilateral military interventions' [48].

The F.B.I. file on Reinhardt closes with several secret memoranda about his anti-war activities and one report from 1 November 1966 includes yet another round of subversive name checks to determine if Reinhardt were also active under any of his former aliases [49]. It is with this group of documents that Reinhardt's file concludes.

Artists associated with Abstract Expressionism did in fact produce several works of this period that were far more topical in orientation than was generally true of their art after the 1930s. Along with Rudolf Baranik's remarkable *Napalm Elegy Series* (1966–1974), there was Barnett Newman's well known 'lace-curtain' sculpture for Mayor Daly of Chicago after the 1968 police repression visited upon counter-cultural forces and anti-war groups during the National Convention of the Democratic Party. Shortly before his death, Ad Reinhardt even made one directly *engagé* political work, a lithograph entitled *No War* (Fig. 15), and created in 1967 as a print/poster for an Artist and Writers Protest portfolio. This print is in the form of a standard U.S. airmail postcard folded back to reveal both the address side and the side with the message. On one side it is addressed to 'War Chief, Washington, D.C., U.S.A.,' while on the reverse side in Gothic calligraphy is one of Reinhardt's declarations through unqualified negation. The list of 24 negatives, begins as follows:

No War
No Imperialism
No Murder
No Bombing
No Napalm
. . .

On the side of the address, he provides one of his famous serial non-definitions of art's relationship to other phenomena (in this case, to War). This list of ten disavowals begins with the following:

No Art of War
No Art in War
No Art to War
No Art on War
No Art by War
. . .

ACKNOWLEDGMENTS

For support in writing this paper I should like to thank the staff of the Archives of American Art of the Smithsonian Institute in Washington D.C., and the staff of the Tate Gallery Liverpool, particularly Penelope Curtis and Anne MacPhee. In addition I should thank J. Kevin O'Brien, Director of the Freedom of Information-Privacy Acts Section, Information Management Division of the Federal Bureau of Investigation, Department of Justice, Washington D.C.

NOTES AND REFERENCES

1 REINHARDT, AD (1943) 'Abstraction vs. Illustration', in: ROSE, BARBARA (Ed) (1991) *Art as Art: The Selected Writings of Ad Reinhardt* (Berkeley, University of California Press) pp. 48–49.

2 (1992) *The New York Times*, 13 August and 26 September. See also GUTTENPLAN, D.D. (1992) 'Stone Unturned', *The Nation*, 28 September, pp. 312–313.

3 See CRAVEN, DAVID and CORRIS, MICHAEL in *Artforum*, Summer 1993, for a discussion of the various political ramifications and ideological implications of these documents for Ad Reinhardt's black paintings.

4 MITGANG, HERBERT (1989) *Dangerous Dossiers* (N.Y., Ballantine Books) p. 9.

5 *Ibid*, pp. 15–17.

6 The public presentation at the *Myth-Making* exhibition critical forum, Tate Gallery Liverpool, for the very first time anywhere of the formerly top secret government documents about Reinhardt, Rothko, and Gottlieb attests *both* to the ongoing, if also limited, access still permitted by the Freedom of Information Act *and* also to the heavily censored form in which these documents will appear (if they are released at all) owing to the executive manoeuvres of the Reagan and Bush Administration.

7 MITGANG, HERBERT (1990) 'When Picasso Spooked the F.B.I.' *The New York Times*, Sunday, 11 November, Section 2, pp. 1, 39.

8 See Mitgang (n.4) pp. 212–214. A 1951 memorandum in Shahn's file states, for example, that although Shahn had 'denied being a Communist,' he was nonetheless 'identified with pro-Communist activities' through the making of posters 'for various trade unions in New York City, and he has

been very successful in the modern art field.' A subsequent F.B.I. memorandum in 1952, the year Charlie Chaplin was being forced to leave the U.S., specifically mentions Shahn as a 'candidate for deportation.'

9 Because this material is presently unpublished and is unpaginated except for the number of pages *within* each separate government memorandum, I shall refer to the documents by means of these localised references. In the future, I shall donate all of this material to the Archives of American Art, Smithsonian Institute, Washington, D.C.

10 F.B.I. File on Ad Reinhardt, Archives of the Department of Justice, Washington, D.C., unpublished, 16 October 1941, p. 1.

11 *Ibid*, p. 11.

12 See ZINN, HOWARD (1980), *A People's History of the United States* (N.Y., Harper & Row) pp. 407–408.

13 (1986, 4 December) *Executive Order 10450: Explanation of Exemptions*, (Washington, D.C., Department of Justice Publishing Wing) p. 1.

14 F.B.I. File on Ad Reinhardt, 5 January 1955, p. 1.

15 which was affiliated with the United Office and Professional Workers of America, the CIO, the American Labor Party, and the American Committee For Peace and Democracy—the latter had been 'cited as subversive by Attorney General Tom Clark' on 21 September 1948.

16 where Ad Reinhardt and painter Norman Lewis taught from 1946–1948 and which was 'designated as subversive by Attorney General pursuant to Executive Order 10450'. See F.B.I. File on Reinhardt (n. 14) p. 11.

17 *All* commentary by the F.B.I. here is blotted out in accordance with 'national security' concerns. It was precisely his identification with this organisation that led to writer Dashiell Hammett's imprisonment for six months in 1951 after he refused to name the various other people who had been associated with this group, among whom were Ad Reinhardt and William Faulkner. In fact, it was his support of the 1951 position taken by the Civil Rights Congress in the Case of Willie McGee that led to Faulkner's being

monitored by the F.B.I. See Mitgang (n.4) pp. 37–42, 89–90.

18 Most of this entry is blackened out owing to the 'b 1' exemption, except for a portion stating that this group is 'a Communist Front' according to the 14 May 1951 *Guide to Subversive Organizations and Publications*.

19 Again, this entry is blotted out almost entirely, except for a reference to Executive Order 10450.

20 Blotted out, except for a citation of Executive Order 10450.

21 F.B.I. File on Reinhardt (n. 14) p. 14.

22 Ad Reinhardt Papers, Archives of American Art, Roll N/69–100: 395–412.

23 (1987) ' "The U.S. Was a Haven for Nazi War Criminals": An Interview with Allan Ryan by Andrew Rosenthal', *New York Times*, Sunday, 26 April, Section E, p. 2.

24 NEWMAN, BARNETT (1962) ' "Frontiers of Space": An Interview with Dorothy Gees Seckler', reprinted in O'NEILL, JOHN P (Ed) (1990) *Barnett Newman: Selected Writings and Interviews* (N.Y., Knopf) p. 251.

25 ADORNO, T.W.; FRENKEL-BRUNS-WIK, ELSE; LEVINSON, DANIEL J.; and SANFORD, R. NEVITT (1950) *The Authoritarian Personality* (N.Y., Harper & Row).

26 HORKHEIMER, MAX and ADORNO, T.W. (1947 [72]) *Dialektik der Aufklärung* (N.Y., Seabury) pp. 204–233.

27 BENEDICT, RUTH and WELTFISH, BENEDICT (1943) *The Races of Mankind*, (N.Y., Public Affairs Committee). For Reinhardt's 'Chronology' see REINHARDT, Ad (1962) 'Art as Art', *Art International*, December, pp. 4–8.

28 *Ibid* p. 24.

29 *Ibid* pp. 14–15.

30 APPIAH, ANTHONY (1985) 'The Uncompleted Argument: DuBois and the Illusion of Race,' *Critical Inquiry*, vol. 12, no. 1, Autumn, p. 21.

31 F.B.I. File on Ad Reinhardt, 22 April 1958, p. 1.

32 F.B.I. File on Ad Reinhardt, 22 June 1958, p. 5.

33 F.B.I. File on Ad Reinhardt, 11 November 1960, p. 1.

34 *Ibid.*

35 F.B.I. File on Ad Reinhardt, 25 January 1962, pp. 1–3. See also F.B.I. File on Adolph Gottlieb, Memorandum from the U.S. Department of State, 8 January 1963, pp. 1–3.

36 F.B.I. File on Gottlieb (n. 35) pp. 1–3.

37 F.B.I. File on Ad Reinhardt, 25 February 1962, pp. 1–2.

38 F.B.I. File on Gottlieb (n. 35) pp. 1–3.

39 *Ibid.*

40 F.B.I. File on Mark Rothko, Memorandum to the White House (Special Assistant to the President, Marvin Watson), 11 January 1965, p. 1.

41 F.B.I. File on Mark Rothko, Memorandum to the White House (Special Assistant to the President), 4 June 1965, p. 1.

42 F.B.I. File on Mark Rothko, 4 June 1965, pp. 1–3.

43 F.B.I. File on Mark Rothko, Memorandum from Head, Counter-intelligence Branch, U.S. Marine Corps, 5 April 1965, pp. 1–4.

44 Reinhardt, 'Art as Art' (n. 27) p. 8.

45 CHOMSKY, NOAM (1979) *The Political Economy of Human Rights*, 2 Vols., (Boston, South End Press).

46 SWEEZY, PAUL (1989) 'U.S. Imperialism in the 1990s', *Monthly Review*, vol. 41, no. 5, October, pp. 5–6.

47 Ad Reinhardt Papers, Archives of American Art, Roll N/69–101: 0081.

48 *Ibid.*

49 F.B.I. File on Ad Reinhardt, 1 November 1966, pp. 1–6.

ANN GIBSON

Norman Lewis in the 'Forties

One of the earliest preserved drawings by Norman Lewis is an untitled wash drawing of an African head in 1932 (Fig. 16). Its rigorous naturalism may come as a shock to those who know Lewis best as an early member of the New York School and a painter of atmospheric abstractions. As with most of those painters now called Abstract Expressionists, Lewis's journey into abstraction was a complex evolution, a struggle with social and political as well as aesthetic systems of meaning. Unlike some of his friends—men like Mark Rothko, Ad Reinhardt, and David Smith—whose importance has been recognised for some time, Lewis was an active participant in two distinct artistic milieus. He was an increasingly significant presence in the circle around the sculptor Augusta Savage, who was by the mid-1930s the most influential artist in Harlem [1], a member of the '306 Group' that began in Charles Alston's studio (i.e. the Harlem Art Workshop), and the treasurer of the Harlem Artists Guild [2]. After World War II, however, Lewis also became closely associated, through his charter membership of 'Studio 35', with the group of artists who would come to be known as the Abstract Expressionists [3]. An abstract painting by Lewis in 1945, *Composition No.1* (Fig. 17), together with the earlier drawing, are emblematic of his position between these two communities.

The apparent change in Lewis's subject-matter, from naturalism to the soft geometry of *Composition No. 1*, might easily be seen as a move from the 'ancestral' imagery of the group of artists surrounding Savage to the 'universal' abstraction of the Abstract Expressionists and therefore as a flight from his Harlem roots [4]. In this paper I would like to argue against this interpretation by looking at Lewis's work during and just after World War II, as he operated between these two constituencies, and to argue, too, that in his effort to create an art that resonated to the demands of both groups, he created a series of unique products whose aesthetic implications have not been fully grasped and whose cultural position has yet to be defined.

In the later 1930s and early 1940s much of Lewis's work showed a solidly figurative social realism (Fig. 18), an amalgam of the painterly realism that characterised the work of Raphael Soyer and the broader surfaces of Diego Rivera. He concentrated on the lives of urban Black workers and families including social and street scenes, his compositions sometimes lit with a flash of ironic sympathy, as for example in an early, untitled, study in which the father reads a newspaper, a

Fig. 16 NORMAN LEWIS *Untitled wash drawing of an African head* 1932 (photo. Jeannie Black)

younger child sings for dinner, and an older child dozes against the father while the mother, whose features are hidden, bends over her washboard.

A true son of the Harlem Renaissance, however, Lewis also actively pursued a knowledge of African Art. During the Museum of Modern Art's *African Negro Art* exhibition in 1935, he asked for and received permission to copy the works on display [5], ambiguously described in the catalogue as demonstrating 'the broadest variety of expression, if not the highest, in Negro art' [6]. Four of Lewis's pastels have been preserved, each a careful representation of a specific object in the show. A pastel labelled *Ivory Coast Baule* in pencil on the border by Lewis, for instance, is a detail of a standing female figure [7]; Lewis's *Figure French Soudan* is a back view of a French Sudanese figure of a seated woman [8]; an untitled pastel is taken from a carved bobbin from the Ivory Coast [9]; and an untitled drawing by Lewis of a mask is from an unillustrated Makonde mask [10].

The results of Lewis's study of African art [11] did not, however, immediately enter his painting in obvious ways. Nor did the influence of Vaclaw Vytlacil, an established painter with whom Lewis was associated through Augusta Savage's Uptown Art Laboratory [12]. By the later 1930s and into the early 1940s, under Vytlacil's enthusiastic encouragement, Lewis's compositions began to loosen. Vytlacil's full impact on Lewis is clearest in such works as *Dishwasher* (1944) and *Sailor and Woman* (1945) (Fig. 19) but it was already apparent by the early 1940s [13].

Fig. 17 NORMAN LEWIS *Composition No. 1* 1945 (photo. Jeannie Black)

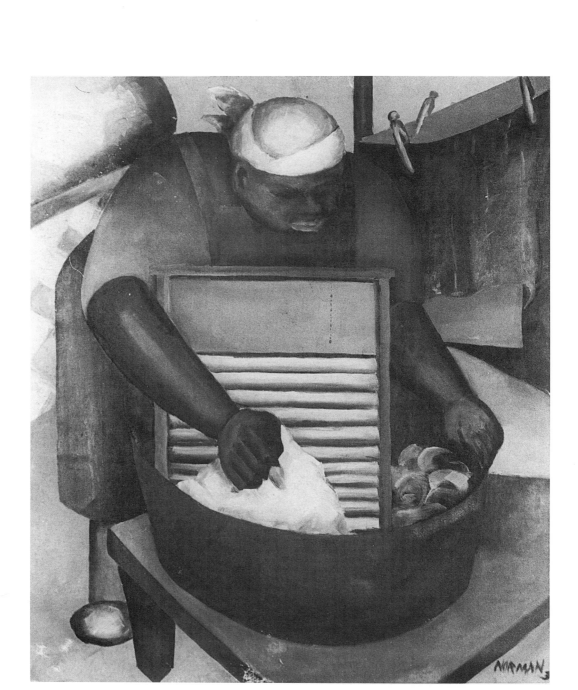

Fig. 18 NORMAN LEWIS *Washerwoman* 1936 (photo. Jeannie Black)

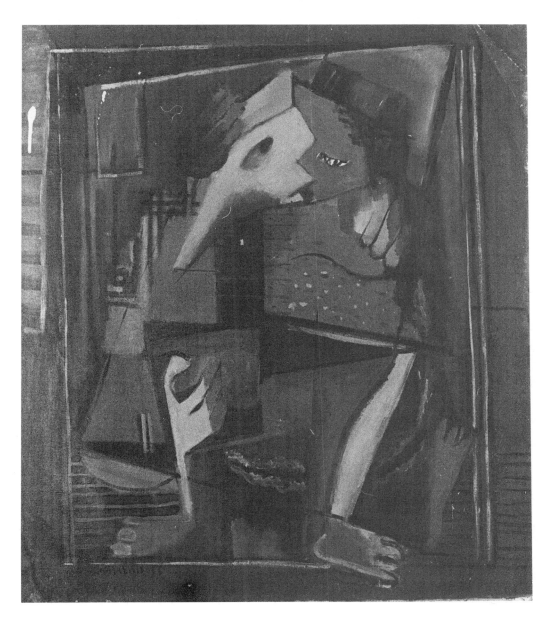

Fig. 19 NORMAN LEWIS *Sailor and Woman* 1945 (photo. Jeannie Black)

As the 1940s began, Lewis was in at least partial sympathy with the position of philosopher and critic Alain Locke, perhaps the most influential voice on art in the Black community as a whole [14]. Since the 1920s Locke had advocated the construction of a Black subject. In 1925 he wrote:

> Our poets have now stopped speaking for the Negro—they now speak as Negroes. [15]

In 1939 he wrote 'we expect from the Negro artist a vigorous and intimate documentation of Negro life itself', giving as examples Archibald Motley's 'Negro city types' and Malvin Gray Johnson's 'Virginia rural types' [16]. Although Locke was willing to admit that national identity might be revealed less directly 'in the subtler elements of rhythm, colour, and atmosphere' and that 'under no condition need we expect the work of the Negro artist to be too different from that of his fellow artists', he was anxious to direct Black abstractionists back to a more recognisable construction of Black difference:

> The Negro artist, doubly sensitive as an artist and as an oppressed
> personality, has often shied off from his richest pasture at the slightest
> suspicion of a Ghetto gate . . . Yet after pardonable and often profitable
> wanderings afield for experience and freedom's sake, the Negro artist, like
> all good artists, must and will eventually come home to the materials he
> sees most and understands best. [17]

Locke's position in the later 1930s may be contrasted to that of a group of White painters, the American Abstract Artists (A.A.A.), with whom Lewis exhibited (although he was not a member) and who numbered among their charter members the painter Ad Reinhardt, perhaps Lewis's closest associate in the New York School [18]. In contrast to Locke's directive, these artists promoted a universalism whose goal was the erasure of difference. Balcomb Greene, who became the chairman of the A.A.A. in 1939, wrote for the catalogue of the organisation's 1938 exhibition that the universality of the 'amorphous and geometric forms' that characterised the work of the members of the association made it impossible for the artists 'to play on national or racial or class prejudices' [19].

Although Lewis was becoming interested in the programme of the A.A.A., his major sympathies, as late as 1942, were still with the position outlined by Locke and evident in the work of most of the artists surrounding Augusta Savage. He listed Locke as one of his referees in his application for a Rosenwald fellowship that year, declaring:

> I should like to paint the Negro in Harlem and throughout the South,
> giving special attention to different forms of labor in different locations.
> Also depicting the Negro doing his part in the National defense. [20]

Lewis's wartime experiences, however, prompted him to question whether picturing 'the Negro' was the most effective means either of expressing his own

identity or of furthering the interests of the Black community. It became apparent to him that creating vital cultural products—even art that was well received and widely distributed—was not necessarily an effective means of combating discrimination. An article in the *New York Post* in 1943 noted that:

> A million copies of CIO War Relief Committee Poster designed by Norman Lewis, the only Negro among the eight artists competing, are being put up in shops and union halls all over the country.
>
> None of the other artists had worked in a war plant and a committee member suggests that the experiences of Lewis, who worked in the Kaiser Shipyards at Vancouver, gave his poster the strength and character which won him the contract.
>
> 'If so, it's interesting,' Lewis says, 'for I quit that job because I couldn't stand the discrimination. Negroes couldn't get into the union and 300 were fired because they were not members. Then there were too many accidents, strange accidents where Negroes got hurt and there was too much intimidation and it was too hard for a Negro to be anything except a laborer.' [21]

By 1944 Lewis's work began to exhibit a radical change. Simmered in experiences like the one in Vancouver, Lewis's new painting responded resistantly to the differences he must long have recognised between the imperatives for Black and White artists. It is worth noting that in this same year, Alain Locke, striking a similar but more conciliatory note than Lewis was to do, saw social documentation in the work of the younger Negro artists as 'only one strand' in an art that also displayed a 'strong decorative interest in design, colour and the technicalities of art' [22]. The evocative, virtuoso technique Lewis had formerly employed gave way to pastiche (Fig. 20) as he ransacked the history of art for modes of representation within which he might contain the conflicting demands of the constituencies to which he responded.

An examination of Lewis's subjects and styles in these paintings of the middle 1940s catalogues the diversity of these demands. In the four street figures in Fig. 20, Lewis plays in one language (abstraction) on another language (social realism)—that more familiar and acceptable mode of representation employed in references to Harlem street life in the work of artists as disparate as Aaron Siskind, Archibald Motley, and Palmer Hayden [23]. With expressionistic rendering he also stabs at the pretensions of gentlemen who wear top hats, waistcoats, and spats (minus shoes). In the second figure from the left, he comments on the street practice of pairing a zoot suit with an apple cap rather than a bomber, and performs an emphatic play on the striations of Songye masks, such as one he would have seen in the MoMA exhibition in 1935, visible on the heads, necks, and arms of the figures [24].

The acid of Lewis's caricatures of street people spills over here onto the direct incorporation of African motifs into contemporary work, criticising this way of

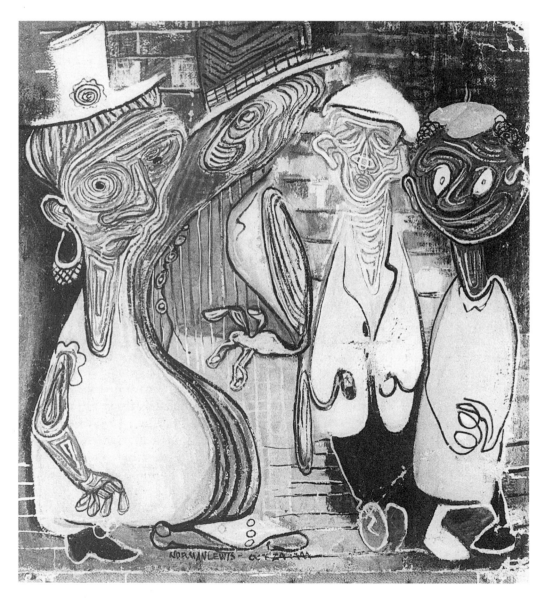

Fig. 20 NORMAN LEWIS *Untitled 10/24/1944* 1944 (photo. Jeannie Black)

using them to impart dignity and power to Black artists' work in much the same way that the wearing of top hats, zoot suits, and gold earrings did little to improve the status of the citizens of Harlem. More importantly, however, the levelling effect of such pastiche also asserts that the aesthetic of a specific African people has a status equal to that of dominant European modes such as social realism and expressionism.

Such parody (which implies an affection for its object at the same time that it mounts a challenge) involves the mimicry of a style or statement as well as a redirection of its accepted meaning: a repetition with difference. Thus the artist is able to say, or picture, one thing but signify something else by quoting a phrase whose implication is rerouted by its context towards an unanticipated object. This was a characteristic of Lewis's conversation, as well as of his painting. "Would Norman Lewis talk on two levels at once?", I asked painter Ernie Crichlow, whose friendship with Lewis dates from the 1930s. "Try five," he said:

> In the middle of a conversation, Norman would flip from one thing to another. Just when you thought he was talking about one idea, you'd find out he'd been thinking about something else as well, all along. [25]

Literary scholars have commented on the practice of such signifying, in which the *apparent* meaning of a statement is the signifier of its actual meaning [26]. Henry Louis Gates Jr., in particular, has stressed the centrality in the Black cultural matrix of this practice of critiquing other texts (in this case other art) as a method of identifying the self and as a vehicle for liberation [27].

In the following year Lewis became progressively more involved in the various forms of European abstraction most compelling to the Abstract Expressionists; he did not, however, forsake either his Harlem subjects or the employment of the ironic pastiche that had come to typify his work. Rather, he put these languages of abstraction at the service of his signifying practice. At first glimpse *Untitled 5/1945* (1945) (Fig. 22) appears to be non-representational, reminiscent of Joan Miró's surrealist nocturnes of the mid-1930s. Further scrutiny, however, reveals it as a barely discernible but full-bellied figure in a waistcoat, whose rounded right side is cloaked in a not-quite-opaque brown panel, overlaid with fragments of rectilinear geometry like those that filled Mondrian's 'plus-and minus paintings' of the mid-1910s.

In the centre glows a white area, circumscribed by a line that economically describes it as a waistcoat. To the left, below and above the waistcoat, are extremely stylised, expressionistic, yellow hand and face, motifs explored in an untitled wash drawing a year earlier (Fig. 21). While both the hand and the face in the more abstract oil painting are flatter than those in the wash drawing, the extremity of Lewis's abstraction of the head in the oil deserves special mention. In the more realistic figure in the wash drawing, the undefined portion of the face on the right may be read as a sign of its drop into shadow, thus still figuring as a representation, however schematic, of a head in three dimensions. The 'head' of

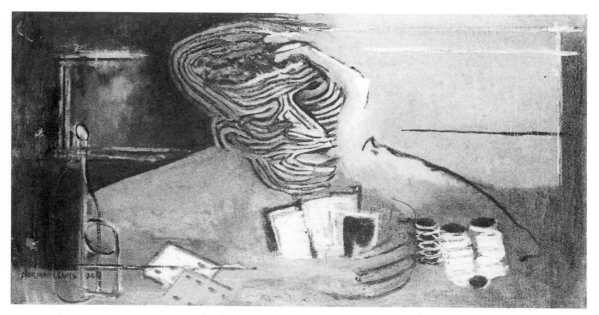

Fig. 21 NORMAN LEWIS *Untitled* 1944 (photo. Jeannie Black)

the oil-painted figure in the waistcoat, however, reads either as a tiny black profile connected to the figure by an umbilical line or, Picasso-like, as two simultaneous views, side and front, in which the black silhouette plays the role of both profile and shadow.

Lewis's use of this device of doubling, however, is more radically abstract than Picasso's, forcing the viewer to question, despite the placement of the form at the top of the torso, whether it really represents a head at all. In uncomfortably meshing surrealism, geometric non-objectivity, realism, expressionism, and cubistic abstraction in the same painting, Lewis parodied the claim of each of these styles to authority, asserting the contingency of each by implying their cultural relativity as well as his mastery of them.

As an American of African descent, Lewis was in a good position from which to observe that representation and what was represented seemed to have more to do with who was in charge of formulating the representation than it did with any intrinsic link between the two. Following World War II there was in America an official emphasis on racial co-operation: major league baseball was integrated; *The Saturday Evening Post* began to publish articles by writers such as Langston Hughes, Zora Neale Hurston, and Walter White [28]; in 1942 Jacob Lawrence joined Edith Halpert's Downtown Gallery; Romare Bearden became a member of the Samuel Kootz Gallery in 1945; and in 1946 Lewis began showing regularly with Marian Willard. There was a significant impulse, in both the Black and the White art communities in New York, towards the kind of abstract universalism described by Balcomb Greene: one that stressed humanity's common condition

Fig. 22 NORMAN LEWIS *Untitled 5/1945* 1945 (photo. Jeannie Black)

rather than its differences; a universalism that expressed, as Robert Motherwell put it:

> the particular acceptances and rejections of men living under the conditions of modern times. [29]

Despite such apparent movements toward equality, however, the war had made irreversible changes in African-Americans' perception of their position in American democracy. The hypocrisy and paradox of fighting a war for freedom against an enemy whose master race ideology was echoed at home by the fact of a segregated armed forces were painfully evident [30]. In the art world, the continued absence of Black artists from most venues of exhibition and sales went unremarked by Whites. Romare Bearden recalled one critic's comment on the absence of Blacks from the Eighth Street Club:

> Now that I think of it, too, I wonder why someone didn't invite some— you might have had a different point of view. [31]

The peculiarities of living in a culture where difference was denied although it was everywhere apparent brought about a crisis. David Driskell has suggested that the experience of W. E. B. DuBois's 'double consciousness'—'that peculiar sensation of always looking at oneself through the eyes of others'—became particularly acute for Black artists in America in the 1940s. They experienced this crisis as a problem of

> whether it was better to be a 'Negro Artist' and develop a racial art or to be an American artist who was a Negro. [32]

Lewis and a few others in the 1940s—artists such as Romare Bearden, Harlan Jackson, Ronald Joseph, and Hale Woodruff—decided it was better to be an American artist who was a Negro.

Earlier than most socially concerned members of the New York School (such as Jackson Pollock, David Smith, and Robert Motherwell), Lewis embraced the possibility of nonfigural, that is, non-representational meaning [33]. He abandoned, for a time, the figure as the basis of his art, having come to the conclusion that art aimed directly at social and political grievances was not an effective tool. Lewis recalled years later in an interview with Vivian Browne:

> I used to paint Black people in their struggle for existence, but I soon found out that this was a waste of time because the very people who you want to see this kind of thing don't see it. I don't think it helps the struggle. So later I became involved in unions; I felt that picketing, and any kind of mass demonstration made more of an impression on people than painting pictures and trying to arrest that same audience. [34]

In his copy of Wolfgang Paalen's *Form and Sense* (1945), Lewis marked in the margin a passage that said that an artist who worked with the 'representative

image'—'the ideal standard of realism in art'—is conventional, and that today *'it is reactionary'* [35]. In 1945, Lewis's painting moved rapidly towards an abstract geometric mode. Paintings such as *Untitled* (1945) (Fig. 23) are strongly stylised, with little to identify their geographic or chronological origins; *Composition No. 1* (Fig. 17) dates from this year also. These and similar efforts of this time parallel Paalen's proclamations, as suggested by Lewis's marking of another phrase in *Form and Sense*:

> no more models, internal and external; the picture with a subject is finished. [36]

However, Lewis's painting appears to have retained schematic references to the figure until about mid-1946. By July of that year he had worked his way into an idiom as abstract as that with which he had experimented in *Composition No.1* the year before, but one whose graphic speed and density made it apparent that he had, indeed, as he said in his 'Thesis' of 1946, grown from what he then saw as

> an over-emphasis on tradition and then propaganda to develop a whole new concept for myself as a painter.

Like Greene and Motherwell, Lewis was after the universal. In paintings such as *Roller Coaster* (1946) (Fig. 24) and *Metropolitan Crowd* (1946) Lewis aimed to express a concept that:

> treats art not as reproduction or as convenient but entirely secondary medium for propaganda but as the production of experiences which combine intellectual and emotional activities in a way that may conceivably add not only to the pleasure of the viewer and the satisfaction of the artist but to a universal knowledge of aesthetics and the creative faculty which I feel exists for one form of expression or another in all men. [37]

In the later 1940s, Lewis's plays on line and colour occasionally recalled earlier subjects, such as music or street scenes. For the most part, however, they were resolutely abstract. Lewis's formal idiom reminded viewers of the paintings of Paul Klee, a personal favourite of Marian Willard, his dealer, and especially of Mark Tobey, also shown by Willard, although Lewis was personally much closer to another member of the Willard stable, Lyonel Feininger. Some of Lewis's work from the later 1940s, such as *Twilight Sounds 3/19/1947* (1947) (Fig. 25), is closer to Feininger's work of that period—such as Feininger's *Courtyard 3* (1949) (Fig. 26)—than it is to that of Tobey. Although Lewis's brush moved with more vigour than either Tobey's or Feininger's, often echoing the motion of his arm and body, critics found Lewis's citation of the individual styles of accepted painters unacceptable. As a critic for the *New York Sun* put it in 1949, Lewis was

> too close for comfort to the style employed by Mark Tobey. One Mark Tobey is enough. [38]

Fig. 23 NORMAN
LEWIS *Untitled* 1945
(photo. Jeannie Black)

Fig. 24 NORMAN LEWIS *Roller Coaster* 1946 (photo. Jeannie Black)

The last sentence is particularly revealing. Lewis's signifying on styles of accepted painters aroused a certain uneasy rejection. The *Daily Worker* reported:

> Although Lewis like Tobey relies on a mesh of lines and floating planes of color, his work appears much more the result of conscious stylization. [39]

In other words, Lewis knew what he was doing.

'Conscious stylisation,' however, in an aesthetic epoch dominated by a desire for myth and intuition, was not a good thing. Not until 1952 did Franz Fanon take Jung to task for apotheosising as the collective unconscious what Fanon saw, rather, as 'simply the sum of prejudices, myths, collective attitudes of a given group' [40]. In the era of Abstract Expressionism, the pursuit of myth was described in existential terms by Harold Rosenberg as a refusal of the given in favour of the absolutely personal:

> The tension of the private myth is the content of every painting of this vanguard. [41]

Fig. 25 NORMAN LEWIS *Twilight Sounds 3/19/1947* (photo. Jeannie Black)

Note that Rosenberg specified that the myth was private. Lewis's pastiche exposed this private world as a social construction. Such appropriation opened the door to a series of disturbing questions [42]. It made it apparent that Lewis was not the passive, almost helpless recipient of 'influence', but that he was, rather, taking things into his own hands, turning the tables—or in this case, the eye—on the dominant tradition [43]. To have accepted Lewis's 'doing' Tobey as a valid element in establishing his own difference—his distinctive identity in relation to the tradition represented by Tobey, Klee, and Feininger—threatened to undercut the ideals of the individual artistic originality and genius by which modern European art had been validated as advanced, important, and therefore valuable.

Lewis's play with the tradition established by Paul Klee did not, however, imply that he courted the unauthentic for its own sake. Signifying on conventions was only one aspect of his complex and ambivalent relation to the art of his time [44]. Lewis was also, one may recall, a charter member of the group around the table at Studio 35 where personal authenticity was an unquestioned value. One of the difficulties in painting, he wrote to his friend the painter James Yeargans:

Fig. 26 LYONEL FEININGER *Courtyard 3* 1949 © DACS 1993.

has to do with the individual, and the questions there are—I. Is it his prime interest?—II. Does he want to do it bad enough? [45]

By 1950, Alain Locke (whom Lewis still listed as one of his referees on an application for a Guggenheim fellowship in 1949) advised artists that:

> the necessary alchemy is, of course, universalized rendering . . . Give us Negro life and experience, but with a third dimension of universalized common denominator humanity. [46]

That 'Negro life and experience' could form the basis for the universal—that the particular could serve as the basis for the general—may have seemed oxymoronic to some. But yoking these two opposites, the general and the particular, was as common among downtown Abstract Expressionists like Willem de Kooning as it was among uptown realists [47]. Lewis's work in the 1940s, however, was characterised by an especially strong quotient of paradox, what might be called 'content by contradiction'—a love-hate reaction to his sources in which ambivalent confrontation was paired with a revitalising optimism [48]. The painful uncertainty of operating within such charged parameters became evident to Lewis as he entered the 1950s:

> I cannot, of course, predict the extent of such a project nor its degree of conclusiveness [he wrote] except to say that it must, at least, include all the elements of a thesis, supported by evidence and brought to either a positive or negative conclusion. [49]

ACKNOWLEDGMENTS

This is a slightly modified version of a paper first published in (1989) *Norman Lewis* (N.Y., Kenkeleba Gallery), May 10—June 25.

NOTES AND REFERENCES

1 BIBBEY, DEIRDRE L. (1988) 'Augusta Savage and the Art Schools of Harlem,' *Augusta Savage and the Art Schools of Harlem* (N.Y., Schomburg Center for Research in Black Culture, The New York Public Library), p. 8. Lewis claimed that he did not 'study' with Savage, who taught primarily sculpture, while his interests lay with drawing and painting; nevertheless, Savage was the 'master' artist in whose atelier Lewis worked as assistant, absorbing and rejecting her style and philosophy.

2 For more information on Lewis's career, see LAWSON, TOM (1976) *Norman Lewis: a Retrospective* (N.Y., The Graduate School and University Center of the City University of New York). See also JONES, KELLIE (1985) *Norman Lewis: The Black Paintings* (Newark, N.J., Rutgers, State University of New Jersey).

3 There is an often reproduced photograph of the three-day round-table session that culminated the Subjects of the Artist School and discussions at 'Studio 35' in 1950. See KARPEL, BERNARD; MOTHERWELL, ROBERT and REINHARDT, AD (Eds) (1951) *Modern Artists in America* (N.Y., Wittenborn, Schultz, Inc.), p. 8. Pictured with Lewis are Seymour Lipton; Jimmy Ernst; Peter Grippe; Adolph Gottlieb; Hans Hoffman; Alfred Barr; Robert Motherwell; Richard Lippold; Willem de Kooning; Ibram Lassaw; James Brooks; Ad Reinhardt; Ric-

hard Pousette-Dart; Louise Bourgeois; Herbert Ferber; Bradley Walker Tomlin; Janice Biala; Robert Goodnough; Hedda Sterne; David Hare; and Barnett Newman. Lewis's appearance in this photograph suggests his close ties with the New York School. His identification with these artists was reinforced by his association with the prestigious Marian Willard Gallery, where he showed with Lyonel Feininger, Morris Graves, Peter Grippe, Richard Pousette-Dart, David Smith, and Mark Tobey, among others, from 1946 through 1956. Lewis's dual position in uptown and downtown groups has been identified as a crucial element in his artistic identity by Jones (n.2) pp. 2–3.

4 'Ancestralism' has been used to describe the position Alain Locke defined in opposition to primitivism. Locke's ancestralism encouraged African-Americans' scholarly—not intuitive—recuperation of their lost heritage, emphasising African art's classicism, discipline, and emotional restraint. See LONG, RICHARD A. (1970) 'Alain Locke: Cultural and Social Mentor', *Black World* 20, November, p. 88.

5 LEWIS, NORMAN (1973) interview with Vivian Browne. 23 August; tape on file at Hatch-Billops Collection, Inc., New York.

6 SWEENEY, JAMES JOHNSON (1935) 'The Art of Negro Africa', *African Negro Art* (N.Y., Museum of Modern Art); (1966 reprint, Arno Press), p. 19.

7 MoMA catalogue (n.6), No. 70 but not illustrated.

8 MoMA catalogue (n.6), No. 5, illustrated.

9 MoMA catalogue (n.6), plate 139.

10 MoMA catalogue (n.6), No. 594. Although not all of these objects were reproduced in the catalogue, the MoMA hired Walker Evans to photograph all the objects in the exhibition. His portfolio of 477 photographs was published in a limited edition entitled *African Negro Art: Photography by Walker Evans* and distributed to selected museums. The Robert Goldwater Library at the Metropolitan Museum of Art has a complete set, as does the library of the MoMA.

11 Lewis did not keep his enthusiasm for African art a secret. In a letter addressed to him in 1937, Charles S. Johnson, a professor at Fiske University, wrote, 'I admired those of your African pieces that I saw, and sensed such an affection on your part for them that I was far from any expectation that you would entrust them for hanging here, much less make a present of one of them to me.' JOHNSON, CHARLES S. to Norman Lewis, October 4, 1937. Norman Lewis Papers, Archives of American Art, Smithsonian Institution, Washington, Roll 91, Frame 670.

12 Savage organised the Uptown Art Laboratory at 321 West 136th Street in 1936. See HOLLAND, JUANITA MARIE (1988) 'Augusta Christine Savage: A Chronology of Her Art and Life, 1892–1962', in: (1988) *Augusta Savage and The Art School of Harlem* (N.Y., Schomburg Center for Research in Black Culture, The New York Public Library) p. 17.

13 Vaclaw Vytlacil, a teacher at the Art Students' League, was one of the founders of the American Abstract Artists. Gwendolyn Bennett recorded in her diary for 15 April 1936 that she and Lewis went to Vytlacil's studio, where Vytlacil 'showed us a staggering number of splendid paintings all done in very modern fashion. One has a feeling [she added] that here you are, face to face with pent-up greatness that will somehow be let loose. By a queer twist of fate we at the Uptown Art Laboratory are to be in on the ground floor. It seems to us now that it has been an unusual opportunity for us to study free of charge with him. It looks like one of the breaks that seldom comes to young artists and especially Negro artists.' Later that month she recorded, 'Vytlacil comes. He is full of praise for Norman's color sketch, for his revival study.' Gwendolyn Bennett Diaries, Schomburg Center for Research in Black Culture, The New York Public Library.

14 Hale Woodruff, for instance, recalled Alain Locke as one of the leading minds of the 1920s and 1930s. See MURRAY, ALBERT (1979) 'An Interview with Hale Woodruff,' *Hale Woodruff, 50 Years of His Art* (N.Y., The Studio Museum in Harlem) p. 17. See also CUREAU, REBECCA T. (1982) 'Toward an Aesthetic of Black Folk Expression,' and

BARNES, JAMES B. (1982) 'Alain Locke and the Sense of the African Legacy', in: LINNEMANN, RUSSELL J. (Ed) *Alain Locke, Reflections on a Modern Renaissance Man* (Baton Rouge, Louisiana State University Press).

15 LOCKE, ALAIN (1925 [1975]) *The New Negro* (N.Y., Athenaeum) p. 48.

16 LOCKE, ALAIN (1939) 'Foreword', *Contemporary Negro Art* (Baltimore, Baltimore Museum of Art, February 3–19) n.p.

17 *Ibid.*

18 Lewis and Reinhardt taught at the Thomas Jefferson School of Social Science and both belonged to the C.I.O.-affiliated Artists' Union in the late 1930s. For Lewis and the A.A.A., see Lawson (n.2). Locke's position was also at odds with that advocated by James Porter, author of PORTER, JAMES (1943 [rep.1969]) *Modern Negro Art* (N.Y., Arno Press and The New York Times), an artist and author whose position appears to have been closer to Lewis's than was Locke's. No contact, however, has thus far been documented between Lewis and Porter. For a discussion of Porter's relation to Locke, see MORRISON, KEITH (1985) *Art in Washington and its Afro-American Presence: 1940–1970* (Washington, D.C., Washington Project for the Arts), Ch.2. My thanks to Dr. Richard Powell for this source.

19 GREENE, BALCOMB (1938) 'In Defense of Abstract Art,' *American Abstract Artists 1938* (repro. N.Y., Arno Press, 1969) pp. 30–31.

20 LEWIS, NORMAN (1942) application for Julius Rosenwald Fund. Dated 1942, 139–43 West 125th Street. Norman Lewis Papers, collection of Mrs. Ouida Lewis.

21 (1943) *New York Post*, October 6; clipping in the Norman Lewis Papers, Smithsonian Institution, Roll 92, Frame 96.

22 LOCKE, ALAIN (1944) 'Foreword', *New Names in American Art* (Washington, D.C., G Place Gallery) June 13—July 4, n. p. Locke cited the work of John Biggers, Elizabeth Catlett, Ernie Crichlow, John Wilson, and Charles White as well as Norman Lewis as examples of the combination of social signifi-

cance and formal aesthetics. On file at MoMA Library, New York.

23 Social realism was the style *de rigueur* for representation of and by Negro Americans, in painting as well as in photography, in the 1930s and the 1940s. See, for instance, BANKS, ANN (Ed) (1981) *Aaron Siskind: Harlem Document, Photographs 1932–1940* (Providence, R.l., Matrix Publication). See also Archibald Motley Jr. in: (1988) *Three Masters* (N.Y., Kenkeleba Gallery). In signifying on this practice, Lewis may have been spurred by the same considerations as his friend Ralph Ellison, for whom naturalism, as Henry Louis Gates, Jr. has suggested, was not 'natural' at all, but merely a hardened convention of representation. Thus, as Lewis's comments at the close of this paper also indicate, it was actually part of the problem itself. GATES, HENRY LOUIS (1987) *Figures in Black* (Oxford and N.Y., Oxford University Press) p. 246.

24 In the *African Negro Art* exhibition at MoMA in 1935, Lewis would have seen an example of a striated Kifwebe mask, Songye, Zaire, made of painted wood (MoMA cat. no. 452).

25 CRICHLOW, ERNIE (1988) telephone interview with the author, December 22.

26 See, for instance, MITCHELL-KERNAN, CLAUDIA (1973) 'Signifying', in: DUNDES, ALAN (Ed) *Mother Wit from the Laughing Barrell* (Englewood Cliffs: Prentice-Hall) p. 325.

27 Gates (n.23), Ch. 9, 'The Blackness of Blackness: A Critique on the Sign and the Signifying Monkey'.

28 See JOHNSON, ABBY ARTHUR and JOHNSON, RONALD MABERRY (1979) *Propaganda and Aesthetics: The Literary Politics of Afro-American Magazines in the Twentieth Century* (Amherst, University of Massachusetts Press) Ch.5: 'Aesthetics of Integration', pp. 123–59.

29 MOTHERWELL, ROBERT (1951) 'What Abstract Art Means to Me,' *Bulletin of the Museum of Modern Art* 18, Spring, p. 12.

30 DALFIUME, RICHARD (1969) 'The "Forgotten Years" of the Negro Revolution,' in: STERNSHER, BERNARD (Ed) *The Negro in Depression and War* (Chicago, Quadrangle

Books), p. 298. My special gratitude goes to Judith Wilson for this reference.

31 BEARDEN, ROMARE (1968) interview with Henri Ghent, 29 June. Romare Bearden Papers, Archives of American Art, Smithsonian Institution, Washington D.C., Roll 3196.

32 DRISKELL, DAVID (1976) 'The Evolution of a Black Aesthetic, 1920–1950', *Two Centuries of Black American Art* (Los Angeles, Los Angeles County Museum of Art) pp. 63, 67, 74.

33 The problem of figuration in Abstract Expressionism is beyond the scope of this essay, but I have discussed it in GIBSON, ANN (1987) 'The Rhetoric of Abstract Expressionism', *Abstract Expressionism: The Critical Developments* (N.Y. and Buffalo: Albright-Knox Art Gallery and Abrams); for the problem of non-referential art, see pp. 77–85 on the 'mystic oxymoron', a category in which much of Lewis's work after mid-1946 might be placed.

34 Lewis (n.5).

35 PAALEN, WOLFGANG (1945) 'The New Image', *Form and Sense* (N.Y., Wittenborn) p. 36. Collection of Mrs. Ouida Lewis. Emphasis is Lewis's.

36 The phrase that Lewis marked continued 'and finished, too, the picture—object, the by-product of architecture. No more painting with a subject,/ but no more pictures without a theme'. The slash was pencilled in by Lewis, marking, apparently, the end of the section that was particularly important for him (and perhaps as significantly, excluding 'but no more pictures without a theme'). In the margin he wrote 'painting today.' Paalen (n.35) 'On the Meaning of Cubism Today', p. 30. Although the marking in Paalen's book implies Lewis's attention if not necessarily his assent to Paalen's formulations, it is important to note that Lewis marked and commented on a number of passages in this book, as well as those in a number of the volumes in his library, and that any assessment of his development in the 1940s will be incomplete without a more inclusive analysis of these sources.

37 LEWIS, NORMAN (1946) 'Thesis'. The full text of this statement is as follows:

'During the past fourteen years, I have devoted the major part of my attention and as much time as finances made possible to becoming a painter. For about the last eight of these years, I have been concerned not only with my own creative and technical development but with the limitations which every American Negro who is desirous of a broad kind of development must face— namely, the limitations which come under the names "African Idiom," "Negro Idiom" or "Social Painting." I have been concerned therefore with greater freedom for the individual to be publicly first an artist (assuming merit) and incidentally, a Negro.

'For the attainment of such a condition, I believe that it is within the Negro artist himself that the greatest possibilities exist since the excellence of his work will be the most effective blow against stereotype and the most irrefutable proof of the artificiality of stereotype in general.

'Believing this as well as desiring a degree of artistic excellence for myself as an individual, I have tried to maintain at least enough curiosity to keep my work moving in new directions and I have seen it pass almost automatically from careless reproduction and then strictly social art to a kind of painting which involves discovery and knowledge of new trends. I, in the process, grew from an over-emphasis on tradition and then propaganda to develop a whole new concept of myself as a painter.

'This concept treats art not as reproduction or as convenient but entirely secondary medium for propaganda but as the production of experiences which combine intellectual and emotional activities in a way that may conceivably add not only to the pleasure of the viewer and the satisfaction of the artist but to a universal knowledge of aesthetics and the creative faculty which I feel exists for one form of expression or another in all men. In this sense, art comes to have a life of its own; to be evidence of the emotional, intellectual and aesthetic level of men in a specific era; to be always changing and going to-

wards greater understanding of human beings; to enrich living for everyone. It comes to be an activity of discovery in that it seeks to find hitherto ignored or unknown combinations of forms, colors, and textures and even psychological phenomena, and perhaps to cause new types of experience in the artist as well as the viewer. Above all, it breaks away from its stagnation in too much tradition and establishes new traditions to be broken away from by coming generations of artists, thus contributing to the rise of cultural and general development.

'In view of this concept of art and the function of the artist, it is my desire to work not only for myself as an artist but for broader understanding as a teacher, in a manner as free from public pressures and faddish demands as possible and with an understanding of cultures other than my own. Thus, I am particularly interested at this time in working for at least a year in Europe, hoping that this may do much towards achievement not only of my own aims, but for the increased awareness towards the Negro artist and among Negro artists themselves.' Reproduced in: (1989) *Norman Lewis: From the Harlem Renaissance to Abstraction* (N.Y., Kenkeleba Gallery).

38 (1949) 'Willard Gallery,' *New York Sun* Friday, 4 March. Willard Gallery Papers, Archives of American Art, Smithsonian Institution, Washington D.C., Roll N/69, Frame 114.

39 (1949) 'The Art Galleries,' *Daily Worker* (N.Y.) Friday, 18 March) p. 12. For the information from this source, I gratefully acknowledge the generosity of Lowery Sims, who opened her Norman Lewis files to me.

40 FANON, FRANZ (1952 [1967]) *Black Skin, White Masks* trans. MARKMANN, CHARLES LAM (N.Y., Grove Press, Inc.) p. 188.

41 ROSENBERG, HAROLD (1952) 'The American Action Painters', repro. in ROSENBERG, HAROLD (1982) *The Tradition of the New* (Chicago, University of Chicago Press) pp. 31–2.

42 Now, of course, the very consciousness with which Lewis incorporated the models he admired appears as a critique of the myth of originality and as an appropriately subversive but understandably ambivalent reaction to the pervasive individualism of Abstract Expressionism. Much has been said recently about appropriation and pastiche as subversive strategies. See, for instance, OWENS, CRAIG (1982) 'Representation, Appropriation and Power', *Art in America* 70, May, pp. 9–21; BUCHLOH, BENJAMIN (1982) 'Parody and Appropriation in Francis Picabia, Pop, and Sigmar Polke', *Artforum* 20, March, pp. 28–34; and JAMESON, FREDERICK (1983) 'Post modernism and Consumer Society,' in *The Anti-Aesthetic* (Port Townsend, Wash., Bay Press) pp. 111–25, esp. 113–17.

43 BHABHA, HOMI K. discussed such a turning in (1986) 'Signs Taken for Wonders: Questions of Ambivalence and Authority under a Tree Outside Delhi, May 1817' in: GATES, HENRY LOUIS Jr. (Ed) (1986) *'Race', Writing, and the Difference it Makes* (Chicago, University of Chicago Press) p. 173.

44 In fact, Joan Murray Weismann recalled that Lewis found Jung's discussion of the universal consciousness much more exciting than anything in Freud (whom he thought was great, only more mundane than Jung), despite the fact that Lewis also recognised Jung's racism. WEISMANN, JOAN MURRAY (1987) Interview with Ann Gibson, June 26, New York City.

45 LEWIS, NORMAN (n.d.) to James Yeargans. From internal evidence probably in the late 1940s. Collection of Paul Yeargans, Montreal, Quebec.

46 LOCKE, ALAIN (1950) 'Self Criticism: The Third Dimension in Culture', *Phylon* II, 4th qtr., p. 393.

47 In discussing the procedures of both Classicists and Romanticists, de Kooning maintained that both kinds of painters 'freed the shapes, the light, the color, the space' in their paintings 'by putting them into concrete things in a given situation. They did think about the possibility that the things—the horse, the chair, the man—were abstractions, but they let that go, because if they kept

thinking about it, they would have been led to give up painting altogether.' DE KOONING, WILLEM (1951) 'What Abstract Art Means to Me,' *Bulletin of the Museum of Modern Art* 18, Spring. Repro. in CHIPP, HERSCHELL B. (1968) *Theories of Modern Art* (Berkeley, University of California Press) p. 558. Elizabeth Catlett, who came to New York in 1941 to study with sculptor Ossip Zadkine, recalled that while both he and she were concerned with the relation of the general to the particular, they differed strenuously in regard to their order. Zadkine believed that the artist should always work from the general to the particular, while she, Catlett maintained, felt strongly that the artist began with particulars and then moved to more general statements. CATLETT, ELIZABETH (1988) Interview with Ann Gibson, June 29, New York.

48 The phrase 'content by contradiction' is Donald Gordon's, drawn from GORDON, DONALD (1982) 'Content by Contradiction,' *Art in America* 70, December, pp. 76–89.

49 LEWIS, NORMAN (1951) 'Plan for Work'. The full text of this statement is as follows:

'For several years I have had a growing conviction that, for the first time, artists in America are seeking, more or less consciously, an aesthetic unique and indigenous to their culture. Indeed, I feel that what is happening among American artists today has begun to assume already the unity and proportions commonly attributed to "movements" or "periods" in art history, nor am I alone in this feeling; cautiously but surely the idea is spreading that the next cohesive and significant aesthetic expression will occur here.

'Obviously, such a conviction carries with it an urgent need in the individual artist for identification with this development through understanding and defining its nature as well as through a clear sense of its direction and some notion of its potentialities. It is from this need that my Plan for Work derives.

'By one in a position of judgment, however, it may well be asked what objective evidence and personal experience exist to raise what is, perhaps, merely private opinion to the level of a conviction worth judging. Admittedly, objectivity seems paradoxical to a meaningful consideration of art and in the scientific sense, it is—nor are personal experiences and feelings noted for their scientific validity. Yet, there are clues, signs, themes, if you will, in the thinking and work of artists and some non-artists today which are significant by their recurrence and those may be listed concisely: (1) group exhibitions reveal more and more a tendency not only away from so-called representation but also away from pure abstraction as it has come from Europe; (2) an ever larger number of artists known for their unwavering attachment to representation seem now either prone to change or else to be losing identification with the majority; (3) critics describe a growing trend towards "subjectivity," that is, towards something highly personal, from which may be emerging a kind of indigenous symbolism; (4) association with artists discloses constant discontent with past glories and present influences from the "outside" as well as deep interest in philosophies and research which emphasize the inner life of the individual on, for example, the Eastern philosophies and the "new" psychologies; (5) phrases such as "new forms" and "a new language" are to be heard almost with the consistency of cliches among people connected with art; (6) commercially, American art is taking its place beside the "old mentors" and European postimpressionists even as it sheds the influence of these; (7) small groups of artists are forming here and there, still uncrystallized for lack of definition, but apparently with a sense of mutual struggle and insecurity in the change; (8) art forums increasingly devote agendas to the question of the direction of art today; and (9) radical experimentation, some of it valuing a deliberate lack of controlled technique, is occurring, as though the thought were abroad that since intellect has proved deficient, some other source must be tapped as well.

'Since its beginning, my work has paralleled those tendencies and this without self conscious effort but rather through a gradual,

seemingly inevitable series of transitions which have had meaning to me only in retrospect, and then meaning too often incomplete or confused. Indeed, the only clear awareness I have had until now has been of a change in the direction of increasing dependence upon myself, resulting inevitably in the urgent need for clarification and definition in my work which, I believe, exists in most artists today.

'So far, this personal development, not to mention the apparently similar development in art generally, is embryonic in the conscious mind; its direction, its permanence, its potentialities are unconsidered. But I believe knowledge is imminent because of the need for it, and that it is for the artist to clarify it first by his work and, if he is able, by words. But the primary fact is that the organization of such knowledge is essential now if the ultimate expression in art is to be achieved, and that this task must be approached earnestly, profoundly and systematically, and not alone theoretically but by the artist as he works. It may happen that the results prove to be totally different from what the clues suggest but this makes their clarification no less urgent.

'Therefore, I suggest for your consideration this Plan for Work; to attempt to achieve over a period of one or two years through my own work primarily and the observation of others secondarily (this being, I believe, the honest emphasis) a communicable formulation of (1) the basis for the growing conviction that art is taking a new and significant direction in America for the first time, and one indigenous and unique to its culture, and (2) to describe the qualities of this direction implicitly and explicitly.

'I realize that personal enthusiasm is not sufficient qualification for this task. Therefore, I submit that eighteen years during which painting and teaching have been the focus of my life, radical yet gradual change in my own work which seems to parallel the general change in art today, constant contest with artists and people connected with art, and the profound belief that neither I nor other artists can longer refuse to face the need for clarification and definition of art, may suit me adequately for this task. Further, I believe that my good fortune in having a place of exhibition may give, to some minds, additional support to my qualifications. And finally, although I have never fancied myself as "a writer," I believe I am capable of getting down formulations and conclusions with sufficient organization and simplicity to make these useful to anyone who might consider them so.

'I cannot, of course, predict the extent of such a project nor its degree of conclusiveness except to say that it must, at least, include all the elements of a thesis, supported by evidence and brought to either a positive or negative conclusion.' Reproduced in: *Norman Lewis* (n.37).

JONATHAN HARRIS

Ideologies of the Aesthetic: Hans Hofmann's 'Abstract Expressionism' and the New York School

INTRODUCTION

This essay will look at three issues raised by the London exhibition of late paintings by Hans Hofmann, held at the Tate Gallery between March and May 1988 [1]. Firstly, it will consider some aspects of the relationship between Hofmann and more famous members of the Abstract Expressionist group of American artists working in New York after the Second World War. The problem to be confronted here is that of the relative obscurity of Hofmann (in comparison, for example, with the fame and critical reputation of Jackson Pollock) despite his close links with the group as a whole, and the apparently exemplary 'New York School' style of his paintings produced in the 1940s and 1950s, instanced in a work such as *Effervescence* (1944).

Secondly, this essay will examine the reasons why John Hoyland, the British abstract artist, wanted to organise and present this exhibition. This requires a discussion of the relationship between Hofmann's and Hoyland's painting practices, and, as a key element of that, the significance of the modernist critical doctrine espoused by Clement Greenberg and his supporters during the 1950s and 1960s. An important consideration here is that of the extent to which Hofmann's own views on the nature and value of abstract art were compatible with those of Greenberg's: a contention here is that Hoyland saw Hofmann's paintings and teachings as a means of legitimising his own practice. While there are fundamental agreements between Greenberg and Hofmann about the nature of abstract art, this essay will point out the latter's belief in the spiritual importance of art and its connotation of moral value which Hoyland also found compelling.

Thirdly, while recognising the overlap of concerns within the writings of Greenberg and Hofmann's paintings and pedagogic principles (as well as the beauty of his compositions and the pleasure they afford), this essay will question Hofmann's belief—arguably, held by Hoyland also—that art is a 'natural' and 'individual' activity, and contend that it should rather be understood as a historical and social activity, situated within particular societies. Given the dominance of formalist and 'humanist-modernist' accounts of the work of the Abstract Expressionists, it is important to attempt to incorporate within an account of

Hofmann an aspect of what has been called 'the historical sociology of avant-gardes' [2].

Hoyland's account of Hofmann, then, must be seen as a particular reading which attempts to raise the status of Hofmann as an artist, and as a theoretician able to explain both his practice and the general efficacy of abstract art. Linked to this pedagogic concern, and discussed in the final part of this essay, is Hoyland's conversation with other abstract artists and the moralism which informs their estimation of Hofmann's artistic worth.

HOFMANN AND ABSTRACT EXPRESSIONISM

Within the popular mythology of Abstract Expressionism (though there are elements of it in more 'serious' scholarship) what characterises the post-war New York artist is his mordant and angst-ridden creativity, symptomatic of which are his regular bouts of suicidal depression and resorts to excessive drinking [3]. On this basis at least, Hofmann's low profile in relation to that of Jackson Pollock or Mark Rothko, is understandable. In the view of William Seitz, Hofmann's work, over a period of sixty years and more, showed 'no hint of melancholy, bitterness or disenchantment' [4]. For Pollock and Rothko, what Irving Sandler described as their 'triumphant' achievements in painting, had led to early death by misadventure and miserable suicide [5]. Hofmann, on the other hand, described by Alan Bowness, as 'one of the most extraordinary creative phenomena in the history of modern art' [6], died in 1966 at the old age of 86, which has been seen as a testament to his happy, fulfilled, and finally recognised career as a great artist.

If the social-typing of Abstract Expressionist artists in the post-war period in America was an active factor—to some extent—in shaping the critical reception of particular artists, then Hofmann's apparent lack of existentialist angst or perennial personal crisis may have effected his artistic credibility and profile in the art market [7]. It must also be remembered that Hofmann was a full generation older than the other Abstract Expressionists and had only finally settled in America when in his fifties. All of these factors, arguably, played a part in Hofmann's perceived detachment from Pollock and the other 'Americanised' Abstract Expressionist artists [8].

However, the issue of Hofmann's critical reputation in the post-war period and the extent to which his painting was assimilable to the dominant stylistic nomenclature, requires the actual examination of such identifying terms and the critical positions from which they were derived. The artists and artworks now dominantly known as 'Abstract Expressionist' had at least two other appellations in the 1950s, which have since become relatively obsolete. These terms were 'action painting', coined by Harold Rosenberg in 1952, and 'American-Type painting', used by Clement Greenberg as the title for an article three years later [9]. Hofmann's relative obscurity is also ironic, given that the critic Robert Coates first used the term 'Abstract Expressionist' to describe paintings by Hofmann on show

at the Mortimer Brandt Gallery in New York, in 1946 [10]. In fact, Coates thought Hofmann's paintings typified the style:

> He is certainly one of the most uncompromising representations of what some people call the splatter-and-daub school, here christened Abstract Expressionism. [11]

Clement Greenberg was equally affirmative in his opinion of Hofmann's work and of his standing in relation to other Abstract Expressionist artists:

> Hans Hofmann is the most remarkable phenomenon in the abstract expressionist 'school' (it is not really a school) and one of its few members who can already be referred to as a 'master'. [12]

Yet, considering these early appraisals, which placed him not simply as an exponent of Abstract Expressionism (though note Greenberg's cautious use of the lower case) but actually as paradigmatic of its stylistic essence, it seems baffling indeed that his work was not included in two of the Museum of Modern Art's important travelling exhibitions, held in 1956 and 1958–59 [13]. Hofmann's status has thus suffered great fluctuations over the past forty years: from high critical acclaim in the late 1940s and early 1950s, through a period of low critical and exhibition visibility, and recently placed in a revisionist spotlight. John Hoyland and Cynthia Goodman both claim that Hofmann should be credited with preempting Pollock's use of drip and pour technique—in a work such as *Effervescence*—and with formulating the repertoire of biomorphic shapes seen as characteristic of Abstract Expressionist painting after 1947–8 [14].

While the factors of Hofmann's age, European ethnicity and apparently pacific temperament may have contributed to his non-association with the American Abstract Expressionists, these conditions must be recognised as necessary but insufficient within an explanation. In formal terms, and in a sense specified by Greenberg which will be discussed in more detail later, Hofmann's paintings through the 1950s and 1960s—for example, his *Pompeii* (1959) (Fig. 27) remained in the 'easel-painting tradition'. Rather than simply describing the size of canvases or the use of traditional painting implements (brushes, supports, etc.), Greenberg used this term to designate an 'epochal orientation', the disposition of the artist to the history of art and to its 'modern' context. In the 1950s, Greenberg argued that, for various reasons, a 'mural mode' (here, Picasso's *Guernica* served as a prefiguration) might be about to supersede easel-painting. This supersession was isomorphic with the shift from a European to an American avant-garde, and was exemplified in Pollock's *Autumn Rhythm* (1950) and Robert Motherwell's *Elegy to the Spanish Republic* (1953–1954) [15]. Hofmann's rectangular, rather than oblong, canvases, thus announced themselves as obdurately 'easel-painting', and thus as equally identifiably 'European' (as was Hofmann himself). On these grounds— which Greenberg defended as primary—Hofmann's paintings were inadmissible as 'American-type' or as 'American Abstract Expressionist'.

Fig. 27 HANS HOFMANN *Pompeii* 1959

It is ironic that Hofmann was excluded from the New York School on these formal grounds, given that his teachings (for which he was much better known in the late 1930s and 1940s) mirrored those of Greenberg's in the 1950s and 1960s in several important respects. In turning now to Hoyland's dependency on Greenberg's understanding of Modernist art, and his particular interest in Hofmann's similar ideas—but which were situated specifically within a 'Eurocentric' artistic framework—we may begin to make sense of the contemporary revaluations of Hofmann's work, and the extent to which Hoyland saw Hofmann as a vehicle for his own modernist perspective on the European-American tradition in the twentieth century [16].

HOYLAND, HOFMANN AND MODERNIST THEORY

Hoyland's short account of Hofmann's work and importance begins, significantly enough, with a revelation of Hoyland's intimacy with the critical maestro of modernist theory, Clement Greenberg. Hoyland relates the story of a trip round New York galleries which he made with Greenberg in 1964. After seeing pictures by Kenneth Noland and Morris Louis, Greenberg took Hoyland to the Kootz Gallery, where two paintings by Hofmann were on show. Hoyland recounts:

> I thought immediately that they were terrific. I did not know at that time that Clem had already written a book on Hofmann in 1961 (which is probably the best book to date). [17]

What Hoyland makes clear, then, is that his own introduction to Hofmann is via the critical recommendation of Greenberg and in the light of post-Abstract Expressionist art—in particular the so-called 'post-painterly abstraction' of Noland and Louis, for example the latter's *Blue Veil* (1958–1959). Hoyland then proceeds to sketch a particular historical vista on the early 1960s in Britain:

> During those years . . . we were regularly bombarded by American art and we awaited each new instalment like food parcels to a half-starved community. [18]

Hoyland's account of those years is really a reminiscence on a time when, according to him, 'serious' British abstract artists were trying to invent a role for themselves in between the romantic naturalism of the St. Ives group and other regional formations and what he described as 'the violent excesses of post-de Kooning abstraction' in America [19]. Compare David Jones's *The Annunciation in a Welsh Hill Setting* (1963–4) and Willem de Kooning's *The Visit* (1966–1967). According to Hoyland:

> We were trying to make a new urban, more uncompromising, abstract art based on rational thinking and visual perception . . . we had felt starved of

an intellectual and perceptual raison d'être for our work and were reacting against what we saw as the quasi-romantic English tradition. [20]

Hoyland says that, of the first and second generations of American Abstract Expressionists, the best hope for abstraction lay with Motherwell and Louis (who had died, virtually unknown, in 1962). Hoyland goes on to argue that Hofmann's paintings were important because they offered to him 'an immediate kinship' and because they 'did' what he thought the best British abstract paintings had been 'doing' during the 1950s; namely:

> confront[ing] the problem . . . of how one could make paintings which were both abstract and figurative at the same time. [21]

Hoyland cites as his examples the British artists Ben Nicholson, Prunella Clough, Ivon Hitchens, Peter Lanyon, Patrick Heron and others [22]. Hofmann, he argued, continued a tradition of great European artists, including Monet, Cézanne, Matisse, Soutine and Vuillard, who had inspired the best British abstract painters. Hofmann

> was a master living in the USA, but exemplifying in his art a new exuberant openness with strongly visible European roots . . . Hofmann seized the initiative from Mondrian's division of the canvas into rectangles and inspired by Matisse's palette marked an art full of reverence to the masters but unfettered by their towering achievements. [23]

Reading in between the gush here, it is plain to see that Hoyland wanted to represent Hofmann's paintings as important elements in a European counter-attack on American modernist dominance. In the wake of Pollock's death in 1956, and the emergence and then market-saturation of Pop Art in the early 1960s in America, Hoyland realised that the critical authority of Greenberg had been severely disturbed. In positing Hofmann's paintings as models for a 'serious' abstract art in those conditions, Hoyland must also have been aware that Greenberg and the modernist art historian, Michael Fried, had condemned Pollock's later works (*c*.1953–1956) as unsuccessful. Fried had also argued that 'successful' abstract works must hold 'in dialectical tension' both figurative and abstract elements [24]. Any relaxation of that tension—towards an overly evocative or illustrative line or shape, or towards a mere decorative pattern—would result in failure, Fried argued.

Hoyland believes that Hofmann's paintings contain such a delicate balance and thereby continue the tradition of (largely) great European modernist artists. This tradition has made itself felt in the British abstract artists he names, and of course Hoyland is anxious to see himself as an heir and representative of the same continuity, as exemplified in *17.3.69* (Fig. 28) and *25.4.69* (Fig. 29). Composition-al similarities between Hoyland's and Hofmann's works, in terms of the domi-nance of chromatic modelling and balancing, the technical application of paint, and

Fig. 28 JOHN HOYLAND *17.3.69* 1969

Fig. 29 JOHN HOYLAND *25.4.69* 1969

the relative neglect of drawn elements, are obvious. Hoyland's interest in Hofmann, therefore, has an important element of self-defence in it: the latter is seen by the former as holding similar beliefs about both the nature and value of art, and about the way art has developed in the twentieth century. Greenberg, for Hoyland, stands as a sort of critical intercessor, to whom appeals can be made regarding questions of relevance and quality. It is possible even to discern an element of prescription in Hoyland's text, regarding the efficacy and direction for contemporary abstract painting, which involves a shift (relatively underplayed as it is) from what Hoyland understands as 'American' to 'European' principles. Such a shift, which Hoyland sees as a continuity in Hofmann's work, is back towards

> the same heroes . . . Hofmann had *reopened* the possibilities for art with a brave affirmation of the greatest achievements of 20th century art and its rich history . . . the Titans: Picasso, Matisse, Miró and Mondrian. [25]

At the same time, Hoyland's theoretical orientation is to Greenberg's formulation of modernist practice: Hofmann is attractive to Hoyland because, like Greenberg, Hofmann believes that illusionistic painting is both 'formally' and 'spiritually' moribund [26]. According to Hofmann, 'representation', 'history', 'allegory', 'symbolism':

> all such aims and accomplishments . . . are outside the artist's real problem, which is entirely pictorial. [27]

While Hofmann concedes, as Greenberg did, that such things are not 'inimical to creative painting' [28], he argues that a painting based on the predominance of 'a line concept' is little more than 'illustration': 'it fails to achieve pictorial structure' [29]. What Hoyland takes from Hofmann then, and what is reflected in Hoyland's own paintings in the 1960s and 1970s, is the adoption of a chromatic, rather than linear, compositional format, as in Hofmann's *Rising Moon* (1965). This preference also provides some indication of the nature of Hoyland's rejection of de Kooning's abstract 'violent excesses': his continued use of 'drawing' and the motif of the nude disqualified him on two counts [30]. More general than that, Hoyland's estimation of the Abstract Expressionists as a group, is not high:

> On the North American continent, with the exception of David Smith and Robert Motherwell . . . (not that they haven't made good art) . . . they don't seem to grasp everything that life has to offer, like the great modern masters, Picasso, Matisse, Miró, etc. To be able to paint an intimate representational painting one day and then do something monumental, classical and abstract during the same week—I mean there is a kind of breadth in great art. Is that a European thing? [31]

Hoyland actually disagrees here, with Greenberg, about the claim, made by the latter, that the Americans had superseded the great European artists in the production of modernist art; Hoyland does not share Greenberg's historicism,

even though his understanding of the nature of painting is tied closely to Greenberg's. Hofmann's teachings, I shall argue, differed in some important respects from Greenberg's also, mainly in relation to the sorts of values which Hofmann invested in painting. Hoyland follows Hofmann's view that art is an activity expressive of human personality and individuality, and also is imbued with a moral and metaphysical dimension. However, a particular selection of statements made by Hofmann *can* suggest that he was an artist whose practice was based on principles wholly derived from Greenberg's philosophical position. William Seitz, in his 1963 account of Hofmann, made out that the artist had, at some point in the 1940s, begun to produce the sort of art which Greenberg would argue for over the next two decades. This was an art with:

> Unhampered autonomy of lines and planes; the elevation of color to primary means; the maintenance of clear 'intervals' between color planes . . . He cast aside the dross of systematic perspective, tonal modelling, literature and illusionism. [32]

Goodman also represents Hofmann as a sort of John the Baptist to Greenberg's Christ: she claims, for instance, that Hofmann's interest in surrealism was exclusively with its formal innovations, in its experimentations with 'spontaneous gestural abstraction' [33]. In her account of Hofmann's exchange with Pollock in 1942, she makes it clear that the latter was not too impressed with the German, who was then known primarily for his teaching [34]. Although Pollock basically told Hofmann to keep his ideas to himself—

> Put up [meaning, presumably, 'paint'] or shut up. Your theories don't interest me [35]

—Goodman claims that Pollock's later explorations with dripped and poured paint stemmed from his seeing Hofmann's drip paintings in his Provincetown studio in 1943.

Whatever the aetiology of Pollock's drip paintings, or their occurrence in relation to the work of Hofmann in the mid-1940s, it is clear that Hoyland wants to see Hofmann and Greenberg as both central to his view of the proper course for abstract art. His task is made easier, given the academic consensus that Hofmann's paintings do accord with Greenberg's stipulations. Moreover, Greenberg himself intimated that Hofmann had preempted his own ideas 'in paint'. This was Greenberg's famous comment that Hofmann had spent the years between 1914 and 1950 'sweating out cubism' [36], which presumably was meant to imply that Hofmann understood the 'real' significance of cubism (according to Greenberg, that is), but was also working on a way of superseding—or at least continuing—it [37].

The actual symmetry between the views of Greenberg and Hofmann is quite striking—at least on some issues. Certainly Hofmann believed, as did Greenberg, that visual art was governed by endogenous 'laws', which related to, and were

conditioned by, the nature of the medium. 'Nature', however, is a term which Hofmann and Greenberg used differently, though sometimes the difference is hard to appreciate. For Greenberg, 'nature' (as in 'the nature of the medium') refers to the medium's material constituents, which also implied a 'way of working' with the medium, while 'nature' for Hofmann has, on occasion, spiritual and metaphysical resonance, which connects to similar meanings articulated by Kandinsky and Mondrian, and to European idealist philosophy [38]. However, Hofmann *also* agreed with Greenberg's view on 'nature' as meaning 'material constituents' and implying an 'authentic' way of working that material:

> The essence of the picture is the picture plane . . . The picture plane must be preserved . . . painting is not representation even though its forms may resemble real objects, but a continuing dialogue between painter and medium. [39]

The halt to Hofmann's painting between about 1914 and the late 1930s (though some works, or representations of works painted between these years, exist) can be explained plausibly in Greenberg's terms: that time, spent 'sweating out cubism', was the period when Hofmann attempted to formulate his theory of the nature of painting, and began teaching it to other artists, both in Germany and then in the United States [40]. Hofmann's reputation as an 'artists' artist' is picked up by Hoyland (who invited five other artists to discuss Hofmann's work [41]) and, again, we find that Greenberg had come to the same assessment in 1955:

> Many people are put off by the difficulty of his art—especially museum directors and curators—without realizing it is the difficulty which puts them off, not what they think is its bad taste. The difficult in art usually announces itself with less sprightliness. [42]

Greenberg went on to claim—and, I would think, with Hoyland's approval—that by 1947 Hofmann was producing 'successful pictures', the originality of which was later exploited by 'others' (though no names are mentioned). Hoyland makes the implicit judgment, in his discussion with five other 'like-minded artists', that Hofmann was a better painter than Rothko because he was more purely 'pictorial':

> his paintings never seemed to rely on having intellectual backing . . . In a way Rothko and Newman led the way to Conceptual Art, away from painting. [43]

Certainly, the value of Hofmann's paintings and teachings is established by Hoyland—as well as by Goodman and Seitz—in terms of his close proximity to Greenberg's theoretical position, and is underwritten by Greenberg's appraisal of Hofmann's work. However, the status of Hofmann as a European artist in America, and Greenberg's understanding of that as a limiting—if not 'regressive'—factor, leads to a bifurcation of critical positions. Greenberg and Hoyland stand, in this debate, on either side of the Atlantic over Hofmann's relevance in the

1960s. At the same time, it is important to consider now the aspects of Hofmann's teachings which, arguably, separate him from Greenberg in a significant way.

HOFMANN, 'THE SPIRITUAL-IN-ART' AND EUROPEANISM

Greenberg's final comments on Hofmann in ' "American-type" Painting' amount to a critical summation of the artist's historical, rather than contemporary, significance:

> Hofmann's art is very much easel painting in the end, with the concentration and the relative abundance of incident and relation that belong classically to that genre. [44]

Pollock, on the other hand, Greenberg argued, was perhaps at the beginning of a quasi-mural or wall-decoration art, pushing the conventions of the easel painting beyond a point where that name adequately described the emergent practice. Although some of Hofmann's paintings 'strain to pass beyond the easel convention' [45], they ultimately cling to it, and therefore to a European tradition which Greenberg saw—for a variety of reasons—as about to be surpassed by American avant-garde artists [46].

As someone twenty years older than Pollock, in the mid-1950s, Hofmann was—not surprisingly—seen as inextricably linked to the European tradition of modernist art: to Matisse, Klee, Kandinsky, Mondrian and, of course, Picasso. Such a background excluded him from being part of what Sandler called 'the triumph of American painting', though it is feasible to regard Hofmann as an artist like Miró or Masson who 'passed the baton' of 'advanced modernist art' to America [47]. Though Hofmann's paintings had been shown in two exhibitions in the mid-1940s, with other Abstract Expressionists—*The Ideographic Picture*, organised by Betty Parsons, and *The Intrasubjectives*, organised by Sam Kootz and Harold Rosenberg [48]—Hofmann's affiliation to Europe and to European artists reasserted itself after the Second World War.

In 1949, a large exhibition of Hofmann's work was presented by the Galerie Maeght in Paris. Hofmann visited the city (the first time since 1930) and went to see Picasso, Braque, Brancusi, and Miró [49]. Rather than seeing New York as the new centre of the post-war art world, Hofmann declared:

> This visit to Paris has been a tremendous inspiration for me, I am made to feel I have roots in the world again. [50]

He then wrote a polemical statement, called *Protest Against Ostrich Attitudes in the Arts* [51], maintaining his pro-French stance. Through these acts Hofmann detached himself from the American artists and the American art-critical machine which was beginning to relate American avant-garde art to the virtues of U.S. democracy in the Cold War [52].

Hoyland's fascination with Hofmann seems to depend, in large part, on

Hofmann's self-proclaimed affiliation with the 'European Moderns': especially with Cézanne and Matisse, but also with Picasso and Mondrian. In the context of the early 1960s and the dominance of Pop Art in Britain and America, Hofmann (along with Noland and Louis) must have seemed to Hoyland and Greenberg, as a reservoir of 'serious' art in a desert of kitsch. Unlike Rothko or Newman, who appeared to Hoyland as artists whose work prefigured the emergence of Conceptual Art, Hofmann was considered—like Picasso or Matisse—a 'real' painter. In fact (as indicated in the following exchange with Anthony Caro) Hoyland seems to equate literal flatness in painting—characteristic of Rothko's and Newman's 'colour-field' washes—with a semantic shallowness:

> *Hoyland*: He rarely painted a smooth picture did he, I mean a slick picture.
> *Caro*: I think this is one of the attractions; there is never anything slick, never anything suave. He never takes the easy route. [53]

Arguably, Hoyland sees Hofmann's 'depth' (both the literal depth of the paint on the canvas and the significant content this is a sign of) in relation to his investment in art as a spiritual activity and as a vehicle for individual creative expression.

While Hofmann's views on the 'nature' of art as a practice sometimes accord with those of Greenberg's, Hofmann's evaluative criteria (a sort of meta-narrative for legitimising his practice) are fundamentally different from Greenberg's Kantian epistemology. For Hofmann:

> the message of the work finds its aesthetic perfection as an entirely independent spiritual reality. [54]

While the nature of this 'reality' remains ineffable for Hofmann, he also says that the 'quality' of a painting reflects the personal 'quality' of the maker and that of the viewer privileged and receptive enough to understand and appreciate such purified creative activity. Sounding rather like Clive Bell, Hofmann argues that the ability to produce Art is innate:

> . . . an artist is born and must possess a degree of intuition, profundity and superiority of mind that cannot be taught . . . the artist's creativity is all but inseparable from that of nature . . . he cares relatively little about the superficial necessities of the material world. [55]

'Nature' here is counterposed to 'material' (and therefore to Greenberg's usage) and implies an idealist conception of reality, and of human creativity. Such sentiments follow in a long line of European artists inspired by beliefs in the mystical, transcendental value of painting, and particularly of German artists bathed in the philosophies of Goethe and Hegel. Such idealist pronouncements were never a structural part of Greenberg's criticism, who probably thought that their rhetorical banality matched their logical redundancy [56]. However, it is clear

from the final section of Hoyland's interview with other artists about the virtues of Hofmann's art, that such views about the value of art and about those capable of both producing and appreciating it, found significant favour.

THE SOCIAL PRODUCTION OF ABSTRACT ART

Greenberg, over a period of thirty years of writing criticism from the early articles for *Partisan Review* up to his 'Complaints of an Art Critic', published in 1967, always presented his views and critical predictions about art as part of a structured and reasoned argument [57]. In this essay I have shown the similarities, as well as pointed towards some of the differences, between Greenberg's and Hofmann's views; I have not tried to fault or question their conceptions of the nature and development of modernist art. Greenberg may have appeared summary or dogmatic in some of his statements, but he nevertheless made them (that is, from about 1940 onwards) in relation to his basic acceptance of Kantian aesthetics and logic. No-one can escape the adoption of at least some *a priori* principles (Greenberg made this necessary recognition the virtue of his critical system), and despite his later disclaimers, his retrospective tract *Modernist Painting* outlines the philosophical basis of his post-war criticism [58].

Unlike the inter-war 'criticism' of Hilla Rebay or Sheldon Cheney, who were concerned explicitly with what they regarded as the metaphysical import of art, Greenberg attempted to relate his stringent observation and description of paintings to his acceptance of Kant's understanding of logical specialisation:

> The essence of Modernism lies, I think, in the use of the characteristic methods of a discipline to criticize the discipline itself—not in order to subvert it, but to entrench it more firmly in its area of competence. Kant used logic to establish the limits of logic, and while he withdrew much from its old jurisdiction, logic was left in all the more secure possession of what remained to it. [59]

Greenberg's critical appraisal of Hofmann's art really consisted of two analytically separable judgments: one based on the formal (visual) characteristics he distinguished (a judgment based on description), and one based on historical overview ('historicist' in the sense that it presumed some sense of a 'past' and a 'future' for painting as a practice) [60]. Greenberg believed the development of painting was governed by autochthonous material characteristics (the flat canvas, shape of the support, constitution of the paint, etc.) which were progressively revealed as determining properties, in 'successful paintings', through their manipulation by particular artists.

Such a 'dialectical' view, although tilted towards the determination by the medium, meant that Greenberg was never, theoretically, concerned with the practice of painting as the index of an artist's personality, or with a painting's ability to 'express' an individual's motivations or psychic characteristics [61]. As

far as I know, he never *denied* the existence of personal motivations or that paintings *can* be seen as carriers of biographical information (nor that these factors may determine some aspects of a painting's visual appearance): he simply regarded this as irrelevant to his own concerns. At the same time, he believed that his 'own' concerns were the most significant aspect of the development of modernist painting.

Unlike Hoyland and Hofmann, Greenberg did not see art primarily in terms of the individual achievement of special creative personalities; obviously he was aware of talent, skill, precociousness even, as necessary in artists. However, it is possible to argue that Greenberg saw the development of art as primarily, and necessarily, a social and conventional, historical process:

> Each time, a kind of art is expected that will be so unlike previous kinds of art and so 'liberated' from norms of practice or taste, that everybody, regardless of how informed or uninformed, will be able to have his say about it. And each time, this expectation is disappointed, as the phase of Modernism in question takes its place, finally, in the intelligible continuity of taste and tradition . . . Nothing could be further from the authentic art of our time than the idea of a rupture of continuity. Art is, among many things, continuity. Without the past of art, and without the need and compulsion to maintain past standards of excellence, such a thing as Modernist art would be impossible. [62]

This passage concludes *Modernist Painting* and we may infer reasonably from this that Greenberg wanted to give the point significant stress. It actually argues that art must be understood as a social, conventional, material, and historical, rather than an individual or ideal process. It goes without saying that his conceptions of 'social', 'material' and 'historical' process leave him far away from Marxist accounts of art (though not necessarily in any logical contradiction with them) [63]. Greenberg's 'restricted' sense of 'social' causation or of painting's 'material determination' is understandable in relation to the dominant explanatory space he gives to Kant's notion of 'logical specialisation'. Arguably, however, Greenberg's account is less *incompatible* with some Marxist explanations of art, than it is with the 'radical individualism' which Hofmann himself espoused on occasions, combining ineffability with philosophical solipsism [64].

'Marxism' and 'modernism', then, are not necessarily antinomic modes of understanding the historical production of art, though particular versions of each have been logically contradictory [65]. One important aspect of each is the way, and the extent to which, factors of determination are established and defended in particular arguments. Another aspect concerns criteria of evaluation, notions of 'quality', and how these are established in relation to notions of determination. On this account, Marxism has suffered controversies far greater, and more often, than Greenbergian modernism [66]. Alan Gouk and Anthony Caro produced two comments on Hofmann exemplifying the radical individualism often associated

with creating abstract art, combined, as it tends to be, with gratuitous snobbery and moralism:

> *Gouk*: It's not only the laymen that have the problems, it's also critics. It's not something you can understand or rationalise. It's something you can feel and see, or you can't. If you are visually illiterate you will fail to see it. *Caro*: [Art] tells us that we are all worthwhile human beings. I also think there is something particularly sick about people who are in love with completely decadent art [no example of what is meant by this is given]. They can't see that this sort of art [Hofmann's] is the highest illustration of the human spirit. [67]

I think Hofmann would probably have agreed with Caro's final comment here, and one gets the impression that the artists Hoyland assembled to talk about Hofmann venerate his teachings as much as his paintings; almost that the one implies the other. Gouk's and Caro's views are obviously debatable, though what perhaps is more important is to consider the situation which has led to such an extreme valorisation of painting. This must involve, as Raymond Williams has argued, the consequences of the secularisation of European society in the late nineteenth and the twentieth centuries and the corresponding sublimation of religious faith—the locus of ineffable belief—into particular areas of cultural production: Art and Aesthetics [68].

In relation to Hofmann and Hoyland, we need to know what has been the particular and more recent historical process which has led to the belief that avant-garde art must move in the direction of abstraction and that a return to forms of 'illusionist' painting would necessarily be a regression [69]. This involves the question of what specific notion of 'individual', as opposed to 'social', life or creativity found favour in America in the post-war period. In the present context of post-modernist eclecticism, with the absence of any recognisable, 'authentic' avant-garde mainstream (that historical contradiction), Hofmann has been recommended, by Hoyland at least, as pointing the way back to the securities of European modernism with, as Gouk and Caro suggest, its putative humanist and individualist values. Hofmann's revival should be seen, therefore, as a modernist response to post-modernism, with moral and political, as well as aesthetic, implications.

ACKNOWLEDGMENTS

I would like to thank staff and students at Sunderland University and the University of Essex for their comments and criticisms on versions of this paper presented between 1990 and 1992.

NOTES AND REFERENCES

1 (1988) *Hans Hofmann: Late Paintings* (London, Tate Gallery); main text by HOYLAND, JOHN. I first took an interest in the work of Hans Hofmann in 1988 when I was invited to give a lecture at the Tate Gallery, London, on the occasion of a retrospective

exhibition of his art. Before then I had been mostly unaware of Hofmann's historical relationship with Jackson Pollock and other Abstract Expressionists during the mid and late 1940s in New York. I was also interested in the fact that the Tate Gallery catalogue for the Hofmann show contained a text by the British abstract artist John Hoyland. What relationship could there be between Hofmann and Hoyland? One linking feature— though a problematic one—was the critical significance of Clement Greenberg for both artists. I was puzzled by the attempt to resurrect Hofmann in the late 1980s. Could his work and ideas in some way fit with a 'modernist post-modernism', or a 'post-modernist modernism'?

2 Eg. as developed by Raymond Williams particularly in his consideration of twentieth-century poets and novelists. In a 1987 lecture entitled 'When Was Modernism?', subsequently reconstructed and published under the same title in WILLIAMS, RAYMOND (1989) *The Politics of Modernism*, (London, Verso), Williams talked of: 'New York . . . as the eponymous city of strangers, the most appropriate locale for art made by the restlessly mobile emigré or exile, the internationally anti-bourgeois artist. From Apollinaire and Joyce, to Beckett and Ionesco, writers were continuously moving to Paris, Vienna and Berlin, meeting there exiles from the Revolution coming the other way, bringing with them the manifestos of post-revolutionary formation.' Hofmann, in political and aesthetic terms, seems to be one of the exiles 'coming the other way', as it were, committed to a strictly idealist evaluation of art. This is not surmise (as it might be with Pollock) for Hofmann wrote and taught extensively and had a systematic philosophy of art. His relative obscurity, therefore, may be put down to his (a) being (and staying) too German and too European, and (b) never being American enough (and in the right ways). Hofmann's own practice was situated in Munich between 1914 and 1932. In 1932 he settled permanently in the USA, living in New York and Provincetown, Massachusetts.

3 See CRANSHAW, ROGER (1983) 'The Possessed: Harold Rosenberg and the American Artist', *Block* 8, pp. 2–10.

4 SEITZ, WILLIAM (1972) *Hans Hofmann* (N.Y., Museum of Modern Art) p. 7.

5 See SANDLER, IRVING (1970) *Abstract Expressionism: The Triumph of American Painting* (London, Pall Mall).

6 Hans Hofmann (n.1) p. 7.

7 Jackson Pollock was featured in *Life Magazine* in 1949, in an article which ridiculed him, but at the same time gave him tremendous publicity. Betty Parsons, the gallery owner and dealer, was able to sell almost all the Pollock paintings she showed at the end of that year. See GUILBAUT, SERGE (1983) *How New York Stole The Idea of Modern Art: Abstract Expressionism, Freedom. and the Cold War* (Chicago, University of Chicago Press) pp. 185–87. Pollock was also photographed and filmed, in technicolour, by Hans Namuth in 1951.

8 Many other Abstract Expressionists, such as Arshile Gorky, Mark Rothko and Willem de Kooning, were of course born outside the United States.

9 Rosenberg published 'The American Action Painters' in *Art News*; in December 1952. Greenberg's '"American-type" Painting' was first published in *Partisan Review*, vol.xxii, no.2, Spring 1955. A revised version appears in GREENBERG, CLEMENT (1961) *Art and Culture: Critical Essays* (Boston, Beacon Press). Extracts in this essay are taken from HARRISON, CHARLES and FRASCINA, FRANCIS (Eds) (1982) *Modern Art and Modernism: A Critical Anthology* (London, Harper and Row) pp. 93–103.

10 See GOODMAN, CYNTHIA (1986) *Hofmann* (N.Y., Abbeville). p. 60.

11 COATES, ROBERT (1946) 'The Art Galleries: Abroad and at Home', *New Yorker*, no.22, March 30th, quoted in Goodman (n.10) p. 60.

12 Greenberg (n.9) p. 96.

13 These were *Modern Art in the United States* and *The New American Painting*. The latter show toured extensively in Europe.

14 Hans Hofmann (n.1) p. 11; Goodman (n.10) p. 45.

15 Greenberg (n.9) p. 103: 'The limits of the easel picture are in great danger of being destroyed because several generations of great artists have worked to expand them. But if they are destroyed this will not necessarily mean the extinction of pictorial art as such. Painting may be on its way towards a new kind of genre, but perhaps not an unprecedented one—since we are now able to look at, and enjoy, Persian carpets as pictures—and what we now consider to be merely decorative may become capable of holding our eyes and moving us much as the easel picture does.'

16 Hoyland's stress on the importance, to Hofmann, of European culture, is clear: 'I read that Hofmann's wife left almost everything in Germany, and got out on the last boat, but she managed to carry for him a Joan Miró, a Georges Braque, a Fernand Léger and a Louis Marcouissis, also some pieces of Biedermeier furniture. They probably cost very little at the time, but she practically took Europe with her, like cultural nourishment.' Hans Hofmann (n.1) p. 19.

17 GREENBERG, CLEMENT (1961) *Hans Hofmann* (Paris, Éditions Georges Fall).

18 Late Paintings (n.1) p. 9

19 *Ibid* p. 9

20 *Ibid*

21 *Ibid*

22 *Ibid*

23 He also mentions William Scott, Keith Vaughan and Terry Frost, p. 10.

24 FRIED, MICHAEL (1965) *Three American Painters: Kenneth Noland, Jules Olitski. Frank Stella*. Reproduced in (1982) *Modern Art and Modernism: Supplementary Documents* (Milton Keynes, Open University): 'There are other paintings, such as *The Wooden Horse* (1948) and *Summertime* (1948) . . . [in which] Pollock seems to have been preoccupied with the problem of how to achieve figuration within the context of a style that entailed the denial of figuration; or to put it another way, with the problem of how to restore to line some measure of its traditional figurative capability, within the context of a style that entailed the renunciation of that capability. Only if we grasp, as vividly and even as painfully as we can, the contradiction implicit in what seems to have been Pollock's formal ambition in these works—to combine figuration with his all-over, optical style—will we be able to gauge the full measure of his achievement in two other paintings of these years.' p. 86.

25 Hans Hofmann (n.1) p. 10

26 In: Seitz (n.4) p. 8

27 *Ibid* p. 18

28 *Ibid*. Greenberg said in 'Modernist Painting' (1960): 'Representation, or illustration, as such does not abate the uniqueness of pictorial art; what does do so are the associations of the things represented'. In Harrison & Frascina (n.9) p. 6.

29 Seitz (n.4) p. 24

30 Greenberg's assessment of de Kooning was much more positive; see Greenberg (n.9) pp. 95–96.

31 Hans Hofmann (n.1) pp. 14–15.

32 Seitz (n.4) pp. 7–8.

33 Goodman (n.10) p. 43.

34 The Hofmann School of Fine Arts opened in 1934. Hofmann began painting full-time in about 1944.

35 Goodman (n.10) p. 49.

36 Hans Hofmann (n.1) p. 17.

37 This was Greenberg's comment on de Kooning, in Greenberg (n.9) p. 96.

38 See KANDINSKY, WASSILY (1914) *Concerning the Spiritual in Art*, repub. (1970) *The Documents of Modern Art*, vol.5 (N.Y., George Wittenborn). Also WORRINGER, WILHELM (1908) *Abstraction and Empathy*, trans. (1963) BULLOCK, MICHAEL (London, Routledge & Kegan Paul); BAHR, HERMANN (1920) *Expressionism*, trans. GRIBBLE, R.T. (London); and CHEYNEY, SHELDON (1934) *Expressionism in Art* (NY, Liveright Publishing Corporation).

39 Seitz (n.4) pp. 18–21

40 For a brief history of Hofmann's life in Germany and the U.S.A., see Hans Hofmann (n.1) pp. 21–25.

41 These were: Anthony Caro, Sheila Girling, Fred Pollock, Alan Gouk and Basil Beattie; see Hans Hofmann (n.1) pp. 13–19.

42 Greenberg (n.9) p. 97

43 Hans Hofmann (n.1) pp. 15–16

44 Greenberg (n.9) p. 97

45 *Ibid* p. 96

46 Greenberg said in (1948) 'The Decline of Cubism', *Partisan Review* 15, no.3, March: 'If artists as great as Picasso, Braque and Léger have declined so grievously, it can only be because the general social premises that used to guarantee their functioning have disappeared in Europe. And when one sees, on the other hand . . . much the emergence of new talent so full of energy and content as Arshile Gorky, Jackson Pollock, David Smith . . . then the conclusion forces itself, much to our own surprise, that the main premises of Western art have at last migrated to the United States, along with the center of gravity of industrial production and political power.'

47 'Paris, whatever else it may have lost, is still quick to sense the genuinely 'advanced'— though most of the abstract expressionists did not set out to be 'advanced'; they set out to paint good pictures, and they 'advance' in pursuit of qualities analogous to those they admire in art of the past', Greenberg (n.9) p. 93.

48 Goodman (n10) p. 60

49 *Ibid*

50 *Ibid* p. 61

51 *Ibid*. Goodman concurs: 'Hofmann's tenacious loyalty to the School of Paris distinguished him from most of the American vanguard, who had become increasingly outspoken about the uniquely American nature of their painting'.

52 See KOZLOFF, MAX (1973) 'American Painting during the Cold War', *Artforum* vol.xi, no.9, May. Kozloff's article is included, in an abbreviated form, in FRAS-CINA, FRANCIS (1985) *Pollock and After: The Critical Debate* (London, Harper and Row), pp. 107–124.

53 Hans Hofmann (n.1) p. 16

54 Seitz (n.4) p. 46

55 *Ibid* p. 15. Compare with Bell's 'The Aesthetic Hypothesis', in BELL, CLIVE (1914) *Art* (London, Chatto & Windus) pp. 3–37. Reproduced in Harrison & Frascina (n.9) pp. 67–74.

56 A gross example of such mysticism masquer-ading as criticism is REBAY, HILLA (1937) 'The Beauty of Non-Objectivity', in exhibition catalogue for Solomon R. Guggenheim collection of non-objective painting. Reproduced in Harrison & Frascina (n.9) pp. 14–148.

57 GREENBERG, CLEMENT (1967) 'Complaints of an art-critic', *Artforum*, vol.VI, no.2, October, demolishes this reasoned structure of argument with the claim that 'Esthetic judgments are given and contained in the immediate experience of art. They coincide with it; they are not arrived at afterwards through reflection or thought. Esthetic judgments are also involuntary: you can no more choose whether or not to like a work of art than you can choose to have sugar taste sweet or lemons sour. (Whether or not esthetic judgments are honestly reported is another matter)', in HAR-RISON, CHARLES and ORTON, FRED (Eds.) (1984) *Modernism, Criticism, Realism: Alternative Contexts for Art* (London, Harper and Row) p. 4.

58 First published in (1961) *Art and Literature* no. 4, Spring. Reproduced in Harrison & Frascina (n.9) pp. 5–10.

59 Greenberg (n.9) p. 5

60 *Ibid* p. 7, though Greenberg stressed that there was no break in practice between the 'past' art and that of the 'modern' period, rather a growth in artists' self-consciousness about visual art's unique nature.

61 For an account of the complexities of the concept of 'expression', see GOODMAN, NELSON (1976) *Languages of Art* (Indianapolis, Hackett Publishing Co.) pp. 85–95. Reproduced in Harrison & Orton (n.57) pp. 174–179.

62 Greenberg (n.28) p. 10

63 I believe Clark comes to the same conclusion in CLARK, T. J. (1982) 'Clement Greenberg's Theory of Art', *Critical Inquiry*, vol.9, no.l, September. Reproduced in Frascina (n.52) pp. 47–63.

64 See LAKE, BERYL(1967) 'A Study of the Irrefutability of two Aesthetic Theories', in: ELTON, WILLIAM (Ed.) (1967) *Aesthetics and Language* (Oxford, Basil Blackwell),

included in Harrison & Orton (n.57) pp. 26–35. *The Chambers Twentieth Century Dictionary* defines solipsism as 'the extreme form of subjective idealism'.

65 Consider the positions in, for example, HADJINICOLAOU, NICOS (1978) *Art History and Class Struggle* (London, Pluto Press) and FRY, ROGER (1920) 'An Essay in Aesthetics', in: *Vision and Design* (London, Chatto & Windus). Reproduced in Harrison & Frascina (n.9) pp. 79–87. These two explanations are, in many respects, logically contradictory, rather than simply different.

66 According to Raymond Williams, Marxists engaged in the issue of artistic worth have tried to 'distinguish . . . progressive kinds of writing and reactionary kinds of writing, to take positions about these . . . At its weakest it amounts to branding certain kinds of literature [or visual art] as good or bad according to their presumed political or historical tendency . . . Not surprisingly, when this variant of Marxist interpretation encountered a much closer kind of literary analysis in the thirties, for example in Leavis (himself engaged and embroiled in moral and cultural discriminations within literature), it suffered a rather decisive defeat. It was seen as crude and reductionist, or at best dogmatically selective.' WILLIAMS, RAYMOND (1983) 'Crisis in English Studies', in: *Writing in Society* (London, Verso) p. 197.

67 Hans Hofmann (n.1) pp. 18–19.

68 See WILLIAMS, RAYMOND (1977) *Marxism and Literature* (Oxford, Oxford University Press), 'Aesthetic and Other Situations'; and (1980) *The Long Revolution* (Harmondsworth, Penguin) pp. 27–28: 'The belief in artistic creation as the medium of a superior reality seems most likely to be held in a period of transition from a primarily religious to a primarily humanist culture, for it embodies elements of both ways of thinking: that there is a reality beyond ordinary human vision, and yet that man has supreme creative powers.'

69 See HARRIS, JONATHAN (1988) 'Mark Rothko and the Development of American Modernism 1938–1948', *Oxford Art Journal* vol.11, no.1, pp. 40–50.

JONATHAN HARRIS

Abstract Expressionism at the Tate Gallery Liverpool: Region, Reference, Ratification

It should be clear from the proceedings of this seminar [1] that there is a considerable amount of disagreement regarding the understanding and evaluation of the work of the Abstract Expressionists. The definition of what, exactly, that 'work' *is* is itself contested and uncertain. Should 'work' refer to only the artefacts—actual paintings and sculptures—understood as the substantive, empirically-privileged objects of study, or should 'the work' be a term for a wider and more complex notion of that which needs to be explained: for example, a notion including the aims, intentions, motivations of artists *and* critics involved, as well as an account of the circumstances within which these agents 'worked'?

Within the latter, or *expanded* form of explanation, the 'empirical artefact' might appear to some to be reduced to the status of a mere residue, while within the former account all that is not part of the 'empirical artefact' might appear to some to be demoted to the periphery, the 'insignificant'. From this preliminary questioning two critical issues arise: firstly, *what* constitutes the 'empirical artefact'? Secondly, *what* constitutes an 'explanation'? Both issues relate to a familiar art-historical distinction: the formulation of 'text/context', or, in another version, the couplet 'intrinsic/extrinsic'. It is arguable that all accounts of Abstract Expressionism maintain *some* form of this distinction—that it is, in fact, an unavoidable feature of the analytic process—but that the form the distinction takes within particular accounts varies to a great degree. The nature of the distinction also importantly relates to operative senses of how 'modernism', as an historical phenomenon, should be understood and to the issue of what *critical value* this entity may still be granted within, for example, the writings of David Craven and Charles Harrison.

If antagonistic versions of 'text/context' operate as a kind of 'deep structure' within what may be called 'the discourse on Abstract Expressionism', then elements of this conflict manifest themselves, *symptomatically*, nearer the 'surfaces' of the discourse. Critics and historians of Abstract Expressionism have preoccupied themselves with clearly *different* objects of study, having little in common in either logical or thematic terms. Yet *some* sense of this profound, or 'deep structural', antagonism and antipathy of views and interests still gets registered, if not adequately articulated. While Craven does have some *very* specific, local disagreements with Nancy Jachec, for instance, about the correct interpretation of

statements made by Barnett Newman and Robert Motherwell concerning existen-
tialist and anarchist philosophy and politics [2], on the whole, and despite the *sense*
of antagonism, there is a high degree of 'non-correspondence' within the
discourse.

It is at the deep structural level, however, in the formulation of 'text/ context'
relations, that the sources of such antagonism will be found. To give an obvious
example: although R. Carleton Hobbes and G. Levine, authors of *Abstract
Expressionism: The Formative Years* [3] do not articulate the logical principles of *their*
form of explanation, it would not be unwarranted to claim that their meticulous
account of the formal pictorial components of early Abstract Expressionist
paintings is motored by 'founding principles', assumptions and values which *could*
be shown to be logically incompatible with, for example, those of Annette Cox, in
her book *Art-as-Politics: The Abstract Expressionist Avant Garde and Society* [4], the
title of which indicates a clearly opposing set of preferences and judgments.

The salience of this example is comparatively rare. Much of the material is far
harder to 'read'. T. J. Clark's recent essay on Jackson Pollock sets out deliberately
to confuse some of the normal ways in which the 'text/context' distinction is
maintained. Approvingly, he quotes Mikhail Bakhtin, saying:

> the so-called context of a work of art is therefore not a mere surrounding,
> separable from form: it is what the speaker or maker has most concretely
> to work with: context *is* text, the context is the medium . . . 'Discourse
> lives, as it were, on the boundary between its own context and another,
> alien context' . . . [5]

Clark has in mind a group of photographs that show fashion models standing in
front of drip-paintings by Pollock. The photographs were published in *Vogue*
magazine, in March 1951 (Fig. 30). They are a launchpad for Clark's discussion of
the problem of 'text/context' formulations. Within *these* photographs Pollock has
been demoted to the role of context, a literal 'background'. Yet Clark believes that
the photographs may *yet* tell us important things about Pollock and his paintings.
The second half of this paper will be an attempt also to put under strain the 'text/
context' opposition and the maintenance of the 'intrinsic/extrinsic' dyad, through
a consideration of 'Myth-Making' at the Tate Gallery Liverpool.

To invoke the three 'Rs' of this paper's subtitle, it may be said that different
versions of the 'text/context' formulation constitute their own conceptual *regions*
of *reference* (that is, that which can be implicated within a particular account) and of
ratification (that is, what notion of value, and criteria of judgment can be deployed
within the account). The identity of the object of study constituted within a
particular explanation arises within, and as a consequence of, the intersection of a
field of references and ratificatory procedures. To take, as an example, Craven's
catalogue essay [6], we may ask: what kinds of materials are relevant to his
account? What gets 'foregrounded'? Do the 'empirical artefacts' claim a *priority* of
attention or do they subsist as one kind of evidence amongst others? Are

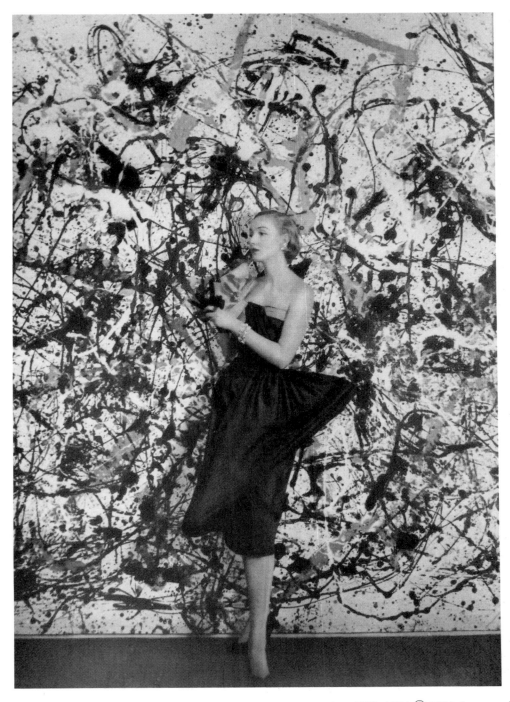

Fig. 30 Model before Pollock drip-painting *Vogue* magazine (US) 1951 © 1951 (renewed
1979) by The Condé Nast Publications Inc.

statements made by artists 'text' or 'context'? Does Craven consider his account of the political and ideological events and processes of the U.S. in the 1950s to be *background* or part of the 'form' to be explained? How might his choices *arise out of*, as well as *lead to*, a particular notion of value, or process of evaluation? Craven wants us to believe that the *actual* paintings and sculptures are 'good', but what kind of 'goodness' has he attributed to them? How might Craven's references and ratifications be contrasted with those of Harrison?

Over the past twenty years or so a part of the discourse on Abstract Expressionism has been devoted to a self-conscious debate about the nature of disagreement, and the various grounds for it. More widely, it is a debate that has taken place within many fields of Art History (though particularly on nineteenth- and twentieth-century topics) and has been generally characterised as that between traditional or 'Modernist' accounts and the 'social history of art'. This is a debate that should *never* have been reduced to two single positions, held to be in opposition, though this is the form in which it has often been represented. For example, despite the value of the Open University's course 'Modern Art and Modernism' (which finished its ten-year run at the end of 1992), its version of this opposition—the dualism of 'Clark versus Greenberg' [7]—has been responsible for further confusion. Although done for perhaps defensible pedagogic reasons, the presentation of this debate as an opposition has allowed a far grosser caricature to develop.

Within the caricature there is one version of an explanation that sees Abstract Expressionism as 'pure', 'authentic' *expression*, be it the expression of individual artists (the 'genius' discourse), or of a determining Zeitgeist (the 'spirit of the times' discourse), or of a critical paradigm or theory normally designated as Modernist with a capital 'M' (the 'Greenbergian' discourse). On the other hand, Abstract Expressionism is seen as a component—guilty or innocent—of a political *conspiracy* or plot, engineered by the C.I.A., or, more broadly, by numerous organs of the U.S. state, in Eva Cockcroft's phrase, as 'a weapon of the Cold War' [8]. Notice how the 'text/context' opposition is played out here: the 'expression' thesis centres on notions of the 'intrinsic', the inside of the form of the *empirical artefact*, as a conduit of a variety of 'contents'. The 'conspiracy' thesis centres on notions of the 'extrinsic', the *external manipulation* of a set of forms whose contents are represented as either actively complicit with this intrigue or mute victims of it.

This caricature is *not* without some value, however. There are important issues and questions that may be submerged if the terms of the polarity are rejected altogether. At the most abstract level, perhaps, the question of the definition of the words 'expression' and 'conspiracy' might slip away, and with them, two focal points of artistic and political theory in the twentieth century. It may be said that, although the terms have proved to be indispensable within art-historical and political analyses respectively, they have also shown themselves to be chronically inadequate, doubtful, problematic and should therefore be held, as Derrida would

say, '*under erasure*', subject to continual crossing out and reinstatement. How the ruling class enables its domination to be produced and reproduced (through the organs of the state and civil society) is as critical, and yet questionable, an issue as how Rothko expresses himself in *Green and Tangerine on Red*. Writers resort to the terms despite their basic unwholesomeness. Noam Chomsky's account of the conspiratorial operation of U.S. foreign policy is a case in point; it is another that Nelson Goodman's strictures are still strictures on 'expression' [9].

If the terms of the polarity are valuable *in themselves* in that they may enable a further questioning and clarification of critical concepts to occur, they are possibly more valuable because of their perhaps unlikely combination within the art-historical domain. Students find that some examination of the modern state, and its relationship to artistic production, has apparently become necessary in order to understand a facet of the *historical* significance of Abstract Expressionism [10]. If they decide, after encountering the evidence and arguments assembled by Cockcroft and others, that this is wholly irrelevant to understanding what 'the work is really about', then at least they *may* have a clearer sense of what actually constitutes the structure and limits of their favoured explanation. From reading Harrison's recent essays on post-war art and criticism [11], it seems that the 'conspiracy' thesis indeed has no pertinence in relation to his particular historical and critical interests. I would welcome his clarification of whether this is the case, and, if it is, an account of why it is irrelevant.

The 'expression/conspiracy' polarity within the discourse on Abstract Expressionism may be read as an example of the broader art-historical debate between the projected abstractions of 'Modernism' and 'social history of art'. This nomination extends the caricature from the level of concept to the level of narrative: 'expression' is a term which operates within the varying 'modernist' narratives—humanist, technicist, mysticist, etc.—while 'conspiracy' theories have normally been associated with Marxist and other more indeterminate 'functional-ist' explanations. Typically it is held that 'modernist' narratives assert the primacy of 'critical' issues (selection, quality of artefacts, etc.) over 'historical' issues which, correspondingly, are said to suppress such questions in favour of attention to social circumstances and ideological frameworks. We are back to the territory of 'text/context' here. Yet *these* are terms of a clear *misrepresentation*, rather than an exaggeration of actual features: Greenberg's 'criticism' was self-consciously driven by an open and *then* implicit sense of social *and* artistic history, while Serge Guilbaut [12] and Clark have made it reasonably clear that, whatever their disagreements with humanist or mysticist 'modernist' accounts, the works produced by the Abstract Expressionists (most certainly Pollock) are Great Works, deservedly part of the Modernist canon, with which they seem to have only minor quibbles. After all, to bother to write about Pollock or Newman at all involves some degree of *complicity*, if not conspiracy, with the Modernist account. It could be interesting to hear how Craven would position his critical approbation in relation to that of Guilbaut's, Clark's and Harrison's.

I have found my own position on this question troubling—especially over the last four years. During that time, while trying to write a part of the new course on modern art for the Open University, I was told, directly and indirectly, as part of a criticism of my explanation of the Abstract Expressionists, that I did not 'like' the 'works'—that is, the 'empirical artefacts'—enough (or at all) and that I was not 'sympathetic' towards them. I am still not sure what it might mean to be 'sympathetic' towards an inanimate object. What may have been meant, however, was sympathy towards the aims and methods adopted by the artists involved; in other words, sympathy with a *particular* account of what 'the works' were supposed to be about, and obviously—in this case—a highly contested issue. This criticism also seemed to arise from the belief that writing about art *follows* from this liking, or sympathy, for these objects and their makers. Well, it was not quite like that for me. The issue, therefore, of *the nature of the 'person' who views* informs the rest of this paper. This is an idea which Harrison uses in *Essays on Art & Language* [13].

The 'Beholder', according to Richard Wollheim [14], was 'the adequately sensitive, adequately informed, spectator' of the work of art, intuitively capable, as well as intellectually prepared, to engage with that 'empirical artefact'. The sheer 'visuality' of a Pollock or Rothko painting might be close to the sort of 'work' Wollheim may have had in mind, though any canonical modernist 'work' would probably do. Harrison believes that the presumption of this 'Beholder' breaks down with the genesis of Conceptual Art—a 'work' not meant to be 'beheld' in Wollheim's terms. 'Visuality', in the late 1960s, became no longer where art was at. Lamenting the dire productions of postmodernist art, along with what he calls 'the tedious zealots of Art for the People' and 'the repulsive puppets of Business Art', Harrison calls for the return of this 'Beholder', as a spectator who might once again be what he calls a 'representative of value in the experience of art'. This returned-Beholder, however, should not be 'gentlemanly', but 'a mad beholder—a beholder run amok'. Further, this mad beholder should have 'patrician facilities' and 'interests' which might 'again be mobilised to relatively emancipatory and critically effective ends' [15]. Now I would like some clarification on what kind of 'emancipation' Harrison has in mind here, as well as on what particular type of madness he may be recommending (there seems to be a code of sorts operating here). But it may be useful to describe my own position as also one of a kind of 'mad beholder', involving a vision that could not *but* see Abstract Expressionism, and the exhibition *Myth-Making: Abstract Expressionist Painting from the United States*, through what Harrison calls a 'paranoid eye'.

My 'mad beholding' is made out of a chronic, no doubt pathological, confusion of 'text' and 'context', 'internal' and 'external', 'viewer' and 'object'. Relating to this is the question of identifying the nature of the 'places' from which people view *and* speak, and the relevance of 'the personal' and 'the social' within the beholding of art. Perhaps Harrison's clearest account of the place from which he speaks in *Essays on Art & Language* occurs when he asserts that:

both the *qualitative presence of Modernism* and its dialectical and dialogical elaboration *are distinct* from the cultural accretion of support structures, institutions and institutional systems of evaluation within which both are represented. [16]

The nature of this 'distinctness' is obviously critical here. On it presumably rests the belief in 'autonomy' to which the writer is committed. Yet identifying the *simple* separateness or distinctness of a phenomenon has little to do with *securing*, epistemologically, the strong notion of 'autonomy'—meaning 'self-governability' and 'independence' of an object or process. Harrison recognises that his distinction is an 'assertion', a founding principle and presumably as such is not amenable to verification empirically (except as a testimony to one's subjective experience): you either believe it or you don't, in the same way that you might believe double-decker buses have been seen on the moon. Because it implies another and radical form of the 'text/context' distinction—'the work, the work, and nothing but the work'—it may be subject to the same kind of strain under which Clark tries to put Pollock's paintings.

I hold that Harrison's distinction is a purely conceptual or mental abstraction and is therefore a form of *idealist historicism*. What might a 'mad beholding' be like based on the opposing premise that modernist art *cannot* be separated historically and socially from the varying 'support structures'? Take *Myth-Making* and its location in the Tate Gallery Liverpool (Fig. 31). To use another Derridan notion, that of the *supplement* [17], what might be the consequences of recognising that that which *is in excess* of the exhibition—in this case, the gallery as a whole, the Albert Dock complex, Liverpool—may actually saturate the content, structure and presentation of the 'empirical artefacts', clarifying and refining aspects of their historical and current meanings within the culture and symbolising transformations at the level of international capitalism?

A short detour is necessary before I pursue this. Students of art history are generally told, at the stage of becoming novice 'beholders' within educational institutions, to leave behind irrelevant personal knowledge and ideas, feelings and values. Doing art history is presented, certainly at degree level, as a task that involves mastering authentic, normative forms of art-historical inquiry. 'Rigour', a fetishised term within the ideologies of academic disciplinarity, is used to designate this adoption of apparently 'hygienic', 'surgical' methods and concepts seen as appropriate to a particular field of study. Any frame of reference perceived as 'external' to the concerns of the field as defined by particular authors or teachers will be dismissed as marginal, irrelevant or as an interference, likely to corrupt or subvert the continuance of proper methods and ideas. In particular relation to studying modern art, for example, it is entirely typical for degree students to be told that their delinquent 'feelings' or 'emotions' should not enter into whatever form of art-historical inquiry is being promoted. The 'ideal' beholder, as in Wollheim's account, is a bleached specimen, as white and abstracted as the walls of

Fig. 31 Tate Gallery Liverpool; installation view of *Myth-Making: Abstract Expressionist Painting from the United States*

the gallery itself. Of course this message contradicts the exhortations routinely made by galleries, which appeal to their own highly specific and limited projection of the personal and social attributes of the adult gallery visitor.

Modernist art-historical accounts of twentieth-century art usually isolate what is called 'the work'—the 'empirical artefact'—and then present it within varying *series of works* that are grouped in a highly limited number of ways—generally by artist, or style, or school. The scholarship of Abstract Expressionism is fairly characteristic of this circumscribed diversity. Within *modernist* accounts, art galleries are regarded, more rather than less, as neutral vehicles for the display of works whose meanings and values have been achieved and ratified elsewhere. The archetypal modern art museum or gallery, following the Museum of Modern Art, New York, was a series of connected white boxes, on the walls of which could be hung series of works, arranged in accordance with the variety of schemata acceptable within the art-historical scholarship at a particular time: individual artist shows, Zeitgeist shows, group or school shows such as *Myth-Making*. How might this show, in Liverpool, be related to the Tate Gallery, the Albert Dock complex and the city as a whole? *What* kind of explanation might be produced? *Who* or *what* might the explanation be for?

If the paintings in *Myth-Making* function as signs and groups of signs, then we can recognise that the Tate Gallery Liverpool is altogether a kind of 'signal box'. The paintings in *Myth-Making* occupy their *own* space, *within* the space of the

'Dockside' room, *within* the space of the Tate as a whole, which exists as part of what is still called the 'Albert Dock', on the Mersey. What kind of a space is this?

It is a space amenable to analysis within the rubric of the earlier 'three Rs': region, reference and ratification. As a gallery or museum of modern art, the Tate Gallery Liverpool may be understood as a physical and institutional component of the 'modernist' discourse outlined earlier, which has historically dominated in accounts of modern art in the twentieth century. The discourse of Modernism includes, therefore, not just the narratives and concepts developed within historical and critical studies of modern art, but also the 'works'—insofar as their meanings and values have been constituted *within* these studies—along with the whole range of institutions given over to display and pedagogy, and the market relations developed to enable and reproduce the commodification of the works as units for economic exchange. If the Tate Gallery Liverpool can be described as a 'signal box', then it is so as part of an international network of institutions and relationships that constitute the *global Modernist Art Business circuit*.

The Albert Dock complex, of which the Tate Gallery is a focal point, may be read as a 'social text' which, though apparently *supplementary* or *distinct* from the experience of visiting the Gallery, might actually provide clues as to the status and function of the Tate within the Modernist circuit. It is clear that the Albert Dock complex—including the Tate—comprises a set of interlocking economic, political and ideological elements which illuminate, as well as concretely embody, the *capitalist modernity* of which the Modernist circuit is a particular cultural facet.

Set up by the Merseyside Development Corporation during the 1980s in order to help rejuvenate the local economy, the Albert Dock complex of shops, offices, restaurants, television station, as well as the Tate Gallery and Maritime Museum, functions as a complex *sign* and *site* for the interplay of transnational, national and regional capitalist and state strategies for investment and control. The search for economic profit goes hand-in-hand with a comprehensive *aestheticisation* of the Dock's historical past, an aestheticisation which mobilises many of the symbols and narratives commonly associated with representations of Liverpool's recent and more distant past. An apparently genuine museum (the Tate Gallery Liverpool) subsists within the Dock's cluster of commercial outlets also given over to forms of display and exhibition, that is, *Animation World*, *Castle Duckula*, and *The Beatles Story Exhibit*. But should *these* exhibits be denied the status and interest granted to the Tate Gallery Liverpool which, after all, also has both a direct and indirect role as a shop within the marketing and 'brand-awareness promotion' of works of art on the Modernist circuit? In this respect it competes with the poster shop next door which displays reproductions of Picasso, Dali, Klee, Matisse, Miró, Klimt, Monet, Kandinsky. Take out Dali and Klimt and this shop has adopted a card-carrying Greenbergian view of the Modernist tradition. Such poster, print and gift-shops adjacent to the Tate Gallery Liverpool reinforce the status of the commodities on display in the gallery and echo the goods *actually* available for sale in the Gallery bookshop.

While some stores demonstrate charmingly blunt Scouse humour in an attempt to warn off potential shop-lifters (one sign reads: 'Free ride in a police car for shoplifters and bagsnatchers'), the Tate is rather coy about its arrangements for protecting the gallery merchandise: guards now go by the more cuddly name of 'invigilators'. Many of the *other* shops and office developments on the dockside parade the importance of display *itself* as the central purpose of the site as a whole.

The Dock itself has been turned from industrial workplace into scenic leisure and consumption fun palace (the now defunct 'Wild West' pub perhaps anticipating customers in 1992 debating the role of Thomas Hart Benton's cowboy paintings as an influence on the young Pollock). The representation of the Dock's historical past within the semiotic of shops and restaurants ('Docklands Café Bar' and 'From Russia With Love') includes shades of *Letter to Brezhnev* and the ruins of a continuing dream of economic recovery. Large corporations concerned with the marketing of commodities internationally as well as locally have also made the Dock their administrative home. It is particularly striking, *judging by the signs*, how the putative status of living on the 'historic Albert Dock' might compare with the capacity of the City of Liverpool to provide decent housing for the people [18].

The Dock complex, therefore, is both an example and symbol of some of the divisions inherent within advanced urban monopoly capitalist culture. On the one hand there is the 'high Modernist art' displayed within the Tate Gallery Liverpool (of which Abstract Expressionist paintings have been taken to represent some of the most refined and replete creations), and, on the other, the mass or popular cultural forms of television—ITV broadcasts daily from the Dock—and of that most Liverpudlian creation: Beatlemania. Note the generosity of the *Beatles Story Exhibit* managers—customers do not have to pay to visit the shop. The shop itself condenses the 'high' and 'low' of Beatlemaniacal cultural commodity consumption: the 'works' (records, tapes) alongside Paul McCartney's recent excursion into opera and the 'fine art' busts of John Lennon which come in five convenient sizes: small, medium, large, extra-large, and extra-extra-large, with prices set accordingly.

How does the Tate Gallery Liverpool *encode* and *recode its* share of the historical and contemporary meanings and values of the Albert Dock complex? If the metropolitan Tate Gallery managers were aware in the mid-1980s that their adjunct would be situated amongst shops, restaurants, offices and luxury 'shag-pads for millionaires' (Charles Jencks's phrase), could they also have forecast that their impending 'blind-date' would be with *Animation World*, *Castle Duckula* and *The Beatles Story Exhibit*? Do the Tate's managers have a view on the rising tide of local postmodern museum culture and whether it can, or should, be repulsed? More radically, perhaps, it may be asked: does the Tate have an inkling that it might *itself* be an integral facet of this 'walk-through experience', 'now available for private hire'?

Physically and semiotically the Gallery narrates part of the social text of the Dock complex concerned with the *aestheticisation* of the site as a nineteenth-century

work-place, during the time when Liverpool and the Dock was a vital relay point for the transportation of commodities and the maintenance of communication between Britain, the Empire and North America. The building's 'restoration' as a museum retains much of its original brickwork and such features as loading winches and other dockside paraphernalia. Its various corporate capitalist sponsors obviously want visitors to remember—despite the new function of the place—that this was a warehouse and loading facility for ships working the trade routes. In this way the Tate serves a *double* function as a mechanism for display within the Modernist discourse: the Gallery shows works of art usually read as 'functionless' and containing their own justification and values ('art for art's sake'), while at the same time it exhibits the fabric of the building *itself* shorn of the original function. The brickwork, loading gear and other elements of the nineteenth-century work process begin to appear as curiously *self-referential*: pillars are painted and glossed like late 1960s minimalist objects, recognisable, yet 'made strange' as part of the aestheticising vision which has recoded the 'objecthood' (to borrow Michael Fried's term) of the Dock complex and all the original artefacts and functions within it.

Myth-Making takes place in a room called 'Dockside': unlike the abstracted, anaemic walls and ceilings of the archetypal modern art museum, *this* space contains original paving stones and pillar supports. The beholder of *Myth-Making*, mad, bad or indifferent, thus finds his or her vision interfered with—both literally, because the pillars block one's sight, and conceptually, in that the building *as* Dock, *as* nineteenth-century workplace, is made to assert and reassert itself, disorganising the normal stream of ideas and perceptions which constitute that part of the Modernist discourse produced and reproduced within the gallery.

Reading the place of *Myth-Making* within the space of the Tate Gallery Liverpool, as part of the Albert Dock development, should lead to a shift in the sense and scale of *what* needs to be explained and why. This form of 'mad beholding', this 'paranoid eye' will not go away, will not close up again. Through it, artistic Modernism, including Abstract Expressionism, becomes intelligible as a moment, or feature, of a much broader, extensive capitalist modernity: 'art works' as a component of the service-sector labour force employed on the Dock constructing literally and symbolically the cultural dimension of what Immanuel Wallerstein called 'the world capitalist system'.

Three sets of issues follow from this recognition:

1. The consequences of commodification for artists (such as the Abstract Expressionists) who understood the nature of the capitalist system and who wanted to oppose it.

2. The value of arguments that posit the *opposition* of so-called 'high' and 'low' cultural forms, given the recognition that all such objects circulate as commodities within the global capitalist system, irrespective of the differing intentions of the makers involved.

3. The likely development and interests of institutions concerned with the display and ratification of art objects, in the context of an *extending private capitalist influence*, through, for example, the sponsoring of exhibitions by those corporate art-lovers from Beck's Bier, Laura Ashley, United Biscuits and Volkswagen.

None of this probably has much interest for the people of Liverpool who do not visit the Albert Dock and for whom there are far more basic issues to do with surviving. Yet the Dock complex, along with previous garden festivals, 'Fame' schools and whatever, have been ploys within a governmental attempt to 'even out the uneven development' characteristic of late twentieth-century 'first-world' capitalism. Merseyside has had a weak and shrinking traditional economy since the 1930s and consequently has been the recipient of state balming fluids of fairly exotic kinds during the 1970s and 1980s. It has long been traditional also, however, to build art galleries on or near the sites of social squalor and potentially dangerous political unrest. The Pompidou Centre in Paris and the Lincoln Center for the Performing Arts in New York, along with the Albert Dock and Tate Gallery Liverpool, have all been attempts by the authorities to neutralise—one way or another—problems represented by the underclasses in contemporary societies. As such, the Tate Gallery Liverpool *condenses* and *coagulates* a strain of metropolitan and transnational culture—a reduced, partial version of the 'avant-garde' and artistic Modernism—within an initiative designed to ameliorate a region of unrest and deprivation: yet another refrain of art, not politics.

NOTES AND REFERENCES

1 This essay is a slightly revised version of the paper as delivered on the occasion of the symposium.
2 See JACHEC, NANCY (1991) ' "The Space between Art and Political Action": Abstract Expressionism and Ethical Choice in Post-war America 1945–1950', *Oxford Art Journal* vol.14, no.2; CRAVEN, DAVID (1992) 'Abstract Expressionism and Existentialism vs Anarchism'; unpublished [?] critique of Jachec's article; CRAVEN, DAVID (1990) 'Abstract Expressionism, Automatism and the Age of Automation', *Art History* vol.13, no.1, March.
3 See CARLETON HOBBS, ROBERT and LEVINE, GAIL (1978) *Abstract Expressionism: the Formative Years* (N.Y., Whitney Museum)
4 See COX, ANNETTE (1982) *Art-as-Politics: the Abstract Expressionist Avant Garde and Society* (Ann Arbor, UMI Research Press).
5 See CLARK, T.J. (1990) 'Jackson Pollock's Abstraction', in: GUILBAUT, SERGE (1990) *Reconstructing Modernism: Art in New York, Paris and Montreal 1945–1964* (Cambridge Mass., MIT Press) p. 177.
6 CRAVEN, DAVID (1992) 'Myth-Making in the McCarthy Period', in: CURTIS, PENELOPE (Ed) (1992) *Myth-Making: Abstract Expressionist Painting from the United States* (Liverpool, Tate Gallery Liverpool).
7 OPEN UNIVERSITY (1983) *A315 Modern Art and Modernism* Blocks 1–13 (various authors) (Milton Keynes, Open University Press).
8 See FRASCINA, FRANCIS (Ed) (1985) *Pollock and After: the Critical Debate* (London, Harper & Row), esp. Section II: 'History, Representation and Misrepresentation—the Case of Abstract Expressionism'.

9 See SALKIE, RAPHAEL (1990) *The Chomsky Update: Linguistics and Politics* (London, Unwin Hyman), esp. Part Two: 'Politics'. See also GOODMAN, NELSON (1984) 'Expression', in: HARRISON, CHARLES and ORTON, FRED (Eds) (1984) *Modernism, Criticism, Realism: Alternative Contexts for Art* (London, Harper & Row).

10 See esp. texts by Noam Chomsky, Eva Cockcroft, Edward Said and Alan Wallach, in: FRASCINA, FRANCIS and HARRIS, JONATHAN (Eds) (1992) *Art in Modern Culture* (London, Phaidon Press in association with the Open University).

11 See HARRISON, CHARLES (1991) *Essays on Art & Language* (Oxford, Basil Blackwell).

12 See GUILBAUT, SERGE (1983) *How New York Stole the Idea of Modern Art: Abstract Expressionism, Freedom and the Cold War* (Chicago, University of Chicago Press).

13 Harrison (n.11).

14 WOLLHEIM, RICHARD (1987) *Painting as an Art* (N.J., Princeton University Press).

15 Harrison (n.11) p. 62.

16 *Ibid.* p. 87.

17 See DERRIDA, JACQUES (1978) *Writing and Difference*, trans. Alan Bass (Chicago, University of Chicago Press).

18 Though Liverpool has built record quantities of economic housing throughout the last fifteen years, it has done so in the face of government directives. It is significant that the government backed Albert Dock while penalising the city council for its housing programme.

CHARLES HARRISON

Disorder and Insensitivity: the Concept of Experience in Abstract Expressionist Painting

I want to address what I take to be the task by which criticism is now defined: the task of making palpable in the experience of modern art's spectators that critique of conservatism which was, and I believe still is, the energising purpose behind those works of art which we distinguish as modern. Two factors have lately added to the difficulty of this task. The first is the dissuasive power of those clamorous voices which have for some while now been announcing the death of the modern itself. Their collective effect is to insinuate the suggestion that it is now unfashionable to associate the critique of conservatism with the pursuit of modernism. The second factor is the assumption prevalent in art history that artistic forms of conservatism and resistance can be distinguished along lines which correspond to the methodological interests and divisions of art history. There is a danger that the anti-academicism of dissident artists will be rendered an academic matter in the quarrels of art history's supposed dissidents.

I take my title from a dictum of Ad Reinhardt's, quoted by David Craven in the catalogue of the *Myth-Making* exhibition:

> A painting of quality is a challenge to disorder and insensitivity
> everywhere. [1]

Reinhardt was careful if not sometimes arch with his words. He did not say a modern painting or an abstract painting or an American painting or a virtuous painting. He said a painting of quality. In what follows, this term will recur. Its use should generally be understood as a kind of quotation. Where I employ it as *oratio recta*, however, I intend it to identify a form of moral and aesthetic power. Craven also quotes from a letter to the *New York Times*, written in 1943 by Adolph Gottlieb and Mark Rothko with help from Barnett Newman:

> No possible set of notes can explain our paintings. Their explanation must
> come out of a consummated experience between picture and onlooker. [2]

This emphasis on the critical importance of experience indicates a gap in the argument that the *Myth-Making* exhibition and catalogue were together designed to offer. If I may paraphrase it crudely, this argument rests on two claims: the first is that the paintings of the Abstract Expressionists are worth looking at; and the second is that the artists' resistance to what came to be the dominant cultural and

ideological values of Cold War America should be understood as the reason why they are worth looking at. To bring these two claims together is to imply that those properties which make the works interesting to look at are significant of the artists' resistance, at least in the sense that those properties may be said to have resistance as a necessary cause.

But to imply a connection is not necessarily to render that connection examinable by the spectator of the paintings in question. The nature of the gap is indicated when we ask just how the artists' resistance might be understood by looking at the works in question; that is to say not simply learned by reading an accompanying text such as Craven's, but understood in terms of properties and effects observable in those works themselves. Most visitors to works of art start with more practical questions than the specialist modern-period art historian. Those of us who sometimes speak to lay people in front of paintings such as these know that explanation often has to commence by showing why the idea that a child of ten could not have painted them is a distraction, and in what respects they are *not* all the same.

There is a dual demand of robustness and specificity which may usefully be addressed to the history of art, when its findings are used to interpret a body of work. This is that those findings should enable us to say of any two relevant works: firstly, how and why they are to be seen as competent—which is to say what is the nature and function of the techniques employed in their making; and secondly, how and why they are different—which is to say in what respects they are individuated. It is unlikely that any general interpretation will withstand the practical test of confrontation with the actual works in question if it does not avail us of answers to these questions.

Let me be clear about one thing. I do not mean to quarrel with Craven's assumption that those public falsehoods which were to become the structural misrepresentations of Cold War culture are of some relevance to the paintings. The political culture with regard to which these painters did their work is of obvious relevance to the work that they did, at least to this extent: were these paintings *not* ethically distinguishable from the normal products of that culture they could not be distinguished as 'paintings of quality'. My concern is with the means by which relevance is established, or, let us say, with the order in which painting and historical background are brought into view.

I mean to attend to some specific paintings in due course, but in order to justify my form of approach I should first lay out some methodological ground. Faced with a body of work like the paintings on view in Liverpool, the normal conventions of art history tend to favour one of two ways of proceeding towards an interpretation. The first departs from an assumption along the lines that works of art are forms of cultural production, and that meaning is nothing if it is not social. The task of interpretation is basically one of critical historical reconstruction; seeing through the misrepresentations of received history; recreating the

context within which the work was actually produced, re-embedding the work within that context, and in the process restoring its distinctive critical function. The reconstructed historical background becomes the frame within which the work is seen, or re-viewed.

The advantage of this method is that it serves to redress the balance of power in the competition to interpret, reducing the authority of the self-appointed sensitive while favouring the industry of the assiduous social historian. The disadvantage is that the status of the individual work as historical testimony tends to be given priority over the recognition and acknowledgement of the specificity of its effects. As the arch-Modernist Michael Fried wrote in a notorious text now nearly thirty years old:

> . . . in general criticism concerned with aspects of the situation in which [a given painting] was made other than its formal context can add significantly to our understanding of the artist's achievement. But criticism of this kind has shown itself largely unable to make convincing discriminations of value among the works of a particular artist. [3]

By contrast then, the second method privileges what it represents as the immediate encounter with the individual work of art. In the words of Clement Greenberg: 'Make sure the experience is there first' [4]. The advantages of first-hand experience presumably need no emphasis, but it should be said that what Greenberg had in mind was something more than the direct scrutiny of a given object. What establishes the particular form of experience in question is that it involves a value judgment—an expression of taste by which the spectator is committed in so far as it is intuitive and involuntary. To adapt a thought from Jasper Johns: as an artist, what you have to mean is what you paint; as a responsive spectator, what you have to mean is what you see. Interpretation according to this second method tends to reverse the procedure of the first. Instead of the work of art being viewed in terms of its historical context, a form of history is what the work is seen as revealing to the imaginative observer of its effects.

It is a distinct advantage of this second method that it prevents the relegation of works of art to the status of illustrations to historical theses. Yet such ways of proceeding are now badly out of favour. Though this may be regrettable it is not surprising. So long as the potential for aesthetic experience is seen as invested in a minority, a kind of power will attach to those who lay claim to it. And so long as the minority in question is identifiable in terms of class, or of race, or of gender, that power will rightly be viewed as symptomatic of an existing distribution of powers. And while it may still be claimed of aesthetic experience that it serves to empower the historical imagination, that claim will be undermined whenever historical inquiry is foreclosed in the name of art's autonomy—as it often has been in the distributive forms of Modernist culture.

As might be expected, the need for such reservations has severely damaged the case—originally proposed by Kant and resuscitated within the Modernist critical

tradition—that judgments of taste can be disinterested. In fact the concept of taste became associated with notable forms of cultural squalor during the 1980s, for reasons which are all too easily matched against the adoption of economic rationales as the deciding factors in political morality. Far from being understood as standing for that kind of imaginative response in which one's ethical being is committed, taste had by then come to signify no more in the public discourses of art than the reassertion of self-satisfied preference and the reinforcement of unreflective habit.

Ironically, this latter state of affairs was not entirely inconsistent with the anti-élitism of the cultural left, and with its campaign to discredit the idea that aesthetic value is separable from economic value. In the world of social history—which is where these kinds of conclusion have largely been pursued—the critic has lately been seen as trading in a debased currency: sensitivity, imagination, discrimination, taste. It seems that those who would argue for attention to the specificity of the work of art—as I wish to do—must find some means to re-establish the experience of art as a form of critical inquiry. What is needed specifically is that expressions of taste—with which criticism cannot help but concern itself—should be re-established not as assertions of preference, but as forms of response to the demands of art—demands which cannot without loss be reduced to a register of economic or political positions.

I wish to assert the priority of the experience of art. Furthermore, I wish to argue that recognition of the distinctive properties and merits of individual works of art is an indispensable means to learn the lessons of history. In pursuit of this end I propose to conjoin the two quotations I referred to earlier: Reinhardt's assertion that a painting of quality is a challenge to disorder and insensitivity, and the statement by Gottlieb, Rothko and Newman to the effect that such explanation as was available for their paintings must follow from a consummated experience between picture and onlooker.

These statements gain in cognitive substance when each is interpreted in the light of the other. Firstly, I propose that it was Reinhardt's unvoiced assumption that the challenge to disorder and insensitivity offered by a painting of quality could succeed only in so far as that quality was established in a consummated experience. Certainly Reinhardt did much in his role as writer and cartoonist to instruct his audience in the nature of this consummation, if only by satirising its false and synthetic forms.

Secondly, I propose that the kind of consummated experience which Gottlieb, Rothko and Newman had in mind was an experience of the picture as a 'painting of quality'. Their works were not just to be seen; they were to be conceived of as partners in the fulfilment of an emotional relationship.

This may seem a straightforward enough conceit—or at least as straightforward as the concept of quality can ever be allowed to be, which is not *very* straightforward. But if the conjunction of these two statements is allowed, it furnishes an interesting corollary; and one which goes some way to removing the stigma of

authoritarianism and complacency now customarily associated with the recognition of quality.

The corollary is this. It is only in so far as the experience of the painting serves as a challenge to disorder and insensitivity that that experience may be said to qualify as a consummated experience of its quality. In other words, the fulfilment of the envisaged relationship involves the meeting of a demand. In consummation deserving of the name, the supposed orderliness and sensitivity of the self is critically reviewed in response to the differentness of the other. The painting is not only to be loved. It is to be loved for itself (and certainly not for its money). As women more often observe than men, there are forms of love that are not worth having. Tears shed in the presence of Rothko's paintings may be signs of sensitivity. They may also be the outpourings of sentimentality and self-regard, and as such tokens of false love—prayers to the wrong God.

I believe that the conjoining of the two quotations sets a two-part agenda to be addressed in the presence of any relevant painting. The first task is to show what is and is not an experience such as Gottlieb, Rothko and Newman might have allowed to be a consummated experience of that painting's quality. The second is to show how and why that experience is necessarily challenging to what Reinhardt called disorder and insensitivity.

Before I proceed let me make clear that my use of these quotations is a move in a kind of game, a game which involves taking the claims and statements of the artists at face value and considering their work as the serious business those claims would have it be: work which, 'if . . . others could read it properly . . . would mean the end of all state capitalism and totalitarianism', in Newman's words [5], or, in Still's, work whose implications, whose 'power for life—or for death' are not to be under-valued [6]. The paintings in question will either bear this load or they will not. But whether they will or not, it needs to be said that the men who painted them (and I mean men) were frequently pretentious to the point of rank charlatanry and perhaps sometimes beyond. The works we treat so seriously could also be represented as ad hoc expedients, botched-together experiments, and improbable tryouts. But of course, they are none the worse for that.

To pick up the thread again, though I shall have a few words to say about Reinhardt's *Abstract Painting No.5* (Fig. 32), I intend to work my way towards what I take to be one of the most demanding works in the *Myth-Making* show, Rothko's *Light Red over Black* (Fig. 33). As the show was hung, Rothko's painting appeared in a complementary relationship with Barnett Newman's *Eve* (Fig. 11) and I shall have this work in mind also in what follows. As literal objects, these paintings are both around seven and a half feet high (2.3m), both between five and six feet wide (1.5–1.8m), both are mounted on conventionally shallow supports.

To talk about a painting must be to talk about its properties and its effects. That talk must start somewhere, with some form of claim about what is seen, felt, evoked and so on. I therefore start by asserting of these two paintings that each in its different way evokes the life-sized figure or portrait. I do not mean by this to

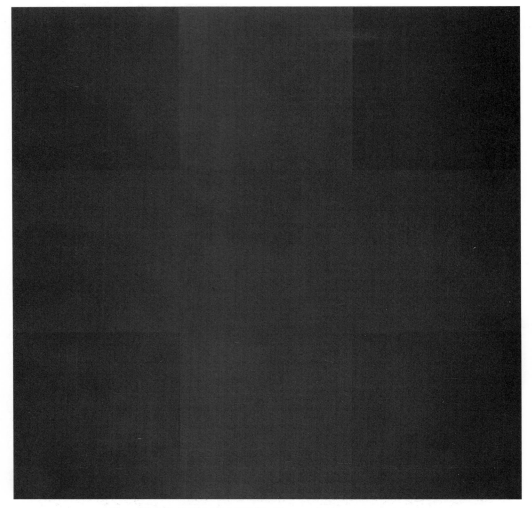

Fig. 32 AD REINHARDT *Abstract Painting No. 5* 1962

suggest that the abstract forms of either of them are derived from some originally readable likeness of a person, so that we might see Newman's *Eve*, for instance, as a kind of extreme reduction from a picture of some Eve. On the contrary. It is not a remote suggestion of likeness that evokes the figure genre, nor even any evident reference to a pertinent style; what are evoked are rather specific types of effect unprecedented in earlier abstract painting, but familiar from the experience of certain life-sized figure paintings—portraits and self-portraits among them. Size and scale have something to do with this, I think; that is to say the evocation is largely a function of the painting under its literal aspect. Or rather, to be more precise, given a literal aspect which evokes the life-size standing figure, what Rothko and Newman subsequently do to the surfaces of their paintings produces

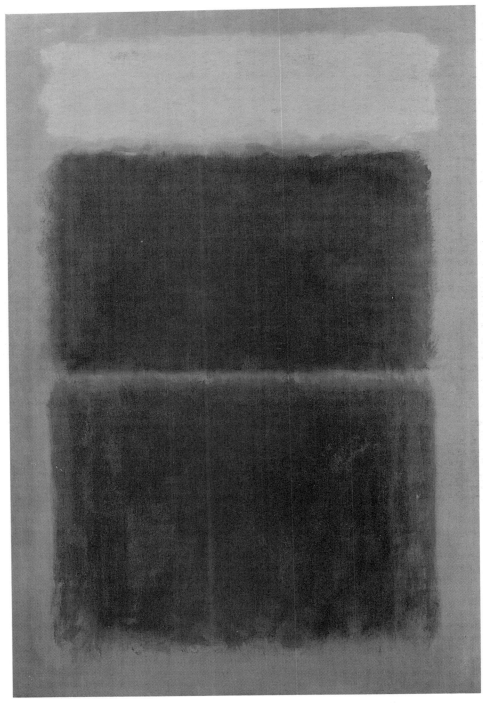

Fig. 33 MARK ROTHKO *Light Red Over Black* 1957 © 1993 Kate Rothko-Prizel &
Christopher Rothko/ARS, New York

effects comparable in qualitative terms to the effects achieved by some painters in pictures of single or at least isolated figures.

I claim no originality for this perception. I have already referred to Newman's flagging of a kind of human content through the titling of some of his pictures— and Newman is one of those artists whose titles have often to be regarded as components of the contents of his works. We also know that he instructed spectators at his earliest exhibitions not to stand back from his large paintings, but to approach them—the implication was clear—as if they were people. As for Rothko, he avowed a continuing interest in the painting of the human figure:

> For me the great achievements of the centuries in which the artist accepted the probable and the familiar as his subjects were the pictures of the single human figure—alone in a moment of utter immobility. [7]

Rothko was later to acknowledge that:

> a time came when none of us could use the figure without mutilating it. [8]

But the identification of painting with person was clearly central to his sense of his work, or at least to his public projection of that work. He wrote of his paintings not as if they were in any sense pictures of people, but rather as if they were possessed of feelings of their own.

> A painting lives by companionship, expanding and quickening in the eyes of the sensitive observer. It dies by the same token. It is, therefore, a risky and unfeeling act to send it out into the world. How often it must be permanently impaired by the eyes of the vulgar and the cruelty of the impotent who would extend their affliction universally! [9]

The effects of abstract paintings are notoriously hard to describe concretely. I shall therefore take the cue which Rothko offers and start by exploring certain effects which can be associated with earlier paintings featuring individual figures. Having established some terms of reference I shall try to transfer these back to the works we are principally concerned with. This will seem at first like a considerable detour. But I hope to show in the end how terms for a demanding relationship between spectator and work of art might be established by an abstract painting, what kind of experience a consummation of such a relationship might be thought to be, and therefore what might and might not be allowed to be a 'painting of quality'.

I start deliberately with an art-historically well-studied example, Manet's *A Bar at the Folies-Bergère* (Fig. 34) [10]. (The distinction I shall make between perceptions of the painting is artificial and experimental. I do not pretend that the forms of perception in question are easily separated in ordinary experience. I separate them as I do for the purposes of illustration.) The figure of the barmaid is not exactly alone, but she is certainly shown as isolated, if only by her self-consciousness, and she is immobile to the extent that within the frame of reference of the picture she

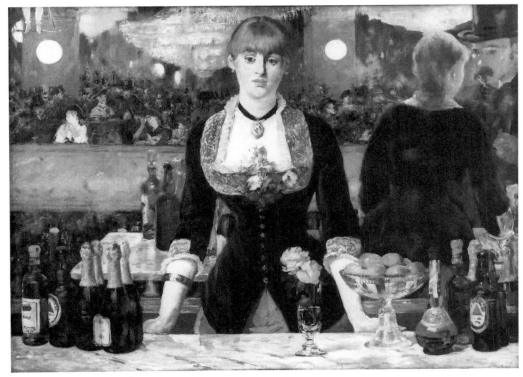

Fig. 34 ÉDOUARD MANET *A Bar at the Folies-Bergère* 1881-2

has no next move which is not a response to the action of another. Now it has become part of the conventional wisdom of modern art history that the painting places the spectator of the picture figuratively in the position of consumer, not just for the carefully described refreshments, but potentially also for the woman herself if she turns out to be for sale. Thus, to become a competent viewer of the painting is to adopt in imagination the role that Wollheim has designated 'the spectator in the picture'. This is a spectator who is not so much represented *in* the painting as represented *by* it. Though not necessarily depicted, the spectator in the picture is necessary to that painting's content, for what is pictured cannot be understood unless it is conceived of as what it is that this specific spectator is seeing. According to this view, to see Manet's painting properly is to see the scene in imagination through the eyes of the customer.

I suppose it would be possible to stop there—as many viewers must have done in the hundred-odd years since the picture was painted. An unreflective regard will allow it to be an attractive picture of an attractive woman, set in engaging and atmospheric surroundings, and organised in such a way that the spectator can easily imagine himself in the woman's presence. The pronoun gives the game away of course, as feminist art historians have been quick to point out. If this is

taken to be the appropriate form of appreciation, then the spectator must be presumed to be a male, and thus a contingent spectator.

To say that the painting makes the bourgeois spectator aware of his complicity in a certain form of sexual economy is certainly to say something relevant about the spectator in the picture. It is to acknowledge the various salients by which his ethical and psychological space are defined. But I am not sure that this acknowledgement of itself advances experience of the painting beyond a simple shift in response to what it pictures. After all, why should the notional spectator's experience be assumed to be uncomplex in the first place? Enjoyment of the evident delights of a picture such as this is by no means irreconcilable with a degree of self-consciousness about the situation the spectator imagines himself as occupying. And there is no need to look any more assiduously or even to look again at Manet's painting to take the point that barmaids at the Folies-Bergère were widely regarded as prostitutes.

In fact it is not only the presumption of a 'gendered spectator' that flags the need for a more complex account of Manet's work. To look carefully is to notice inconsistencies and discontinuities in the way the scene is put together. The barmaid and her reflection cannot quite be made to match—for instance, one has earrings, the other does not; and if the figure at the far right is supposed to be a reflection of the client-cum-spectator, how are we to sort out an angle of vision which will match with the woman's direct outward gaze? In general the relationship between the painting's illusory or metaphoric properties and its factitious or literal properties will not settle around a single imaginary position.

Nor can the relations of figure and ground be resolved in such a way as consistently to produce the barmaid as figure and the rest as ground. When all of the painting is attended to there is no viewpoint which consistently isolates the woman as an object of the spectator's focus. Like the first viewers of Manet's painting we are faced with a choice—a kind of demand. We can hold on to the idea that the painting represents the viewpoint of the spectator-as-customer, and see its inconsistencies and evasions as kinds of involuntary mistake—that is to say as forms of incompetence. Or we can accord priority to the actual characteristics of the painting—that is to say accept the discontinuities as intentional—and see what it is that that leads us to see. I think the second position must always have been a difficult one to adopt. The evidence is that it is still difficult. It involves exerting oneself sufficiently with regard to the painting to see past the spectator the picture seems initially to presuppose. Seeing being what it is and painting being what it is, this cannot be adequately done without some disassembling of the deeply habitual structure of experience that that spectator represents.

There are three points I wish to draw out, in order finally to reconnect my discussion of Manet's picture to the explicit concerns of this paper and, I hope, of the symposium as a whole. The first is that the one account of the painting does not simply cancel out the other. The spectator who proceeds beyond the persona of the unreflective customer is left with the simultaneous possibility of seeing the picture

as what the imaginary customer sees, *and* of seeing the painting as it were from the position of the painter—of being both a sheep and a goat.

In this sense the painting may be regarded as the ground on which the spectator's own capacity to experience is laid open to critical diagnosis. The second point is that I find it hard to conceive how one might explain a shift from the first level of attention to the second if not by speaking of some intuition that the exertion involved will be repaid—which is to say an intuition of relative aesthetic worth. The third point is that it is only in the making of this shift that the spectator can come fully to experience the painting for itself—which is to say as something other. For it is only once the spectator as customer is dislodged from his position as sole arbiter of the painting's content that a different kind of painting can be seen to emerge. This is in fact the painting whose emergence the artist must himself have watched over: a constructed and changing thing, with which a very different imaginative relationship is sustainable; one in which what is felt for in imagination is not just the possibility of consumption, but the subjective condition of that look that looks back out.

To experience the painting in this way is indeed to face a challenge to those forms of sexual and social disorder and insensitivity for which the appropriating regard of the spectator-as-customer might be taken to stand. For the conclusion to which I seem to be leading is that when the aesthetic power of the *Bar* is fully experienced, the painting is experienced as a kind of self-portrait. If this conclusion seems fanciful, consider the kinds of staging and artifice involved in the painting of an actual self-portrait, and consider the form of imaginative concentration required of the spectator if he or she is fully to experience the resulting picture *as* a self-portrait. I offer two examples: a woman to put the men upon their imaginative mettle—Paula Modersohn-Becker's *Self Portrait*, 1906 (Fig. 35)—and a man, Rembrandt, whose *Artist in his Studio* of 1629 (Fig. 36) faces the imaginative viewer with a question fundamental to representation: who is it that is seeing and who is being seen?

Rembrandt will take us in the end back to Rothko, and to Rothko's preoccupation with what he called 'the human drama'. I have set up various requirements to satisfy and various motifs to pursue. Let me try to gather them together. I have suggested that interpretation needs on the one hand to avail us of an account of relevant techniques and competences, and on the other to enable significant distinctions to be made between one like work and another. The point of my use of Manet's work as example was to suggest that interpretation will always fall short if the experience on which it is based is not an experience of the aesthetic individuality and power of the work—that is to say, if the relationship between spectator and painting is not consummated. I have also suggested that this consummation involves the meeting of a critical demand. On the one hand the painting sets into position before itself an imaginary spectator in whose person a repertoire of accustomed responses—we might even say a form of ideological existence—can be conjured into being. The art of doing this is the art of

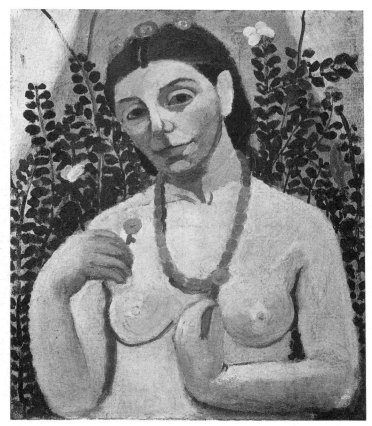

Fig. 35 PAULA MODERSOHN-BECKER *Self Portrait* 1906 courtesy Öffentfliche Kunstsammlung Basel, Kunstmuseum (photo. Martin Bühler, Basel)

composition—the means by which the passing spectator is as it were attracted into the sphere of the painting. On the other hand the painting demands a level of attention to its literally artificial character, to the difficult dialectics of its surface-depth and figure-ground relations. This attention is not quite like the kind of attention required to get the picture. It is both qualitatively different and critically directed. That is to say, at a certain point it will involve the spectator in some cognitive difficulties with the form of ideological life the picture refers to or, as it were, starts in. There is no great drama in this though. This is what art of any interest has to do in order to maintain the possibility of a liberal culture. It must make critical demands on the attention of the spectator.

On the matter of *quality* of attention the work of Ad Reinhardt is clearly didactic, and *Abstract Painting No.5* can be used to fill out the point I am trying to make. This is, as it were, a very slow painting. It will disclose its colours and the divisions of its surface only to those who attend to it to the exclusion of all else, those who exert themselves enough for the eyes to adjust to its specific demands, and for minute

Fig. 36 REMBRANDT VAN RIJN *Artist in his Studio* 1629 Zöe Oliver Sherman Collection. Given in memory of Lillie Oliver Poor. Courtesy Museum of Fine Arts Boston

differences of hue to register at the very lowest level of tonal depth. It does not matter much that these differences turn out to delineate a division of the surface on the basis of a cross; or rather it matters that they delineate no more than that. For the experience of the painting needs *not* to be an experience of recognition, beyond acknowledgement of the most minimal of figure-ground relations. The point is that there is no 'something else' that the painting refers to. The experience it offers is the one you just had; the experience of giving all your attention to an other. The painting exists to be the occasion of that experience for the spectator, which is to say the occasion of an experience that is explicitly not one which forms of disorder and insensitivity can in any sense direct. The technical skills employed are those which serve this end. But if the painting is not given the attention it requires, it remains altogether black and meaningless, while the ordinary patterns of experience persist without benefit of contrast. It is in the giving of an unaccustomed degree of attention, then, that the relationship between painting and spectator is possibly consummated.

I do not want to lean too hard on the example of Reinhardt's work, since I

believe that that reductiveness which constitutes its didacticism is also a kind of limit on its breadth, and thus a limit on its hold over the imagination. In the fastidious world of Reinhardt's painting, we miss the psychological complication and variety which Manet's work has to offer, or Rembrandt's for that matter. This has something, I think, to do with the fact that it appears to presuppose a straightforward choice: attention or inattention, the one possibility as it were excluding the other. In the work of the earlier painters the level of experience I have called an experience of the painting's aesthetic worth is allowed to coexist with the very form of response it invites us to re-examine. Indeed, this irreducible connection to a world of unaesthetic responses is an assurance of realism in their work.

But how were this breadth and this realism to be achieved in paintings which, it seemed, could no longer contain the very figures which were their traditional vehicles? It is quite clear from statements made by Rothko and Newman in the 1940s that this was for them the explicit form of a besetting problem. It is also, I think, clear from the paintings they made that they were determined to find means to solve the problem; that is to say to enable a realism and breadth in the experience of abstract works which could stand comparison with the experience of the best figure paintings. (In the context of this comparison, the direction of Reinhardt's work could be seen as a kind of *via negativa*. Its militant disconnectedness from the world of the unaesthetic implies a form of idealism.)

This is not the place and there is not the scope to address the question of just why the human figure seemed to become unavailable to these painters when it did; why, in Rothko's words, none of them could use the figure after a certain point without mutilating it—though the issue is one to which art history and art criticism could usefully devote more substantial imaginative resources than have been deployed so far. It is a question which has considerable bearing on our means of conceptualising the more recent and current practice of art, on our general understanding of figuration and its problems, and, at a still deeper level, on our grasp of the complex historical conjugations of 'no longer' and 'not yet'. In a more localised sense the question is also of relevance to the claim advanced for Norman Lewis's work through his inclusion in the *Myth-Making* exhibition. It has to be said that this work looks very thin in the company of the full-blooded abstractions of Newman, Rothko and Still, precisely because the superficial and frenchified modernity of its effects is vitiated by the endemic conservatism of its figuration.

What I do want to consider, in pursuit of a conclusion, is the techniques employed by Rothko to produce effects which were not so much figurative in themselves as capable of being matched against those of the figure paintings he admired. I also wish briefly to consider the relationship between similarity and difference in his work as a whole. To build on the platform of example which I have tried to create, I conceive of a spectator in front of *Light Red over Black*—one who attempts to adopt the imaginary position which its composition defines. In fact, there is no need to invent such a spectator. If you watch people in a museum

addressing a Rothko painting in earnest, you will usually see them shuffling to and fro, standing up and standing back, in search of the best position from which to see it. For the spectator who attends sufficiently to the technical character of the painting, the optimum position will be the one where the painting completely fills the visual field, and is thus potentially all-absorbing.

This will in some sense be like a social or sociable distance from another person. But what defines it as the appropriate viewing distance is in fact a carefully adjusted series of tone and colour relationships and an equally careful balance of detail and mass. Stand too close and you lose the sense of the whole; stand too far back and you can no longer fully discriminate between differently painted areas. But stand where you can just distinguish the closest and darkest tonal relationships, and the fine seams of lightest colour will appear vivid and complex. From too far back the hovering central shapes establish themselves as substantial forms against an indefinite spatial ground. From too close up they simply read as opaque surfaces, lying inertly across a literal foreground. At the optimum viewing distance, the relations between figure and ground become transitive, while the conceptual line dividing the literal from the metaphorical loses all practical application.

There are various points to be made here. The first is that the techniques employed by Rothko are entirely unmysterious. What he does is to distribute some of the less hackneyed and less eye-catching forms of illusion across large pictorial surfaces. The effects in question are those in which figure-ground relations are blurred through overlap and overlay and through precise adjustment of largely warm colour and tone. As his work continues the colours used tend to become more frequently low-key and the tones darker. In face of all the talk about Rothko's deepening depression, it is worth observing that the effect of this development is increasingly to purge the pictorial atmosphere of literary-picturesque associations and to apply an ever finer tuning to the dialectical relations of surface and depth, figure and ground, literal shape and metaphorical effect.

What Rothko seems to be doing is narrowing the gap between what can be seen by the ordinary enchanted spectator and what is experienced in attending to the painting's technical effects. Of course it could be suggested that to concentrate upon the specialised practical demands of this refinement day in day out over several decades was to risk a kind of spiritual exhaustion. But such interpretations as might follow from that suggestion would at least be based on realistic types of relation between practical criticism and psychological biography, and would not have to rely on the mere reading-in of romanticised hearsay.

Of Newman's work it can also be said that it relies upon entirely unmysterious kinds of illusion, though his method is to play upon those reciprocating relations of edge and area in which placement and quality of line are the critical functions. As Newman himself observed, if he made a distinct contribution it was in his drawing. Just *how* we see one of his typical paintings depends to a large extent on what we see as occurring spatially on either side of a vertical division. And this will be decided not simply by the drawing of the edge in question, but by the

relationship between on the one hand its distinctive technical character—sharp or soft, thinly or thickly painted, masked or free-brushed and so on—and on the other the *quantities* of colour and tone deployed on either side of it.

In the work of both painters, the significant types of effect are those which define and qualify the imaginative experience of the spectator. The tendency of Rothko's work is to draw the spectator into an absorbing spatial illusion. The tendency of Newman's is to enclose, as if the painting were the point of generation of a spatial envelope within which both the spectator and its own literal surface are included. But in both cases the possibility of submission to the full force of this effect—the possibility of consummation of the experience the painting has to offer—depends upon a kind of suspension of those normal habits of recognition which we tend to defend as the conditions of our physical and social placement.

Let me try to put this point plainly by reference to the kinds of argument I have used so far. Properly to see a canonical Rothko painting—literally to be able to distinguish what one is looking at—is to concentrate all one's attention on the point of optimum balance between a series of near irresolvables. To do this in the context of representation can be deeply disorienting in a way which goes beyond the merely physiological. It may be experienced as a kind of desituation of one's self. The evidence is that many people find this experience variously alarming or depressing or sad, as deprivation of the contingent sense of self can often be. But loss of the contingent sense of self is also the condition of consummation in any full relationship. It is as if at one level the paintings are like kinds of vacuum, which we hasten to fill with meaningful memories of dawns and sunsets, or with tears, lest they leave us for dead. But should we instead exert ourselves to register the actual aesthetic power of the painting, it will become clear that loss of self in the other is not to be feared as a ceasing to be. Rather it is a form of consummation in which there is risk but no threat.

I speak of two levels and it must appear as if I mean to establish a kind of hierarchy. But to do this would be to ignore the demand of realism which Rothko's painting, like Manet's, both meets in itself and makes of the spectator. The point is that the supposedly 'higher' level of experience—let us call it the level of the aesthetic—has no practical virtue if it is simply a form of forgetting of those responses by which our circumstanced selves are more ordinarily represented.

To put this point another way, we might say that painting's challenge to disorder and insensitivity is mounted as a pursuit of aesthetic worth, and as a demand of assiduousness in the attention of the spectator. This demand is brought home in the experience of the spectator through the painter's manipulation of the effects of figure and ground, surface and depth. It is in this sense, not in the conveying of attitudes to what is depicted, that art establishes its critique of conservatism—that is to say it does it at the fundamental level where our intuitions intersect with our cognitive habits. But of course the grounds of that critique have to be set up in whatever terms the actualities of our social and historical

circumstances may dictate, and the modern conditions of conservatism being what they are, these are likely to be the terms of the truism, the cliché, the euphemism, the half-truth and the innuendo. For Rothko, this seems to have meant setting up conventional forms of the atmospheric and the picturesque as kinds of façade to be ruined. As he himself noted, for Rembrandt the task was to wrest the portrayal of each individual sitter to the point at which the underlying problems of represen-tation could be engaged [11]. For Rothko himself, the different atmospheric character of each distinct painting served to pose anew the same basic problem: how to establish the individual as a *qualitative* presence in the overwhelming context of what, with the exaggerated bravura of the actor-manager, he called 'the whole of man's experience' [12].

It is time, finally, to return to the concept of painting as self-portrait. The point about experiencing someone's self-portrait *as* a self-portrait is not that you come to see the picture as representing yourself, but, on the contrary, that you take on in imagination the experience and activity of the other as the paint defines it. As I hope I have made clear, I believe the substantial ambition that Rothko and Newman had for their abstract paintings was that they could be made to demand as much of the spectator.

As a project for painting this was certainly far from the psychological agenda of McCarthyism. I do not think, however, that the resulting works are 'paintings of quality' because of this distance. I think the distance is an incidental function of that pursuit of aesthetic sufficiency which was the artist's traditional vocation. The painters I have been discussing were New York liberals. They were doing what liberals have to do to make high culture under the conditions of modernity. The tendency to conscript the paintings of the Abstract Expressionists *en bloc* as forms of opposition to the ideological machinations of the Cold War is in the end no more defensible than the tendency to see them as wholly implicated. It obscures the ethical complexity of the paintings' origins, it misrepresents their considerable distance from other works by other painters who were more explicitly singled out by the witch-hunters, and it reduces them to tokens which become qualitatively indistinguishable one from another.

We do not have to worry about the virtuousness of art's position in relation to historical issues. In the last instance the worth of art must indeed depend upon the possibility of its address to substantial issues, be they the psychological problems of gender relations, the social problems of class relations, the geopolitical problems of economic relations, or still others which our forms of study do not allow us to recognise—the academic forms of our study no doubt being themselves sympto-matic of some substantial unacknowledged problems. The issues and problems of modern existence can either be made palpable through a playing on the relations of the literal and the metaphorical, or they cannot be dealt with by art.

On the other hand, we do need to concern ourselves with art's quality and with our capacity to experience it. It is getting to seem as if terror of consummation

might be the real postmodern condition. Yet if the artists are to be trusted, our capacity for consummation is the real measure of our power to resist disorder and insensitivity [13].

NOTES AND REFERENCES

1 REINHARDT, AD (1946) 'How to Look at Space'; quoted by CRAVEN, DAVID (1992) 'Myth-making in the McCarthy Period', in: CURTIS PENELOPE (Ed) (1992) *Myth-Making: Abstract Expressionist Painting from the United States*; (TGL) p. 20.

2 *Ibid*. p. 17.

3 FRIED, MICHAEL (1965) *Three American Painters* (Fogg Art Museum); reprinted in HARRISON, CHARLES and WOOD, PAUL (Eds) (1992) *Art in Theory 1900–1990* (Oxford, Blackwell) p. 770.

4 GREENBERG, CLEMENT (1983) 'Greenberg on Criticism', television programme in: *A316 Modern Art and Modernism* (Milton Keynes, Open University).

5 NEWMAN, BARNETT (1962) 'Interview with Dorothy Gees Seckler', *Art in America*, vol.50, no.2; reprinted in Harrison & Wood (n.3) p. 766: 'Almost fifteen years ago Harold Rosenberg challenged me to explain what one of my paintings could possibly mean to the world. My answer was that if he and others could read it properly it would mean the end of all state capitalism and totalitarianism. That answer still goes.'

6 STILL, CLYFFORD (1959) Letter to Gordon Smith; reprinted in Harrison & Wood (n.3) p. 586: '. . . let no man undervalue the implications of this work or its power for life:- or for death, if it is misused.'

7 ROTHKO, MARK (1947) 'The Romantics were prompted'; *Possibilities* No. 1; p. 84; reprinted in Harrison & Wood (n.3) p. 564.

8 ROTHKO, MARK (1958) from a lecture given at at the Pratt Institute, as transcribed by Dore Ashton and published in the New York Times, 31 Oct. 1958.

9 ROTHKO, MARK (1947) statement in *Tiger's Eye*, vol.1 no.2, p. 4; reprinted in Harrison & Wood (n.3) p. 565.

10 In what I have to say about this painting I draw specifically on conversations with Paul Smith, and to some extent on the work of Tim Clark and Richard Wollheim. See CLARK. T. J. (1985) 'A Bar at the Folies-Bergère' in: *The Painting of Modern Life* (London); and WOLLHEIM, R (1987) 'The Spectator in the Picture' in: *Painting as an Art* (Princeton).

11 GOTTLIEB, ADOLPH and ROTHKO, MARK (1943) 'The Portrait and the Modern Artist', typescript of a broadcast on 'Art in New York', Radio WNYC, 13 Oct; printed in (1987) *Mark Rothko 1903–1970* (London, Tate Gallery) p. 79.

12 *Ibid*. 'Today the artist is no longer constrained by the limitation that all of man's experience is expressed by his outward appearance. Freed from the need of describing a particular person, the possibilities are endless. The whole of man's experience becomes his model, and in that sense it can be said that all of art is a portrait of an idea.'

13 'If I must place my trust somewhere, I would invest it in the psyche of sensitive observers *who are free of the conventions of understanding*. I would have no apprehension about the use they would make of the pictures for the needs of their own spirit. For if there is both need and spirit, there is bound to be a real transaction.' ROTHKO, MARK (1954) in: letter to Katherine Kuh, archives of the Art Institute of Chicago, quoted in Rothko 1903–1970 (n.11) p. 58. My italics.

NANCY JACHEC

Myth and the Audience: the Individual, the Collective and the Problem of Mass Communication by the Early 1950s

By and large the literature addressing the relationship between Abstract Expressionism and myth has agreed that the mature, post-war phase of this movement was, to a greater or lesser extent, a continuation of the Surrealism-influenced phase of the war years, reiterating its interest in the mythological in essence if not in appearance [1]. Apropos of this, it has been argued that a process of reduction, of paring down the figurative image to its simplest visual and ideational essence in order to achieve the 'tragic and timeless' nature of myth, underlies the visual changes in Abstract Expressionism by the mid-1940s [2]. The artists' statements most commonly used by scholars to interpret this relationship appeared in 1943 within months of each other—a letter published in the *New York Times* in June by Adolph Gottlieb, Barnett Newman, and Mark Rothko, and a radio broadcast in New York City in October, during which Gottlieb and Rothko aired their views. In these communications the artists discussed their motivations for using mythological subject matter. Arguing that it was a means of escaping the mundane, the particular and the temporal, myth embodied 'basic psychological ideas' shared by humanity trans-historically:

> . . . they are the eternal symbols upon which we must fall back to express basic psychological ideas. They are the symbols of man's primitive fears and motivations, no matter in which land or what time, changing only in detail but never in substance . . . And modern psychology finds them persisting still in our dreams, our vernacular, and our art, for all the changes in the outward conditions of life . . . [3]

The importance these artists invested in the universality of the image suggests an underlying concern with wanting to communicate with as many people as possible. They described the sort of audience which could have a meaningful transaction with their work as 'artistically literate', acquainted with the 'global language of art':

> That is why we use images that are directly communicable to all who accept art as the language of the spirit . . . [4]

Serge Guilbaut has explained how their use of myth during the mid–1940s enabled the Abstract Expressionists to locate themselves within this new audience, having given up the aesthetics of the Popular Front:

> While using automatism, myth, and surrealistic biomorphism, the modern American painter kept intact one aspect of his political experience from the thirties and held on to one cherished notion: the idea that the artist can communicate with the masses, though now through a universal rather than a class-based style. [5]

The shedding of this surrealistic imagery marked a similar relocation in regard to the audience. The disappearance in the late 1940s of the figurative elements which had previously characterised most Abstract Expressionist work suggests a change of intention, since the artists' statements concerning 'subject matter' remained relatively constant. It is therefore necessary to understand what this content was before an explanation of the changes within its various modes of visual representation can be attempted. Throughout the 1940s they maintained an interest in depicting the idea: Rothko, for example, defending the degree of abstraction in his work, remarked in the 1943 broadcast that 'all of art is a portrait of an idea' which draws on experience as opposed to external appearances [6]. He reiterated this same relationship between abstraction and the idea in 1949, by which time his work had become entirely abstract.

This argument for abstraction as fundamental to the expression of an idea was forcefully articulated in Newman's introduction to the Betty Parsons Gallery show *The Ideographic Picture* of 1947. Although the works by participating Abstract Expressionists had mythological or literary titles, and possessed some degree of figuration—Newman showed both his markedly biomorphic *Gea* and *Euclidian Abyss*, which was prototypical of his mature 'zip' paintings; Rothko, *Tiresias* and *Vernal Memory*; with Clyfford Still contributing *Quicksilver* and *Figure*—Newman's definition of the ideograph as a symbol representing an object without expressing its name, and as a vehicle for pure feeling, was critical of both pure abstraction and objective representation as either mere formalism or an 'overload of scientific truth' [7]. The kind of abstraction Newman defended, as Harold Rosenberg pointed out, was a fusion of abstract form and concrete meaning [8].

Clearly, a divorce between the external, visible object and the idea was underway. The paintings included in the next big group exhibition, *The Intrasubjectives*, held at the Kootz Gallery in 1949, deepened the rift, de Kooning, Motherwell, Pollock and Rothko having jettisoned the figure. The exhibition catalogue, promoting this new style of painting, was prefaced by a quotation from the Spanish phenomenologist José Ortega y Gasset's essay 'On Point of View of the Arts'. He described the history of painting as a singular movement toward simplification: 'First, things are painted; then sensations; finally, ideas' [9].

This sundering of idea and ostensible object was also the theme of Harold Rosenberg's essay for the exhibition, interpreting Abstract Expressionism as the

most complete realisation of Ortega's projection for the development of modern painting to date. Along with the departure of the figurative image came a growing lack of concern with the broad audience which the figure was supposed to reach. By 1950, confidence in the ability of the artist to communicate with a universal audience, and even the belief in being able to do so, was no longer in evidence. The following statement from the *Modern Artists in America* symposium, which was dominated by Abstract Expressionists, suggests that this was the case. Several of the artists agreed that:

> The thing that binds us together is that we consider painting to be a profession in an ideal society. We assume the right of insisting that we are creating our own paradise . . . We go out into normal society and insist on acting on our own terms. [10]

A rift between the artist and mainstream society had developed, and a new attitude toward it had emerged, making a limited audience seem preferable. The question of taste, and the related issue of spectatorship, what the artists' relationship with society should be, were implicit in the question Robert Motherwell, speaking here as moderator, posed to the discussion panel: 'Is the artist his own audience?' [11] The response to this question unanimously confirmed a tenuous relationship with spectator—the artist, working from his or her subjective feelings, could not, rather would not, guarantee contact with the audience. Newman remarked:

> I think it would be very well if we could title pictures by identifying the subject matter so that the audience could be helped. I think the question of titles is a social phenomenon. The story is more or less the same when you can identify them . . . I think the possibility of finding language still exists, and I think we are smart enough. Perhaps we are arriving at a new state of painting where the thing has to be seen for itself. [12]

This suggests that the artists' goal of making the spectator 'see the world our way', as they had expressed it in the *New York Times* letter, was still being pursued, except that by this time the artists were not willing to make this easier by using universal means of communication such as representational forms or language. Their expectations of their audience had clearly altered, the desire for collective communication giving way to a wariness of communication on a mass level, evidenced by the quip:

> We shouldn't be accepted by the public . . . the public is concerned with the average. [13]

On the basis of this, it is safe to say that by the early 1950s the Abstract Expressionists had redefined their ideal spectator. Clearly there was a connection between their move towards abstraction and their changing standards of spectator-

ship, which reflected a new distaste for collective communication. This discrediting of the collective, not only as a desirable audience for fine art but in most of its social manifestations, also characterised the social, political and philosophical positions shared by these artists and the intellectual circles in which they moved.

The opinions of the latter are most accessible in the Leftist little magazines with which the Abstract Expressionists were linked, the artists being familiar with some of the writers and certainly the art critics working for *Commentary*, *Partisan Review*, *Politics*, and later *Dissent*. Broadly speaking, their intersecting concerns at the end of the Second World War were the impact of totalitarianism on individual freedom and agency, and the related problem of social organisation in the industrial state. Uncertainty about the ability of the collective to safeguard individual liberty was at the heart of Leftist intellectual debate by the end of the war, the primacy of the individual and the rejection of centralised government eclipsing any faith in collective agency and the social systems which supported it. The methods by which totalitarianism both created and exploited the masses prompted a critical rethink amongst Leftist artists and intellectuals, including the Abstract Expressionists, of those social theories which viewed the mass as political agent, and led to a reaffirmation of theories of individualism in American political commentary [14].

Accounts and analyses of the Nazi death camps were important to this reassessment. Widely discussed in the American Leftist press from 1944 to 1947, the concentration camp was understood by both its American and European commentators as the deadly convergence of technological manufacturing processes and mass society. The preface to *Commentary*'s series 'The Crisis of the Individual', which first appeared in late 1945, while Elliot Cohen was editor with Clement Greenberg as coeditor, poignantly described this relationship:

> In our time, the individual human being has been more violently debased than in many centuries. Every aspect of the human personality—his civil rights, his individuality, his status, the regard in which he is held, the dignity accorded him—all have been violated. We have seen living human beings used as beasts of burden and guinea pigs, and their dead bodies treated as natural resources . . . the inviolability of the individual human being has been so much a part of our Western civilization, it has been taken for granted. Whatever advances we hoped for in our culture were based on this ideal. Now men are beginning to suspect that its submergence is more than a temporary by-product of war—a suspicion that has been underlined by the unleashing of atomic energy. [15]

Most independent Leftists agreed that the destruction of the individual identity was at the heart of this process [16]. Hannah Arendt noted that

> the insane mass manufacture of corpses is preceded by the historically and politically intelligible preparation of living corpses [17]

She argued that individuality was formed by the ability to make ethical choices, and that the deprivation of this faculty enabled the atrocities to happen. Assessing the political implications, she concluded that this departure from rationality spelled the end for all political systems based on rationality, as well as the notion of good coming dialectically out of evil, which were central to both Marxist and Progressivist thought. Sociologist C. Wright Mills, commenting on the nature of the American intellectual's political outlook by the mid-1940s, underscored the extent to which the optimism of the socialist 1930s had diminished in the United States:

> Many who not long ago read John Dewey with apparent satisfaction have become vitally interested in such analysts of personal tragedy as Sören Kierkegaard. [18]

Quick to apply the insights of the Europeans to the situation at home, Mills expressed doubts about the organisational practices employed by the corporation, which he characterised as analogous to those of the centralised state. Arguing that in both cases decisions affecting the mass were made by a centralised and inaccessible authority:

> Organized industrial irresponsibility is a leading feature of modern industrial societies everywhere.

To Mills and other intellectuals, the helplessness of the individual in the face of the mass organisation was the essence of modern tragedy [19].

Although the publications concerned represented a number of positions on this issue, there was general agreement on the overall approach to take: their tone was one of resignation and working within the situation, since previous strategies for the restructuring of society had been discredited by the Nazi and Stalinist regimes. Consequently, choices for improvement were limited: siding with democracy against totalitarianism meant giving up any strategies involving collective action, leaving the individual with the responsibility for humanising industrially organised society. As a result, myth was under attack as the tool used to validate centrally organised institutions, which fostered mass-mentality because of its identification with the shared, the common, and the ideological.

Discussion surrounding this issue usually relied on the language of Karl Popper, and, although it would be a mistake to say that the Leftist intellectuals under consideration identified with Popper's position, the framework in which he positioned totalitarianism in relation to democracy helped shape the debate for intellectuals of all political persuasions. His book *The Open Society and its Enemies*, first published in 1945, attacked historicism in both its Marxist and totalitarian forms as inimical to democracy. Setting 'piecemeal' or pragmatic reform against 'utopian' social engineering, he criticised the latter for both divorcing social theory from practical situations and relying on myth in order to do so. He described the totalitarian society as closed, essentially tribal, and substituting belief in a future

ideal society to be achieved by 'magical forces' or, in the case of Marxism, science. The open society, in contrast, was more dynamic because it 'sets free the critical powers of man':

> Critical conventionalism . . . merely asserts that norms and normative laws can be made and changed by man, more especially by a decision or convention to observe them or to alter them, and that it is therefore man who is morally responsible for them. [20]

Unfortunately, Popper failed to mention the practical difference between criticism and action. American intellectuals, while aware of the problem of individual agency as Mills described it, undervalued this distinction as well. In their firm stand against totalitarianism, they were, by the 1950s, willing to coexist with the mass culture produced by industrial democracy by maintaining a critical perspective, which they thought would preserve the ideals of socialism until the conditions were right for their implementation. Mills by this time was advocating such an approach [21], as did die-hard socialist and future editor of *Dissent*, Irving Howe, who argued that although Stalinism indeed limited the possibilities for socialist activity in the United States, and could force 'temporary expedients in the area of power', there was no reason why ideas should be similarly compromised [22].

This choice between democracy and totalitarianism dominated political discussion during Abstract Expressionism's maturative years, and its influence on the artists involved is clear in their actions and statements. For example, Gottlieb and Rothko participated in the founding of the Federation of Modern Painters and Sculptors in 1940 to help protect culture from 'the totalitarianism in thought and action' of these regimes, and their resistance to it strengthened throughout the decade [23]. By the mid-1950s, the Abstract Expressionists had reconciled themselves to existence within capitalist democracy in spite of its levelling effects on culture.

Partisan Review's symposium *Our Country and Our Culture* (1952), which Guilbaut described as the commemoration of the death of opposition amongst the avant-garde, in spite of whatever reservations certain artists may have had in regard to their integration into American mainstream society, sought to maintain high art in an industrial, democratic, and therefore unavoidably mass culture [24]. Challenging Ortega y Gasset's assessment of the masses as the embodiment of the mediocre, the editors maintained that democratic values were preferable to totalitarian values in 'purely human terms . . . whatever the cultural consequences may be . . .' [25]. The artist's task in this state of affairs was to re-establish the audience for high art which had perished along with the class system:

> . . . mass culture not only weakens the position of the artist and the intellectual profoundly by separating him from his natural audience, but it also removes the mass of people from the kind of art which might express

their human and aesthetic needs. Its tendency is to exclude everything which does not conform to popular norms; it creates and satisfies artificial appetites in the entire populace . . . [it] converts culture into a commodity. [26]

The cultural crisis, as *Partisan Review* described it, provides a background against which the actions and statements of the Abstract Expressionists can be placed. It is clear that Gottlieb, for example, shared these concerns in his 1954 lecture 'The Artist and Society'. While acknowledging that the buying power of the middle classes forced art to compete with other commodities, abandoning the work to 'the lowest common denominator of aesthetic response', he nonetheless appreciated the freedom which democracy permitted in artistic production:

> In an *open* situation, the artist can at least display initiative, assert the pure values of art, and exercise his freedom . . . To suggest that a sluggish, materialistic public, or our industrial system, or any social manifestation other than outright repression hampers creativity would be plausible, were it not for the impressive body of creative work this side of the iron curtain. [27]

That abstract art did not have widespread public support was a liberation for Gottlieb. He continued:

> Whether people actually need art at all seems to me questionable . . . certain individuals need art, but society or people in the mass get along quite well without art. [28]

What Gottlieb suggested can be described as the modern artists' wilful exclusion from the mass, a deliberate seeking of an exclusive audience. He was not alone in his views—Motherwell in the same year argued on behalf of an exclusive audience to protect painting from complete commodification. Painting, to him, may have been lost to market forces, yet it could still appeal to its intended audience by means of its elevated, and to the uninitiated, purely formal, content [29].

The question remains as to how an awareness of these issues may have manifested itself in the marked contrast between Abstract Expressionist painting between the mid and late 1940s. The work of Mark Rothko during that time provides the basis for a speculative answer, since a series of his paintings, with accompanying statements of intent, were published in several New York avant-garde magazines during the late 1940s, which afford some insight into how he wished to present his work to the public. Rothko's statements in the early 1940s rarely addressed the issue of the spectator directly, although his interest in expressing 'basic psychological ideas' was rapidly being shed by the middle of the decade. In the winter of 1947–48 reproductions of several of his surrealist paintings (Figs. 37, 38) were published in *Possibilities* with his statement 'The Romantics Were Prompted . . .', in which he cast doubt over his earlier intentions. The forms

Fig. 37 MARK ROTHKO Illustrated work (1944), *Possibilities*, Winter 1947–48 © 1993
Kate Rothko-Prizel & Christopher Rothko/ARS, New York

Fig. 38 MARK ROTHKO Illustrated work (1944), *Possibilities*, Winter 1947–48 © 1993
Kate Rothko-Prizel & Christopher Rothko/ARS, New York

in these paintings, he acknowledged, were unique, emerging from the 'unknown', having 'no direct association with any particular visible experience'. Their dissociation from the everyday, Rothko implied, was needed 'in order to destroy the finite associations with which our society increasingly enshrouds every aspect of our environment'. It is clear in the following that he was referring to the commodification of culture:

> The unfriendliness of society to his activity is difficult for the artist to accept. Yet this very hostility can act as a lever for true liberation. Freed from a false sense of security and community, the artist can abandon his plastic bank-book, just as he has abandoned other forms of security. Both the sense of community and of security depend on the familiar. Free of them, transcendental experiences become possible. [30]

Although the pictures, dating from 1944, did retain a strong sense of figuration, Rothko hinted in the text that abstraction could be the means of shedding this false sense of community, since figurative images inevitably had material associations with the increasingly commodified world [31].

That same winter he had expressed concern in *The Tiger's Eye* over the impact that the less than ideal spectator would have on the meaning of his work:

> A picture lives by companionship, expanding and quickening in the eyes of the sensitive observer. It dies by the same token. It is, therefore, a risky and unfeeling act to send it out into the world. How often it must be permanently impaired by the eyes of the vulgar and the cruelty of the impotent who would extend their affliction universally! [32]

The previous issue of *Tiger's Eye* featured several of Rothko's paintings executed in the same year, which more clearly straddled figurative representation and biomorphism than the *Possibilities* pictures. Taken together, the 1947 statements suggest that Rothko's work was becoming increasingly abstract in response to the expansion of mass culture and the tastes it fostered. The letter he sent to the curator of his exhibition in Chicago in 1954, by which time his painting had become completely abstract, indicates that a rarification of audience was behind his consecutive breaks with the believed universally accessible elements in painting—figurative representation, biomorphic form, literary titles—the latter having been pared down to numbers or simple descriptions of the colours on his canvases.

Rothko explained why he would not provide a statement to accompany his pictures:

> There is the danger that in the course of this correspondence an instrument will be created which will tell the public how the pictures should be looked at and what to look for. While on the surface this may seem an obliging and helpful thing to do, the real result is paralysis of the mind and imagination . . . If I must place my trust somewhere, I would invest it *in the psyche of the sensitive observers who are free of the conventions of understanding*. I would have no apprehensions about the use they would make of these pictures for the needs of their own spirits. For if there is both need and spirit, there is bound to be a real transaction. [33]

Who were these more sensitive viewers, and what were the implications of being free of the conventions of understanding? A return to 1949, the year Rothko produced his first wholly abstract paintings, and the discourse which surrounded their presentation to the public, provides an opportunity to interpret how Rothko and like-minded artists wished their art to function. Rothko's terse statement accompanying his 'New Paintings' of 1949 (Figs. 39, 40) in the October issue of *The Tiger's Eye* described the painter's work as a movement towards clarity, towards the idea unclouded by associative thought, which he called 'swamps of generalization' which could merely describe or represent, but not *be* ideas [34].

Coincidentally, he was participating in the group exhibition called *The Intrasubjectives*, mentioned earlier in connection with the notion of modern painting as the embodiment of pure idea. Harold Rosenberg, whom Rothko three years earlier had described as having one of the 'best minds in the business' [35], pursued Ortega's argument for the content of modern painting as the pure idea, the ideal object, distanced from the external world of objects and the everyday by the artist's

Fig. 39 MARK ROTHKO Illustration 'New Paintings', *The Tiger's Eye*, October 1949 ©
1993 Kate Rothko-Prizel & Christopher Rothko/ARS, New York

mind. Ortega's contempt for the mass and the culture which it both produced and
consumed would have been familiar to New York intellectuals at this time—his
essay 'The Dehumanisation of Art', which argued that the incomprehensibility of
abstract, non-referential art to the majority of the population was the means of
preserving an élite culture, had been reprinted in New York in 1948. And the
importance of his thought for Rosenberg, at least insofar as it defined modern art as
exclusively a product of the imagination, is clear in the following passage from the
Intrasubjectives text:

> The modern painter is not inspired by anything visible, but only by
> something he hasn't seen yet. No super-lively kind of object in the world
> for him . . . Things have abandoned him, including the things in other
> people's heads (odysseys, crucifixions) . . . he begins with nothingness . . .
> The rest he invents. [36]

Fig. 40 MARK ROTHKO Illustration 'New Paintings', *The Tiger's Eye*, October 1949 ©
1993 Kate Rothko-Prizel & Christopher Rothko/ARS, New York

Clearly, the mythological as the collective and shared was no longer relevant. What needed to be recognised by the audience was the nothingness in modern painting, painting as the space in which things are situated, as the medium of encounter with those things. By 1952 Rosenberg had defined this void more precisely as the space in which individual experience occurred [37]. During the late 1940s, however, he was still concerned with why the void in painting had become necessary, his argument for Abstract Expressionism as the divorce of fine art from the everyday was contingent upon it. The explanation lies in his views on the nature of experience. Rosenberg had previously written on the distinction between fine and mass art, communication playing a crucial part. The artist, he argued, worked from individual experience, which was non-mythical because it was free of external referents. The producer of mass culture, on the other hand, took his start from the experience of others:

> The more exactly he grasps, whether by instinct or through study, the existing element of sameness in people, the more successful is the mass–culture maker. Indeed, so deeply is he committed to the concept that men are alike that he may even fancy that there exists a kind of human dead center in which everyone is identical with everyone else, and that if he can hit that psychic bull's-eye he can make all of mankind twitch at once. [38]

The collective, for Rosenberg, had become an audience for mediocrity, attempts to address it would

> result in the same contrived and unseeing art, whether the assignment is made by a movie producer, a party cultural official, or by the artist himself as a theoretician of social relevance. [39]

The only means of preserving painting from the levelling effects of the mass audience was to place distance between them, and the Abstract Expressionists, clearly aware of this, abandoned the images and ideology of the collective in favour of 'a private myth, addressed to a no-audience' [40].

Abstract Expressionist painting by the 1950s, then, can be seen as having developed through a dialogue with larger issues involving the political and social theories of collectivism, individualism, and their impact on culture, which consequently involved the renunciation of both proletarian aesthetics and kitsch by reinstituting notions of élitism and exclusivity. This departure from the main-stream was achieved through formal means, which Tim Clark has defined as Modernism's characteristic exhausting of the medium 'by pulling it apart, emptying it, producing gaps and silences' [41]. This silence, he has convincingly argued, is in essence negation, 'the lack of consistent and repeatable meanings' [42], something like what Rosenberg called the 'nothingness' of modern painting.

Consequently, it should not be seen as the reinstatement of a system of aesthetics based on class tastes. The formal innovations of Abstract Expressionism in the late 'forties can be seen as the evasion of a situation in which the artist had lost control

of the meaning of his or her work, and this condition was propagated, Rosenberg explained, by the absence of myth which the artist would have shared with the whole community as a medium of communication [43]. The restrictions which some of these artists placed on the exhibition of their pictures by the early 1950s can be interpreted as a response to the situation which Rosenberg described. For instance, in 1952 Rothko refused the Whitney Museum permission to either exhibit his work in its annual exhibition, or purchase his work on the grounds that 'the real and specific meaning of the pictures [would be] lost and distorted' [44]. Similarly, Still withdrew his canvases from public audiences because exposure to 'indoctrinated parasites' would negate their value [45]. So divisive were their expectations of what a painting should mean that the Abstract Expressionists came to resist exhibiting as a group at all [46]. The collapse of belief in the possibility of collective communication which underscored this self-willed isolation meant, to use Rosenberg's language, the deliberate replacement of the universally accessible image with a 'private myth', an experience which defied communication. The abstractness of Abstract Expressionist painting of the 1950s can, consequently, be seen as an abnegation of the values it espoused at its outset. Its 'silence', an effort to preserve both individualism and aesthetic sensibility, can therefore be read as a renunciation not only of its art historical precedents but of social engagement as well [47].

ACKNOWLEDGMENTS

Special thanks to Beth Joffrion of the Archives of American Art, Smithsonian Institution, for making available many of the documents cited in this paper, and to Andrew Hemingway for his helpful comments.

NOTES AND REFERENCES

1 ASHTON, DORE (1972) *The Life and Times of the New York School* (London, Adams & Dart) has described the relationship between Surrealism and Abstract Expressionism as one of 'fusion'. She argued that Abstract Expressionism retained the Surrealist elements of 'risk' and 'event' in the creative process, with the intention of accessing the unconscious, the interest in doing so having been reinforced by the influx of Surrealist painters as well as psychoanalysts from Europe, such as Bettelheim, Fromm, Horney and Rank into the United States during World War II (pp. 115 and 122). Yet it combined these procedures with the formal principles of Modernism such as flatness and simplicity of expression (pp. 115 and 128). CHAVE, ANNA (1989) *Mark Rothko: Subjects in Abstraction* (Yale University Press) took a similar approach, arguing for the enduring importance of automatism as more than just technique: 'It was a means of conjuring and realizing subjects by probing the unconscious, where the seeds of myth were supposedly stored' (p. 77). In this way the Surrealist discovery of 'the mythical possibilities in everyday life' was inherited by the Abstract Expressionists. COX, ANNETTE (1982) *Art-as-Politics: the Abstract Expressionist Avant-Garde and Society* (Ann Arbor, UMI Research) provides an interesting account of the relationship between Abstract Expressionism and Surrealism during the early 1940s, based on a shared redefinition of myth (pp. 39–46). She concludes, however, that in spite of their attempts to distance themselves from Surrealism in the late 1940s,

the Abstract Expressionists were permeated with its influence (p. 51 and 54–5).

2 See, for example, the discussion of Rothko's and Gottlieb's formal innovations in POLCARI, STEPHEN (1991) *Abstract Expressionism and the Modern Experience* (Cambridge University Press) pp. 144–5, 171, 176–8.

3 GOTTLIEB, ADOLPH and ROTHKO, MARK (1943) *The Portrait and the Modern Artist*, typescript of the radio broadcast *Art in New York*, Radio WNYC, 13 October, reprinted in the (1987) Tate Gallery, London, exhibition catalogue *Mark Rothko*, p. 81.

4 *Ibid* p. 80.

5 GUILBAUT, SERGE (1983) *How New York Stole the Idea of Modern Art: Abstract Expressionism, Freedom, and the Cold War*, trans. Arthur Goldhammer (Chicago, University of Chicago Press) pp. 110, 113. Guilbaut includes the Abstract Expressionists here as part of a larger intellectual trend exemplified by Dwight Macdonald.

6 *Ibid* p. 79.

7 NEWMAN, BARNETT (1947) 'Introduction', *The Ideographic Picture* (N.Y., Betty Parsons Gallery) 20 January—8 February. Ad Reinhardt Papers, Archives of American Art, Smithsonian Institution, Washington DC, N/69–104.

8 ROSENBERG, HAROLD (1978) *Barnett Newman* (N.Y., Brazillier) p. 30.

9 ROSENBERG, HAROLD (1949) *The Intrasubjectives* (N.Y., Samuel M. Kootz Gallery) 14 September—3 October, unpaginated. Ad Reinhardt Papers, Archives of American Art, N/69–104. Ortega y Gasset's essay appeared in full in the previous month's edition of *Partisan Review*.

10 Principally Robert Motherwell, Ad Reinhardt, and Bernard Karpel. See (1951) *Modern Artists in America*, no. 1, especially the exchange between Newman and Motherwell, p. 21.

11 *Ibid* p. 15.

12 *Ibid*.

13 *Ibid*. See exchange between Barnett Newman and David Hare.

14 See PELLS, RICHARD (1989) *The Liberal Mind in a Conservative Age: American Intellectuals in the 1940s and 1950s* (Middleton, CT., Wesleyan University Press) pp. 130–38, for a concise account of the issues underlying the Leftist intellectuals' disillusionment with Marxism as a result of wartime events. It is important to note that the buttressing of democracy and individualism came from a broad spectrum of Leftists, from pragmatists as disparate as DEWEY, JOHN 'What I Believe', in: FADIMAN, CLIFTON (Ed) (1939) *I Believe* (London, Allen & Unwin); ARENDT, HANNAH (1951) *The Burden of Our Time* (London, Allen & Unwin), as well as ex-communists and fellow travellers, as the contributors to *Partisan Review*'s 1947 symposium 'The Future of Socialism', indicates. Granville Hicks, editor of *The New Masses* in the 1930s, Sidney Hook, George Orwell and Arthur Schlesinger, Jr. addressed whether or not socialism could serve as a basis for Leftist activity after the abuse of the masses by the totalitarian regimes; a redefinition of socialism was uniformly called for which would invest agency in the individual who would freely determine his or her activism in local work or social communities.

15 GREENBERG, CLEMENT (1945), 'The Crisis of the Individual', (Editor's preface) in: *Commentary*, vol. 1, no. 2, December, p. 1.

16 See, for example, BETTELHEIM, BRUNO (1944) 'Behavior in Extreme Situations', *Politics*, August, pp. 199–209; ARENDT, HANNAH (1953) 'Understanding Politics', *Partisan Review*, vol. XX, no. 4, July-August, pp. 377–92, which encapsulates many of the ideas which subsequently appeared in her highly influential book ARENDT, HANNAH (1958) *The Human Condition* (Chicago, Chicago University Press). See also the serial 'The Crisis of the Individual', in: *Commentary*, the first essay of which appeared in November 1945.

17 ARENDT, HANNAH (1948) 'The Concentration Camps', *Partisan Review*, vol. 15 (2), no. 7, July, p. 751.

18 MILLS, C. WRIGHT (1944) 'The Powerless People: the Role of the Intellectual in Society', *Politics*, April, p. 68.

19 *Ibid* p. 69. See also MACDONALD, DWIGHT (1945) 'The Responsibilities of

Peoples', *Politics*, March, and (1946) 'The Root is Man' I and II, *Politics*, April and July, in which he discussed the parallels between big business and mass murder, as well as mass mentality and social control, and the function of myth as reinforcing that social system. Writers for the *Partisan Review* also took this perspective. See for example SCHLESINGER, ARTHUR Jr. (1947) 'The Future of Socialism: the Perspective Now', *Partisan Review*, vol. 14, no. 3, May-June; RAHV, PHILIP (1949) 'Disillusionment and Partial Answers', *Partisan Review*, vol. 15 (1), no. 5, May, and (1953) 'Myth and the Power-house', *Partisan Review*, vol. 20, no. 6, November-December, in which he put things in a nutshell: 'Individuality is in truth foreign to myth, which objectifies collective rather than personal experience. Its splendor is that of the original totality, the pristine unity of thought and action, word and deed. The sundering of that unity is one of the tragic conditions of historical develop-ment . . .', p. 641.

20 POPPER, KARL (1952) *The Open Society and its Enemies*, vol. 1 (London, Routledge & Kegan Paul). The introduction briefly and clearly outlines Popper's position and objec-tives. See also p. 61.

21 MILLS, C. WRIGHT (1952) 'Our Country and Our Culture', *Partisan Review*, vol. 19, no. 4, July-August, p. 449.

22 HOWE, IRVING (1954) 'This Age of Con-formity', *Partisan Review*, vol. 21, no. 1, January-February, p. 30. Howe remained a committed socialist throughout the 'forties and in 1954 helped to found and edit the magazine *Dissent*. The editorial statements accompanying the first issues make clear that the magazine intended to carry out Howe's suggestions for the preservation of the ideals of socialism. Many of the Abstract Expressionists were involved with *Dissent*—in 1961, the editors and an Art Committee composed of, among others, critic Thomas B. Hess, de Kooning, Motherwell, Rosen-berg and Meyer Schapiro, assembled an art exhibition and sale to rescue the magazine from financial trouble. Among the 38 con-tributing artists were Gottlieb, Hartigan,

Kline, the de Koonings, Motherwell and Newman. Patricia Passlof Papers, Archives of American Art, N/69–45.

23 See COX, ANNETTE 'The Abstract Expressionists and Depression Radicalism', in; Cox (n.1), p. 28. Cox has shown the extent to which Gottlieb and Rothko were committed to the anti-communist activities of the Federation, resigning in 1953 when it voted to stop political action; p. 29.

24 Guilbaut (n.5), pp. 65–6.

25 (1952) Editor's preface, 'Our Country and Our Culture', *Partisan Review*, vol. 19, no. 3, May-June, p. 285.

26 *Ibid.*

27 GOTTLIEB, ADOLPH (1955) 'Art and Society', *College Art Journal*, vol. 14, no. 2, Winter, p. 98. My italics.

28 *Ibid* p. 101.

29 MOTHERWELL, ROBERT (1954) 'The Painter and the Audience', *Perspectives*, no. 9, Autumn, pp. 109–10.

30 ROTHKO, MARK (1947–48) 'The Roman-tics Were Prompted', *Possibilities I*, Winter, p. 84.

31 *Ibid.*

32 ROTHKO, MARK (1947) 'The Ides of Art', *The Tiger's Eye*, no. 2, December, p. 44.

33 Quoted in KUH, KATHERINE (1954) 'Mark Rothko', *The Art Institute of Chicago Quarterly*, vol. XLVIII, no. 4, 15 November, p. 68. My italics.

34 ROTHKO, MARK (1949) 'Statement on His Attitude in Painting', *The Tiger's Eye*, no. 9, October, p. 114.

35 ROTHKO, MARK (1946) 'Letter from Mark Rothko to Barnett Newman', Barnett Newman Papers, Archives of American Art, 3481.

36 Rosenberg (n.9).

37 ROSENBERG, HAROLD (1959) 'The American Action Painters', in: *The Tradition of the New* (N.Y., Horizon) pp. 30–1. This essay originally appeared in the December 1952 edition of *Artnews*.

38 ROSENBERG, HAROLD (1948) 'The Herd of Independent Minds', *Commentary*, vol. Vl, no. 9, p. 244.

39 *Ibid* p. 251.

40 Rosenberg (n.37) pp. 31, 37–8. It should be

noted that the rupture between modern painting and the audience was not a satisfactory solution to this crisis of taste. The effect, he argued, was to make art an industry of its own, for critical consumption; p. 35.

41 CLARK, T. J. 'Clement Greenberg's Theory of Art', reprinted in FRASCINA, FRANCIS (Ed) (1985) *Pollock and After: the Critical Debate* (London, Harper & Row), p. 58.

42 *Ibid* p. 59.

43 *Ibid*.

44 ROTHKO, MARK 'Letter to Mr. Lloyd Goodrich', reprinted in (n.3) p. 86.

45 STILL, CLYFFORD (1948) 'Letter to Betty Parsons', 20 March; Betty Freeman Papers, no. 4060, Archives of American Art, 4060.

46 Chave (n.1) p. 5.

47 Rosenberg (n.37) p. 31.

FRED ORTON

Action, Revolution and Painting

A raised arm has many meanings.
Convictions falter with desire; the arm remains.
(Harold Rosenberg, 'The Men on the Wall')

There was a time, in the late 1950s and early 1960s, when explainers of Abstract Expressionism valued Harold Rosenberg's writings and took them into account. After that, he was increasingly marginalised, overlooked, or uncited. One reason for this was the increasing and what came to be almost exclusive attention which was given to the writings of Clement Greenberg. This is not to say that the focus was misdirected, for Greenberg is a necessary if insufficient text. Critical art history needs him, but if it is not to rehearse its histories of Abstract Expressionism exclusively with reference to his ideas of the triumph of a depoliticised art practice, apolitical painting and art for art's sake, Greenberg's cannot be taken as the only story.

This is precisely where Rosenberg takes on importance. Rosenberg's writings on art and culture provide us with another necessary but insufficient corpus producing a knowledge of Abstract Expressionism, a corpus which is indispensable if we want to explain the politics of the production of Abstract Expressionism. Many of the Abstract Expressionists—most of the Irascibles and others—regarded their work as having a social and political content which Rosenberg, as close as anyone to the studio talk and closer than more or less anyone to its politics, was committed to explaining. This he did consistently and more vividly than any other explainer of Abstract Expressionism—not as an apologist or as an opponent but as someone keeping his preoccupations up to date and well oiled.

One of the aims of this essay is to bring Rosenberg in from the margins he is so often made to occupy, and to begin writing against the grain of those bits of conventional wisdom which represent his ideas as naive, romantic, quasi-philosophical, theatrical, and as reconciling an avant-garde ideology with the ideology of post-war liberalism. It sets out to situate Rosenberg with respect to the changes in New York leftism in the 1930s and 1940s, and then to use his writings on drama and the proletariat, which focus on issues of action and agency, as relevant to understanding his characterisation of action painting in the 1952 essay, 'The American Action Painters'—one of the first published attempts to endow Abstract Expressionism with meaning [1]. My concern is to offer a political

reading of this essay in order to replace the lazy existentialist-humanist reading which has become paradigmatic.

Part of the significance of 'The American Action Painters' has to be located in the way Rosenberg shows that the political impasse which many on the left currently regard as uniquely 'postmodern' was already inscribed within the Modernism which emerged in the United States circa 1940, and that this sense of impasse was international and not narrowly American. Action painting, for Rosenberg, was painting about the possibility of a radical change that had not happened in the 1930s and 1940s—far from it—and could not happen in the 1950s. It was a possibility that neither he nor his 'American Action Painters' could afford to abandon. No more can we.

The politics of action painting were determined by the failure of the proletarian revolution and its continuing regeneration within the dialectical dynamism of capitalism, with acting out the possibility of radically transforming the situation, while forever failing to do so. It will become clear as this essay proceeds that the negation of the negation played out in action painting could never produce the redefinition of identity that would negate the negative identity given to the proletariat in capitalism. The action painters could not succeed in culture where the proletariat had failed in politics. Action painting could not compensate at the symbolic level for the fact that the political action which would redefine the proletariat did not, at that moment, seem to be available to it as a class. Instead, action painting was caught up in the failure of the proletariat, but the action painters glimpsed that that failure was not total.

In this reading of Rosenberg's 'The American Action Painters', the action painter was not a middle-class artist playing with symbolic or surrogate revolutionary gestures, acting out, in art, a drama of political agency and identity that no social class is able to do. Action painting was not revolutionary gesturing. It was painting concerned with the dialectical possibility of a revolution whose outlines can neither be defined nor denied.

I

 who thrust his fist into cities
 arriving by many ways
 watching the pavements, the factory yards,
 the cops on beat

 walked out on the platform
 raised his right arm, showing the fist clenched
 'comrades, I bring news'

 came back then skies and silhouettes,
 facing the bay, of sailors

who no longer take the sea
because of strikes, pay-cuts and class-unity

'comrades, I bring news'

of the resistance of farmers
in Oneida county on a road
near a small white cottage
looking like a Xmas card,
4 shot, the road was blocked
glass to blow their tires

there was one guy we grabbed
some bastard of a business man
learning to play State Trooper
one of the boys tackled him neat as he ran

Behold my American images get it straight
a montage of old residences bridges shops freights
Xmas, the millions walking up and down
the tables where applications are received
the arguments that will yet get down to something

in the center of this a union-hall
and on the platform he
with right arm crooked, fist clenched
'comrades, I bring news'

That poem by Rosenberg appeared in the *Partisan Review* for January–February 1935 [2]. Titled 'The Front', it refers to the life circumstances of millions of Americans around Christmas 1934, some five months into the sixth year of the Great Depression: to capitalism in crisis, mass unemployment and applications for benefit, organised labour and class unity and class struggle in town and country. At the centre is a union-hall, and out on to its platform walks someone who raises his right arm, fist clenched, and addresses the assembly: 'comrades, I bring news'. I cannot describe the specific circumstances of the poem's making or limit the excess of meaning available for its strikes, pay cuts, and so on, nor extend the particularity of that event in Oneida County. What can be said—leaving aside a discussion of its structure and the momentum of its syntax—is that Rosenberg's poem, dedicated by its title to the United Front, was meant to participate in winning the workers' support for revolutionary organisations and for an agreement on action of some kind—insurrection, if not revolution.

Aged twenty-eight when he wrote 'The Front', Rosenberg had already earned himself something of a reputation as a poet and intellectual. *The Symposium*, edited by James Burnham and Philip Wheelwright and described as a journal of

philosophical discussion, had published several of his essays, including, in 1932, the seminal 'Character Change and the Drama' [3]. He had also edited with H. R. Hays an 'experimental quarterly' called *The New Act* [4]. And Harriet Moore's *Poetry: A Magazine of Verse,* which published all kinds of verse, conventional and innovative, had regularly printed his poetry and commissioned book reviews from him, and would continue to do so throughout the 1930s and 1940s [5].

In 1936 he was considered, by William Phillips and Philip Rahv, to be one of the poets who had achieved 'the much desired integration of the poet's conception with the leading ideas of the time'. This 'desired integration' was achieved by way of an awareness that the necessary revolt was aesthetic as well as social, and that as such it was 'a revolt within the tradition of poetry rather than against it' [6].

'The Men on the Wall', published a year earlier in 1934, may well be one of Rosenberg's first poems to make reference to the historical and social circumstances of its writing [7]. It uses some stereotypical metaphors of state, worker and capitalist power:

> [. . .] a sword
> in the hand of the arm
> flowers from a sleeve of gold brocade
>
> [. . .] and that arm's fist
> whose khaki cuff is stained with grease,
> is yours, and clasps the hammer of your resolve.
> And whose contending tendons flex with threat
> against the background factories and glass?
>
> [. . .] the wind still affirms
> the faces of ruminants with folded arms,
> the men below, divining peace before their doors,
> the azure casings of whose blood are torn
> by no quick hemorrhage of indissoluble event;
> whose ecstasy, despair and rage
> are hidden escapades that lift no arms. [8]

But at the end of the poem, the men on the wall stay there, 'entranced somnambulists', on the night shift. It is a poem which seems more symptom than criticism of the moment that inscribes it, a social poem with a tendency to leave its workers working and only half-awake. By the end of the year when Rosenberg wrote 'The Front', that tendency had changed, or been clarified; the workers were unemployed, less dreamy, and politicised.

'The Front' is a socialist poem, and as the editors of *Partisan Review*, the year-old journal of the John Reed Club of New York, were keen to point out it was the first poem that Rosenberg had published in a 'proletarian magazine' [9]. The John Reed Club was founded in 1929, the year the Great Depression began and the year when Stalin's first Five Year Plan was adopted. Initiated by and affiliated to the

International Union of Revolutionary Writers, the Club was, from the outset, influenced by the Proletcult movement, led by members of the Communist Party, and dedicated to the belief that art was a weapon in informing, educating and radicalising the worker. It had branches in most large cities and many of them published their own periodical of literature and art, the best known being that of the New York branch, *Partisan Review* [10].

The Rosenberg of 'The Front' is a Marxist and probably a fellow traveller of the C.P.U.S.A., a poet and critic committed to the artist's capacity to participate in the class struggle [11]. But he was short lived. The authorial 'I' which 'The Front' and *Partisan Review* had inaugurated was put in the position of having to manoeuvre itself when in July-August 1935 the Seventh Congress of the Comintern promoted the

> broadest united front [. . .] the establishment of a unity front with social democratic and reformist organisations . . . with mass national liberation, religious-democratic and pacifist organisations, and their adherents [. . .] for the struggle against war and its fascist instigators. [12]

Unlike the United Front this 'Popular Front' was not a strategy of class struggle but of class co-operation. One almost immediate result of the Popular Front was that the Proletcult movement was abandoned.

The Popular Front had been written on the wall for some time. The writing was there, for example, in January 1935 in the call put out by the National Committee of the John Reed Club, under instructions from the C.P.U.S.A., for an American Writers' Congress to undertake an 'exposition of all phases of a writer's participation in the struggle against war, the preservation of civil liberties, and the destruction of fascist tendencies everywhere'. [13]

The American Writers' Congress met at the end of April and Rosenberg reported its proceedings in the July issue of *Poetry* [14]. He was obviously impressed by the representative of a group of Pennsylvania miners who were prepared to print and circulate 10,000 copies of any poem that they could recite or sing together and by an appeal on behalf of 300 workers' theatres for works to perform [15]. He thought that here

> it became possible to see how poetry might step forth from the little magazines [. . .] and walk once more upon the stage and street. [16]

How, in other words, art might achieve a valid constituency and a valid agency. However, it was clear to him that, faced with the dangers to society of fascism and war, the writer was forced to play his part not in revolution, but in society's effort to protect its peace, freedom, and progress [17].

The questions were: what was the role of the writer in the social movement, and what was the best mode of performance [18]? The answers were provided by Earl Browder in his opening address: one could not be converted automatically into a literary genius just by calling oneself 'Marxist'; revolutionary art could succeed

only 'through achieving superiority as art, not through politics'; 'the socially conscious writer need not engage in organisational activity at the expense of writing'. The attitude of his party was: 'better a good writer than a bad organizer' [19]. Browder's party was the C.P.U.S.A. Indeed, he was its General Secretary and national spokesman, a familiar figure on a wide variety of platforms.

After quoting Browder, Rosenberg made a point of mentioning Waldo Frank who 'also attacked "leftism" ' and who 'would not capitulate easily to dogma, outside control' [20]. Frank, an editor of the C.P. Journal *New Masses*, would go on to represent the League of American Writers, the organisation which came out of the American Writers' Congress, at the Popular Frontist First International Congress of Writers for the Defense of Culture which met at Paris in June. Rosenberg, the revolutionary poet and critic writing in the liberal–democratic *Poetry*, pointed out, reassuringly, and following Browder's line, that though 'the Congress turned its face left, it donned no red uniform' [21].

Later that year Rosenberg became active in Popular Front art politics and art theory through his involvement with *Art Front*. *Art Front* was the official publication of the Artists Union, the militant trade union that had emerged from the Unemployed Artists Group set up by the John Reed Club of New York in 1933 and which, in 1935, came to represent the interests of the artists employed on the Federal Art Projects. *Art Front*'s political orientation was, of course, never in doubt. It was dominated by the Communist Party, committed to art as propaganda, and to guiding its members in their role as revolutionary artists. However, it was always prepared to debate whether the art they were to produce should be social realist or modernist, expressionist, surrealist, abstractionist, etc.—there was, after all, no Party-line on art at the time, even in the Soviet Union. In a sense, *Art Front* was the New York communist and left art community's public conversation about art and politics. Moreover, it was at that time the only periodical in the United States which was primarily concerned with art and politics. At the end of 1935, the editors signified *Art Front*'s sympathetic attitude to modernist art by bringing onto the board Joseph Solman, Max Spivak and the assistant who had been assigned to him by the W.P.A., Harold Rosenberg [22].

Rosenberg's 'beginnings' as a practising art critic can be located in the work he produced for *Art Front*: [23] a translation of Fernand Léger's Museum of Modern Art lecture 'The New Realism' [24]; reviews of the Museum of Modern Art's *Van Gogh* and *Cubism and Abstract Art* shows [25]; several book reviews, including one of Salvador Dali's *Conquest of the Irrational* [26] and a review of an exhibition of William Gropper's paintings at the A.C.A. gallery in which he stated that

> the revolutionary painter, far from being a grim specialist of a world seen in contracted focus, is precisely the major discoverer of new pictorial possibilities as well as of new uses for the old [. . .] by his easy and graceful mastery of the materials of social struggle, by his presentation of

it, as it were, *from the inside*, without strain, [the revolutionary painter] carried forward the possibility of technical discovery in revolutionary art. [27]

Recent art history has produced several versions of how the American left was affected by the Russian-French Non-Aggression Pact of 1935 and the inception of the Popular Front, by the three show trials in Moscow of August 1936, January 1937 and March 1938 of prominent intellectuals and party leaders and activists (including, in his absence, Leon Trotsky), by the signing of the Russian-German Non-Aggression Pact in August 1939 and the collapse of the Popular Front [28]. Large numbers of intellectuals who began the decade in support of the Communist Party lost faith at certain points—abruptly, reluctantly, with such disillusion that they could not be reconciled to it. As we have seen, Rosenberg's support for the Party survived the shift from the United Front to the Popular Front. It also survived the Moscow Trials of 1936 and 1937 but was abandoned before the signing of the Russian-German Pact in 1939 [29]. The moment of the move away, early or late, is important as an indicator of the intensity of his commitment to and subsequent disillusion with the Party line and Soviet communism.

For Marxists like Rosenberg, who were disillusioned with the Communist Party but who remained committed to Marxist politics and the revolutionary function of the artist and intellectual, one place to go was to the personality and writings of Trotsky—not to the Trotsky of the Civil War and the Red Army, but to the outlawed peripatetic Trotsky of the 1930s, analysing fascism and Stalinism and still committed to keeping a radical Marxist project going.

For Trotsky, theorist and exile in Mexico, revolution and art became in certain respects alike as forms of human activity. As he made clear in his letter of 1 June 1938 to the founding conference on the Fourth International, they were inseparable and he approached both in the same way:

> I have always forced myself to depict the sufferings, the hopes and struggles of the working classes because that is how I approach life, and therefore art, which is an inseparable part of it. The present unresolved crisis of capitalism carries with it a crisis of all human culture, including art . . .
>
> Only a new upsurge of the revolutionary movement can enrich art with new perspectives and possibilities. The Fourth International obviously cannot take on the task of directing art [. . .] give orders or prescribe methods. Such an attitude towards art could only enter the skulls of Moscow bureaucrats drunk with omnipotence. Art and science do not find their fundamental nature through patrons; art, by its very existence, rejects them [. . .] Poets, artists, sculptors, musicians will themselves find their paths and methods if the revolutionary movement of the masses dissipates

the clouds of skepticism and pessimism which darken humanity's horizon today . . . [30]

Trotsky wrote another letter two weeks later, this time to the editors of *Partisan Review* who published it in the August-September issue under the title 'Art and Politics' [31]. This expanded what he had written to the Fourth International. 'Art and Politics' got Trotsky inside the still Marxist but by then anti-Stalinist *Partisan Review*. He reappeared in the next issue when the journal made its relationship with him more secure by publishing the Manifesto of his International Federation of Revolutionary Writers and Artists [32].

Rosenberg reconnected with *Partisan Review* at just this moment, when it was beginning to identify with Trotskyism. He re-entered it in the winter issue with a long critical discussion of Thomas Mann's idealistic, anti-radical anti-fascism [33]. To the summer issue he contributed replies to a questionnaire symposium on 'The Situation in American Writing' [34], and a commentary on Arthur Rosenberg's *Democracy and Socialism*: 'By his sly shift in historical meanings', this author converted the 'principle of "permanent revolution" into that of coalition governments and the Popular Front' [35]. He also signed the statement issued by the Trotskyist League of Cultural Freedom and Socialism with its demand: 'COMPLETE FREEDOM FOR ART AND SCIENCE. NO DICTATION BY PARTY OR GOVERNMENT' [36]. A year later, in December 1940, the journal published his essay, thoroughly Trotskyist in its art and politics, on the fall of Paris [37].

The foregoing describes part of the historical matrix which produced 'Harold Rosenberg'. It serves its purpose by enabling a reading of 'The American Action Painters' as a text situated in and inscribed by a particular Marxist tradition, by the mutation and modification of New York Marxism related to the C.P.U.S.A., by the setbacks of the late 1930s, and by the espousal of international Trotskyism with its notion of agency and of the freedom of art. Rosenberg's Marxist 'beginnings' were in the early and mid-1930s, in the art and politics of the Great Depression and the New Deal, the union movement, public protests, federal agencies, resistance and strikes, the United Front and Popular Front. The encounter with Marxism and Marxist politics was significantly different for him, and for many of his comrades, than it was for those persons who began with Marx around 1939, disenchanted with Russia and the C.P.

The 'Harold Rosenberg' I have produced from 'The Front' and a little bit of history and biography was not the kind of critic of art and culture who in the late 1930s and early 1940s quoted Marx word for word to get noticed by New York's left intelligentsia only to jettison that Marxism once it had served its purpose. In the 1950s, he was scathing about those persons of the 'turning generation' who adapted to 'Couch Liberalism' [38]. There was, it seems to me, nothing superficial or opportunistic about his Marxism; and his commitment to it was long lasting.

II

Another clenched fist, a 'rapping of the soldier's fist', begins 'The Fall of Paris' where it announces the German army's entry into the city on 14 June 1940. In this essay Rosenberg was not particularly interested in the demise of Paris as the French capital. It was more important to him as 'the laboratory of the twentieth century': the place that had drawn artists from all over Europe and America and which had become the site of their collective practice producing new ways of seeing and representing. Rosenberg, like Trotsky, thought that the continuity of culture mattered, even through revolutions and periods of social upheaval; but with the fall of Paris that continuity had been terminated. As far as Rosenberg was concerned, the cultural laboratory had not been working very effectively for ten years or so, but 'the rapping of the soldier's fist' announced its closure [39].

Rosenberg considered that twentieth-century Paris was to the intellectual what America had been in the nineteenth to the pioneer. It was, he thought, a place where no one class was able to impose its purpose and representations on artistic creation, and where individual nationalities and cultures were blended; and yet where what was alive in various national cultures might be discovered. What Paris stood for was thus the opposite of individualism and nationalism in culture because in it and through it the art of every individual and nation was increased. It was, in effect, the International of culture. At the end of the 1930s and the beginning of the 1940s, with civil war in Europe, and when cultural production was being directed by state bureaucracies in the United States and the Soviet Union, what had been achieved by Paris provided evidence for him that cultural internationalism was possible as a creative communion which could sweep across boundaries [40].

Rosenberg's Paris was a material place with a particular physiognomy and a lot of ideology. It was the French capital at a certain moment, say 1907–1929, and the artists who gathered there. It was also the style which was produced there: 'the Paris style', 'the Paris Modern', 'Modernism' or 'the Modern' [41]. However, Rosenberg realised that the Internationalism of Paris was not 'the actual getting together of the peoples of different countries'. And he also realised that the Modern

> was an inverted mental image . . . with all the transitoriness and freedom from necessity of imagined things. A dream living-in-the-present and a dream world citizenship—resting not upon a real triumph, but upon a willingness to go as far as was necessary into nothingness in order to shake off what was dead in the real. A negation of the negative. [42]

This negation was not the practice of merely saying 'no'. It was not a practice of pure negativity. Following Marx and Engels following Hegel, Rosenberg took the 'negation of the negative' as an immanent dialectical moment of development, becoming, mediation and transition. The negation of the negation is a dynamic for change [43].

Rosenberg saw the Modern as 'the style of today'—'the contemporary as

beginning in 1789' [44]—and by reference to it as a 'negation of the negative' he pointed to its critical, resistive and emancipatory potential in the development of an advanced, liberating, revolutionary consciousness. Paris had been central to it as the site of the International of culture but not to the modern as a temporality because 'the social, economic and cultural workings which define the modern epoch are active everywhere' [45].

And just as the International of culture had a capital, Paris, so in the 1920s the political International—the Third International—had a capital, Moscow. 'It is a tragic irony of our epoch,' writes Rosenberg

> that those world centres were not brought together until the signing of the Franco-Soviet pact in 1935 when both were already dead. Then the two cadavers of hope embraced farcically, with mutual suspicion and under the mutually exclusive provincial slogans: DEFENSE OF THE USSR and FRANCE FOR FRENCHMEN. [46]

And what happened to the modern formulae perfected by Paris and Moscow and discarded with the Russian-French Non-Aggression Pact and the inauguration of the Popular Front? They were taken over by Germany and adapted to its particular aims.

> In that country politics became a "pure (i.e. inhuman)" art, independent of everything but the laws of its medium . . . Against this advanced technique, which in itself has nothing to do with revolutionary change, the Paris of the Popular Front compromise was helpless. [47]

The demise of the Modern was inseparable from revolutionary defeat and the defeat of the revolutionary idea, i.e. from the rise of Stalinism and fascism and the rehegemonisation of nationalism and individualism, and the working class's loss of political independence. The fall of Paris merely made it definitive.

Despite this, 'The Fall of Paris' manages to end optimistically—just. Against the fascist modernist mysticism 'dreaming of an absolute power to rearrange life according to any pattern of its choice', Rosenberg glimpsed the possibility of 'other forms of contemporary consciousness, another Modernism' [48]. But he found it impossible to predict where the centre of this new phase of the Modern would be located.

III

By the late 1940s–early 1950s, it had become possible for Rosenberg to identify the new International of culture—if not the International of politics—and to discuss the significance of the movement or style produced by it. He does this in 'The American Action Painters' which was published in the issue of *Art News* for December 1952. Like 'The Front' and 'The Fall of Paris', 'The American Action

Painters' begins with a gesture; this time it is taken from Apollinaire and set epigrammatically with a fragment from Wallace Stevens:

"*J'ai fait des gestes blancs parmi les solitudes.*" APOLLINAIRE
"The American will is easily satisfied in its efforts to realise itself in knowing itself." WALLACE STEVENS

One thing which needs to be immediately established is what it is that Rosenberg thought was 'American' about 'American action painting'. He was obviously trying to write something about a kind of collective identity, but there is nothing nationalistic, patriotic or chauvinistic about his use of 'American' or his idea of what kind of person the 'American' action painter might be. 'American' has to be understood as meaning a kind of ethnic diversity and cosmopolitanism [49]. You only have to read his 1959 essay, 'Tenth Street: A Geography of Modern Art', to see how clearly the material and ideological space of the American action painters was, in Rosenberg's scheme of things, related to the International of culture he had described nineteen years before in 'The Fall of Paris' [50]. Here, in this essay, 'the new American "abstract" art' is the kind of painting made around 10th Street, New York, by displaced persons, immigrants, the sons and daughters of immigrants, and by Americans who have 'moved' there [51] maybe for reasons similar to those of the artists, writers, etc. who travelled from all over the world to Paris and produced the Modern.

In 'The American Action Painters' the artist is figuratively and literally a pioneer and an immigrant. And just as the earlier International of culture was determined partly by the physical character of its place of production and by the qualifying and the blending of nationalities and class positions which was possible there, so 'Tenth Street' was determined not only by its geography—Rosenberg writes that it 'has not even the picturesqueness of a slum' [52], it is 'devoid of local colour', a 'neutral zone' [53]—but also by the unfixing and mixing of nationalities, races, classes, and ideologies which happened there [54].

In 1940 Rosenberg had described the Paris 'International' as a 'No-Place'; in 1959 he described the area around 10th Street as a 'no-environment' [55], it was all places and none of them [56]. As the new site of cultural internationalism, 'Tenth Street' transcended the internationalism of the moribund Paris 'International' of the 1930s. Its 'ethnic openness'—its 'Americanness'—went beyond the 1930s fighting talk of 'internationalism' [57]. And its 'American' action painting went beyond the dogma of 1930s 'modernism' [58]. I will consider this double 'going beyond' later, but for the moment I want to stay with Rosenberg's notion of 'American' and 'Americanness' and consider how it relates to his thinking about identity and action.

One of Rosenberg's most interesting considerations of 'Americanness' occurs in his 1949 essay 'The Pathos of the Proletariat' [59]. This was the second of two essays on class and class struggle—the first was 'The Resurrected Romans' of 1948 [60]—which he wrote at a time when he was concerned with 'the drama of modern

history as conceived by Marx—a drama in which individual identity and action are replaced by collective actions formed out of historical processes and myths' [61]. Both essays, but particularly 'The Pathos of the Proletariat', are significantly inscribed by what he had written in 1932 in 'Character Change and the Drama'. We need to look into 'Character Change and the Drama' before we consider 'Americanness' in 'The Pathos of the Proletariat' and start rereading 'The American Action Painters' because it is in this early essay that he develops most fully those ideas on the making of an 'identity' and the relation of this to individuality which are so central to his politics.

What Rosenberg wrote in 'Character Change and the Drama' was informed as much by his studies in law school as by his interest in the theatre and the mechanics of tragedy [62]. Legal definitions were important for his argument. He explained that the law totally defines an individual by his 'overt acts', by what he did in particular circumstances. The law does not recognise 'personality', a person with a biography, a life pictured as fully and precisely as possible. It is only interested in a person's actions, an 'identity' to which its judgments are applied [63].

Rosenberg goes on to argue that in *Hamlet* the Prince is transformed from a 'personality' (a thoroughly naturalistic, psycho-biographical character) into a dramatic 'identity' (a character relevant to and able to perform the role required by the plot in which he is located) [64].

Hamlet has all the qualities required for action; what he lacks is the identity structure which would fit him to be a character in the drama, a oneness with his role originating in and responding to the laws of his dramatic world. The change occurs when he acquires a certainty with regard to his feelings, and when his capacity for action is no longer the expression of his 'personality' but accords with the dramatic rules of the situation in which he finds himself. He breaks with one character and 'becomes' another: 'This is I, Hamlet the Dane.' From that moment,

> his action hustles the play to its tragic close and the apparently accidental character of his revenge serves to emphasise that he is controlled at the end not by the conflicting intentions of a self but by the impulsions of the plot. Transformed from the image of a personality into that of a dramatic identity, he has found at last his place in the play. [65]

Here, in Rosenberg's legalistic thinking about character change in *Hamlet*, we find a key for understanding his reading not only of Marx on class and class struggle, but also of the American action painters and American action painting. This paragraph near the end of 'Character Change and the Drama' is crucial:

> Individuals are conceived as identities in systems whose subject matter is action and the judgment of actions. In this realm the multiple incidents in the life of an individual may be synthesized, by the choice of the individual himself or by the decision of others, into a scheme that pivots on a single fact central to the individual's existence and which, controlling his behavior

and deciding his fate, becomes his visible definition. Here unity of the 'plot' becomes one with unity of being and through the fixity of identity change becomes synonymous with revolution. [66]

Fifteen years later, in 'The Pathos of the Proletariat', the identity change which becomes synonymous with revolution is that made by the 'hero of Marx's drama of history' whose 'action is to resolve the tragic conflict and introduce the quiet order of desired happenings' [67]. The hero was not to be an individual but a particular kind of collective identity, a social class: the proletariat [68]. But for an American radical like Rosenberg, four or five years after World War II, the social revolution seemed unlikely: capitalism was secure; its internationalisation well advanced; Soviet communism was discredited. The revolutionary processes of capitalism had not genuinely illuminated the worker about himself nor united him with other workers. Existence had not yet determined a revolutionary conscious-ness. Instead, it had determined a revolutionary politics and propaganda, a collective 'I' defined and confirmed by the Party and its bureaucracy [69]. But unlike many Marxists, Rosenberg was not claiming or complaining that the proletariat had not lived up to its appointed form of consciousness or had failed in the role imagined and written for it. Rather, the problem of the agency of revolutionary change which had previously been thought of in terms of the individual had now become a central preoccupation, and one which he puzzled in terms of class. The question which concerned him in 'The Pathos of the Proletariat' was how the proletariat's character and consciousness might be transformed into a revolutionary consciousness and identity.

The proletariat had been on stage since the industrial and bourgeois revolutions, but if it had only the social character and function assigned to it by the process of production, what did it mean to speak of it as revolutionary [70]?

Rosenberg finds answers, or partial answers, to this question in Marx's *The Class Struggles in France*, *The Civil War in France*, and especially in *The Eighteenth Brumaire of Louis Bonaparte*. In these 'historical-literary' writings, the class transcends its given form and its economic function and 'expresses its collective personality and acts with an intelligence and spirit peculiar to itself' [71]. It is apparent to Rosenberg that, in these texts, 'the essence of class definition consisted for Marx in this active character shaping spirit' [72]. He finds this implicit in the statement: 'The working class is revolutionary or it is nothing.' In terms of 'Character Change and the Drama', the class would be defined 'by the coherence of its acts and with the fact in which they terminated'. Without this 'identity' or 'character' the proletariat would merely be a 'personification' [73], and as a personification it would be nothing. Since Rosenberg believes that dialectically and by definition the proletariat must be more than a personification, that its existence presupposes a revolutionary consciousness and will, and that its own direct decisions and acts—and not decisions or actions taken on its behalf—must be the basis of any change considered to be socialist, he argues that the self-consciousness

which converts it from 'social character' to 'character' or historical actor is an aspect of revolution and of revolutionary practice [74]. The proletariat must come to consciousness through its own action, its own response to the structural contradictions of capitalism. 'Both class awareness and class identity rise out of class action' [75].

To the question of how the proletariat's 'social character' might be transformed, Rosenberg finds an answer in that part of *The Eighteenth Brumaire*, where Marx writes that the proletarian revolution will be characterised by its total abandonment of the past:

> The social revolution cannot draw its poetry from the past but only from the future. It cannot begin with itself before it has stripped off all superstitions in regard to the past. Earlier revolutions required world-historical recollections in order to drug themselves concerning their own content; the revolution of the nineteenth century must let the dead bury the dead. There the phrase went beyond the content; here content goes beyond the phrase. [76]

Whereas the bourgeois revolutions had been performed in costumes borrowed from the past, with ghosts of dead heroes presiding over events—like the ghost of Hamlet's father—the social revolution has to be without recourse to myth, and must be clear concerning its content. The proletariat, called into existence by the bourgeoisie and a product of modern industry, is without a past. Its revolution 'is to owe nothing to that repertory of forms out of which history has supplied earlier revolutions with the subjective means for meeting their situation' [77]. Pastless, the proletariat must begin its revolution, become one with the drama of history, with a profound asceticisation of mind and imagination realising itself for what it is, the personification of wage labour [78].

In other words, there will come a moment when the proletariat, as the first condition of historical action, must surrender its given character and function under capitalism. It will then act to fulfil its historical role, develop a form of revolutionary consciousness and 'identity', and come to exist at the level of political struggle.

Rosenberg regarded the pastlessness of the proletariat as the key to its 'character' and its revolutionary role. Here, in 'The Pathos of the Proletariat', he developed the idea that the proletariat and the American are 'similar' or analogous with regard to their pastlessness and their capacity for action. As an immigrant, or the descendant of immigrants, the American is regarded as detached or estranged from his or her origins—the culture, traditions, places, things, even the human relations, of Europe—and this constitutes a kind of pastlessness; 'the American exists without the time dimension' [79]. Also, he does not meditate, he acts; and his

self consciousness arises through the 'practical movement' [80] . . . For the American action is but a natural response to need or desire (whether his action can satisfy that need is another question). [81]

This 'similarity' might seem a bit flim-flam now but it would have seemed less so in the 1940s when Lenin's and Trotsky's views on American agriculture and industry were more part of left conventional wisdom than they are today [82]. That is to say, the assimilation of the values attaching to 'American' with those attaching to proletarian in 1949 worked because of the job it was doing and the context in which it was uttered.

Many of the attributes of the proletariat as the potential embodiment of the spirit of the modern are, inescapably, attributes of the American, [83] unquestionably the best available model of the new-fangled; from Marx to Lenin to Trotsky, American practices have been cited to illustrate qualities needed under socialism. [84]

However, the American is no revolutionary: 'his history has been one of setting limits to his revolutionising' [85].

But how does the 'similarity' work? What is it supposed to illustrate with reference to the proletariat's character change and the drama of history?

Speaking half-figuratively, [86] to become a human being the proletarian must '*Americanize*' himself, that is, overcome the void of his past by making a new self through his actions. [87]

IV

It should be clear from the foregoing that Rosenberg's idea of 'action'— 'American-action'—came out of the very particular way he read Marx's writings. As far as his thinking about 'action' in 'action-painting' is concerned, I doubt that he found much of use for what he wanted to write in Hans Namuth's photographs of Jackson Pollock painting which appeared in the *Art News* for May 1951 [88]. Some persons think they were important for him, but the point is that he did not need to see—or see photographs of—any of the artists work—Pollock, Willem de Kooning, Barnett Newman, whoever—to write what he *saw* their painting *as* or *as of* [89]. On the other hand, I can see why, in 1947, some passages in Richard Huelsenbeck's 'En Avant Dada' caught his eye amongst the proofs of Robert Motherwell's Dada anthology [90]. In one passage, which he and Motherwell included in *Possibilities*, you can read:

The Dadaist should be a man who has fully understood that one is entitled to have ideas only if one can transform them into life—the completely active type, who lives only through action, because it holds the possibility of achieving knowledge. [91]

That seems compatible with how he read Marx. Motherwell has said that Rosenberg's notion of 'action' derives from Huelsenbeck [92]. There was more to it than that, indeed more to it than I have written here. But then, beginnings are over determined.

We can now start reading 'The American Action Painters' and answer the question posed about action painting in its first section: 'Modern Art? Or an Art of the Modern?' For Rosenberg, writing in 1952, Modern Art is painting which has caught up with, or is catching up with, what was produced by the 'School of Paris', the academic, moribund Modern of the late 1920s-1930s. It is painting secure in the knowledge of what art is, practising its immediate past, enabled and supported by a stable structure. This Modern Art is what has to be negated in and by any radical art practice: an Art of the Modern will be that negation [93].

But Modern Art is not only painting. As Rosenberg points out, the category could also include architecture, furniture, household appliances, advertising 'mobiles', a three-thousand year old mask from the South Pacific, even a piece of wood found on a park bench [94]. Modern Art has nothing to do with style, with when it was produced, why, by whom, for whom, etc., and more or less everything to do with the social power and pedagogy of those persons who designate it as 'psychologically, aesthetically or ideologically relevant to our epoch' [95]. It is a 'revolution of taste' conducted by those persons who value it and contested by those who do not. Responses to it represent 'claims to social leadership' [96]. Rosenberg was alluding to that aspect of the struggle for leadership within the ruling class which, during the Cold War, was fought with claims about Modern Art. On one side, there was that fraction (the international-ist-multinationalist 'business liberals') which valued it, collected it, and made it available to the public in those bits of the cultural apparatus owned and controlled by it—the Museum of Modern Art, New York, was a prime site—and for whom Modern Art had 'a supreme Value [. . .] the Value of the New' [97]. On the other side there was that fraction (the isolationist-nationalist 'practical conservatives') which regarded Modern Art as un-American, subversive, 'snobbish, Red, immoral etc.' [98], and whose views were represented publicly by the likes of Congressman George A. Dondero. Rosenberg, who understood how Modern-ism—or those aspects of Modern Art which were synonymous with his Art of the Modern—put the politics of both class fractions at risk [99], regarded this struggle, restricted to 'weapons of taste' and at the same time addressed to the masses, as a 'comedy of a revolution' [100], i.e. a farce.

The professional enlighteners of Modern Art use action-painting in their struggle and for their pedagogic and profit-making purposes [101], but they do not understand it. Their judgment is a matter of taste, of identifying 'resemblances of surface', and of perpetuating beliefs about what painting is and what is to be valued as 'modish' [102]. So they failed to grasp 'the new creative principle' which set action painting apart from twentieth-century picture making [103].

Rosenberg's action painting has nothing to do with taste or with 'the all too clearly rationalised' 'previous mode of production of modern masterpieces' [104]. It was a different kind of practice to that of the earlier abstractionists of the International of culture or, as it was called in 'The American Action Painters', the Great Vanguard [105]. The Modern, or the Great Vanguard, was historically and culturally specific to Paris, 1907–29. Action painting was historically and culturally specific to an art community associated with 10th Street, New York, 1945–52. It was that community's response in relation to the unevenness of history and to what Rosenberg regarded as a break in the Modern. Not surprisingly—nor illogically according to his order of things—Rosenberg's action painters regarded the style of the Great Vanguard as dead or as something to be transcended. Though it is possible to see a cutaneous similarity between their work and previous abstract painting, the two kinds of painting are crucially different with regard to their functions. Rosenberg said that what the action painter produces 'has separated from' the Great Vanguard and from what the taste bureaucracies and formalism have designated Modern Art because it is determined by and produced with an awareness of a new function for painting [106]. Rosenberg's use of 'the Modern' remained consistent since 'The Fall of Paris' and continued to mean—as it did in 'The Pathos of the Proletariat', where he talked about 'the spirit of the modern' [107]—the style of the progressive consciousness of the epoch. Action Painting then, is not Modern Art but an Art of the Modern.

Rosenberg points out that most of the artists he has in mind were over forty when they became action painters. Before then, many of them had been

'Marxists' (WPA unions, artists' congresses) [. . .] trying to paint Society. Others had been trying to paint Art (Cubism, Post-Impressionism).

It amounted to the same thing. They had been trying to paint the Modern. By 1940 both the Society and the Art of the Modern were dead. 'The Fall of Paris' had written their obituaries. It is in this double demise, not in 'the war and the decline of radicalism in America', that Rosenberg locates the beginnings of action painting:

At its center the movement was away from, rather than towards. The Great Works of the Past and the Good Life of the Future became equally nil. [108].

It was at this moment of 'grand crisis' [109] when the two Moderns of Art and Society became nothing, and were recognised as having failed, that it became possible to make an Art of the Modern again. However, the ideas, beliefs, theories, practices, materials and methods of Art and Society which survived were useless to those artists who were concerned to deal with the crisis and work it out in practice. 'Value—political, aesthetic, moral' had to be rejected [110]. But this rejection did not, as it had done with Dada and Surrealism after the First World War, take the

form of condemnation or defiance. This time the reaction was, not surprisingly, 'diffident' [111], distrustful of Society and uncertain about 'Art', 'creation', 'creativity', 'individuality' and the 'identity' of the artist.

In coming to nothing the two Moderns provided artists with a major resource for any vanguard practice: *nothingness.* With the idea of nothingness and with severely reduced material equipment the action painter 'decided to paint . . . just TO PAINT' [112]. There was no intention

> to reproduce, re-design, analyse or 'express' an object, actual or imagined. What was to go on the canvas was not a picture but an event. The painter no longer approached his easel with an image in his mind; he went up to it with material in his hand to do something to that other piece of material in front of him. [113]

The image that was produced by 'staining' the canvas or by 'spontaneously putting forms into motion upon it' [114] was the indexical—and occasionally the iconic—mark or trace of those actions [115]. Initially that was all there was to it. But then the painter began to take stock of the way the surface was marked, started to attend to the 'act of painting', to what might be learned about painting and art and about himself as an artist: 'What matters always is the revelation contained in the act' [116]. Action painting is, in Rosenberg's account of it, painting at the point of formation, when everything has to be redone; it is Ur-painting at the moment of thematisation; but it is not yet, and may never become, painting as art [117].

We are now near to understanding this new painting which Rosenberg regards 'as an act that is inseparable from the biography of the artist', that is 'a "moment" in the adulterated mixture of his life', that is 'of the same metaphysical substance as the artist's existence', and that has 'broken down every distinction between art and life' [118]. But we will not understand it if we see it as Modern Art, i.e. in relation to 'the works of the past, rightness of colour, texture, balance, etc.', or as expressing or representing some aspect of the artist's existence, for example, his 'sexual preferences or debilities' [119]. Taking the hint from the reference to 'the critic who goes on judging' [120] (and recalling what he had written previously in 'Character Change and the Drama' about the way the law defines a person by his acts), it seems clear that Rosenberg understands action painting as a given sequence of acts which enable a judgment by the painter and the critic, a judgment which is an inseparable part of recognising the painter's 'identity'.

> The law is not a recogniser of persons; its judgments are applied at the end of a series of acts [121]. With regard to individuals the law thus creates a fiction, that of a person who is identified by the coherence of his acts with a fact in which they have terminated (the crime or the contract), and by nothing else. The judgment is the resolution of these acts. The law visualises the individual as a kind of actor with a role whom the court has located in the situational system of the legal code. [122]

In understanding an action painting or the 'act-painting' as an act which is 'inseparable from the biography of the artist', Rosenberg does not see it as a mere attribute of or clue to the painter's 'psychology, philosophy, history, mythology, hero worship' [123]. Nor, if the action painter is to be understood in terms of the commonly ascertainable elements of his acts—his action paintings—should he ever be made to be more than he could have possibly performed. 'In contrast with the person who is recognised by the continuity of his being, we may designate the character defined by the coherence of his acts as an "identity" ' [124]. This, if we follow Rosenberg, is how we are to understand the action painter: as an 'identity'. The action painter's activity is intended to define his 'identity' at a moment of 'grand crisis':

> With the American, heir of the pioneer and the immigrant, the foundering of Art and Society was not experienced as a loss. On the contrary, the end of Art marked the beginning [. . .] of an optimism regarding himself as an artist [. . .] On the one hand, a desperate recognition of moral and intellectual exhaustion; on the other, the exhilaration of an adventure over depths in which he might find reflected the true image of his identity . . . Guided by visual and somatic memories of paintings he had seen or made—memories which he did his best to keep from intruding into his consciousness— he gesticulated upon the canvas and watched for what each novelty would declare him and his art to be. [125]

Aware that their ideological and material conditions were thoroughly immiserated, and freed from, or wanting to be free from, past ideas and beliefs, the action painters acted according to their historical circumstances and entirely in their own interests. The 'saving moment' occurred 'when the painter first felt himself released from Value—myth of past self-recognition' and 'attempted to initiate a new moment' in which he would 'realise his total personality—myth of future self-recognition' [126]. It was here that the painter's character change became, like Hamlet's or like the '*Americanised*' proletariat, synonymous with revolution. This is Rosenberg on revolutionary action in 'The Pathos of the Proletariat'.

> For the worker action is but a possibility, the anguishing possibility of transforming himself into an individual. Hemmed in on the bare, functional stage of industrial production, altogether 'there', without past or vision of paradise, he is, except for this possibility of acting, a mere prop, a thing that personifies. Speaking half-figuratively, to become a human being the proletarian must '*Americanize*' himself, that is, overcome the void of his past by making a new self through his actions. Yet all the relations of capitalist society forbid the working class to act except as a tool. Hence its free act must be a revolutionary act, one that must subdue 'all existing conditions' and can set itself no limits. The proletarian victim of the modern cannot enter the historical drama as an actor without becoming its

hero. In 'the indefinite prodigiousness of their aims', as Marx described them in *The Eighteenth Brumaire,* the workers signify that with them revolution is a need of the spirit, a means of redemption. Before Marx's internal pioneer opens a frontier without end. [127]

This is what he wrote, or rewrote, in 'The American Action Painters'.

The revolution against the given, in the self and the world, which since Hegel has provided European vanguard art with theories of a New Reality, has re-entered America in the form of personal revolts. Art as action rests on the enormous assumption that the artist accepts as real only that which he is in the process of creating. 'Except the soul has divested itself of the love of created things . . .' The artist works in a condition of open possibility, risking, to follow Kierkegaard, the anguish of the esthetic, which accompanies possibility lacking in reality. To maintain the force to refrain from settling anything, he must exercise in himself a constant No. [128]

The action painter can only produce effectively if he is in relation to the dominant culture as a proletarian, an alienated proletarian, a proletarian within a class. Action is the prerequisite of class 'identity'. For the proletariat, which is held in an alienated, exploited fixed-relation, any free act, any action made spontaneously and without recourse to myths of the past or to a Utopian future, will be, by definition, revolutionary and will begin the revolution in permanence. Action is also the prerequisite of the vanguard painter's 'identity'. In the crisis period of 1940 and after, the painter could either remain inactive and continue to paint Art and Society, or he could rid himself of all considerations except those demanded by his historical situation, directly encountered, and . . . just PAINT. He could produce Modern Art or an Art of the Modern, make art or 'original work demonstrating what art is about to become' [129].

As I read them, 'The Pathos of the Proletariat' and 'The American Action Painters' are the essays of a Marxist who *refused* to be forced into a pessimism which would be quite alien to the Marxist tradition [130]. The Harold Rosenberg who wrote 'The Front' was still here, residually, in these essays of the late 1940s and 1950s. The proletariat still had the potential for revolution:

So long as the category exists, the possibility cannot be excluded that it will recognise itself as a separate human community and revolutionise everything by asserting its needs and its traditionless interests. [131]

And the American action painters provided evidence that there was still some potential for personal revolt and for insurrection. For Rosenberg, 'good' action painting left 'no doubt concerning its reality as an action and its relation to a transforming process in the artist' [132]. Weak or 'easy' action painting lacked 'the dialectical tension of a genuine act, associated with risk and will' [133]. The painter

seemed to be able to act out an 'identity'—'Dramas Of As If' [134]—which the proletariat, at that moment, could not.

Maybe the action painter's action was always, at some level, a failure—unless, as seems unlikely, it was part of a 'revolution' whose outlines were not perceptible in political terms, but whose potential could only be denied at the cost of an entire loss of self.

Rosenberg was able to remain optimistic because his analyses incorporated the dialectic. When it appeared, the dialectical method, which combines the negativity of man's social experience with the need for change, introduced an essential, confident movement into his writing. Remember: the Paris Modern represented

> a dream living-in-the-present and a dream world citizenship—resting not upon a real triumph, but upon a willingness to go as far as was necessary into nothingness in order to shake off what was dead in the real. A negation of the negative.

For Rosenberg, that was what the work of American action painters was. If action painting had any meaning, it was about revolutionary political agency arising from the contradictions of capitalism, the reality of which could not be totally excluded if the prospect of radical change was to be kept open . . . sometime . . . somewhere. . . . Action painting was the sign that the possibility of revolution was not totally closed down, that the dynamic of revolution was still there [135]. Action painting was that, or it was nothing.

> *I am nothing and I should be everything.*
> Karl Marx [136]

NOTES AND REFERENCES

Abbreviations
AA: ROSENBERG, HAROLD, (1970) *Act and the Actor: Making the Self* (N.Y., World Publishing Co) (University of Chicago 1983)
DP: ROSENBERG, HAROLD (1973) *Discovering the Present/Three Decades in Art, Culture and Politics* (Chicago, The University of Chicago) (Phoenix Edition 1976)
TN: ROSENBERG, HAROLD (1959) *The Tradition of the New* (Horizon) (The University of Chicago Phoenix Edition 1982)

1 ROSENBERG, HAROLD (1952) 'The American Action Painters', *Art News* vol.51, no.8. December. pp. 22–23. 48–50. Reprinted in *TN* (1982) pp. 23–39.

2 ROSENBERG, HAROLD (1935) 'The Front', *Partisan Review* vol.11, no.6, January-February, p. 74.

3 ROSENBERG, HAROLD (1932) 'Character Change and the Drama', *The Symposium* vol.III. no.3. July. pp. 348–369. Reprinted in *TN* (1982) pp. 135–53. See also his other work for *The Symposium*: 'Myth and Poem', vol.11. no.2. April 1931, pp. 179–91; a review of William Empson's *Seven Types of Ambiguity*, vol.11, no.3, July 1931, pp. 412–18; a review of Kenneth Burke's *Counter-Statement* and Montgomery Belgion's *The Human Parrot and other essays*, vol.III, no.1, January 1932, pp. 116–18; and a review of Jules Romains' *Men of Good Will*, vol.IV, no.4, October 1933, pp. 511–14.

4 Rosenberg and Hays published three issues of *The New Act*, Number One, January 1933, Number Two, June 1933, and

Number Three, April 1934. *Poetry, a Magazine of Verse*, vol.45, no.6, March 1935, p. 357, referred to it as an 'experimental quarterly'. *The New Act* published articles by René Daumal, Paul van Ostayen, Henry Bamford Parkes, George Plekhanov, Ezra Pound. Samuel Putman, and Parker Tyler. For Rosenberg's contributions see 'Note on Class Conflict and Literature', *The New Act* Number One, January 1933, pp. 3–10, and 'Sanity, Individuality and Poetry', *The New Act*, Number Two, June 1933, pp. 59–75, two essays in which he developed the ideas on class conflict and individuality that he had first written in 'Character Change and the Drama', 1932.

5 Rosenberg's contributions are indexed in *Thirty Years of Poetry: a Magazine of Verse. Index to Vols. 1–60; October 1912—September 1942* (inclusive) and *Index to Fifty Years of Poetry, Vols. 1–100, 1912–1962* (N.Y., AMS Reprint Company, 1963).

6 PHILLIPS, WILLIAM and RAHV, PHILIP (1936) 'Private Experience and Public Philosophy', *Poetry*, vol.48, no.2, May, p. 104.

7 ROSENBERG, HAROLD (1934) 'The Men on the Wall', *Poetry*, vol.44, no.1, April, pp. 3–4.

8 *Ibid.*

9 (1935) 'Contributors', *Partisan Review*, vol 11, no.6, January-February, p. 2.

10 On the John Reed Club and *Partisan Review* see AARON, DANIEL (1961) *Writers on the Left: Episodes in American Literary Communism* (N.Y., Harcourt, Brace & World, Inc.); GILBERT, JAMES BURKHART (1968) *Writers and Partisans: a History of Literary Radicalism in America* (N.Y., Wiley); PELLS, RICHARD H (1973) *Radical Visions and American Dreams: Culture and Social Thought in the Depression Years* (Wesleyan University Press); WALD, ALAN (1974) 'Revolutionary Intellectuals: *Partisan Review* in the 1930s', *Occident* n.s. viii, Spring, pp. 118–33; HOMBURGER, ERIC (1986) *American Writers and Radical Politics, 1900–1939: Equivocal Commitments* (N.Y., St. Martin's Press).

11 Considering the secrecy which continues to surround membership and which was deliberately fostered by the C.P., it's very difficult to know who was and who was not a member of the C.P.U.S.A. And there are conflicting reports. It seems that being a member demanded a kind of discipline that most writers and artists would not be able to accept. One has to remember that the C.P.U.S.A. was partly committed to democratic centralism and to the strategic use of writers and artists. Because it could not accommodate any criticism from members at local levels of organisation, it would not accept into its ranks any really independent figures, and they, in turn, would not accept its dictates. My guess is that Harold Rosenberg was a fellow-traveller.

12 (1935) 'The Coming Writers Congress', *Partisan Review* vol.II, no.6, Jan-Feb, pp. 94–6. See p. 95. The Congress, it was announced, would also 'develop the possibilities for wider distribution of revolutionary books and the improvement of the revolutionary press, as well as relations between revolutionary writers and bourgeois publishers and editors'. It was clear from this that when the Congress met at the end of April it was to be less concerned with revolution than with establishing good relations with the literary bourgeoisie and with fighting fascism.

13 DEGRAS, JANE [TABRISKY] (1965) *The Communist International 1919–1943: Documents Vol 3* (London and New York: Oxford University Press), p. 375. quoted in HALAS, DUNCAN (1985) *The Comintern* (London: Bookmarks), p. 143, an excellent discussion of the Comintern's revolutionary period.

14 ROSENBERG, HAROLD (1935) 'The American Writers Congress', *Poetry* vol.46, no 4, July, pp. 222–7.

15 *Ibid.*, p. 226.

16 *Ibid.*, pp. 226–7.

17 *Ibid.*, p. 225.

18 *Ibid.*

19 *Ibid.*

20 *Ibid.*

21 Rosenberg is using Browder's speech to the Congress which was intended to reassure

the non-communist writers that the C.P. had no intention of putting them into 'uniforms'. This mention of 'uniforms' was a clear reference to EASTMAN, MAX (1934) *Artists in Uniform* (N.Y.).

22 Here I have relied on MONROE, GERALD H (1973) 'Art Front', *Archives of American Art Journal*, vol.13, no.3, pp. 13–19. The editorial board's shift towards modernism was made partly as a result of pressure which had been brought to bear by some modernist members of the Union—Solman, Ilya Bolotowsky, Balcomb Greene, Mark Rothkowitz, Byron Browne, George McNeil, and others—and partly because the Popular Front made it necessary to open up the editorial board to modernism. The move did not go uncontested. Rosenberg's place was secured at the expense of Solman's and Spivak's and several others, and then only on the advice of a visiting official of the French Communist Party who sat in on a crucial board meeting. In *Poetry*, vol.5, no.4, January 1938, p. 234, Rosenberg is referred to as a 'poet, critic, and painter of murals'.

23 Rosenberg's first piece for *Art Front* was a report on an Artists Union demonstration outside the C.A.A. on 15 August 1935, at which 83 W.P.A. artists and art teachers were arrested, see 'Artists Increase their Understanding of Public Buildings', *Art Front*, November 1935, pp. 3, 6.

24 ROSENBERG, HAROLD, translator, LÉGER, FERNAND (1935) 'The New Realism', *Art Front*, December , p. 10.

25 ROSENBERG, HAROLD (1936) 'Peasants and Pure Art', January, pp. 6, and (1936) 'Cubism and Abstract Art', *Art Front*, June, p. 15.

26 ROSENBERG, HAROLD (1936) 'Book Reviews', *Art Front*, March, pp. 13–14. See p. 14.

27 ROSENBERG, HAROLD (1936) 'The Wit of William Gropper', *Art Front*, March, pp. 7–8.

28 The most complete and still the best account can be found in the rich detail of Chapter One 'New York, 1935—1941: The De-Marxization of the Intelligentsia' in GUIL-

BAUT, SERGE (1983) *How New York Stole the Idea of Modern Art: Abstract Expressionism, Freedom and the Cold War* (The University of Chicago Press).

29 In 1937 Rosenberg published several things in *New Masses*, the cultural magazine of the C.P.U.S.A. which always affirmed the validity of the Moscow Trials and the communist line. 'Portrait of a Predicament', his very hostile review—in the context of *New Masses* it could not have been anything but hostile—of William Saroyan's *3 Times 3* appeared in the same issue as 'The Moscow Trials: an Editorial', *New Masses*, February 9, 1937, see p. 24. Other writings are: 'What We May Demand', *New Masses*, March 23, 1937, pp. 17–18, an article on literature and major political writings (i.e. 'But the least we may demand from literature is that it equal the best political and historical writings of our time in the consciousness of its own subject matter. Only thus can it probe the wound of humanity which the act of thinking and of political combination is part of the effort to cure [. . .] no poem or novel of the past few years can equal as a literary expression of modern human consciousness the Communist Manifesto or Marx's Eighteenth Brumaire'); 'Aesthetic Assault', a review of Jules Romains' *The Boys in the Back Room*, *New Masses*, March 30, 1937, p. 25; and 'The Melancholy Railings', a poem, *New Masses*, July 20 1937, p. 3. However, he did not publish in *New Masses* after July 1937, and he did not put his name to 'The Moscow Trials: A Statement by American Progressives' endorsing the trials: *New Masses*, May 3, 1938, p. 19. This break with *New Masses* helps date his move away from the C.P.

30 TROTSKY, LEON (1937–38) *Writings of Leon Trotsky* /1937–38/ (N.Y., Pathfinder Press, 1970), pp. 351.

31 TROTSKY, LEON (1938) 'Art and Politics', *Partisan Review*, August September, vol.V, no.3, pp. 3–10.

32 See BRETON, ANDRÉ and RIVERA, DIEGO (1938) 'Manifesto: Towards a Free Revolutionary Art', *Partisan Review*, Fall, vol.VI. no.1, pp. 49–53. It is generally

agreed that this text is substantially Trotsky's.

33 ROSENBERG, HAROLD (1939) 'Myth and History', *Partisan Review* vol.VI, no.2, Winter, pp. 19–39.

34 (1939) 'The Situation in American Writing', *Partisan Review* vol.VI, no.4, Summer, see pp. 47–9.

35 ROSENBERG, HAROLD (1939) 'Marx and "The People" ', *Partisan Review* vol.VI, no.4, Summer, pp. 121–5, see p. 124.

36 (1939) 'Statement of the L.C.F.S.', *Partisan Review*, vol.VI, no.4, Summer, pp. 125–7, see p. 127. He also signed the League's Manifesto (1939) 'War Is The Issue!', *Partisan Review*, vol.VI, no.5 Fall,, pp. 125–7. See Rosenberg on the L.C.F.S. in (1955) 'Couch Liberalism and the Guilty Past', *Dissent: a Quarterly of Socialist Opinion*, vol.11, Autumn, pp. 317ff., reprinted in *TN* (1982), pp. 238–9.

37 ROSENBERG, HAROLD (1940) 'On the Fall of Paris', *Partisan Review*, vol.VII, no.6, December, pp. 440–8; reprinted under the title 'The Fall of Paris' in *TN* (1982), pp. 209–220.

38 See ROSENBERG, HAROLD (1955) 'Couch Liberalism and the Guilty Past', *Dissent: a Quarterly of Socialist Opinion*, vol.11, Autumn, pp. 317ff., reprinted in *TN* (1982), pp. 221.

39 *TN*, 209.

40 *TN*, 209–210.

41 *TN*, 21 211.

42 *TN*, 212–213.

43 In the dialectical process of development 'The old quality is negated by its opposite [. . .] thus constituting the first negation. However, the superseded quality does not remain in its original form but, by another process of negation, develops into the next stage, the negation of the negation. Marx, Engels and other classical Marxist philosophers developed the concept from Hegel, but gave it a materialist content and stressed its dynamic aspect of development. However, as Engels and Lenin insisted, neither negation nor the negation of the negation in dialectics amounts to the total denial or rejection of the old. Thus socialism is basically a negation of capitalism, yet the former also embodies the best elements of the latter . . .' (WILCZYNSKI, J (1981) *Encyclopedic Dictionary of Marxism, Socialism and Communism* (Berlin and New York, De Gruyter), p. 382).

In 'The Pathos of the Proletariat', *AA*, 35, Rosenberg quotes this fragment from *Capital* with reference to the Hegelian dialectic as summarised by Marx: 'it includes in its comprehension an affirmative recognition of the existing state of things, at the same time also, the recognition of the negation of that state, of its inevitable breaking up'. For the classic formulation of the negation of the negation see FOWKES, BEN (trans, 1976) MARX, KARL *Capital I* (Harmondsworth and London: Penguin/New Left Review, 1976), p. 929: 'The capitalist mode of appropriation, the result of the capitalist mode of production, produces capitalist private property. This is the first negation of individual private property, as founded on the labour of the proprietor. But capitalist production begets, with the inexorability of a law of Nature, its own negation. It is the negation of the negation. This does not re-establish private property for the producer, but gives him individual property based on co-operation and the possession in common of the land and the means of production.'

However, the negation of the negation cannot produce a self-sustaining positivity. Accordingly the positive value of the social revolution must be constituted through successive stages of development and transition. The social revolution prevents the dialectical movement coming to an end; the proletariat will continually remake society and itself.

ZIZEK, SLAVOJ (1989) *The Sublime Object of Ideology* (London: Verso), pp. 176–7, provides this useful gloss on the negation of the negation and identity which is also helpful with regard to reading what Rosenberg writes, *TN*, 32, about the American action painters' 'revolution against the given, in the self and in the world': 'This is also, in a nutshell, the logic of the "negation of the negation", this double, self-referen-

tial negation does not entail any kind of return to positive identity, any kind of abolition, of cancellation of the disruptive force of negativity, of reducing it to a passing moment in the self-mediating process of identity; in the "negation of the negation", the negativity preserves all its disruptive power; the whole point is just that we come to experience how this negative, disruptive power, menacing our identity, is simultaneously a positive condition of it. The "negation of the negation" does not in any way abolish the antagonism, it consists only in the experience of the fact that this immanent limit which is preventing me from achieving my full identity with myself simultaneously enables me to achieve a minimum of positive consistency, however mutilated it is.

'This, then, is the "negation of the negation", not a kind of "superseding" of negativity but the experience of the fact that *the negativity as such has a positive function*, enables and structures our positive consistency. In simple negation there is still the pre-given positive identity which is being negated, the movement of negativity is still conceived as the limitation of some pre-given positivity; while in the "negation of the negation", negativity is in a way *prior to what is being negated*, it is a negative movement which opens the very place where every positive identity can be situated.'

44 *TN*, 214.
45 *TN*, 215.
46 *Ibid*.
47 *TN*, 218.
48 *TN*, 220.
49 See HOLLINGER, DAVID A (1975) 'Ethnic Diversity, Cosmopolitanism and the Emergence of the American Liberal Intelligentsia', *American Quarterly* vol. XVII, no 2, May, pp. 133–51, especially with reference to Rosenberg pp. 146–7: 'Although it would be an exaggeration to say that New York took the place of Paris as the cultural capital, the temporary ascendancy of Hitler in Europe suddenly transformed America, as Kazin put it in [*On Native Grounds*] 1942, into a repository of

Western Culture in a world overrun by its enemies. This impression was not simply a general one; it had the specific reinforcement of the new intellectual migration. However parochial and nativist American society remained in the 1930s and early 1940s, it at least managed to accept a number of prominent political dissenters and non-Aryan physicists, philosophers, and psychoanalysts driven out of Central Europe. The presence in America of spirits like Thomas Mann, Jacques Maritain, and Albert Einstein, noted Kazin, intensified one's pride in trying to create here "a new cosmopolitan culture". Values once associated with Europe, especially Paris, now had no physical, geographical, social foundation more solid than that provided by the United States. Suddenly America did not seem so outrageously provincial. This is the context in which we must see the legendary patriotism of the intelligentsia in the Cold War era.

'With varying degrees of certainty and enthusiasm, the intelligentsia of the 1940s and 1950s believed that the United States had become a viable, if imperfect embodiment of the cosmopolitan ideal. This "nationalism" triumphed only when it was felt to be distinct from the sensibility of the same name that had been so firmly rejected by the likes of Bourne, Cohen, and Rosenberg [in 'On the Fall of Paris']. The superiority of America to the Soviet Union was partially described in terms of the greater freedom and diversity that seemed to characterize American society. One needs neither to quarrel with nor to affirm the appropriateness of this assessment to understand that much of its persuasiveness derived from the actual social circumstances of the intelligentsia at the time its members had come out of their various exiles—expatriation, the Diaspora, displacement from contemporary Europe—to find not simply America, but to find each other. Feeling, in each other's presence, that cosmopolitanism was substantially a fact, they could not only choose sides in the Cold War, but could even show selective appreciation for American provincialism. The life

depicted in [AGEE, JAMES and EVANS, WALKER] *Let us now Praise Famous Men* was in no way a threat and could be drawn upon as a source of insight, in accordance with the cosmopolitan ideal. The same could be felt about even Brooklyn or the Lower East Side; [KAZIN, ALFRED] *A Walker in the City* could scarcely have been written until its author was utterly secure not simply as an American but as a cosmopolitan'.

50 ROSENBERG, HAROLD (1959) 'Tenth Street: A Geography of Modern Art', *Art News Annual* XXVIII, pp. 120–37, 184, 186, 190, 192; reprinted with slight modifications in (1973) *DP*, pp. 100–109.

51 *DP*, 102.

52 *DP*, 103.

53 *DP*, 104.

54 *DP*, 106.

55 *DP*, 104.

56 See *DP*, 104, 'Identical with rotting side streets in Chicago, Detroit, and Boston, Tenth Street is differentiated only by its encampment of artists. Here de Kooning's conception of "no environment" for the figures of his *Women* has been realised to the maximum with regard to himself.' According to HESS, THOMAS B (1968) *Willem de Kooning* (N.Y., The Museum of Modern Art) pp. 78–9, the idea of 'no environment' was developed by de Kooning while he worked on *Woman I* (1950–52) to refer to 'the American urban scene and its lack of specificity. Everything has its own character but its character has nothing to do with any particular place'. ROSENBERG (1973) in *Willem de Kooning* (N.Y., Abrams), p. 15, refers to de Kooning arriving at his concept of 'no style' ' as an aspect of 'the act of painting': 'Transient and imperfect as an episode in daily life, the act of painting achieves its form outside the patternings of style. It cuts across the history of art modes and appropriates to painting whatever images it attracts into its orbit. "No Style" painting is neither dependent upon forms of the past nor indifferent to them. It is transformal . . .' Given that in 'The Fall of Paris', 1940, Rosenberg had discussed the

Paris Modern as a 'No-Time' and the Paris 'International' as a 'No-Place' it seems likely that de Kooning developed the idea of 'no environment' from Rosenberg. That is to say, the idea was probably a resource which Rosenberg and de Kooning shared, and shared with other persons in their bit of the New York avant-garde artistic community, with John Cage, for example. As pointed out in SHIFF, RICHARD (1987) 'Performing an Appearance: On the Surface of Abstract Expressionism', in AUPING, MICHAEL (Ed) *Abstract Expressionism: the Critical Developments* (Harry N Abrams Inc. in association with the Albright-Knox Art Gallery), p. 121, note 77, 'The concept "no style", indicating both emptiness and plenitude, might also be related to the teachings of Zen'—as indeed it was for Cage.

Here it is worth recalling part of the statement which Cage wrote to accompany Robert Rauschenberg's *White Paintings* (1951) when they were exhibited at the Stable Gallery in September 1953:
'To Whom:

> No subject
> No image
> No taste
> No object
> No beauty
> No message
> No talent
> No technique (no why)
> No idea
> No intention
> No art
> No feeling
> No black
> No white (no *and*)

'After careful consideration, I have come to the conclusion that there is nothing in these paintings that could not be changed, that they can be seen in any light and are not destroyed by the action of shadows.'

Maybe—it's possible—Rosenberg had Rauschenberg's *White Paintings* in mind when he wrote in 'The American Action Painters', *TN*, 26: 'The new American painting is not "pure" art, since the extrusion of the object was not for the sake

of the esthetic. The apples weren't brushed off the table in order to make room for perfect relations of space and color. They had to go so that nothing would get in the way of the act of painting. In this gesturing with materials the esthetic, too, has been subordinated. Form, color, composition, drawing, are auxiliaries, any one of which— or practically all, as has been attempted logically, with unpainted canvases—can be dispensed with.'

If, in 1952, he did have Rauschenberg's *White Paintings* in mind, then he seems to have changed his mind, or at least modified it later. In 1969 he told this story against them, see (1972) 'Icon Maker Barnett Newman', *The De-definition of Art* (New York: Collier Books, 1973), p. 91: 'The late Barnett Newman worked with emptiness as if it were a substance. He measured it, divided it, shaped it, colored it. He might even be said to have had a proprietary interest in it; when Rauschenberg, some years after Newman's first exhibitions, at the outside of the fifties, showed four unpainted canvases joined together, the older artist commented, 'Humph! Thinks it's easy. The point is to do it with paint.'

57　*DP*, 104.

58　*Ibid.*

59　ROSENBERG, HAROLD (1949) 'The Pathos of the Proletariat', *The Kenyon Review*, vol XI, no 4, Autumn, pp. 595–629, reprinted in *AA*, pp. 2–57.

60　ROSENBERG, HAROLD (1948) 'The Resurrected Romans', *Kenyon Review*, vol X, no 4, Autumn, pp 602–20, reprinted in *TN* (1982), pp 154–77.

61　*AA*, 206.

62　Born in New York City in 1906, Rosenberg attended City College, 1923–24, Brooklyn Law School, and graduated with a law degree from St Lawrence University in 1927.

63　*TN*, 138.

64　*TN*, 146–149.

65　*TN*, 149.

66　*TN*, 152. Rosenberg is here rewriting that bit of Marx's third thesis on Feurbach which goes: 'The coincidence of the changing of circumstances and of human activity or self-changing can be achieved and rationally understood only as a revolutionary practice.' By 1933 the *political* reading would have become unavoidable.

67　*AA*, 14.

68　*AA*, 15.

69　*AA*, 47.

70　*AA*, 17–18.

71　*AA*, 19.

72　*Ibid.*

73　*AA*, 21.

74　*AA*, 22.

75　*Ibid.*

76　*AA*, 23.

77　*Ibid.*

78　*Ibid.*

79　*AA*, 27. Rosenberg has a note here: '★One effect of American indignation is to play down the difference in spiritual form of a nation with a past of immigration, pioneering and democratic revolts. The official American view is that America has a culture, too; in other words, an inheritance like any other country. Yet American writers and artists know through experience that they cannot hope to define themselves as individuals so long as they follow European models in respect to the past, even a past of their own. *Moi, je suis barbare*, defiantly declared a character in one of Dostoyevsky's stories. It would be a gain for American consciousness if it, too, boldly accepted its predicament as a nation (aging) of "new men".'

80　*AA*, 28.

81　*AA*, 31.

82　On the place the United States held in Lenin's thinking, see (1970) *Lenin on the United States: Selected Writings by V.I.Lenin* (N.Y., International Publishers). Trotsky's most extended discussion of the economics and politics of U.S. monopoly capitalism is to be found in the introduction to his book (1939) *The Living Thoughts of Karl Marx* (Philadelphia, D.M.McKay Co.) which was published separately as (1947) *Marxism in the United States* (N.Y., Workers Party Publications).

83　Rosenberg has a note here: ' ★ In comparing

the American and the proletariat we are thinking of them, of course, not as categories, where they overlap (since many Americans are wage workers), but as collective entities or types—the first actual, the second hypothetical.'

84 *AA*, 29.

85 *AA*, 30.

86 Rosenberg has a note here: ' ★ Only *"half"* figuratively, since becoming Americans has been the actual salvation chosen by millions of workingmen from older nations. With the proletariat there is more to the impulse to become an American than the desire for economic opportunity, flight from oppression, etc. Primarily, it is a will to enter a world where the past no longer dominates, and where therefore that creature of the present, the workingman, can merge himself into the human whole. Thus proletarians immigrate to America in a different spirit from middle-class people or peasants, who from the moment they enter "American time" experience it as something disconcerting and even immoral, and whose nostalgia for their homelands and customs is often communicated from one generation to the next. But America's thin time crust, that seems so desolate to immigrants of other classes, is precisely what satisfies the proletariat and has provided so many workers with the energy to become leaders of industry. Becoming American is a kind of revolution for foreign proletarians, though it is a magical revolution rather than a revolutionary act. It alters the workingman's consciousness of himself; like a religious conversion it supplies him with a new identity. But this change does not extinguish his previous situation as a character in the capitalist drama; he is still in the realm of economic personifications. As an American, too, a social-economic role will be assigned to him: worker, farmer, capitalist. The elimination of these abstract types continues to call for a transformation of the historical "plot".'

87 *AA*, 32. CANNON, JAMES P (1960) 'Trotsky in the United States', *Internationalist Socialist Review*, Fall; reprinted in (1969) *Leon Trotsky: the Man and his Work* (N.Y., Merit Publishers), pp. 87–88. Cannon quotes this fragment from Trotsky's (1926) 'Europe and America', which is relevant here: 'In this "revolutionary Marxist critique of Americanism . . . we do not at all mean thereby to condemn Americanism, lock, stock, and barrel. We do not mean that we abjure to learn from Americans and Americanism whatever one can and should learn from them. We lack the technique of the Americans and their labor proficiency . . . to have Bolshevism shod in the American way—there is our task! . . . If we can get shod with mathematics, technology, if we Americanise our frail socialist industry, then we can with tenfold confidence say that the future is completely and decisively working in our favor. Americanised Bolshevism will crush and conquer imperialist Americanism".'

88 GOODNOUGH, ROBERT (1951) 'Pollock paints a picture', photographs by Hans Namuth, *Art News*, vol.50, no.3, May, pp. 38–41, 60–61.

89 See what Rosenberg wrote in his review of ROBERTSON, BRYAN (1961) *Jackson Pollock* (N.Y., Abrams) with regard to Pollock or something Pollock is supposed to have said to him: ROSENBERG, HAROLD (1961) 'The Search for Jackson Pollock', *Art News*, vol.59, no.10, February, pp. 59–60: 'according to Robertson . . . "During a conversation in 1949 with Harold Rosenberg, Pollock talked of the supremacy of *the act of painting* as in itself a source of magic. An observer with extreme intelligence, Rosenberg immediately coined the new phrase: action painting". (Robertson's italics). The aim of this statement is obviously to present Pollock as the originator of Action Painting in theory and in practice, if not in name . . . The statement is, of course, entirely false, and whoever informed Mr. Robertson that this conversation took place knew it was false. Pollock never spoke to Rosenberg about about the "act of painting", of its "supremacy" (to what?) or of any "source of magic" in it. This can easily be demonstrated. The con-

cept of Action Painting was first presented in the December, 1952, *ARTNews*, so that if the conversation described by Robertson had taken place in 1949 Rosenberg did not produce the phrase "immediately" but waited three years. It may have required that much time for him to penetrate the depths of Pollock's observation, but in that case one would be justified in questioning his "extreme intelligence". On the other hand, Rosenberg had *published* writings on the subject of action as constitutive of identity as far back as 1932; in 1948, a year before the alleged tip-off, he further elaborated the topic in an essay in *The Kenyon Review* entitled "The Resurrected Romans", which may have had something to do with "magic" but nothing to do with Pollock or with painting. A conversation between Pollock and Rosenberg did occur in 1952, immediately preceding the composition of "The American Action Painters" but in this talk Pollock said nothing about action. He spoke of identifying himself with a tree, a mode of self-stimulation not unknown in the tradition of which we have been speaking and more relevant to the paintings for which he is famous. He also attacked a fellow artist for working from sketches, which in Pollock's opinion made the artist "Renaissance" and backward (this point was reported in the "Action Painters" essay, though without mentioning names). In the last years, Robertson informs us, Pollock liked to refer to the canvas he was working on as "the arena"—this term was garnered from "The American Action Painters", which says: "At a certain point the canvas began to appear to one American painter after another as an arena in which to act." Apparently, Pollock, or someone presently speaking for him, wished to acquire this thought for himself exclusively, although Rosenberg told Pollock, in the presence of a witness, that the article was not "about" him, even if he had played a part in it . . .'

Despite this the idea that Pollock was somehow the model for 'action painting' or provided Rosenberg with the idea, or that Namuth's photographs of Pollock at work

did, persists. See, for example, the letters exchanged between Rosenberg and William Rubin in *Artforum*, April 1967, pp. 6–7 and, especially, May 1967, p. 4, correspondence concerning RUBIN, WILLIAM (1967) 'Jackson Pollock and the Modern Tradition, Part I', *Artforum*, February, pp. 14–22. See also ROSE, BARBARA (1979) 'Hans Namuth's Photographs and the Jackson Pollock Myth: Part One: Media Impact and the Failure of Criticism', *Arts Magazine*, vol.53, no.7, March, pp. 112–19, especially pp. 112–13; and more recently SOLOMON, DEBORAH (1987) *Jackson Pollock: a Biography* (N.Y., Simon and Schuster) p. 210; LANDAU, ELLEN G (1989) *Jackson Pollock* (N.Y., Abrams) pp. 85–6; and NAIFEH, STEVEN and SMITH, GREGORY WHITE (1989) *Jackson Pollock: an American Saga* (N.Y., Clarkson N. Potter) pp. 703–7.

90 (1965) 'An Interview with Robert Motherwell', *Artforum*, vol.IV, September, p. 37: 'At that time I was editing "Dada" proofs of Huelsenbeck's which ultimately appeared in the Dada anthology [MOTHERWELL, ROBERT (Ed) (1951) *The Dada Painters and Poets: an Anthology* (N.Y., Wittenborn, Schulz, Inc) pp. 22–48] as "En Avant Dada" . . . Harold came across the passage in proofs in which Huelsenbeck violently attacks literary esthetes, and says that literature should be action, should be made with gun in hand, etc.'

91 (1947–48) *Possibilities*, no.1, Winter, pp. 41–3. (1951) *The Dada Painters and Poets: an Anthology*, p. 28.

92 (1965) 'An Interview with Robert Motherwell', *Artforum*, vol.IV, September, p. 37.

93 *TN*, 23–24.

94 *TN*, 35–36.

95 *TN*, 36.

96 *Ibid*.

97 *TN*, 37.

98 *TN*, 36.

99 On the internationalist 'business liberals' and the old-guard 'America First', isolationists as fractions of the U.S. ruling class, see the books of DOMHOFF, G. WILLIAM, for example (1967) *Who Rules America?*

(Englewood Cliffs, N.J., Prentice Hall) and (1978) *The Powers That Be: Processes of Ruling Class Domination in America* (N.Y., Random House). In (1953) 'Revolution and the Idea of Beauty', *Encounter*, vol.I, no.3, December, pp. 65–8 (reprinted and revised as 'Revolution and the Concept of Beauty', *TN*, 1982, pp. 74–83) Rosenberg discusses the use made of Modern Art by the likes of Representative George A Dondero (Michigan) and Alfred H Barr Jr. in (1952) 'Is Modern Art Communistic?' *New York Times Magazine*, 14 December, pp. 22–3, 28–30. Here is an example from the *Encounter* version pp. 65–6: 'You can take it from a noisy U.S. Congressman that modern art is subversive. Or you can take it from a philosophical anarchist, Herbert Read, who writes in his *The Philosophy of Modern Art*: "The modern movement in the arts which began to reveal itself in the first decade of the century was fundamentally revolutionary . . . When I characterise this movement as fundamentally revolutionary, I attach a literal meaning to these well-worn words".

'The *New York Times*, which hesitates to give the embarrassing label of revolutionary to things now hanging in respectable American homes and museums, recently printed an article demonstrating that abstract and expressionist art was banned in Nazi Germany and is outlawed in the U.S.S.R. If the Nazis and Communists have disapproved of the modernist mode, how can it be radical? But this way of defending modern art is surely a bit sly. The antagonism to modern art of Fascists or Communists does not exonerate it of subversiveness. It could even, perhaps, show just the opposite: that modern art is so subversive it is looked upon as a danger even by "revolutionary" regimes. (Another possible interpretation is that the hostility, which was not evident in the early years of Fascism and Bolshevism, is proof that these movements in time stopped being revolutionary.)

'It would seem that what one can say is that modern art is revolutionary, but that

this revolution is neither Communist nor Fascist [. . .]

'It is not important therefore to try to remove the confusions inherent in the notion of revolutionary art, even if that were possible. It is necessary, however, to expose the fact that there is a confusion, especially now that the adulteration of art with politics (and of politics with art) has ceased to be innocent. Today, everyone ought to be aware that revolution in art and revolution in politics are not the same thing, and may even contradict one another. But this awareness is kept under cover for professional reasons. What takes its place is sophisticated impure play upon the ambiguities of the revolutionary position, radical painters being palmed off as respectable (as in the *New York Times* article), philistine work screaming that it is changing the world. The result is an atmosphere of *mauvaise conscience*, or, more simply, of dupery and semi-dupery. Today, the poison of bad conscience about revolution is the specific malady of art.'

100 *TN*, 36.
101 *TN*, 37.
102 *TN*, 38.
103 *TN*, 39.
104 *TN*, 24.
105 *Ibid.*
106 *Ibid.*
107 *AA*, 29.
108 *TN*, 30.
109 *Ibid.*
110 Which is not to say that there is not a political, aesthetic and moral purport to Action Painting as 'painting in the medium of difficulties'. See the note provided by Rosenberg, *The Tradition of the New* (McGraw Hill paperback, 1965), and the subsequent reprints, *TN*, 33–34: 'As other art movements of our time have extracted from painting the element of structure or the element of tone and elevated it into their essence, Action Painting has extracted the element of decision inherent in all art in that the work is not finished at its beginning but has to be carried forward by an accumulation of right gestures. In a word, Action

Painting is the abstraction of the moral element in art; its mark is moral tension in detachment from moral or aesthetic certainties; and it judges itself morally in declaring that picture to be worthless which is not the incorporation of a genuine struggle, one which could at any point have been lost.'

111 *TN*, 30.

112 *Ibid.*

113 *TN*, 25.

114 *Ibid.*

115 For an interesting discussion of the indexical and iconical in Abstract Expressionism see SHIFF, RICHARD (1987) 'Performing an Appearance: On the Surface of Abstract Expressionism', *Abstract Expressionism: the Critical Developments*, pp. 94–123.

116 *TN*, 26–27.

117 For an account of Ur-painting see WOLL-HEIM, RICHARD (1987) *Painting as an Art* (Princeton University Press), pp. 19–25, p. 359, n. 9.

118 *TN*, 27–28.

119 *TN*, 29.

120 *TN*, 28.

121 Rosenberg has a note here '★Razkolnikov, for example in *Crime and Punishment*, sought judgment so that his act would be completed and he could take on a new existence.'

122 *TN*, 136.

123 *TN*, 28.

124 *TN*, 136.

125 *TN*, 31.

126 *Ibid.*

127 *AA*, 31–32.

128 *TN*, 32.

129 *TN*, 24.

130 Here I had in mind something of what Alasdair MacIntyre writes in his conclusion to (1981) *After Virtue: A Study in Moral Theory* (University of Notre Dame Press), pp. 243–4: 'Here I was of course speaking of Marxists at their best in say Yugoslavia or Italy; the barbarous despotism of the collective Tsardom which reigns in Moscow can be taken to be as irrelevant to the question of the moral substance of Marxism as the life of the Borgia pope was to that of the moral substance of Christianity. None the less

Marxism has recommended itself precisely as a guide to practice, as a politics of a peculiarly illuminating kind. Yet it is just here that it has been of singularly little help for some time now. Trotsky, in the very last years of his life, facing the question of whether the Soviet Union was in any sense a socialist country, also faced implicitly the question of whether the categories of Marxism could illuminate the future. He himself made everything turn on the outcome of a set of hypothetical predictions about possible future events in the Soviet Union, predictions which were tested only after Trotsky's death. The answer that they returned was clear: Trotsky's own premises entailed that the Soviet Union was not socialist and that the theory which was to have illuminated the path to human liberation had in fact led into darkness.

'Marxist socialism is at its core deeply optimistic. For however thorough-going its criticism of capitalist and bourgeois institutions may be, it is committed to asserting that within the society constituted by those institutions, all the human and material preconditions of a better future are being accumulated. Yet if the moral impoverishment of advanced capitalism is what so many Marxists agree that it is, whence are these resources for the future to be derived? [. . .]

'A Marxist who took Trotsky's last writings with great seriousness would be forced into a pessimism quite alien to the Marxist tradition, and in becoming a pessimist he would in an important way have ceased to be a Marxist. For he would now see no tolerable alternative set of political and economic structures which could be brought into place to replace the structures of advanced capitalism. This conclusion agrees of course with my own. For I too not only take it that Marxism is exhausted as a political tradition, a claim borne out by the almost indefinitely numerous and conflicting range of political allegiances which now carry Marxist banners—this does not at all imply that Marxism is not still one of the richest sources of ideas about modern

society—but I believe that this exhaustion is shared by every other political tradition within our culture.'

131 *AA*, 557.

132 *TN*, 33.

133 *TN*, 34.

134 *TN*, 27.

135 ROSENBERG, HAROLD and MOTH-ERWELL, ROBERT (1947–48) 'Possibilities', *Possibilities*, no.I, Winter, p. 1: 'If one is to continue to paint or write as the political trap seems to close upon him he must perhaps have the extremist faith in sheer possibility.'

136 MARX, KARL (1844) 'Introduction' *Critique of Hegel's Philosophy of Right*.

FRED ORTON

Footnote One: the Idea of the Cold War

This paper is nothing more than a footnote to be added to the histories of Abstract Expressionism's belonging to a Cold War polity [1]. The very idea of the Cold War is a problem. If we want to consider questions like 'What were the circumstances in which a national bourgeoisie, in pride of its victory, came to want something as odd and exotic as an avant-garde of its own?' and 'To what extent was the meeting of class and art practice in New York in the later 1940s more than just contingent?'—the kinds of questions asked of Abstract Expressionism by the Social History of Art—we would be well advised to consider what sets of ideas and beliefs are mobilised when we appropriate the idea of the Cold War as a resource with which to ask our questions and research and write our answers [2].

The idea of the Cold War is of limited use for understanding U.S. foreign and domestic policy at the beginnings of the post-war world, which is to say that it is of limited use for understanding Abstract Expressionism's place and function in—what has been referred to as—'the world fiction called America' [3] between 1946 and 1956 or thereabouts. The idea of the Cold War has the form of an irreconcilable conflict between two different social systems: the U.S.A. and the Soviet Union; the Free World and the Communist Bloc; democracy versus red fascist [4] or socialist totalitarianism. The Cold War is a constraining notion, a closure, which conditions us not to probe deeper the real determinations of foreign and domestic policy, and the violence and conflict which were an integral part of them. At some level—the level of language, of procedure, of presuppositions about world making—Abstract Expressionism belonged to these determinations, was part of their effected violence and conflict.

Revisionist historians have shown that U.S. foreign policy in the early post-war period was determined not so much by the fear or the threat of the Soviet Union as by a concern that the U.S. would retreat to the isolationism, nationalism, and economic depression of the 1930s [5]. When the U.S. emerged from the Second World War as the strongest military and economic nation on the globe, it did so with policy makers who were confident of their ability to reconstruct the world according to objectives which they had identified before it entered the war. Between 1939 and 1941 they had come to the conclusion that the war was going to end with the U.S. in a position of global domination [6]. The question was: 'How do we organise the world?' Essential to that planned for new world organisation was the conviction that there should be no fundamental changes, no redistribution

of income and power, no modification of the basic structures of and within the U.S. It was the world that had to be reconstructed, not the U.S., changed so that a certain kind of business—a certain kind of national bourgeoisie—could operate and profit without restriction wherever it needed to. What was required was a world of politically reliable, stable, conservative and subservient capitalist nations and free access to their markets and raw materials. In geographical terms the minimum necessary 'Grand Area'—as it was referred to—included the entire Western Hemisphere, the British Empire and the Commonwealth, the Far East, China and Japan.

However, neither Congress nor Joe Public were likely to endorse or pay for such an expansionist and interventionist foreign policy unless they could be persuaded that the war was not yet fought and won. They were persuaded of this in 1947 when Britain's withdrawal of financial and military aid to Greece presented President Truman and his advisers with an opportunity they could not afford to miss. The Truman Administration realised that here was the basis for consolidating U.S. power in the Middle East and for mobilising Congressional and public support for an expansionist foreign policy. Initially the problem was articulated as a need to prevent Greece going Left. The U.S. was committed to intervene to prevent the defeat of the fascist government there. In a larger context, however, the problem of the British withdrawal was regarded as a crisis in the world economy and a test of the U.S. ability to cope with it. The Soviet Union was not an originator of these conditions nor was it a protagonist in Greece. Stalin was well aware that Greece was an area central to U.S. power. The Russians had no role to play there.

On 12 March 1947 President Truman went before a joint session of Congress and delivered his 'Doctrine'. Truman appealed for financial and military aid for Greece, a country devastated by the Germans and threatened still further by Communist led terrorist attacks along its borders with Albania, Bulgaria, and Yugoslavia. He conceded that the Greek government was not perfect, but maintained that it needed the support of the U.S. if Greece was to become a self-supporting democracy and survive as a free nation. He also argued that Greece's neighbour Turkey needed U.S. aid so that it could continue the 'modernisation' of its national integrity which was essential for preserving order in the Middle East. Truman asserted that if Greece fell to the communists the effect on Turkey would be immediate and serious. Confusion and disorder would spread through the Middle East and the effect of this would be far reaching for the West. This being the case, Truman continued, it had to be U.S. policy to support free peoples everywhere and at any time to maintain their free institutions and national sovereignty against aggressive movements whether armed minorities within a country or external pressures that sought to impose their totalitarian regimes. Poland, Rumania, and Bulgaria were given as examples. Finally, Truman requested that Congress appropriate $400 millions for aid and stressed that though he did not intend to send troops to the Middle East there was a need for military

and civilian personnel to be sent to help administer and offer advice. He got everything he asked for [7].

The importance of the Truman Doctrine to U.S. foreign policy cannot be overestimated. With it the U.S. replaced Britain as the economic and strategic power in the Middle East, and more than that. For the purposes of this paper the most important thing about it—and Noam Chomsky pointed this out in a lecture he gave at the Polytechnic of Central London in 1981—is what a 'marvellous device' the Cold War was

> for mobilising the domestic population in support of the aggressive and interventionalist policies of America's ruling class under the threat of a super power enemy. [8]

The rhetoric of the Truman Doctrine and the idea of the Cold War obfuscates the fact that ruling class interest was the main determination of the move which the U.S. made from traditional expansionism to imperialism after World War II. Chomsky's mention of 'America's ruling class' was, for me, his talk's moment of blindness and insight. Insight because it so clearly tied an idea of class to the Truman Doctrine. Blindness because Chomsky gave little indication of what, or who, 'America's ruling class' was. It was too bloc-like; it needed fractionalising; and those fractions had to be understood as functioning in terms of alliances with other class fractions; and all those fractions had to be understood as engaged in a struggle—class struggle—in and through which they would achieve political and cultural representation.

In several books published between 1967 and 1979, G. W. Domhoff was at pains to describe and document the existence in the U.S. of a national social upper class of businessmen and their descendants that came into existence in the late-nineteenth century as owners of the means of production which was held together by such institutions as stock ownership, trust funds, intermarriages, private schools, exclusive clubs and resorts [9]. It makes up less than one per cent of the population and owns or controls—or did so until quite recently—not only the major corporations and banks, etc., which dominate the U.S. economy, but also the foundations and universities, the largest of the mass media, major policy making and opinion forming organisations, the executive branch of government, the regulating agencies, the federal judiciary, the military, the C.I.A., and the F.B.I. To all extents and purposes Domhoff's object of study was the processes of ruling class domination within the U.S. As far as I am aware, however, he never made it clear—though he provided the evidence for doing so—that at any moment in its history the class which controls the State and the cultural apparatus is but one fraction of that social upper class he so fully documented. He knows the class is fractionalised but he does not realise the importance of this for answering the kinds of questions he is interested in asking—questions like '*Who Rules America?*' or 'Who are *The Powers That Be* at any historically specific moment?'

Not surprisingly—inevitably—the fractions are based on antagonisms, the most

important of which are clashes between different business interests or different kinds of capital. To make this point Domhoff uses an observation of C. Wright Mills:

> In the higher circles of business and its associations, there has long been a tension, for example, between the 'old guard' of practical conservatives and the 'business liberals', or sophisticated conservatives. What the 'old guard' represents is the outlook, if not always the intelligent interests, of the more narrow economic concerns. What the 'business liberals' represent is the outlook and interests of the newer propertied class as a whole. They are 'sophisticated' because they are more flexible in adjusting to such political facts of life as the New Deal and big labour, because they have taken over and used the dominant liberal rhetoric for their own purposes, and because they have, in general, attempted to get on top of, or even slightly ahead of, the trend of these developments rather than to fight it as the practical conservatives are wont to do. [10]

I have my quibbles with this and they are obvious enough. But it is a useful observation.

The 'old guard' are the nationally oriented businessmen whose associations are the National Association of Manufacturers, the Chamber of Commerce of the United States, the American Enterprise Institute, and the American Security Council, and generally they are right-wing Republicans. The 'old guard' tends towards 'America First' isolationism, the flag propped up by guns, self-sufficiency in terms of production and consumption, circulation and exchange, and expansion but only in the Western Hemisphere. The 'business liberals' are internationalists, committed to an 'Open Door' policy. Primarily East Coasters, their main concern is with making money and keeping it on a grand scale through investment and trade that covers the world. They operate through their own policy-making institutions such as the Council on Foreign Relations, the Council on Economic Development, the Business Advisory Council, the Democratic Party and the moderate wing of the Republican Party. The key fractional conflict between the 'old guard' and the 'business liberals' was articulated over foreign policy, between nationalism and internationalism.

The image of the U.S. during the period from the end of the First World War to its entry into the Second World War is one of isolationism. It begins, I suppose, when Congress, vetoing an overtly activist foreign policy, rejected unqualified U.S. membership of the League of Nations and, thereafter, moved further into isolationism and nationalism when the depression hit in 1929. It is possible to exaggerate this, but the clear contrast with the period following the outbreak of the War in 1939 points to a difference between those who held State power in the 1920s and 1930s and those who came to hold that power at the end of the 1930s and to exercise it in the 1940s. Before the War it was held by the 'old guard' nationalists.

After the War it was held by those who needed to get their finance capital out and about in the world and by those who had most to gain by avoiding crises in their expanding industries by an expansionist and interventionist foreign policy, the 'business liberal' internationalists [11].

The 'business liberals' struggled for ruling class power during the 1920s and 1930s but it was not until they gained control over foreign policy formulation and implementation between 1939 and 1941 (the moment can be dated very accurately) that they achieved that power. In a sense the Truman Doctrine marked the consolidation of the 'business liberals' achieving power at home (in the modern period foreign policy determines domestic policy) and inaugurated the implementation of its aims abroad. Truman may have spoken his tenets in the name of the American people but his Doctrine was delivered very much on behalf of that fraction—the ruling fraction—of the national bourgeoisie whose political and economic interests he and his administration represented. And having achieved their desired power the 'business liberals' then had to defend it and struggle to retain it at home and abroad.

The class struggle between the ruling 'business liberals' and the 'old guard' was most publicly carried on in the private institutions of the cultural apparatus. Here, the State Power, legal and political, controlled by the 'business liberals' could be effectively used against it by the 'old guard'.

Louis Althusser, philosophising about ideology and the State, got this much right when he wrote that

> *no class can hold State power over a long period without at the same time exercising its hegemony over and in the State Ideological Apparatuses . . .* This last comment puts us in a position to understand that the Ideological State Apparatuses may be not only the *stake*, but also the *site* of class struggle, and often of bitter forms of class struggle. [12]

This, I suggest, is how we should understand the various attacks made on modernist art between 1946 and 1956. They have to be seen as an aspect of the class fractional struggle within that bit of the U.S. national bourgeoisie which owned the means of production, as incidents fought out using the rhetoric of the Cold War: the 'business liberal' internationalists being, as it were, *for* modernist art; the 'old guard' nationalists being, as it were, *against* it.

The first site of this particular struggle seems to have been the exhibition of seventy-nine paintings which the State Department purchased to tour Europe and Latin America in 1947, *Advancing American Art* [13]. This exhibition included work by Walt Kuhn, John Marin, Max Weber, William Gropper, Ben Zion, Ben Shahn, Stuart Davis, Yasuo Kuniyoshi, Adolph Gottlieb, William Baziotes, and Jack Levine. It was attacked in the pages of the *New York Journal-American* and the other seventeen daily papers owned by the 'old guard' nationalist Randolph Hearst. *The New York Journal-American* referred to it as a 'Red Art Show,' and pointed to 'left-wing painters' like Davis, Gropper, and Zion and others who were said to be

members of Communist-front organisations [14]. The show was made up of the work of 'a lunatic fringe' and concentrated 'with biased frenzy' on what was 'incomprehensible, ugly, or absurd' [15]. It was also attacked by various groups like the National Academy of Design, Allied Artists, The Salgamundi Club, the Society of Illustrators, and the American Artists Professional League. The criticism of the American Artists Professional League was typical:

> the exhibition devalued all that was noble in art, was one sided, and was influenced by radical European trends not indigenous to our soil. [16]

The State Department, under scrutiny from Congressional appropriation committees and worried about the future of the Office of Information and Cultural Affairs, capitulated, cancelled the exhibition, and recalled it from abroad. What happened with *Advancing American Art* seems to have set the the pattern, strategy and language used in subsequent struggles with and against modernist art. Later, after the United States Information Agency had been formed and had started sending art abroad in the 1950s, criticism that modern art was un-American, Communistic, and lunatic was usual. Of course, some of the exhibitors were or had been members of the Party, were Jewish, or had oriental names but anti-Communism, anti-Semitism and racism characterised both fractions of the national ruling bourgeoisie and the various fractions of the proletariat. The real issue obscured by this was which class fraction of the national bourgeoisie was going to advance the idea of modern American art abroad and at home.

The leading spokesman of the 'old guard', nationalist position on modern art was Congressman George Dondero, the Republican representative for Michigan's 17th. Congressional District [17]. Dondero entered Congress in 1932 opposed to Roosevelt's domestic and foreign policy. Under Truman he developed into an outspoken anti-Communist. He seems to have become interested in art during the struggles over *Advancing American Art* in 1947–48. In 1953, after the Republican victories, he was appointed Chairman of the House Committee on Public Works. He retired in 1956. The kind of Social History of Art which makes its case with Dondero usually does so with reference to only four speeches, all made in the House of Representatives in 1949, followed up by a sometimes quoted interview reported in *Harper's Magazine* (this was an unfriendly interview in an important 'business liberal' owned magazine; it is, of course, a Harper & Row publication) [18]. The speech of 16 August 1949 is favoured, the one that has in it the passage that goes like this:

> All these isms are of foreign origin, and truly should have no place in American art. While not all are media of social or political protest, all are instruments and weapons of destruction. [. . .] Cubism aims to destroy by designed disorder. Futurism aims to destroy by the machine myth. [. . .] Dadaism aims to destroy by ridicule. Expressionism aims to destroy by aping the primitive and insane. [. . .] Abstraction aims to destroy by the

creation of brainstorms. Surrealism aims to destroy by the denial of reason [. . .] [19]

Dondero knew his Modernism. The 'isms' and the chronology he used were surely appropriated from the art historical tradition mapped by the museum which was one of his major targets, the Museum of Modern Art, New York. But, if I am right, this attack went beyond the museum to those who owned it and whose interests in culture it represented; a hint is there in a reference—it comes near the beginning of the speech—to 'those who are now in the big money, and who want to remain in the big money', who are *confusing* 'the legitimate artist', *disarming* 'the arousing academician,' and *fooling* 'the public' [20]. 'Those who are now in the big money'? These persons are surely not the artists or the museum directors and curators.

In 1950 the directors of the MoMA, N.Y., the Institute of Contemporary Art (previously the Museum of Modern Art), Boston, and the Whitney Museum of American Art, N.Y., put out a joint response to Dondero's attack.

> We . . . reject the assumption that art which is esthetically an innovation must somehow be socially or politically subversive, and therefore un-American. We deplore the reckless and ignorant use of political or moral terms in attacking modern art. We recall that the Nazis . . . and . . . the Soviets suppressed modern art . . . and that Nazi officials insisted and Soviet officials still insist upon a hackneyed realism saturated with nationalistic propaganda. [21]

In December 1952, *The New York Times Magazine* published 'Is Modern Art Communistic?' by Alfred H. Barr Jr., Director of Collections at the MoMA, N.Y. This was a belated and rather weak response to attacks on modern art in New York and Los Angeles in 1951 and to Dondero's 1952 speech in the House. Barr concludes:

> It is obvious that those who equate modern art with totalitarianism are ignorant of the facts . . . Those who assert or imply that modern art is a subversive instrument of the Kremlin are guilty of fantastic falsehood. [22]

For many persons Dondero's speeches offered appealing slogans. His constituency extended far beyond Michigan's 17th. District. Disregarding consideration of who that constituency was—though it has been hinted at—Dondero's attack on Modernism and Communism, as with Joseph McCarthy's broader attack, masked the real issue being contested which was the struggle for class power between the nationalists and the internationalists [23]. Dondero's attack on Modernism must be seen as but an aspect of this broader struggle. What he was doing was attacking the fraction whose systems of beliefs, values, images and techniques of representation—whose ideologies—were represented in the cultural apparatus by modernist art and by the claims that were be made for it by, for example, Alfred H. Barr Jr.

I want to look at one more struggle in the cultural apparatus and how it can be understood as having been determined by the class struggle on which I have been insisting. It is another favourite example of the Social History of Art concerned with this period. In 1956 an exhibition organised by the magazine *Sports Illustrated* titled *Sport in Art* was sponsored by the United States Information Agency to tour the U.S. and thereafter to travel to Australia during the Olympic Games which were being held there [24]. The show was assembled by the American Federation of Arts, and one of its destinations was the Dallas Museum of Art, Dallas, Texas.

The Dallas Museum had been criticised locally for over emphasising

> all phases of futuristic, modernistic, and non-objective [art] . . . [and for] promoting the work of artists with known communist affiliation to the neglect of . . . many orthodox artists, some of them Texans, whose patriotism . . . has never been questioned. [25]

The terms are familiar enough. Four months before *Sport in Art* arrived in Texas some of the exhibited works had been attacked on the grounds that they were by artists accused of having been aligned with 'the Communist-Socialist international group of subversives' [26]. These works were Ben Shahn's drawing of a baseball game, Yasuo Kuniyoshi's skating scene, another skating scene by Leon Kroll, and a painting of a fisherman by William Zorach. The museum's trustees defended the show but failed to mollify the criticism of the Dallas County Patriotic Council, a group made up of sixteen organisations including the Dallas posts of the American Legion and the Veterans of Foreign Wars. The exhibition went on show. The Patriotic Council had to be content with picketing outside and inside. Evidently persons were allowed to stand beside the pictures in question to warn the public that these were works by 'Reds' [27].

Sport in Art was a 'business liberal' affair. *Sports Illustrated*, the magazine which instigated it 'to cultivate the periphery of [its] field through publicity' was a Time Inc. publication owned by Henry Luce and backed by many well known members of the Eastern side of the 'business liberal' fraction, including representatives of Morgan and Rockefeller interest groups. Luce's wife, Clare Booth, was not only U.S. ambassador to Italy but also a trustee of the MoMA, N.Y. The Dallas Museum's trustees were led by Stanley Marcus, an important Texas 'business liberal', head of the big store Niemans-Marcus—which co-sponsored *Sport in Art* at the museum—and soon to become a member of the International Council at the MoMA, N.Y. It is a relatively straightforward matter, then, to identify those who were responsible for *Sport in Art* with a particular fraction of the ruling class. It is not so easy to do this with those who, in Dallas, protested against it [28]. As a group, they cannot be obviously and directly linked, as I linked those persons who protested *Advancing American Art*, to a key individual member of the nationalist isolationist fraction. It would be useful to know who owned the *Dallas Morning News* which closely followed the controversy (and may have effected it.) At this stage, I would like to eliminate Harold Lafayette Hunt from my enquiries. A

footnote in Jane de Hart Mathews's essay 'Art and Politics in Cold War America' directs us to him via an article in *Art News* [29]. I do not need Hunt to make the case, but he would be detail to make it with because he was a very important Texas new-monied nationalist, an oil millionaire who financed McCarthy, and no friend of the 'business liberal' internationalists [30].

The activities of the Communism in Art Committee of the Dallas Patriotic Council reverberated across the federation to Washington and forced the USIA to back out of sending *Sport in Art* abroad. *The New York Times* reported the decision on 21 June:

> The agency declined to comment today on the reasons for its stand on art matters . . . The problem has been extremely troubling for officials of the USIA, including Theodore Streibert, its Director.

Sport in Art was Streibert's third problem with 'subversive art' in 1956. Objections had been raised about an exhibition put together from U.S. university and college collections which was to travel abroad, because it contained a picture by Picasso who was a member of the French Communist Party. The Picasso problem had been solved but another plan to send abroad 100 twentieth-century American paintings to Europe had to be dropped because the American Federation of Arts who put the package together refused to allow the artists to be vetted for their political beliefs, or to remove works by ten 'social hazards' [31].

Almost immediately Streibert appeared before a Senate Foreign Relations Sub-Committee chaired by Senator J. William Fulbright (another member of the International Council at the MoMA, N.Y.) to explain the cancellations. Streibert stated that the USIA had 'a policy against the use of paintings by politically suspect artists in its foreign art shows' but refused to comment on reports 'that the cancellations were made because of charges of pro-Communism against some of the artists represented.' After the hearing Fulbright commented that he thought that art should be judged 'on its merits'; that he was not clear how the USIA could test the loyalty of artists, that 'looking into their political beliefs' was 'really an impossible task;' and that unless the agency changed its policy 'it should not try to send any more exhibitions overseas' [32]. The USIA did not change its policy; and it did not send any exhibitions of modern art overseas for quite a while. That job was taken over by the International Council at the MoMA, N.Y. [33], that is to say by the institution which by the mid 1950s was recognised as the international centre of collecting, exhibiting and disseminating knowledge of modernist art owned, as all Social Historians of Art know, by the Rockefellers and Whitneys, key members of the United States ruling class at that moment.

In this 1946–56 Cold War the Abstract Expressionists are conspicuous not by their presence but by their absence. They are not absent presences. *They were absent.* Those artists who figured in the cancelled *Advancing American Art* were not Abstract Expressionists, or were not yet Abstract Expressionists. Were there any Abstract Expressionists, Action Painters, 'American-Type' Painters, or New

American Painters in 1946? And none of those shown in *Sport in Art* ten years later were Abstract Expressionists either. That is hardly surprising. The Abstract Expressionists were not interested in representing or expressing sport in art. Well, maybe Pollock's *Number 23, 1951 "Frogman"* and De Kooning's *Woman and Bicycle* of 1952–53 could have been included; but the point is that they were not.

Dondero was not interested in Abstract Expressionism or the Abstract Expressionists. And Jackson Pollock was beyond paying the slightest attention when, in 1959, Congressman Francis Walter claimed that he was one of 34 of the 67 artists in a USIA exhibition of that year who had 'affiliations with Communist causes' [34].

Sure, Abstract Expressionism belonged to the MoMA, N.Y., to its collections and to the tradition it helped establish as the history of modern art. The MoMA, N.Y., got onto it very quickly. And it always included Abstract Expressionism when it sent its selections of the best of contemporary American art to the São Paulo and Venice Biennales of the 1940s and 1950s, though it never sent Abstract Expressionism abroad unchaperoned until the posthumous *Jackson Pollock* retrospective of 1956. But it did this sending as a private institution not accountable to Congress in the way the Office of Information and Cultural Affairs or the USIA were. And this was the way the 'business liberals' preferred it. And it was the MoMA, N.Y., who sent *The New American Painting* abroad to tour Europe in 1958, and brought it home as the *Triumph of American Painting*, as the most up to the moment movement in its international history of modern art [35]. Maybe we can talk of Abstract Expressionism's belonging to the Cold War at this point, but only, I suggest, if we pose the problem of its belonging in terms of how the MoMA, N.Y., created a tradition for modern art and situated Abstract Expressionism within that tradition at the moment when the fraction of the U.S. ruling class which owned the museum made its move to win and secure hegemony in a world market more or less of its own devising. It is not my intention to consider this here.

Of course, the Abstract Expressionists knew about the Cold War and its effects. 'Marvellous device' it may have been, but its effects were real enough. What did David Caute tell us [36]? 9,500 federal civil servants were dismissed; 15,000 federal civil servants resigned while under investigation; 3,800 seamen were fired; 600 teachers were dismissed; over 300 persons were blacklisted in movies, television and radio; 500 state and municipal employees were dismissed; and some 500 people were arrested for deportation because of their political convictions. The number of scientists and university teachers who lost their jobs ran into hundreds. And then, in case we forget, there were executions of Julius and Ethel Rosenberg. Beside that the suppression and coercion of artists, the censoring of murals, and the cancellation of art exhibitions might seem small beer.

Art News regularly commented on these matters in its editorials. But, somehow, the Abstract Expressionists were beyond all this. What they did was peripheral to it; and at the periphery they were to become central to the modernist tradition

which was always an international tradition in art. As the self-professed avant-garde they situated themselves *in* their paintings and *in* their practice beyond the class struggle. Whichever story you prefer—Rosenberg's or Greenberg's [37]—it is a narrative of non-involvement in the class struggle. But ideologically removed from it, they were, nevertheless, related to it by—to appropriate a phrase of Greenberg's from 'Avant-Garde and Kitsch'—the umbilical cord of gold that attached them to the ruling class fraction of the national bourgeoisie and helped sustain their basic needs and their desires either 'just TO PAINT' or to develop 'the history of avant-garde painting [which] is that of a progressive surrender to the resistance of its medium.'

Whichever story you think their collective art practice best illustrates and whatever their paintings looked like, both the artists and their paintings were put to use by those persons and institutions that appropriated them: the 'business liberals' who desired a modernised American art on the international model established by Europe. And those future uses or future contexts must have been imagined by the Abstract Expressionists and must have determined, to some extent, how and even what they painted. In other words, one determination of Abstract Expressionism must have been an imagined use or misuse of it by the 'business liberals' in their struggle for power at home and abroad. After all, the Abstract Expressionists were not political simpletons; many of them were or had been 'Marxists,' had been members of Works Progress Administration unions and artists' congresses. They knew who bought their art and took it travelling.

NOTES AND REFERENCES

1 This is the text of my paper 'Abstract Expressionism: Weapon of the Cold Taste War' presented at the TGL seminar. It has been only slightly modified for inclusion in this collection and is really published as work-in-progress.

2 See CLARK, T.J. (1992) 'In Defence of Abstract Expressionism', unpublished paper, *XXVIII International Congress of the History of Art*, Berlin, for the kinds of questions still most worth asking of Abstract Expressionist paintings.

3 *Ibid.*

4 For 'red fascism' see ADLER, LES K. and PATERSON, THOMAS G. (1977) 'Red Fascism: The Merger of Nazi Germany and Soviet Russia in the American Image of Totalitarianism, 1930s-1950s', *American Historical Review*, 75, April, pp. 1046–64.

5 The literature on the Cold War is enormous. To my mind the basic books are still KOLKO, GABRIEL (1969) *The Roots of American Foreign Policy* (Boston, Beacon Press) and KOLKO, JOYCE and KOLKO, GABRIEL (1972) *The Limits of Power: The World and United States Foreign Policy, 1945–1954* (New York, Harper & Row). For a very interesting essay-length discussion see COX, MICK (1986) 'The Cold War as a System', *Critique 17: A Journal of Socialist Theory*, pp. 17–82.

6 See the rich detail in SHOUP, LAWRENCE H. and MINTER, WILLIAM (1977) *Imperial Brains Trust* (New York and London: Monthly Review Press), an extended study of the work of the Council on Foreign Relations and United States foreign policy.

7 See Kolko and Kolko (n.5), Chapter 12, 'The 1947 Crisis: The Truman Doctrine and American Globalism'. See also Shoup and Minter (n.6), Chapter 4, 'Shaping a New

World Order: The Council's Blueprint for World Hegemony, 1939–1975'.

8 An edited and shortened transcript of Noam Chomsky's talk was published as 'The cold war is a device by which superpowers control their own domains. That is why it will continue.' in (1981) *The Guardian*, Monday 15 June, p. 7.

9 Domhoff's books include: DOMHOFF, W.G. (1967) *Who Rules America?* (Englewood Cliffs, N.J., Prentice Hall); (1970) *The Higher Circles* (N.Y., Random House); (1972) *Fat Cats and Democrats* (Englewood Cliffs, N.J., Prentice Hall); (1974) *The Bohemian Grove and Other Retreats* (N.Y., Harper & Row); and (1978) *The Powers That Be: Processes of Ruling Class Domination in America* (N.Y., Random House). *Who Rules America?* and *The Powers That Be* proved the most useful for thinking about the character of the United States ruling class. In *Who Rules America?* Domhoff presented evidence for the existence, in the United States, of a 'social upper class' of rich businessmen and their descendants. His aim was to develop the work of E. Digby Baltzell, C. Wright Mills, Paul Sweezey, and R. Dahl to show that the 'national upper social class' was a 'governing class'. The weakness of this work is, as Domhoff indicates, that it is 'beholden to no theory about the dynamics of history or the structure of society'. Nevertheless, his definition of a 'governing class' as a 'social class which owns a disproportionate amount of the country's yearly income, and contributes a disproportionate number of its members to the controlling institutions and key decision making groups in the country' is compatible with a Marxist definition of capitalism's ruling class as the social class that owns the means of production, exercises state power and controls all aspects of social life. In *The Powers That Be* Domhoff referred to his seminal work as providing 'a description of the sociological structure of the ruling class', 'the clearly demarcated social class which has "power" over the government (state apparatus) and the underlying population in a given nation (state)'. However, Domhoff does not make it clear that at any particular moment

the United States ruling class is but one fraction of the national socio-economic class of possessors that he so fully documents.

10 MILLS, C. WRIGHT (1956) *The Power Elite* (New York, Oxford University Press) p. 122, quoted in Domhoff *Who Rules America?* (n.9) pp. 28–29.

11 See Shoup and Minter (n.6), Chapter 1, 'A Brief History of the Council' for the role of the Council on Foreign Relations in this move to power.

12 ALTHUSSER, LOUIS (1971) 'Ideology and Ideological State Apparatuses: Notes Towards an Investigation' in: ALTHUSSER, LOUIS (1971) *Lenin and Philosophy and other Essays* (London, New Left Books) pp. 39–40.

13 On *Advancing American Art* see HAUPTMAN, WILLIAM (1973) 'The Suppression of Art in the McCarthy Decade', *Artforum*, 12, October, pp. 48–52, MATTHEWS, JANE DE HART (1976) 'Art and Politics in Cold War America', *American Historical Review*, 81, October, pp. 762–87; and especially LITTLETON, TAYLOR D. and SYKES, MALTBY (1989) *Advancing American Art: Painting, Politics, and Cultural Confrontation at Mid-Century* (Tuscaloosa and London, The University of Alabama Press) (introduction by Leon F. Litwack).

14 See Littleton and Sykes (n.13) p. 26.

15 *Ibid* p. 27

16 Open letter to Secretary of State James F. Byrnes published in (1946) *Art Digest*, 21, pp. 32–33, quoted in Matthews (n.13) p. 777; and in Littleton and Sykes (n.13) p. 29.

17 On George Dondero see EGBERT, DONALD DREW (1967) *Socialism and American Art in the Light of European Utopianism, Marxism and Anarchism*, (Princeton, NJ, Princeton University Press) p. 125 and pp. 132–133; Hauptman (n.13) pp. 48–49; and Matthews (n.13) pp. 772–73, 775–76.

18 For lists of Dondero's speeches see Egbert (n.17) p. 125, note 238; and Mathews (n.13), p. 773, note 43. See also GENAUER, EMILY (1949) 'Still Life with Red Herring', *Harpers Magazine*, 199, p. 89. The two most important speeches of 1949—'Communists

Manoeuvre to Control Art in the United States' and 'Modern Art Shackled to Communism'—are reprinted in HARRISON, CHARLES and WOOD, PAUL (Eds) (1992) *Art in Theory 1900–1990: An Anthology of Changing Ideas* (Oxford, Blackwell) pp. 654–658.

19 See Dondero's speech 'Modern Art Shackled to Communism', United States House of Representatives, 16 August, 1949 in Harrison and Wood (n.18) p. 657.

20 See Dondero's speech 'Modern Art Shackled to Communism'. Harrison and Wood omit this paragraph which can be found in CHIPP, HERSCHEL B. (1968) *Theories of Modern Art: A Source Book by Artists and Critics* (University of California Press) p. 496.

21 See Egbert (n.17) p. 125, note 238.

22 See BARR, ALFRED H. Jr. (1952) 'Is Modern Art Communistic?', *New York Sunday Times Magazine*, December 14, pp. 22–23, 28–30.

23 Domhoff *Who Rules America?* (n.9), p. 75–76, citing ROWAN, HOBART (1964) *The Free Enterprisers* (New York, Putnam) p. 77, points out that 'The incident which triggered McCarthy's censure . . . was his high-handed treatment of yet another member of the power elite [that is to say, the 'business liberal' power elite], corporate leader Robert T. Stevens of Andover, Yale, J. P. Stevens & Company, General Electric, and Morgan Guaranty Trust [who] was serving as Secretary of the Army when embarrassed by McCarthy on nationwide television: "During the May 1954 meeting at Homestead, Stevens flew down from Washington for a weekend reprieve from his televised torture. A special delegation of Business Advisory Council officials made it a point to journey from the hotel to the mountaintop airport to greet Stevens. He was escorted into the lobby like a conquering hero. Then, publicly, one member of the BAC after another roasted the Eisenhower Administration for its McCarthy-appeasement policy. The BAC's attitude gave the Administration some courage and shortly thereafter former senator Ralph Flanders (a Republican and

BAC member) introduced a Senate resolution calling for censure." '

24 On *Sport in Art* see Egbert (n.17) p. 134; Hauptman (n.13) pp. 50–51; COCKCROFT, EVA (1974) 'Abstract Expressionism, Weapon of the Cold War', *Artforum*, June, pp. 40–41; and Matthews (n.13) pp. 769–70.

25 Resolution of The Public Affairs Luncheon Club, 15 March, 1955 quoted in part by Hauptman (n.13) p. 50.

26 See Egbert (n.17) p. 134.

27 See Matthews (n.13) p. 770.

28 Matthews (n.13) gives some names including that of Legionnaire Colonel Alvin Owsley—also noted by Hauptman (n.13)—who 'had begun compiling his own directory in 1921, which, with names from the annual reports of the House Un-American Activities Committee and congressional speeches, constituted a formidable list of "subversives" against which local citizens could check the names of writers, composers, actors, and artists that appeared in local newspapers and museum catalogs'. Matthews also notes Colonel John Mayo, B. I. F. McCain—also a Legionnaire and past President of the Dallas Chamber of Commerce—and Riveau Basset, a local resident and traditional artist.

29 See Matthews (n.13); and DEVREE, CHARLOTTE (1956) 'The U.S. Government Vetoes Living Art', *Art News*, 55, p. 35.

30 For the moment H. L. Hunt must remain a circumstantial representative of the class fraction that owned some of the means of production in Dallas which was known to be opposed to the 'business liberal' internationalists. In 1953 *Look* magazine in its feature 'The Ring Around McCarthy' named him as one of three Texas oil millionaires who were backing McCarthy. As founder of 'Facts Forum', an ultra-conservative radio and television station programme with hundreds of local outlets, he used McCarthy as a featured speaker, and distributed copies of *McCarthyism: The Fight for America* to interested listeners. He also published the *American National Research Report* which

named Communist and Communist front organisations and described their activities. Glimpses of H. L. Hunt can be had in FRIED, RICHARD M. (1976) *Men Against McCarthy* (New York, Columbia University Press) p. 277; OSHINSKY, DAVID M. (1983) *A Conspiracy So Immense: The World of Joe McCarthy* (London and New York, The Free Press) p. 301, 302–3; and REEVES, THOMAS C. (1969) *Freedom and the Foundation: The Fund for the Republic in the Era of McCarthyism* (New York, Alfred A. Knopff) p. 64.

31 The cancellations were reported by Anthony Lewis in an item headed 'Red Issue Blocks Europe Art Tour. U.S. Information Unit Fears 10 Painters in Show May Be Pro-Communist. Action Called A Fiasco', (1956) *The New York Times*, June 21, p. 33.

32 See 'Exhibits Ban Works Of Accused Artists', (1956) *The New York Times*, 28 June, p. 21.

33 See the report PRESTON, STUART (1956)'To Help Our Art. Council Will Circulate Exhibitions Abroad', *The New York Times*, 30 December, X, p. 15, which announced the foundation of 'The International Council at the Museum of Modern Art' which planned to take over the museum's international programme in July 1957. Its purpose was summed up by its President Mrs. John D. Rockefeller III in this way: 'Our plans call for financing a program, response to which clearly demonstrates the need not only for its continuation but also for its expansion. Despite the valuable activities being carried out by the United States Government, and through it other private and public organizations receiving Government grants, we feel that in accordance with American traditions a large share in the initiative for patronage of the arts and for sending exhibitions abroad should be the responsibility of privately sponsored orgaizations'. Preston pointed out that 'No longer simply a museum activity, the Council, whose first aim is fund raising, will endeavor to make its contribution a thoroughly national one and to employ the talents of specialists the country wide. Some of the immediate projects which the Council is taking over financially are United States participation in three major international art exhibitions and a show of modern painting to travel in Europe.' See also (1956) *The New York Times*, 16 December, p. 53, and 28 December, p. 20.

34 See CRAVEN, DAVID (1992) 'Myth-Making in the McCarthy Period', *Myth-Making. Abstract Expressionist Painting from the United States* (Tate Gallery Liverpool) p. 7, p. 42 note 4. Craven does not point out that Pollock had been dead for three years and that, rather than 'late', the attack was somewhat *belated*.

35 It is often overlooked that it was Alfred H. Barr Jr., and not Irving Sandler, who first wrote about Abstract Expressionism as the 'triumph' of American painting. Note the last paragraph of his 'Introduction' to the catalogue of *The New American Painting* organised by the International Program of the Museum of Modern Art, New York under the auspices of the International Council at the Museum of Modern Art, New York 1958–1959: 'To have written a few words of introduction to this exhibition is an honour for an American who has watched with deep excitement and pride the development of the artists here represented, their long struggle—with themselves even more than their public—and their present triumph.'

36 See CAUTE, DAVID (1978) *The Great Fear. The Anti-Communist Purge under Truman and Eisenhower* (London, Secker & Warburg).

37 See ROSENBERG, HAROLD (1952) 'The American Action Painters', *Art News*, vol. 51, no.8, December, pp. 22–23, 48–50, reprinted in ROSENBERG, HAROLD (1982) *The Tradition of the New* (The University of Chicago Phoenix Edition) pp. 23–39; and GREENBERG, CLEMENT (1955) ' American-Type" Painting', *Partisan Review*, XXII, pp. 179–196, reprinted in GREENBERG, CLEMENT (1961) *Art and Culture: Critical Essays* (Boston, Beacon Press), pp. 208–29.

PHYLLIS ROSENZWEIG

Ad Reinhardt: Problems and Curatorial Ethics: Does It Matter Who Painted It?

INTRODUCTION

The contemporary American artist Louise Lawler subtitled one of her installations (which included photographs of details of famous works of art in homes of wealthy collectors, gallery or museum storage or display, or pre-auction exhibition) with the question: 'Does it matter who owns it?' Keeping in mind similar questions about how value accrues to works of art, and the authority and thus responsibility of institutions like museums, I have subtitled this paper: 'Does it matter who painted it?' The subjects of this inquiry are the four paintings by Ad Reinhardt in the collection of the Hirshhorn Museum and Sculpture Garden, and the various ethical questions regarding their display raised by what we know about Reinhardt's painting technique and the physical histories of these paintings.

PAINTINGS BY AD REINHARDT IN THE HIRSHHORN MUSEUM AND SCULPTURE GARDEN COLLECTION

Of the four paintings by Ad Reinhardt in the Hirshhorn Museum's collection only one is generally on view; the other three are in storage and of these two are currently deemed, for all intents and purposes, unexhibitible. Each one of these paintings presents a particular problem, and I will review them in order of their original dates of execution.

Number 8, 1950 (Blue), 1950

This painting (Fig. 41), along with two others by Reinhardt, was purchased by Joseph H. Hirshhorn from the Marlborough-Gerson Gallery, New York, 13 June 1969, two years after Reinhardt's death. During Reinhardt's lifetime all three paintings had remained in the artist's collection [1]. We know that the blue painting was exhibited at least twice while Reinhardt was alive: in 1965 in the Los Angeles County Museum of Art's exhibition, *New York School: The First Generation* [2], where it is listed in the catalogue as having been lent by the artist (I will return to this exhibition again when I discuss the next painting); and again in 1966–67, when it was lent by him to the Jewish Museum, New York, for a one-person show, *Ad Reinhardt Paintings*, organised by Lucy R. Lippard [3]. The painting has been lined.

Fig. 41 AD REINHARDT *Number 8, 1950 (Blue)* 1950 (photo. Lee Stalsworth)

We also know from scattered notes in the museum's files that this painting (along with a black one which I shall mention shortly) had been in a conservator's studio in 1971–72, where it was 'sealed' and that the bill for that and any other treatment it may have received was sent to the Marlborough Gallery [4]. Some areas of cracking have been in-painted by one of the Hirshhorn Museum's conservators and the painting appears to be in generally good condition.

Number 90, 1952 (Red), 1952

Along with the blue painting, Joseph Hirshhorn also purchased *Number 90, 1952 (Red)* (Fig. 42) from the Marlborough-Gerson Gallery in 1969. Like the blue painting, it too had been loaned by Reinhardt both to the 1965 Los Angeles County Museum of Art and the 1966–67 Jewish Museum exhibitions. Like the blue painting, it has also been lined.

We know both more, and less, about the history of this painting's physical condition and treatment than that of *Number 8, 1950 (Blue)*. From correspondence in the Reinhardt papers in the Archives of American Art, we know that Frieda Kay Fall, then the Registrar at the Los Angeles County Museum of Art, wrote to Reinhardt on 4 May 1965 to advise him that this painting had 'suffered damage.' Along with her letter she included detailed diagrams, photographs and condition descriptions of severe surface cracking, and noted that:

> The condition of the painting is principally due to circumstances in the production of it, as specified in the report. The progressive conditions have been worsened because the painting was rolled 'outside-in'. It was also rolled too tightly; the diameter of the roll was too small for the size of the canvas.

Fig. 42 AD REINHARDT *Number 90, 1952 (Red)* 1952 (photo. Lee Stalsworth)

> Unfortunately [she notes] since the damage was not incurred directly by mishandling of our museum staff the insurance company is unable to offer funds for the restoration of the painting. [5]

Nonetheless, in 1966, Reinhardt was awarded $500 in damages, having told the insurance company he planned to repair the painting himself [6].

We do not know what, if any, other treatment was proposed or proceeded with. However, the painting was apparently in good enough condition to be included in the Jewish Museum exhibition which opened in November 1966, and it entered the Hirshhorn Museum collection without any evidence of surface marring.

We do know that Reinhardt was in the habit of repairing his own work by repainting all or parts of it. Letters in his, and Lucy Lippard's, papers in the Archives of American Art record two such instances of this work, the results of which did not, apparently, always please the paintings' owners [7]. The letters in Reinhardt's papers specifically refer to a 'black' painting but Lucy Lippard notes that he often repainted earlier work as well:

> . . . if a canvas had not been sold, and if Reinhardt was not fully satisfied with it, he often made quite radical changes. Some of the red and blue canvases were repainted in acrylic instead of oil in the sixties; this produced an unavoidable difference in paint quality and at times in color. (The largest red and pink canvas shown in the Jewish Museum's 1966 retrospective [this is the Hirshhorn painting], for instance, lacks the richness of many of its

contemporaries in oil; its size—it had to be rolled—had dictated a repainting in plastic paint.) And at times he simply used the canvas again for a new painting after the old one had been photographed. [8]

Further testing is required to verify whether or not *Number 8, 1950 (Blue)* and *Number 90, 1952 (Red)* have, indeed, been painted over in acrylic. The red painting has, meanwhile, developed another problem. A white, powdery film has developed on the painting's surface—a condition similar in appearance to that which had developed on the seven 'black-form paintings' by Mark Rothko installed on the West and East walls of the Rothko Chapel in Houston, Texas, and which was brought to our attention by Carol Mancusi-Ungaro, Chief Conservator for the Menil collection, which owns the chapel, when she saw our red painting in August 1990.

In 1990 Mancusi-Ungaro wrote about the Rothko murals:

> Three years after the murals were installed [they were installed in 1971, after Rothko's death], a curious whitening began to appear on the surface of the black-form paintings. In 1974, attributing the problem to mold, a restorer familiar with Rothko's *oeuvre* washed some of the murals which regained temporarily their rich black appearance . . . Upon the reappearance of the whitening, another conservator briefly examined the paintings in 1978 and attributed the effect to extreme humidity levels in the chapel. In 1979, a consultant supported this contention and suggested further that deterioration possibly related to the materials used by the artist or by the restorer might be occurring at the surface itself. [9]

Mancusi-Ungaro began working on the Rothko paintings in 1980. Using a variety of techniques she was able to determine that the white efflorescence was indeed caused, in part, by Rothko's technique and materials in these particular paintings. In them he had covered an underlayer of acrylic polymer with a top layer of an egg-yolk/oil emulsion. The emulsion, which had given a quiet lustre to Rothko's black forms, gradually formed fatty acids which, in combination with the plasticiser in the acrylic layer had:

> Upon repeated exposure to moisture from installation in an environment of fresh concrete, former treatments, and ambient climatic conditions . . . diffused to the surface and formed crystalline deposits. [10]

The Rothko paintings were eventually successfully cleaned with solvents.

The condition of our red Reinhardt painting may not be due to a similar combination of causes. We have no evidence that Reinhardt used emulsion, and Carol Stringari has pointed out to me that blanching or crystallisation on red surfaces can have a number of explanations including the migration of elements from different binders and water soluble components of some acrylic paint formulations [11]. Nonetheless, it is somewhat disturbing that when another

curator, familiar with Reinhardt's work, looked at this painting in June 1990 he suggested that the condition was mould and that the painting should be washed down—an apparent reference to the earlier, and problematic, diagnosis and treatment of the Rothko chapel murals [12]. This exchange suggests the need for better communication between curators and conservators museum-wide.

Abstract Painting, 1956

This (Fig. 43) is the only painting by Ad Reinhardt that was purchased by Joseph Hirshhorn in the artist's lifetime. He purchased it from a dealer in 1963 along with paintings by Magritte, Matta, and André Masson. The dealer's invoice and letters in the Reinhardt files in the Archives of American Art indicate that the painting went directly from Reinhardt's studio to the dealer. There is no known exhibition history for the painting prior to its purchase by Joseph Hirshhorn and its ultimate gift to the Museum and it appears to be in pristine condition; that is, it appears to be an exemplary, unadulterated Reinhardt painting, typical of the vertical 'black' paintings he made in the mid-1950s, which preceded the square format he used in the 1960s.

A few shiny black marks appear on the painting's surface. These marks were noted both by William Rubin and by the artist's widow on separate visits to the Hirshhorn Museum, and were particularly visually disturbing to both of them, as they are to our director, who prefers to keep the painting off view. As far as we can determine these shiny areas are caused by oil that has risen to the surface since the painting was completed. Similar shiny areas are visible on paintings in other collections, including a vertical 'black' painting from 1957 in the collection of the Museum of Modern Art, which has not been restored [13].

Number 119, 1958 (Black), 1958–62

Joseph Hirshhorn purchased this painting along with *Number 8, 1950 (Blue)* and *Number 90, 1952 (Red)* from the Marlborough-Gerson Gallery in June, 1969. It had also been exhibited at least twice in Reinhardt's lifetime. In 1963 it was included in the Art Institute of Chicago's *66th Annual American Exhibition* [14], and is listed in the catalogue as having been lent by the Betty Parsons Gallery, then Reinhardt's dealer. Like the blue and red paintings it too had also been lent by Reinhardt to the 1966–67 Jewish Museum exhibition. It had also been in a conservator's studio with the blue painting in 1971–72 and Marlborough-Gerson was billed for its treatment but, again, we have no record of exactly how, or why, it was treated [15].

This painting has been off-view since 14 August 1975, when a vandal drew a swastika on it (Fig. 44), leaving an oily finger mark. We rejected the possibility of having the painting totally repainted, which we believed was the only method of treating damage to Reinhardt's pastel-like matt surfaces. An attempt to tone down the mark was unsuccessful and resulted in a larger, highly visible patch (Fig. 45).

The Hirshhorn's 'black' painting has been deemed unshowable in its present

Fig. 43 AD REINHARDT *Abstract Painting* 1956 (photo. Lee Stalsworth)

Fig. 44 AD REINHARDT Detail of *Number 119, 1958 (Black)* 1958–62 after vandalism
(photo. Lee Stalsworth)

Fig. 45 AD REINHARDT *Number 119, 1958 (Black)* 1958–62 after vandalism and attempted repair (photo. Lee Stalsworth)

condition. Its damage presented us with an ethical dilemma: to preserve a genuine work of the artist's hand, even if it cannot be shown because of unsightly damage, or to have it totally repainted in order to make it presentable for public viewing. The question has become more complicated.

When we recently examined this painting in our conservation lab, side by side with the earlier and, as far as we know, untreated, 'black' painting, certain differences became apparent. Brush marks were visible on the surface of the earlier painting, as well as rich variations of purples and blues, which comprise its 'blacks.' By contrast, the surface of the later painting appeared to have a uniform, dead grey (non)colouration and a mechanical (air-brushed?) look, leading us to speculate that it may have been resurfaced at some point by someone other than Reinhardt.

DOES IT MATTER WHO PAINTED IT?

As with much discussion surrounding Ad Reinhardt's work, this question is complex and the answer is not easy. The debate over what best represents his intentions is laced with contradictory statements by the artist and is coloured as well by subjective and shifting interpretations of what constitutes the inherent value of a work of art.

Commentary on the issue of 'authenticity' and the importance of the artist's hand as revealed in the brushstroke has appeared in the work of contemporary artists such as Gerhard Richter and David Reed, and the belief in the importance of the artist's brushstroke was satirised closer to Reinhardt's own time by Robert Rauschenberg in his twin 'Abstract Expressionist' paintings, *Factum I* and *Factum II*.

Reinhardt's own statements about this issue appear contradictory. In his 1957 'Twelve Rules for a New Academy,' Reinhardt wrote:

> No brushwork or calligraphy. Handwriting, hand-working and hand-jerking are personal and in poor taste. No signature or trademarking. 'Brushwork should be invisible.' 'One should never let the influence of evil demons gain control of the brush.' [16]

Thus, Reinhardt's own view of his work *vis-à-vis* Abstract Expressionism is problematic. While he often demanded for his work (and painting, in general) that it contain no content, no spirituality, no emotion, etc., some of his most ardent early supporters (notably Thomas B. Hess) discussed his work in terms of brush-strokes and mystical experience.

Despite his many disagreements with them, Reinhardt was a member of a generation of artists who valued traditional materials and hands-on practices of art making. Reinhardt's association with the Abstract Expressionists, and the implied belief in the inherent value of 'the artist's hand,' were emphasised in the catalogue of the recent *Ad Reinhardt* exhibition organised by the Museum of Contemporary Art, Los Angeles and the Museum of Modern Art, New York [17]. This

exhibition included photographs of Reinhardt at the Artists' Symposium in 1950, and four 1966 photographs of him painting in his studio, including a close up of his hand applying paint to the canvas with a brush, which had originally been published in *Life Magazine* in 1967 [18]. Yve-Alain Bois's essay in the catalogue emphasises Reinhardt's growing significance in the 1960s, a time when the romance of painting was increasingly suspect and artists such as Donald Judd advocated having their work factory fabricated [19].

Is there any evidence that Reinhardt would have authorised a restorer to work on his paintings during his own lifetime? Did he, for instance, have someone work on the Hirshhorn Museum's red painting between the time of the Los Angeles and Jewish Museum exhibitions? And what do we know about the technique, care, and condition of Reinhardt's paintings in his lifetime?

We do know that Reinhardt painted his 'black' paintings on 'sized (not raw) Belgian linen canvas,' and that he used 'a handful of Bocour hand-made pigments with linseed oil turpentined off' [20]. The 'lean' paint film produced the subtlety that Reinhardt sought, but made his pictures particularly fragile. As Bois noted, when Reinhardt was included in the Museum of Modern Art exhibition *Americans 1963*:

> the ['black'] canvases were badly installed (much too brightly lit, roped off and hung too high so that people would keep their hands off them). [21]

Reinhardt himself considered it significant enough to indicate on his chronology, written for the Jewish Museum catalogue in 1966:

> 1963 Six paintings in New York and six paintings in Paris get marked up and have to be roped off from the public.
> 1964 Ten paintings in London get marked up. [22]

Lucy Lippard wrote:

> The black paintings demand a different lighting from other paintings and are incompatible with almost anything in group exhibitions . . . Reinhardt says 'dim, late afternoon non-reflecting twilight is best outside. No chiaroscuro.' Museums and galleries are hard put to meet these conditions. A common mistake is over-lighting and a common result is that noses and fingers are rubbed up against the surfaces, destroying the paintings until the artist can find time to repaint them completely. The impatient viewer sees nothing immediately and feels constrained to touch instead of look. A velvet rope hardly seems valid and Reinhardt has recently begun to put deep white platforms before each canvas as a barrier to affectionate curiosity [this method was followed in the Museum of Modern Art installation of the Reinhardt show]. 'The picture leaves the studio as a purist, abstract, non-objectlve work of art,' he has commented rather wistfully, 'returns as a record of everyday (surrealist, expressionist) experience ('chance' spots, defacements, hand-markings, accidents,

'happenings,' scratches), and is repainted, restored into a new painting painted in the same old way (negating the negation of art), again and again, over and over again, until it is just 'right' again. [23]

Reinhardt's need to repaint his own work was reemphasised in the *Life Magazine* article, mentioned above, that came out just after the close of his Jewish Museum exhibition:

> Today in his Manhattan loft, Reinhardt continues to create ever-darkening variations on his 'ultimate' painting. His canvas is laid down flat to assure the even application of pigment. Reinhardt spends much of his time repainting works that have gone out on exhibition, because they usually come back bearing the fingerprints of the curious and the incredulous. In repainting he makes the canvases even darker than they were at first. [24]

Reinhardt stated several times that only he could restore his own paintings. If other people attempted to do this it became their work, not his:

> Only I can make my painting and restore it.
> Another artist who would make my painting makes his painting and not mine. [25]

This was restated in 1966:

> This painting is my painting if I paint it.
> This painting is your painting if you paint it.
> This painting is any painter's painting. [26]

In an interview with Bruce Glaser published in 1966 Reinhardt stated:

> this painting of mine is not my painting in a way, although only I can make my painting, and also restore it. Someone else who would make this painting would be making his painting. The process and problem of painting is reduced to something that has only to do with the essence. Doing anything else would be beside the point or would be done for some other reason. [27]

When Glaser later asked:

> Do you mean that if somebody actually painted the exact painting that you just painted it would still be his painting, and not yours, but it would be the best kind of painting?

Reinhardt replied:

> Yes. It would be as impersonal, or personal, a statement as anyone would want to make it.

When Glaser asked why Reinhardt did not have someone paint them for him, Reinhardt replied:

> Someone else can't do them for me. They have to do their own for themselves. But I'm not quite sure why. It's a little like asking why I paint. I certainly don't believe in having someone else carry out my painting. It's not really that kind of idea. And also, just as I still use a brush and oil on canvas, I wouldn't go into blowguns or new materials or anything like that. Those would be unnecessary—though I'm not maintaining an old handicraft-do-it yourself idea either. I'm merely making the last painting which anyone can make. [28]

Lippard also noted:

> Reinhardt is categorically opposed to the use of accident, at least at the service of an automatist, surrealist, expressionist mystique. Each painting is solved according to what happens in the drying, the quality of the paint, the weather and how it affects the drying, the mixing of the paints; 'even the canvases don't handle the same way twice.' In such a rejective idiom, every minute change is charged with unexpected importance. A mere six projects exhaust all the schematic possibilities of the red-blue-green combination that constitutes most of the 'black' paintings (one color for the ground, one for each of the directional divisions). In the 'colorless' canvases, the subtler differences in warmth and coolness offer possibilities as unlimited as the three color variations.
>
> He opposes mechanical techniques; the edges of his invisible forms are precisely measured but painted by hand; masking tape is not used because the faint relief line results in 'texture' and destroys the singleness of the surface. He has no interest in 'new materials' or in having someone else fabricate the work for him. In retaining the idea that the maker and creator of a work of art cannot be separated, that it is only in the act of conceiving *and* fabricating that the artist has any stake in his work . . . [29]

Lippard later wrote that:

> Reinhardt's refusal of fabrication outside the studio; his dislike of taped edges and industrial surfaces, his antipathy to the Minimalists' 'materialism,' and his insistence on the highest moral and aesthetic standards for art and artists separated him from the younger generation's more programmatic approach [30].

She also noted that:

> Reinhardt always painted thinly, avoiding even the slightest relief or obvious brushstrokes which might catch the light as an edge [Thus] there is in all of his work a very slight roughness of touch, a deliberate

archaism or vestige of painterliness . . . For while Reinhardt de-emphasized gesture and process, he applied the paint itself quite sensuously, if understatedly. One is aware of a painted surface. Insisting that the maker is inseparable from the creator of a work of art, he contended that only in the double act of conceiving and fabricating does the artist have any stake in his own work . . . [31]

Given the contradictory evidence of Reinhardt's own writing and that of his contemporaries, what best represents his work? The unretouched, 'authentic' paintings from his own hand, which nevertheless bear the marks of life, what he claimed to disdain as surrealism, and the passage of time which he said he abhorred? Or is it possible that pristine finishes on his paintings which may have been restored by other hands best represent the 'timeless' objects he sought to create?

The four paintings in the Hirshhorn Museum collection remain problematic in terms of these questions, and in the absence of certain conclusive information. Along with chemical and technical analysis more research is needed to determine, if possible, what was done to the red painting and by whom when Reinhardt was alive; how, when and why the three Marlborough-Gerson paintings were treated; to what extent it can be determined if any over-painting was done by Reinhardt or by a later restorer on any of these works; and finally, whether it matters.

In a recent article, Donald Kuspit cited Theodor Adorno's statement that the art museum turns the work of art into an educational document. While Kuspit does not really address the issues under discussion here, he does go on to ask:

What is the right way of documenting the art object? What kind of document is it anyway? The answers depend on what the art document is supposed to educate us to. [32]

In the case of Reinhardt's paintings, we may soon not be able to tell an 'authentic' from a resurfaced one. Whether or not this matters is a philosophical question but somehow I believe it does. Issues of fetishism aside, I would argue that, given its moral authority, the museum as an institution has an obligation to preserve its 'historical documents' as well as to document them accurately.

ACKNOWLEDGMENTS

This paper developed from a report prepared for a colloquium on the *Conservation of Twentieth-Century Art*, given at the Institute of Fine Arts, New York University, Spring 1992, by Antoinette King, Chief Conservator, The Museum of Modern Art, New York. I am grateful to Dr. King, to Carol Stringari, who is now Associate Conservator at the Solomon R. Guggenheim Museum, Abram Lerner, former Director, James T. Demetrion, Director, and Stephen E. Weil, Deputy Director of the Hirshhorn Museum, Lawrence Hoffman, Clarke Bedford and Susan Lake of the Hirshhorn's Conservation Department, David Craven, and Alan Wallach for their help and support.

NOTES AND REFERENCES

1 Information on provenance, exhibition and publication histories on all of these paintings comes from records in the Hirshhorn Museum's archives, unless otherwise indicated.

2 TUCHMAN, MAURICE (Ed) (1965) *New York School: The First Generation: Paintings of the 1940s and 1950s*, exhibition catalogue (Los Angeles County Museum of Art, 16 July–1 August) with statements by the artists and critics, biblio.

3 LIPPARD, LUCY R. (1966) *Ad Reinhardt Paintings* exhibition catalogue (New York, The Jewish Museum, 23 November 1966–15 January 1967) Preface by Sam Hunter, with a chronology by the artist.

4 Papers in the Hirshhorn Museum archives include: a handwritten note attached to letter dated 9 February 1971, 'worked on—surfaces are complete'; a handwritten note on a memo attached to a letter dated 20 July 1971 '2 Reinhardt ready for seal'; a letter from the conservator dated 26 May 1972 indicating he has billed Marlborough for this and a black Reinhardt painting. The 9 February letter is in reply to a general request from Abram Lerner, the Museum's former director, for more information regarding condition and proposed treatment. The conservator's reply indicates that this request is difficult to comply with, and states: 'Although we keep a record of surface finishes used, there is no need for us to record what the painting was cleaned with, the chemicals used, etc. since the method of conservation depends upon the current problem./ For future conservation, it is the surface finish which is most important; the painting remains as it always was. If the original media was acrylic, we use acrylic; if oil, we use oils, etc./ Should you wish us to record the finishes (varnish, seal, etc.) used on each painting, we will be happy to comply.' There is no record that this was pursued further.

5 Ad Reinhardt Papers, Archives of American Art, N/69–101, Frame 0144. In a letter in the Hirshhorn Museum archives, Thomas Kellein, Staatsgalerie Stuttgart, called this correspondence to our attention.

6 Ad Reinhardt Papers N/69–101, Frame numbers 0164–5; 0192–3, 0203; 0232. The Reinhardt papers in the Archives of American Art contain only incoming correspondence. I am grateful to Tamra H. Yost, Associate Registrar, Los Angeles County Museum of Art, for providing me with additional information from their files.

7 Ad Reinhardt Papers, N/69–101, Frames 037, 061, 074, 077, 127, 145, etc., and Lucy Lippard Papers, Archives of American Art, Box 12/19. The undated handwritten draft of a letter in Lucy Lippard's files demonstrates Reinhardt's famed irascibility, and seems worth quoting in full: 'Look what do you think you bought for $150, a can of beans? Stop sending threatening letters to Betty Parsons Gallery and crying as if the customer is always right.// 'How do you know your painting now, repainted, is not worth $1500? I would charge at least $150 for restoring.// 'Do you think restoring is a simple matter? Of course it will be another painting—the old one is gone forever, and who's responsible?// 'If you cared that much about it, why didn't you take proper care of it? You're the vandal.// 'The gallery was considerate enough of you to provide you with another painting because you wanted to show your collection someplace, were they not? Well, the least you can do is let the gallery alone.// 'Its not their fault you damaged the painting. Its not their fault that I will do what I have to whenever I feel like it.'

8 LIPPARD, LUCY R. (1980) *Ad Reinhardt* (New York: Harry N. Abrams) p. 114.

9 MANCUSI-UNGARO, CAROL C. (1990) 'The Rothko Chapel: Treatment of the Black-Form Triptychs' in: *Cleaning Retouching and Coatings: Technology and Practice for Easel Paintings and Polychrome Sculpture: Preprints of the Contributions to the Brussels Congress, 3–7 September 1990* (London: International Institute for Conservation of Historic and Artistic Works), pp. 134–7. On the Rothko murals see also: MANCUSI-UNGARO, CAROL C. (1981) 'Preliminary Studies for the Conservation of the Rothko Chapel Paintings: An Investigative

Approach' in: *AIC Preprints* (Philadelphia, 27–31 May) pp. 109–113; MANCUSI-UNGARO, CAROL C. and AUFDER-MARSH, CARL (1988) 'The Conservation of Two Triptychs in the Rothko Chapel' in: *AIC Preprints* (New Orleans, Louisiana, June 1–5) pp. 267–8; and CRANMER, DANA (1970) 'Painting Materials and Techniques of Mark Rothko: Consequences of an Unorthodox Approach,' in: *Mark Rothko 1903–1970*, exhibition catalogue (London: Tate Gallery) pp. 189–197. I am grateful to David Craven for bringing this last essay to my attention.

10 Mancusi-Ungaro, 1990 (n.9) p. 136.

11 From a meeting with Carol Stringari, 2 April 1992, at the Museum of Modern Art, where she was then in the conservation department. I am extremely grateful for her time and assistance.

12 See n.9

13 *Number 87*, 1957. Purchase 1969. I am grateful to Carol Stringari for the information that this painting is unrestored.

14 (1963) *66th Annual American Exhibition: Directions in Contemporary Painting and Sculpture*, exhibition catalogue (the Art Institute of Chicago, 11 January–10 February).

15 See n.4. An additional handwritten message that appears to record a telephone conversation with the conservator notes, 'dark painting—must be worked on in light.'

16 REINHARDT, AD (1957) 'Twelve Rules for a New Academy', *Art News* 56, May, p. 38; reprinted in ROSE, BARBARA (Ed) (1975) *Art as Art: The Selected Writings of Ad Reinhardt* (New York: Viking/ The Documents of 20th Century Art), p. 205; reprinted also, in a slightly different version, in Lippard (n.8) pp. 140–141; and in Bois (n.17) pp. 116–7.

17 BOIS, YVE-ALAINE (1991) *Ad Reinhardt* (New York, Rizzoli), exhibition catalogue (the Museum of Modern Art, New York, May 30–September 2; the Museum of Contemporary Art, Los Angeles, October 13–January 5, 1992), preface by William Rubin.

18 BOURDON, DAVID (1967) 'Master of the Minimal', *Life Magazine*, February 3, pp. 45–51

19 Lucy Lippard also discussed Reinhardt's importance for artists in the 1960s in her essay for the 1966 Jewish Museum catalogue (n.3).

20 Notes in Reinhardt's handwriting, Lucy Lippard Papers, Box 13/19. See also REINHARDT, AD (1965) 'Reinhardt Paints a Picture', *Art News* 64 (March) p. 40; reprinted in Rose (n.16) p. 11. Social correspondence from Leonard Bocour appears scattered throughout Reinhardt's papers in the Archives of American Art.

21 Bois (n.17) p. 12

22 (1966) 'Chronology by Ad Reinhardt', (n.3) p. 36; reprinted in Rose (n.16) p. 8, and in Bois (n.17) pp. 107–109

23 Lippard (n.3), p. 22

24 Bourdon (n.18) p. 48.

25 Lucy Lippard Papers, Box 12/19

26 REINHARDT, AD (1966) 'Ad Reinhardt: Three Statements *Artforum* 4, March, p. 34; reprinted in Rose (n.16) pp. 84–5

27 GLASER, BRUCE (1966) 'An Interview with Ad Reinhardt', *Art International* 10, December 20, p. 18; reprinted in Rose (n.16) pp. 12–13.

28 Glaser (n.27) p. 18; Rose (n.16) p. 13.

29 Lippard (n.3) p. 26.

30 Lippard (n.8) p. 122.

31 *Ibid.* p. 155.

32 KUSPIT, DONALD (1992) 'The Magic Kingdom of the Museum', *Artforum* 30, p. 60.

APPENDIX

List of works in the exhibition *Myth-Making: Abstract Expressionist Painting from the United States*, Tate Gallery Liverpool, 10 March 1992 – 10 January 1993

WILLIAM BAZIOTES (1912–63); *Mammoth* 1957; oil on canvas 1219 x 1524mm; presented to the Tate Gallery by Mr & Mrs L S Field 1972; T01693

JAMES BROOKS (b.1906); *Boon* 1957; oil on canvas 1803 x 1730mm; presented by Friends of the Tate Gallery 1959; T00253

ARSHILE GORKY (1904–48); *Waterfall* 1943; oil on canvas 1537 x 1130mm; purchased with assistance from Friends of the Tate Gallery 1971; T01309

ADOLPH GOTTLIEB (1903–74); *The Alchemist* 1945; oil on canvas 711 x 908mm; purchased 1980; T03094

ADOLPH GOTTLIEB (1903–74); *Labyrinth No.2* 1950; oil on canvas 914 x 1219 mm; Tate Gallery, purchased 1980; T03095

FRANZ KLINE (1910–62); *Meryon* 1960–1; oil on canvas 2359 x 1956mm; purchased 1967; T00926

WILLEM DE KOONING (b.1904); *Women Singing II* 1966; oil on paper mounted on canvas 914 x 610mm; presented by the artist through the American Federation of Arts 1970; T01178

LEE KRASNER (1908–84); *Gothic Landscape* 1961; oil on canvas 1768 x 2378mm; purchased 1981; T03291

NORMAN LEWIS (1909–79); *Mumbo Jumbo* 1950; oil on canvas 1283 x 667mm; collection of Mr R F Lewis, N.Y.

NORMAN LEWIS (1909–79); *Klu Klux* 1963; oil on canvas 255 x 1016mm; collection of Mrs O Lewis, N.Y.

BARNETT NEWMAN (1905–70); *Eve* 1950; oil on canvas 2388 x 1721mm; purchased 1980; T03081

JACKSON POLLOCK (1912–56); *Yellow Islands* 1952; oil on canvas 1435 x 1854mm; presented by Friends of the Tate Gallery (purchased out of funds provided by Mr and Mrs H J Heinz II and H J Heinz Co. Ltd.) 1961; T00436

JACKSON POLLOCK (1912–56); *Naked Man with Knife* c.1938–41; oil on canvas 1270 x 914mm; presented by Frank Lloyd 1981; T03327

JACKSON POLLOCK (1912–56); *Birth* c.1938–41; oil on canvas 1164 x 551mm; purchased 1985; T03979

JACKSON POLLOCK (1912–56); *Summertime: Number 9A* 1948; oil and enamel on canvas 848 x5550mm; purchased 1988; T03977

JACKSON POLLOCK (1912–56); *Number 14* 1951; enamel on canvas 1465 x 2695mm; purchased with assistance from the American Fellows of the Tate Gallery Foundation 1988; T03978

AD REINHARDT (1913–67); *Abstract Painting* c.1951–2; oil on canvas 2032 x 1067mm; purchased 1972; T01531

AD REINHARDT (1913–67); *Abstract Painting No.5* 1962; oil on canvas 1524 x 1524mm; presented by Mrs Rita Reinhardt through the American Federation of Arts 1972; T01582

MARK ROTHKO (1903–70); *Untitled* c.1951–2; oil on canvas 1890 x 1008mm; presented by the Mark Rothko Foundation 1986; T04148

MARK ROTHKO (1903–70); *Light Red Over Black* 1957; oil on canvas 2327 x 1527mm; purchased 1959; T00275

DAVID SMITH (1906–65); *Agricola VIII* 1952; bronze and steel painted sculpture 806 x 539 x 476mm; lent by Candida and Rebecca Smith 1991; L01609

DAVID SMITH (1906–65); *Agricola IX* 1952; steel sculpture 930 x 1450 x 50mm; lent by Candida and Rebecca Smith 1991; L01023

CLYFFORD STILL (1904–80); *1953* 1953; oil on canvas 2359 x 1740mm; purchased 1971; T01498

ANNE MacPHEE

Abstract Expressionism: a Selected Bibliography

1. UNIQUE MATERIALS IN THE ARCHIVES OF AMERICAN ART, WASHINGTON D.C., SMITHSONIAN INSTITUTION

William Baziotes, N 70/21
Byron Brown, NBB2m 97
Clement Greenberg, N 70/7
Peggy Guggenheim, ITVE I
Samuel Kootz, NY 65/I
Barnett Newman Papers
Ad Reinhardt, N 69/99 and N 69/104
Artists for Victory Papers,115–16
Federation of Modern American Painters and Sculptors (Federation Papers), N69/ 75
Jackson Pollock Papers
Mark Rothko Papers
The Mark Rothko Foundation, New York
Willard Gallery Papers

2. BOOKS AND CATALOGUES

ALLOWAY, LAWRENCE (1975) *Topics in American Art Since 1945* (N.Y., Norton)
—— (1980) *The Interpretive Link: Abstract Surrealism and Abstract Expressionism 1938–48* (Newport Beach, Cal., Newport Harbor Art Museum)
—— (1984) *Network: Art and the Complex Present* (Ann Arbor, Mich., UMI Research Press)
ALPEROVITZ, GEAR (1970) *Cold War Essays* (N.Y., Anchor)
AMERICAN ABSTRACT ARTISTS (Eds.) (1957) *The World of Abstract Art* (N.Y., George Witternborn)
ARONSON, JAMES (1970) *The Press and the Cold War* (Boston, Beacon Press)
ARNASON, H. HARVARD (1960) *Sixty American Painters 1960: Abstract Expressionist Painting in the Fifties* (Minneapolis, Walker Art Center)
—— (1961) *American Abstract Expressionists and Imagists* (N.Y., Solomon R. Guggenheim Museum)

———— (1968) *History of Modern Art* (N.Y., Harry N. Abrams)

ASHTON, DORE (1962) *The Unknown Shore: A View of Contemporary Art* (Boston and Toronto, Little, Brown)

———— (1979) *The New York School: A Cultural Reckoning* (N.Y., Penguin)

AUPING MICHAEL (Ed.) (1987) *Abstract Expressionism: The Critical Developments* (London, Thames and Hudson)

BARKER, VIRGIL (1959) *From Realism to Reality in Recent American Painting* (Lincoln, University of Nebraska Press)

BAUR, JOHN I. H (1951) *Revolution and Tradition in Modern Art* (Cambridge, Mass., Harvard University Press)

BAUR, JOHN I. H., LLOYD GOODRICH, DOROTHY C. MILLER, JAMES THRALL SOBY, FREDERICK S. WIGHT (Eds.) (1957) *New Art in America* (Greenwich, Conn., New York Graphic Society; N.Y., Frederick A. Praeger)

BARTHES, ROLAND (1957) *Mythologies* (Paris, Seuil)

BELL, DANIEL (1976) *The Cultural Contradictions of Capitalism* (N.Y., Basic Books)

BLESH, RUDI (1956) *Modern Art USA: Men Rebellion, Conquest, 1900–1956* (N.Y., Alfred A Knopf)

BUETTNER, STEWART (1981) *American Art Theory 1945–1970* (Ann Arbor, Mich, UMI Research Press)

CALAS, NICOLAS (1968) *Art in the Age of Risk and Other Essays* (N.Y., E. P. Dutton)

CALAS, NICOLAS, and ELENA CALAS (1967) *The Peggy Guggenheim Collection of Modern Art* (N.Y., Harry N. Abrams)

CANADAY, JOHN (1962) *Embattled Critic* (N.Y., Farrar, Straus & Cudahy)

CELENTANO, FRANCIS (1957) *The Origins and Development of Abstract Expressionism in the United States* (Unpublished Master's Thesis, New York University)

COX, ANNETTE (1982) *Art-as-Politics: The Abstract Expressionist Avant-Garde and Society* (Ann Arbor, Mich., UMI Research Press)

EGBERT, DONALD DREW (1967) *Socialism and American Art* (Princeton, Princeton University Press)

ETZHOLD,THOMAS and GADDID, JOHN LEWIS (1978) *Containment Documents on American Policy and Strategy, 1945–1950* (N.Y., Columbia University Press)

FOSTER, STEPHAN C (1981) *The Critics of Abstract Expressionism* (Ann Arbor, Mich.,UMI Research Press)

FREELAND, RICHARD M (1971) *The Truman Doctrine and the Origins of McCarthyism* (N.Y., Schocken)

FRASCINA FRANCIS (Ed) (1985) *Pollock and After: The Critical Debate* (London, Harper and Row)

FRIEDMAN, B.H. (Ed.) (1959) *School of New York. Some Younger Artists* (N.Y., Grove Press)

FULLER, PETER (1980) *Beyond the Crisis in Art* (London, Writers and Readers)

GELDZAHLER, HENRY (1965) *American Painting in the Twentieth Century* (N.Y., Metropolitan Museum of Art)

———— (1969) *New York Painting and Sculpture: 1940–1970* (N.Y., E. P. Dutton and Co.)

GOODRICH, LLOYD, and JOHN I. H. BAUR (1961) *American Art of Our Century* (N.Y., Frederick A Praeger)

GRAHAM, JOHN D. (1937) *System and Dialectics of Art* (N.Y., Delphic Studios)

GREENBERG, CLEMENT (1961) *Art and Culture: Critical Essays* (Boston, Beacon Press)

———— (1964) *Post Painterly Abstraction* (Los Angeles Los Angeles County Museum of Art)

GUGGENHEIM, PEGGY (1946) *Art of This Century: Informal Memoirs of Peggy Guggenheim* (N.Y., Dial Press)

———— (1960) *Confessions of an Art Addict* (N.Y., Macmillan)

GUILBAUT, SERGE (1983) *How New York Stole the Idea of Modern Art: Abstract Expressionism, Freedom, and the Cold War* (Chicago, The University of Chicago Press)

HENNING, EDWARD B (1966) *Fifty Years of Modern Art, 1916–1966* (Cleveland, Cleveland Museum of Art)

HESS, THOMAS B (1951) *Abstract Painting: Background and American Phase* (N.Y., Viking Press)

HOFMANN, HANS (1948) 'Statement', *Search for the Real and Other Essays* (Andover, Mass., Adison Gallery of American Art, Phillips Academy)

HOBBS, ROBERT CARLETON, and LEVINE GAIL (1978) *Abstract Expressionism: The Formative Years* (N.Y., Whitney Museum)

HUNTER, SAM (1959) *Modern American Painting and Sculpture* (N.Y., Dell, Laurel edition)

———— (1966) 'American Art Since 1945', *New Art Around the World: Painting and Sculpture* (N.Y., Harry N Abrams)

JANIS, SIDNEY (1944) *Abstract and Surrealist Art in America* (N.Y., Reynal & Hitchcock)

JOHNSON, ELLEN (1982) *American Artists on Art From 1940–1980* (N.Y., Harper & Row)

KEPES, GYORGY (1960) *The Visual Arts Today* (Middletown, Conn., Wesleyan University Press)

KOOTZ, SAMUEL M (1943) *New Frontiers in American Painting* (N.Y., Hastings House)

KOZLOFF, MAX (1965) 'The New American Painting', in: KOSTELANETZ, RICHARD (Ed) *The New American Arts* (N.Y., Horizon Press)

———— (1968) *Renderings: Critical Essays on a Century of Modern Art* (N.Y., Simon & Schuster)

KRAMER, HILTON (1973) *The Age of the Avant-garde: An Art Chronicle 1956–1972* (N.Y., Farrar, Strauss & Giroux)

KUH, KATHERINE (1962) *The Artist's Voice: Talks with Seventeen Artists* (N.Y. and Evanston, Ill., Harper and Row)

KUSPIT, DONALD (1979) *Clement Greenberg: Art Critic* (Madison, Wis., University of Wisconsin Press)

———— (1984) *The Critic Is Artist: The Intentionality of Art* (Ann Arbor, Mich., UMI Research Press)

LARKIN, OLIVER W. (1960) *Art and Life in America* (rev. ed., N.Y., Holt, Rinehart and Winston)

LEVY JULIEN (1936) *Surrealism* (N.Y., Black Sun Press)

LIPPARD, LUCY (1981) *Ad Reinhardt* (N.Y., Abrams)

McCOUBRY, JOHN W. (1963) *American Tradition in Painting* (N.Y., Braziller)

McDARRAH, FRED W. (1961) *The Artist's World in Pictures* (N.Y., E. P. Dutton)

MADDOX, ROBERT JAMES (1973) *The New Left and the Origins of Cold War* (Princeton, Princeton University Press)

MENDELOWITZ, DANIEL M. (1960) *A History of American Art* (N.Y., Holt, Rinehart & Winston)

MILLER, DOROTHY (1952). *Fifteen Americans* (N.Y., Museum of Modern Art)

MITCHELL, W.J.T. (Ed) (1983) *The Politics of Interpretation* (Chicago, University of Chicago Press)

MOTHERWELL, ROBERT (Ed) (1947–1955) *Documents of Modern Art* (N.Y., Witternborn Schultz)

MOTHERWELL, ROBERT, and AD REINHARDT (Eds) (1952) *Modern Artists in America* (N.Y., Witternborn Schultz)

MUSEUM OF MODERN ART (1959) *The New American Painting* (N.Y., MoMA)

O'BRIAN, JOHN (1986) *Clement Greenberg: The Collected Essays & Art Criticism* (Chicago and London, University of Chicago Press); Vol. I 'Perceptions and Judgments 1939–44'; Vol. II 'Arrogant Purpose 1945–49'

O'HARA, FRANK (1959) *Jackson Pollock* (N.Y., Braziller)

PEARSON, RALPH M. (1954) *The Modern Renaissance in American Art* (N.Y., Harper and Row)

PELLEGRINI, ALDO (1966) *New Tendencies in Art* (N.Y., Crown)

POGGIOLI, RENATO (1968) *The Theory of the Avant-garde* (Cambridge, Harvard University Press)

POLCARI, STEPHEN (1991) *Abstract Expressionism and The Modern Experience* (Cambridge, Cambridge University Press)

PONENTE, NELLO (1960) *Modern Painting: Contemporary Trends* (Lausanne, Albert Skira)

RASMUSSEN, WALDO (1966) *Two Decades of American Painting* (N.Y., Museum of Modern Art)

READ, HERBERT (1948) *Culture and Education in a World Order* (N.Y., Museum of Modern Art)

RODMAN, SELDEN (1957) *Conversations with Artists* (N.Y., Denvir–Adair)

ROSE, BARBARA (1967) *American Art Since 1900: A Critical History* (N.Y., Frederick A Praeger)

———— (Ed.) (1968) *Readings in American Art Since 1900: A Documentary Survey* (N.Y., Frederick A Praeger)

ROSENBERG, BERNARD, and NORRIS FLIEGAL (1965) *The Vanguard Artist: Portrait and Self-portrait* (Chicago, Quadrangle Books)

ROSENBERG, HAROLD (1959) *The Tradition of the New* (N.Y., Horizon Press)

———— (1966) *The Anxious Object: Art Today and its Audience* (N.Y., Horizon Press)

———— (1969) *Art Works and Packages* (N.Y., Horizon Press)

———— (1972) *The De-Definition of Art* (N.Y., Horizon Press)

———— (1973) *Discovering the Present* (Chicago, University of Chicago Press)

———— (1975) *Art on the Edge: Creators and Situations* (N.Y., Macmillan)

———— (1985) *Art and Other Serious Matters* (Chicago, University of Chicago Press)

———— (1985) *The Case of the Baffled Radical* (Chicago, University of Chicago Press)

SANDLER , IRVING, LUCY LIPPARD, G.R. SWENSON, and WALDO RASMUSSEN (1966) *Two Decades of American Painting* (N.Y., Museum of Modern Art)

SANDLER, IRVING (1970) *The Triumph of American Painting* (N.Y., Harper and Row)

———— (1978) *The New York School: The Painters and Sculptors of the Fifties* (N.Y., Harper and Row)

SEITZ, WILLIAM C (1955) *Abstract Expressionist Painting in America*, Unpublished Ph.D. dissertation, Princeton University

SHAPIRO, DAVID and SHAPIRO CECILE (Eds) (1990) *Abstract Expressionism: A Critical Record* (Cambridge, Cambridge University Press)

SOBY, JAMES THRALL (1948) *Contemporary Painters* (N.Y., Museum of Modern Art)

SOLBERG, CARL. *Riding High: America in the Cold War* (N.Y., Mason and Lipscome, 1973.

SOLOMON, ALAN (1969) *Painting in N.Y., 1944 to 1969* (Pasadena, Calif., Pasadena Museum of Art)

STEINBERG LEO (1972) *Other Criteria: Confrontations with Twentieth Century Art* (N.Y., Oxford University Press)

THEOARIS, ATHAN (1971) *Seeds of Repression: Harry S Truman and the Origins of McCarthyism* (Chicago, Quadrangle)

TUCHMAN, MAURICE (1965) *The New York School: The First Generation: Paintings of the 1940s and 1950s* (Los Angeles, Los Angeles County Museum)

WARREN, FRANK A. III (1966) *Liberals and Communism: The 'Red Decade' Revisited* (Bloomington, Indiana University Press)

WESCHLER, JEFFREY (1977) *Surrealism and American Art, 1931–37* (New Brunswick; Rutgers University Art Gallery)

WIND, EDGAR (1963) *Art and Anarchy* (London, Faber & Faber)

3. ARTICLES

ACKERMAN, JAMES S. (1969) 'The Demise of the Avant-garde: Notes on the Sociology of Recent American Art.' *Comparative Studies in Society and History*, October

ALLOWAY, LAWRENCE (1963) 'The American Sublime' *Living Arts*,1, No. 2, June

ARMSTRONG, RICHARD (1964) 'Abstract Expressionism Was an American Revolution,' *Canadian Art*, XXI, No. 93, September-October

ASHTON, DORE (1959) 'Painting in New York Today', *Cimaise*, Series 4, No 2, November-December

——— (1964) 'Abstract Expressionism Isn't Dead', *Studio*,CLXIV, No. 883, September-October

BENJAMIN, WALTER (1970) ' The Author as Producer.' *New Left Review* 62, July-August

BERGER, JOHN (1958) 'The White Cell.' *New Statesman*, 22 November

BOWNESS, ALAN (1967) 'The American Invasion and the British Response.' *Studio International* (London), June

BRADEN, THOMAS W. (1967) 'I'm Glad the CIA Is Immoral.' *Saturday Evening Post*, 20 May

CALAS, NICOLAS (1967) 'Subject Matter in the Work of Barnett Newman.' *Arts*, November

CLARKE, T.J. (1982) 'Clement Greenberg's Theory of Art.' *Critical Inquiry*, 9 September

COCKCROFT, EVA (1974) 'Abstract Expressionism: Weapon of the Cold War.' *Artforum* 12, June, pp.39–41

COLT,PRICILLA (1964) 'Notes on Ad Reinhardt.' *Art International* (Lugano), October

CRAVEN, DAVID (1990) 'Abstract Expressionism, Automatism and The Age of Automation.' *Art History*, Vol.13.No. 1. March

DAVIS, STUART (1943) 'What About Modern Art and Democracy?' *Harper's* 188, December

DE KOONING, ELAINE (1950) 'Hans Hofmann Paints a Picture.' *Art News*, February

——— (1955) 'Subject: What, How or Who?' *Art News*, LIV, No.2, April

DONNELL, RADKA ZAGAROFF (1964) 'Space in Abstract Expressionism.' *Journal of Aesthetics*, Winter

DUNLOP, IAN (1979) 'Edvard Munch, Barnett Newman and Mark Rothko: the Search for the Sublime.' *Arts Magazine,*. Vol. 53, No. 6, February

EPSTEIN, JASON (1967) 'The CIA and The Intellectuals.' *New York Times Review of Books*, April 20, pp.16–21

FERREN, JOHN (1958) 'Epitaph for an Avant-Garde: The Motivating Idea of the Abstract Expressionist Movement as Seen by an Artist Active on the New York Scene,' *Arts*, XXXIII, No. 2, November

FINKELSTEIN, SIDNEY (1947) 'National Art and Universal Art.' *Mainstream* 1, No. 3, Summer, pp.345–61

FIRESTONE, EVAN R (1981) 'Color in Abstract Expressionism: Sources and Background for Meaning'. *Arts Magazine*, March

FRIEDMAN, MARTIN (1963) 'Private Symbols in Public Statements.' *Art News*, May

FULLER, PETER (1979) 'American Painting Since the Last War.' *Art Monthly* (London), July-August

GIBSON, ANN (1981) 'Regression and Colour in Abstract Expressionism: Barnett Newman, Mark Rothko, and Clifford Still.' *Arts*, March

GOLDIN, AMY (1965) 'Harold Rosenberg's Magic Circle.' *Arts*, November.

GOLDWATER, ROBERT (1949) 'A Symposium: The State of American Art.' *Magazine of Art*, March

—— (1961) 'Art and Criticism.' *Partisan Review*, May-June

GOLUB, LEON (1955) 'A Critique of Abstract Expressionism,' *College Art Journal*, Vol. 14, No 2, Winter

GOTTLIEB, ADOLPH (1954) 'The Artist and the Public.' *Art in America*, December

—— (1955) 'Artist and Society: A Brief Case History.' *College Art Journal*, Winter

GREENBERG, CLEMENT (1940) 'Towards a New Laocoon.' *Partisan Review*, VII no. 4, July-August, pp.296–310

—— (1945) 'Most Important Art Teacher of Our Time.' *The Nation*, 21 April

—— (1948) 'The Decline of Cubism.' *Partisan Review*, March

—— (1959) 'Hans Hofmann: Grand Old Rebel.' *Art News*, January

—— (1962) 'After Abstract Expressionism,' *Art International*, VI, No.8, October 25

—— (1965) 'America Takes The Lead, 1945–1965.' *Art in America*, August

—— (1967) 'Complaints of an Art Critic'. *Art Forum*, Vol. VI. no.2, October

GUILBAUT, SERGE (1980) 'The New Adventures of the Avant-Garde in America,' *October*, Winter

HAUPTMAN, WILLIAM (1973) 'The Suppression of Art in the McCarthy Decade.' *Artforum*, October

HERBERT, JAMES D (1984–85) 'The Political Origins of Abstract Expressionist Criticism.' *Telos*, Winter

HERON, PATRICK (1968) 'A Kind of Cultural Imperialism' *Studio International* (London), February

HESS, THOMAS B (1951) ' Is Abstraction Un-American?' *Art News*, February
—— (1953) 'Reinhardt: The Position and Perils of Purity.' *Art News*, December
—— (1963) 'The Phony Crisis in American Art.' *Art News*, Summer

HOFMANN, HANS (1955) 'Hofmann Explains his Paintings.' *Bennington College Alumnae Quarterly*, Fall

HUDSON, ANDREW (1966) 'The Case for Exporting Nation's Avant-garde Art.' *Washington Post*, 27 March
—— (1967) 'Scale as Content.' *Artforum*, December

HUNTER, SAM (1964) 'Abstract Expressionism—Then and Now.' *Canadian Art*, September-October

JARRELL, RANDALL (1957) 'The Age of the Chimpanzee; A Poet Argues Devil's Advocate Against the Canonization of Abstract Expressionism,' *Art News*, LVI, No 4, Summer

JEWELL, EDWARD ALDEN (1943) 'In the Realms of Art: A New Platform, 'Globalism' Pops into View.' *The New York Times*, 13 June

JUDD, DONALD (1967) 'Jackson Pollock.' *Arts*, April
—— (1970) 'Barnett Newman.' *Studio International* (London), February

KAPROW, ALAN (1958) 'The Legacy of Jackson Pollock.' *Art News*, October

KAVOLIS, VYTAUTUS (1963) 'Abstract Expressionism and Puritanism.' *Journal of Aesthetics and Art Criticism*, Spring

KINGSLEY, APRIL (1985) 'Adolph Gottlieb in the Fifties: Different Times Require Different Images.' *Arts*, September

KOSLOFF, MAX (1965) 'The Critical Reception of Abstract Expressionism.' *Arts*, 40, no.2, December, pp.27–33

KRAMER, HILTON (1953) 'The New American Painting,' *Partisan Review*, XX, No 4, July-August
—— (1959) 'Critics of American Painting,' *Arts*, XXXIV, No. 1, October
—— (1964) 'Notes on Painting in New York,' *Arts Yearbook*, No.7
—— (1973) 'American Painting During the Cold War.' *Artforum*, May

KRAUSS, ROSALIND E (1982) 'Contra Carmean: The Abstract Pollock.' *Art in America*, Summer

KUSPIT, DONALD (1978) 'Meyer Schapiro's Marxism.' *Arts*, November

LANGSNER, JULES (1951) 'More About the School of New York.' *Arts & Architecture*, May

LARSEN, SUSAN C. (1974) 'The American Abstract Artists: A Documentary History, 1936–41.' *Archives of American Art Journal*, 14, no. 1, pp.2–7

LASCH, CHRISTOPHER (1967) 'The Cultural Cold War.' *The Nation*, 11 September

LEJA, MICHAEL (1990) 'Jackson Pollock: Representing The Unconscious'. *Art History*, Vol.13. No 4, December

LEVINE, NEIL (1965) 'The New York School Question.' *Art News*, September

LONGREN, LILLIAN (1958) 'Abstract Expressionism in America.' *Art International* (Lugano), April

LUCIE-SMITH, EDWARD (1968) 'An Interview with Clement Greenberg.' *Studio International*, January

LYOTARD, J.F. (1984) 'Sublime and the Avant-Garde.' *Artforum*, April

MACAGY, DOUGLAS (1949) 'Mark Rothko.' *Magazine of Art*, January

McBRIDE, HENRY (1949) 'Review: Jackson Pollock.' *New York Sun*, 29 December

———— (1953) 'Abstract Report for April.' *Art News*, April

MARSHALL GEORGE C. (1947) 'Announcement of Secretary of State Marshall: No More Government Money for Modern Art.' *New York Times*, 6 May, p. 24

MATTER, MERCEDES (1946) 'Hans Hofmann.' *Arts & Architecture*. May

MATTHEWS, JANE. 'Art and Politics in Cold war America'. *American Historical Review*, October 1976.

MOTHERWELL, ROBERT (1944) 'Painters' Objects.' *Partisan Review*, Winter

———— (1954) 'The Painter and the Audience.' *Perspectives USA*, Autumn

MYERS, JOHN BERNARD (1960) 'The Impact of Surrealism on the New York School,' *Evergreen Review*, IV, No.12, March-April

NEWMAN, BARNETT (1947) 'The First Man Was an Artist.' *Tiger's Eye*, October

———— (1948) 'The Sublime is Now.' *Tiger's Eye*, Vol.1, No.6. December

ORTON, FRED and GRISELDA POLLOCK (1981) 'Avant-gardes and Partisans Reviewed.' *Art History*, September

PACH, WALTER (1950) 'Art Must be Modern.' *Atlantic Monthly* 185, May, pp.44–48

PARTISAN REVIEW (1952) 'Our Country and its Culture: a Symposium.' *Partisan Review*, May-June

PAVIA, PHILLIP (1960) 'The Unwanted Title: Abstract Expressionism,' *It Is*, No. 5, Spring

PAVIA, PHILLIP and IRVING SANDLER (1960) 'The Philadelphia Panel.' *It Is*, Spring

POHL, FRANCIS K (1981) 'An American in Venice: Ben Sherman and United States Foreign Policy at the 1954 Venice Biennale.' *Art History*, March

PORTER, FAIRFIELD (1962) 'Class Content in American Abstract Painting.' *Art News*, April

READ, HERBERT (1956) 'An Art of Internal Necessity.' *Quadrum* (Brussels), No. 1

———— (1960) 'Social Significance in Abstract Art.' *Quadrum* (Brussels), No. 9

REINHARDT, AD (1953) 'The Artist in Search of an Academy.' *College Art Journal*, Spring

———— (1954) 'Who Are the Artists.' *College Art Journal*, Spring

———— (1956) 'The Art-Politics Syndrome: A Project in Integration.' *Art News*, November

———— (1957) 'Twelve Rules for a New Academy.' *Art News*, May

———— (1962) 'Art-as-Art.' *Art International* (Lugano), December

———— (1964) 'The Next Revolution in Art: Art-as-Dogma.' *Art International* (Lugano), March

REISE, BARBARA M. (1968) 'Greenberg and the Group: A Retrospective View.' *Studio International*, Part 1, Vol. 175. No. 901, May, pp.245–257; Part 2, Vol. 175. No 902, June 1968, pp.314–316

———— (1970) 'The Stance of Barnett Newmann.' *Studio International* (London), February

ROMANOW, A. (1962) 'Mister Barr's Abstract Souvenir.' *Art News*, January

ROSE, BARBARA (1979) 'Hans Namuth's Photographs and the Jackson Pollock Myth: Media Impact and the Failure of Criticism.' *Arts*, March

ROSENBERG, HAROLD (1960) 'Critic Within the Act,' *Art News*, LIX, No 6, October

———— (1964) 'After Next, What?' *Art in America*, April

ROSENBLUM, ROBERT (1961) 'The Abstract Sublime.' *Art News*, February

ROTHKO, MARK et al. (1947) 'The Ides of Art: The Attitudes of Ten Artists on Their Art and Contemporariness.' *Tiger's Eye*, December

RUBIN, WILLIAM (1958) 'The New York School: Then and Now,' *Art International*, 11, Part 1, Nos.2–3 and Part 2, Nos. 4–5

RUSSELL, JOHN (1959) 'The New American Painting Captures Europe.' *Horizon* (London), November

SANDLER, IRVING (1959) 'Discussion: Is There a New Academy?' *Art News*, Summer and September

SCHAPIRO, MEYER (1956) 'The Younger American Painters of Today.' *The Listener*, 26 January

———— (1957) 'The Liberating Quality of Avant-Garde Art.' *Art News*, Summer

SECKLER, DOROTHY (1963) 'Artist in America: Victim of the Culture Boom?' *Art in America*, December

SEELEY, CAROL (1950) 'On The Nature of Abstract Painting in America.' *Magazine of Art*, 43, May, pp.163–68

SEIBERLING, DOROTHY (1959) 'Abstract Expressionists,' Part I: 'Baffling U.S. Art: What it is About,' *Life*, XLVII, No. 19, 9 November; Part II: 'The Varied Art of Four Pioneers,' XLVII, No. 20, 16 November

SEITZ, WILLIAM (1963) 'The Rise and Dissolution of the Avant-Garde.' *Vogue*, September

SHAPIRO, DAVID, and SHAPIRO, CECILE (1976) 'Abstract Expressionism: The Politics of Apolitical Painting.' *Prospect* 3, pp.175–214

SIVARDS, SUSAN (1984) 'The State Department 'Advancing Modern Art ' Exhibition of 1946 and the Advance of American Art.' *Arts Magazine*, April

SLOANE, J.C. (1961) 'On the Resources of Non-objective Art.' *Journal of Aesthetics and Art Criticism*, Summer

SOBY, JAMES THRALL (1949) 'Does Our Art Impress Europe?' *Saturday Review*, 6 August, pp.142–49

SPAETH, ELOISE (1951–52) 'America's Cultural Responsibilities Abroad.' *College Art Journal*, Winter

STEINKE, JOHN, and WEINSTEIN, JAMES (1963) 'McCarthy and the Liberals.' *Studies on the Left*, 2, no.3, pp.43–50

SUTTON, DENYS (1949) 'The Challenge of American Art.' *Horizon* (London), October

SWEENEY, JAMES JOHNSON (1955) ' Recent Trends in American Painting.' *Bennington College Alumnae Quarterly*, Fall

SYLVESTER, DAVID (1956) 'Expressionism, German and American,' *Arts*, XXXI, No 3, December

TILLIM, SIDNEY (1957) 'Jackson Pollock: A Critical Evaluation.' *College Art Journal*, Spring

TROTSKY, LEON (1938) 'Art and Politics.' *Partisan Review*, August–September, pp.3–60

YOUNG, MAHRONI SHARP (1969) 'The Metropolitan Museum of Art Centenary Exhibition 1: The New York School.' *Apollo* (London), November

Index

key:
§ = works of art
¶ = illustrated work of art
§§ = writings
§§§ = exhibitions